First published in Great Britain 2024 by Lost in Cult
This edition published in Great Britain 2024 by Expanse
An imprint of HarperCollins*Publishers*
1 London Bridge Street, London SE1 9GF
www.farshore.co.uk

HarperCollins*Publishers*
Macken House, 39/40 Mayor Street Upper,
Dublin 1, D01 C9W8, Ireland

EDITORIAL DIRECTION Abram Buehner and Damien McFerran
EDITORIAL SUPPORT AND PROOFING Benjamin Hayhoe
LEAD DESIGNER Nikki Duffett
ADDITIONAL DESIGN Eliza Marzec, Jordan Rosenberg and Jeff Wiggins
ART DIRECTION Stephen Maurice Graham
CREATIVE DIRECTION Jon Doyle

SPONSORED BY
Embracer Games Archive
Learn more at https://embracergamesarchive.com

SPECIAL THANKS
The Embracer Games Archive, HarperCollins, Expanse, Andrew Dickinson, Ellie Stores, Andrew Leung, the Lost In Cult team,
the Time Extension Team, the Hookshot Media team, the Retro Computer Museum and our incredible backers.

IMAGE RESOURCES
Hannah Kwan Cosslemon, Stephen Maurice Graham, Imogen May, Damien McFerran, LaunchBox Games Database, The Cover Project,
Wikipedia, Internet Archive, MobyGames, Nintendo, Sega Retro, GameStop, Amazon, Walmart, Best Buy, Microsoft, Bungie, eBay,
Arcade1Up, GameFAQs, C64 Wiki, Atari, Sega, The Dot Eaters, Retro Consoles Wiki, CNET, Polygon, Play-Asia, The Verge

ISBN 978 0 00 861658 8
Printed in India
001

This book contains FSC™ certified paper and other controlled
sources to ensure responsible forest management.

For more information visit: www.harpercollins.co.uk/green

THE CONSOLE CHRONICLES

Established in 2022, Time Extension aims to celebrate the rich history and incredible cultural impact of video gaming. The brainchild of Hookshot co-founders Damien McFerran and Anthony Dickens, the site's goal is to look back into the past to uncover hidden gems, proclaim stone-cold classics and shed light on the human stories behind cherished games, companies and systems — as well as covering remasters, re-releases and 'new' retro hardware. Hookshot's network also includes Nintendo Life, Push Square and Pure Xbox.

● Foreword 004

The Story of Generation 1 006
Magnavox Odyssey 014
PONG 020

The Story of Generation 2 026
Atari 2600 036
Intellivision 044
ColecoVision 050
My First Day at Atari 056

The Story of Generation 3 060
Nintendo Entertainment System 068
Famiclone Dreams 076
Cutting Time 080
Sega Master System 084
Atari 7800 092
Commodore 64 098

The Story of Generation 4 106
PC Engine 116
Sega Mega Drive 124
SNES 132
The Tragedy of Selling Hardware 140
Neo Geo 144

The Story of Generation 5 152
3DO Interactive Multiplayer 160
Atari Jaguar 164
Sega Saturn 170
PlayStation 178

An Ode to PS1 Kiosks 186
Twilight Translations 192
Nintendo 64 196

The Story of Generation 6 208
Dreaming in Argentina 216
Sega Dreamcast 220
PlayStation 2 228
GameCube 236
Visions of Nintendo's Future 248
Xbox 252

The Story of Generation 7 262
Xbox 360 270
Finishing the Fight 278
PlayStation 3 282
Wii 290
The Library We Overlook 300
Indies As We Know Them 306

The Story of Generation 8 314
Wii U 322
To Lose Console Wars 328
PlayStation 4 332
Xbox One 340
Family Game Nights 348
Nintendo Switch 352

Generation 9: The Story So Far 360

Preservation Through Use 374

FOREWORD.

words *Kit Ellis & Krysta Yang*

If you were to ask us about the defining moments in our childhoods, we'd both immediately tell you about one pretty darn high on both of our lists: getting an NES for Christmas. We may have received our respective systems in different years alongside different games, but the magic of being granted access to a near-unlimited source of adventure, storytelling and exploration will remain unforgettable, shaping our lives from that point forward. The mind-bending puzzles in *The Legend of Zelda* led us to the meticulous narrative of *Final Fantasy*, and from there, to limitless possibilities of *Grand Theft Auto* with countless experiences in between — all made possible by video game consoles.

Decades after those Christmas surprises, we had the opportunity to work at Nintendo and get a glimpse into how consoles and their wonderful games are made. To our relief, working at Nintendo didn't deflate our love or enthusiasm for games, but rather, it gave us a new perspective on why we love them in the first place. We were able to meet the people who played a part in creating consoles like the Nintendo Switch, coming to understand that these systems are not simply collections of technological components. They result from the very human act of creation meant to enable game developers' limitless imaginations.

There really is nothing like the console generation cycle in most other forms of entertainment. A new system is released, games are developed for it, people enjoy them, but after a number of years, we all start over from scratch. It's a highly unusual practice, if you stop to think about it. Most consumer products feature immediately apparent evolutionary lines as they change over time, but with consoles, the possibility of radical change is often what can either drive the medium forward or bring a company to ruin. We saw this ourselves firsthand, as the runaway success of the Wii and motion controls led to the multi-screen disappointment of the Wii U. But after that, redemption was found once again through the unexpected hybrid innovation of the Nintendo Switch. Some aren't so lucky to be afforded an opportunity to reverse their fortunes after a console misstep. A simple internet search will take you through any number of 'what if' scenarios for how Sega could still be in the console business. That sense of generational upheaval, no matter how abrupt it may seem, is one of the reasons why video games have changed so much over a relatively short period of time.

As two people born in the '80s, we feel increasingly lucky that we've been able to see, experience, and participate in the great majority of console gaming's history. We regularly hear from fans who tell us that their first console was the GameCube or Wii. Many of these fans have been able to build up encyclopaedic knowledge of the games and systems that came before their time. But there really is no substitute for being there. The conversations in schoolyards or family gatherings, bingeing multiplayer games with friends at a sleepover, the excited trips to a store to see if the big new game had arrived yet — these were core experiences that, in some cases, remain as memorable as the games themselves. As video games become a more mature medium and more people become a part of the gaming community, books like this one play an invaluable role in providing the all-important context around how we all made it to this point.

Over the years, many have claimed that the time for video game consoles will soon be coming to an end. And yet they endure, stronger than ever. Sure, a contemporary TV can probably crunch plenty of pixels on its own, and a modern smartphone is a miracle capable of doing almost anything. Despite the steady march of advanced, consolidated technology, there is something elemental about having a device dedicated to games, the form of art and entertainment that matters the most to many of us. So much in our lives is disposable now — but we've all held onto a game console beyond the point of playing it frequently or even functioning properly. Our NES systems gave up the ghost a long while ago. Yet they are still with us, and we would never let them go. Sometimes we pick them up and look at them longingly, taking in the details as if for the first time. They represent the joy and memories inside all of us, and the possibility of all we hope to experience in the future. We're honoured to be a part of this book, and we hope you enjoy reading it!

art *Stephen Maurice Graham*

5

THE STORY OF GENERATION 1.

words Christian Donlan

Video games are made of light, but they also draw certain qualities from the hard-ware — the plastic and silicon and exotic metals — that they run on. The arrival of the home console, as a result, marks the point where video games first become personable, and even domestic. Arcade machines have their own distinct pleasures, and over the years they have hosted many of the same games that people play on consoles. They have frequently served as those games' points of origin, too. But hefty coin-operated cabinets are games created for a world in which people travel to the machine itself, and generally play it in specific shared settings, like a bar or an arcade.

With consoles, though, games came to the players. Since the '70s, we've brought these machines back to our homes, back to our living rooms, and installed them under the television set. The battle for plug sockets, the snarl of tangled cables that must be navigated every now and then, the fight for a little window of ownership of the TV screen in a busy household. These are all phenomena of home consoles. Consoles have brought certain unique luxuries too: luxuries in terms of time and of access. There's no queuing amongst strangers for the cabinet with home consoles. There's no feeding in money for each turn, each extra life.

And there's more, too. You frequently stand at an arcade game, but consoles are enjoyed seated, ideally on a sofa, with a controller in hand and a world unfolding on the nearby screen. The console itself can be lifted and moved around, all angles inspected. With its buttons and ports, it's a fiercely tactile object.

Because of this last quality in particular, it can be hard to decide where to start with consoles. The history of these strange and delightful machines — and of modern video games in general — properly gets going towards the end of the 20th Century. But the origin of things that carry a hint of the video game console can be traced as far back as you want to go.

To put it another way: as long as there have been machines, there have been people who wanted to mess around with them for the sheer fun of it. You see something of this impulse, say, in a letter that Geoffrey Chaucer once wrote to his ten-year-old son regarding an astrolabe, an early scientific instrument that served as a portable model of the cosmos.

"This was a must-have technology," says the art historian Neil MacGregor in an episode about the astrolabe on his radio show, A History of the World in 100 Objects. Like "techy boys of every generation," MacGregor explains, Chaucer's son was eager to get ahold of this new and cutting-edge mechanism. What emerges in Chaucer's letter is a sense that he has a glimmer of understanding that his son wanted, more than anything, to play with the astrolabe, to make sense of it through interaction.

Chaucer's letter dates from the late 1300s, but there's something very modern to it. It hints to us that there is a sense of play inherent in many mechanisms.

The more standard history of video games themselves makes this same point again and again. Tennis for Two, created by the American physicist William Higinboth-am in 1958, for a public exhibition at Brookhaven National Laboratory in Long Island, used an oscilloscope to render, as the name suggests, a game of tennis. Needless to add, the computer Tennis for Two ran on was more traditionally used to simulate

photography Damien McFerran

001

001
TV Tennis Electrotennis
1975

002
Tele-Spiel ES-2201
1975

trajectories of things other than tennis balls. Equally, *Spacewar!*, the space combat game from 1962 whose design would heavily inspire the world's first commercial arcade games a few years later, was hacked together on a PDP-1 computer at MIT for no purpose other than the sheer delight in making it all work.

From games like *Spacewar!* and *Tennis for Two* we got arcade games, and from arcade games, we very quickly got home consoles. But the early consoles, particularly the first generation of consoles, a grouping which loosely refers to machines released in the '70s and very early '80s, are extremely odd beasts to modern eyes. Sure, they generally had a box that plugged into a television and controllers of some sort that players used to interact with the games that unfolded on the screen, but artistically and creatively they can seem very distant from the machines sat next to our televisions today.

This is never truer than at the very start of things.

Initially released in 1972, the Magnavox Odyssey was the first home console. The Magnavox Odyssey, what a beautifully awkward name. The past and the future colliding in two words and six syllables. Anyone purchasing the machine at the time for $99 — a huge amount for a consumer device like this, clocking in somewhere around $700 or more in 2023 money — would receive the console, which came in the form of a curvy, sculpted plastic plinth, and two controllers attached to it by cables. The controllers were designed to sit on a flat surface and each came with a reset button and three dials.

Despite being unprecedented in consumer electronics — and despite its expense — it can be hard to conceive of just how basic the Odyssey is by today's standards. The Odyssey could not generate sound, and could only display three square dots and a line on the TV screen. From these simple elements designers had to construct all of its games, which in turn came on 'game cards,' or printed circuit boards that slotted into the main machine. It gets weirder — or, perhaps, more inventive, depending on your viewpoint. To differentiate the various games — to separate tennis, say, from a game about skiing in the mountains — plastic overlays were also included with the Odyssey that could be stuck to the TV screen, providing a little more context for the basic graphics. Ingeniously these overlays used TV static to stay in place.

It's telling that alongside the controllers and overlays, the Odyssey also shipped with things like dice and poker chips and cards and counters. Seen in this context, the Odyssey starts to make at least a sort of sense. The first games console was seen by the company that produced it — if not by the people who actually created it — as being a simple extension of the kind of family game nights that might normally revolve around Monopoly, or cards, or Backgammon. It was a games console, but what unfolded on the screen might not contain the entirety of the game being played, in the same way as you cannot play a full game of Monopoly or Backgammon with just a board.

The creator of the Odyssey, the engineer Ralph Baer, who hated the inclusion of these physical playing pieces, had initially come up with the idea for a machine that played games on a television back in the early '50s, but it was August 1966, after the concept returned to him unbidden, when he would write-up a pitch document.

Baer was working for the military contractor Sanders Associates at the time. The concept for a TV games machine went through various prototypes over the next few years, while the proposed sales price, which Baer hoped would be around $25, started to inch higher and higher. As a military contractor, Sanders eventually decided to sell the rights for the machine to another company rather than produce it internally, and Magnavox, a US consumer electronics outfit that would soon be purchased by Philips, signed on at the start of 1971, with the console launching in late 1972.

Sales for the Odyssey were slow, partly because the idea was so new and unusual, and partly because the price was steep and the Odyssey was only available through Magnavox dealers. Baer was furious at what he saw as the over-engineering of the machine and its high cost. His simple games, made of dots and lines, were meant to be the output of a console that could comfortably be an impulsive kind of purchase. $25 would be no big deal to a lot of households, whereas $100 was a serious outlay. Despite a weak start, the console was released in markets outside of the US in 1973, before being discontinued in 1975, at which point a series of Odyssey dedicated systems, ditching the game cards for games stored within the machine itself, were released.

Despite its limited success, and its more exotic elements such as those screen overlays, the Odyssey is the first product that recognisably looks like a home video game console. It may not have been the breakthrough product any fledgling industry needs in order to truly get going, but it had a direct impact on at least one of the machines that followed it, which would prove much more successful.

Nolan Bushnell discovered *Spacewar!* as an undergraduate at the University of Utah in the '60s and became hooked on its challenging combat and futuristic visuals. Already something of an entrepreneur, Bushnell created a bespoke version of the game, which he called *Computer Space*, and which was released as an arcade game in 1971. *Computer Space* is truly a beautiful machine, with a gloriously curvy fiberglass body, all smooth surfaces and metallic glitter. But like *Spacewar!* itself, *Computer Space* was incredibly complicated to play, requiring players to not only control ships and fire projectiles, but engage thoughtfully with the in-game physics. It was not made

003

004

for the quickfire turnaround play and heavy foot traffic of a machine parked at the back of a noisy bar.

1,500 *Computer Space* machines were built and, despite early hopes, no more were ever ordered. Regardless of this early failure, and perhaps carrying useful lessons from it, in 1972 Bushnell went on to start his own company. He named it Atari, after a term in the Japanese game Go, whose rough equivalent is "check" in Chess.

That year, Bushnell gave the young engineer Al Alcorn, Atari's second employee, a ping-pong game to design and create as his first project with the company. Alcorn was a creative thinker and added his own elements to the basic game as he worked, including a ball whose speed accelerated during play, and paddles that would send the ball ricocheting away at different angles depending on where they were struck.

Alcorn's design became the arcade game *Pong* — a model of simplicity when compared to *Computer Space*, with player instructions cut down to a single sentence, which has long since entered the general culture of video games: *Avoid missing ball for high score*. And *Pong*, following a legendary test run at Andy Capp's Tavern in Sunnyvale California, became a gigantic hit — big enough to usher in at least one new industry.

Something else happened at that point, too. Just as Atari started marketing *Pong* in 1972, Magnavox took Bushnell's company to court. The claim was simple: Atari's game infringed several of Baer's patents, and Magnavox also had witnesses that stated that Bushnell had seen the Odyssey at a trade-show before work on *Pong* began.

Bushnell settled the suit quickly and for a relatively small fee. It turned out to be a brilliant move, since Atari became a licensee — Magnavox's sole licensee, for a while. Atari had gotten a killer deal, but at least Magnavox could reflect on the fact that, as *Pong*'s success continued, the ailing Odyssey console got a lift in sales, too.

Atari grew quickly, and the company produced Atari Home Pong in 1975. The machine used the same digital technology as the Atari arcade games instead of the

Countless Consoles

Amazingly, an entire book could be filled up with first generation game consoles alone. There are hundreds and hundreds of systems in this enterprising generation where everyone had an equal chance of dominating the burgeoning industry.

003
Interton Video 3000
1976

004
TV Fun Sportsarama 402 - 402C
1977

analog technology used by Odyssey, and the machines cost much less to produce because the component prices were getting cheaper as they evolved. Atari Home Pong was compact and toylike, with chunky plastic, bright PONG branding, and two dials on either side of the console for players to use.

Home Pong was not a video game console in the same way as the Odyssey, because it only played *Pong*. Regardless of this, it was the device that proved that there was a market for consoles in general. In a great bit of deal-making, Atari Home Pong was carried by the department store Sears, and sold 150,000 units in its first season. According to Steven L. Kent in his book The Ultimate History of Video Games, its success was so dramatic that it knocked the reigning champion of the Sears catalogue off its pedestal. Based on the amount of page space compared to the dollars grossed, Home Pong displaced the mighty Adidas Sneaker.

Pong, like *Tennis for Two*, and like many of the games on the Odyssey, looks so simple at first that its success might seem baffling. But once you play it, even now, its appeal becomes clear. Somewhere within the simplicity of the design, *Pong* has genuine character. The additional elements Al Alcorn added to the simple gameplay gave *Pong* a distinct feel in the hand, allowing players to spend time mastering the angle of return and learning how to deal with the increase in the speed of the ball as a match continued.

This is important. How a game feels — or how two similar games might feel subtly different to play — is such a crucial part of video games, and often a major differentiator between success and failure. But this feel is so often a wordless thing, manifesting as a vaguely perceived richness and character that one game has and another simply doesn't. And yet, here it is, right at the point at which the industry really gets going.

Competitors started to arrive towards the end of this first generation of machines. Japan's first home console, released by Epoch in 1975, actually beat Atari Home Pong to the market. The company's TV Tennis Electrotennis was, like Atari, a Magnavox licensee, but its simple take on the ball-and-paddles genre could not compete with Atari's game and the machine was not a success.

Elsewhere, Coleco's Telstar series saw the release of a number of dedicated machines, starting in 1976. They were met with a lot of success. More notably, perhaps, Nintendo, a company that would eventually come to define home video games for several generations, released a series of dedicated consoles of its own. The third of these would feature the early work of Shigeru Miyamoto. Miyamoto had come to the company, which had started out in the 19th century making playing cards before expanding into a bewildering array of markets, with the hope of becoming a toymaker.

Taken as a whole, the first generation of home consoles can be hard to get a clear sense of. Despite their ingenious designs, machines like the Magnavox Odyssey were clearly the result of a medium in its artistic infancy, and while Ralph Baer had offered a glimpse of a future in which consoles ran games that could be plugged in, played, and then swapped out for others, many competitors found it easier and cheaper to go the dedicated route with consoles that played a single game or a handful of simple games built into the machine.

Looking back at these machines, though, it's hard not to feel a thrill at the sheer oddity of some of them — with their controllers that were designed to be sat flat in front of players like quiz show buzzers and manipulated via dials and knobs, their casings not yet settling into anything approaching a standardised design.

This, more than anything, is the mark of the first generation perhaps. It's the mark of companies from around the world taking a gamble on a marketplace where so much of the basic terrain was still up for grabs.

First generation consoles are dated, inevitably, but they're also fascinating. Buy one on eBay and coax it to work on a modern TV, and the experience you'll have is perhaps not so different to that of Geoffrey Chaucer's son fiddling with the moving parts of an astrolabe, turning things this way and that — occasionally, through the thick mists of confusion, receiving fleeting glimpses of the movement of the heavens.

005

005
Telstar Arcade
1977

Savouring Variety

While many assume that first-generation consoles just play Pong or Pong-adjacent games, that's not necessarily true. The SHG Black Point, for instance, features racing titles alongside its ball-based fare. While the overwhelming majority of early games and games systems were concerned with replicating real-life sports, there were still a lot of provocative design decisions being made which laid the groundwork for genres to come.

006

007

008

009

006
Telstar Ranger
1977

007
TV Sport 2002
1977

008
Color TV-Game 6
1977

009
Tele-Sports IV
1978

The modern games marketplace is global, but our hardware really just comes from US or Japanese companies. During the first generation, companies around the world from Germany to Russia to Hong Kong to Italy and more were trying their hand at manufacturing their own consoles.

010

011

012

013

010
Telstar Colortron
1978

011
Color TV-Game Racing 112
1978

012
BSS 01 (1979)
1979

013
TV VADER
1980

the story of generation 1.

MAGNAVOX ODYSSEY.

words *Lewis Packwood*

It all began here. The Magnavox Odyssey, released in 1972, was the world's very first video game console. There was no precedent, no established template for what a home console should do or look like. In fact, the terms 'video game' and 'console' weren't even in widespread usage at this stage: a television advert for the Odyssey in 1972 called it an 'electronic game simulator.'

First Released:
1972

Manufacturer:
Magnavox

Launch Price:
US $99.99

The Odyssey looks alien, sleek, and unique, a product of the Space Age design ethic that swept the world in the '60s, echoing the futuristic shape of rockets and satellites. It's easy to draw a line between the Odyssey's curvaceous white plastic sides and designer Eero Saarinen's famous Tulip chairs, or the curvy seats made by Danish design hero Verner Panton. Humans first walked on the moon just three years before the Odyssey was released, and the console looks like it could well be a prop in Stanley Kubrick's smash-hit 1968 film *2001: A Space Odyssey*. Is the name a coincidence? Probably not.

But it also is a swansong for this Space Age design aesthetic. The final Apollo mission launched in the same year the Odyssey was released, by which point public enthusiasm for space exploration had dramatically cooled. No subsequent console would copy its looks, opting instead for more utilitarian designs.

However, the wood effect that graces the base of the Odyssey would survive, seen again on consoles such as the Fairchild Channel F and the Atari VCS. It may seem strange now to witness wood being incorporated into the design of a video game machine, perhaps the ultimate juxtaposition of low and high tech, but it was common practice in the '70s. Early radios and televisions featured wooden cases, partly to make them blend in with other living room furniture, and even when plastic became the predominant production material, it was still often given a traditional wood patina.

The Odyssey controllers feature a design just as startling as the console itself, and look utterly unlike anything you'd find attached to a gaming machine today. These two chunky rectangular white boxes are designed to sit on a tabletop and are tethered to the mother console via some impressively thick beige cables. A single button on top is labelled 'Reset' — which typically resets the ball in games — while the right side features a dial for adjusting vertical position, and the left side has one for horizontal position. But the left-side dial also has another dial nested on top of it, which is cryptically labelled 'English.' Chiefly a North American term, 'English' is what's usually known as 'side spin' in British English, and this dial is used to move the ball upwards or downwards in games of *Odyssey Tennis* — but more on that later.

Fascinatingly, there was no power cable in the Odyssey box. Instead, the console was powered by six C batteries, which were included with the machine, although an AC adaptor was sold separately. It also came with an 'Antenna Game Switch,' a box that plugged into the aerial terminals on the back of the television. The aerial cable and the RF cable from the console were then attached to the box, and a switch let you flick between 'GAME' and 'TV' to "select either Odyssey or regular television viewing, without having to disturb your antenna connections," according to the manual. Various consoles, such as the NES, would copy this idea in years to come, but the Odyssey did it first. Another quirk of the Odyssey (which was also replicated on some later consoles) is that it has a speed control on the back, which speeds up or slows down the ball in various games.

In contrast to its retro-futuristic Space Age exterior, the inside of the Odyssey looks positively archaic to modern eyes. Microprocessors are notably absent — they wouldn't

photography *Damien McFerran*

15

014

find their way into consumer computers and consoles until the mid-'70s. Instead, the interior of the Odyssey is a complicated nest of wires, capacitors, diodes and transistors, more resembling an old radio than a video game machine.

The Odyssey is not a programmable game console like the later Atari VCS, where game code is saved onto ROM cartridges and then processed by the console's CPU. Instead, it's hardwired, analogue. There is no CPU. Instead, there are discreet modules — jumbles of diodes and transistors — which control things like RF output and vertical and horizontal sync, as well as four 'spot generators.' These four spot generators produce four rectangles: one for player one, another for player two, one for the ball, and one for a line across the screen, which is used to represent the centre line in games such as *Tennis*. And that's all the Odyssey could do: generate four rectangles. There was no sound capability either, and it was strictly black and white — but it's amazing what you can do with four white boxes.

The Odyssey's cartridges, referred to as 'game cards' in the manual, didn't actually have games saved on them, per se. Instead, they rerouted the Odyssey's logic circuitry — simply diverting current between circuits — to change which rectangles were displayed and what behaviour they exhibited. For example, one configuration would cause the ball to bounce back when it hit a player's rectangle; another would cause one player's rectangle to disappear when it was hit by another's. The console came with 12 games: *Table Tennis, Tennis, Football, Hockey, Ski, Submarine, Cat and Mouse, Haunted House, Analogic, Roulette, States* and *Simon Says*. Interestingly though, it only came with six game cards, with some cartridges being used for more than one title. The American football game, for example, used card #3 for passing and kicking plays, and card #4 for running plays. Game card #3 was also used for *Tennis, Hockey*, and *Analogic*.

015

Screen overlays were used to differentiate between the games. These wafer-thin pieces of plastic were held to the screen by static generated by the cathode-ray tube television, although charmingly, the Odyssey was also packaged with a roll of frosted sticky tape for fixing the overlays in place, just in case they kept falling off. Each overlay was provided in two sizes: one smaller version to fit TV sets between 18 and 21 inches and a larger one

Anatomy of a Light Gun

The Magnavox Odyssey Light Rifle belongs to a rare crop of light guns whose design is largely indistinguishable from a real firearm. Before the days of obviously fake weaponry like the NES Zapper, the name of the game was making as realistic a weapon as possible. The Famicom Gun, which was a dead ringer for a cowboy revolver, is another iconic example.

014
Magnavox Odyssey Console
1972

015
Magnavox Odyssey² Console
1978

for sets between 23 and 25 inches. Televisions didn't get much bigger than that in the early '70s.

What's fascinating about these games and their accompanying overlays is that they show the Odyssey was something of a hybrid: a halfway house between the exciting and dynamic video games to come and the traditional board games and parlour games of the past. The Odyssey box came with a wide selection of accessories to be used with the games, including poker chips, stick-on numbers, various board game-style cards, dice, fake money and a football game board. And, as is the case with board games, it was entirely possible to cheat in Odyssey games too.

In *Ski*, for example, the aim was to guide your rectangle along a wriggling dashed-line ski run printed on the screen overlay in the quickest time possible (players provide their own stopwatch). Going off the course or touching a tree or mountain would result in a time penalty — but the console can't tell if you've gone off the course. It's up to the other player to judge whether your rectangle has veered astray. One can imagine the arguments between siblings as they engaged in animated debates about whether the other player's box had touched a tree.

The variety of games packaged with the Odyssey is quite remarkable considering it was limited to displaying four rectangles. A good example is *Haunted House*, which features fantastically complicated rules, along with some unique gameplay where one player acts as

an invisible Ghost and the other plays as a Detective. The Ghost player hides at one of the 'clue positions' on the screen overlay of the haunted house while the Detective player turns their back (again, providing ample opportunity for cheating). The Ghost then manoeuvres the Detective's rectangle to touch theirs, prompting the Ghost rectangle to disappear, after which they return the Detective rectangle to the start, and the Detective is asked to turn around (presuming they haven't been peeking the whole time).

Then the Detective has to carefully guide their rectangle to each of the clue locations in the house, picking up a physical clue card for each one, while carefully avoiding the windows — appearing in one of the windows will mean they have to return to the last clue position. If the Detective draws near to the Ghost, the Ghost player presses the Reset button to reveal their rectangle and shouts 'Boo!'. If the Detective touches the Ghost, they lose half of their clue cards, and the aim is for each player to take turns playing as the Detective in an attempt to reach the secret treasure at the top of the house, with the winner being the one who has gathered the most clue cards along the way. Oh, and there are secret message cards to collect, too, with various different instructions. There's a *lot* going on here, considering it's just two white boxes on a screen.

Another ten games were sold separately — *Fun Zoo, Baseball, Invasion, Wipeout, Volleyball, Handball, Brain Wave, W.I.N., Basketball* and *Interplanetary Voyage* —

016
Attack of the Timelord!
1982

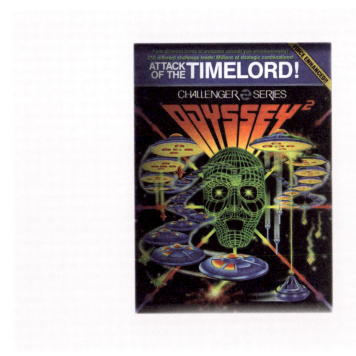

each with their own accessories and screen overlays. In addition, *Soccer* was included with consoles sold outside the United States, and purchasers could also receive a free copy of the game *Percepts* by mail order if they registered their console. The Odyssey even had a rifle-like light gun accessory that was available to buy separately and came with four games: *Prehistoric Safari*, *Dogfight*, *Shootout*, and *Shooting Gallery*.

Although it's regarded to be the first video game console, the Magnavox Odyssey by no means marked the debut of video games. The mathematician Alan Turning wrote a chess computer program on paper back in 1948, although it was too complicated to run on the machines of the time. Physicist William Higinbotham created a tennis game that was displayed on an oscilloscope in 1958, and Steve Russell and various other researchers at the Massachusetts Institute of Technology developed the space combat game *Spacewar!* in 1962. The first arcade video game, *Computer Space* from Atari (then known as Syzygy Engineering), appeared a year before the Odyssey.

But the Odyssey's history goes back a long way. Its designer, Ralph Baer, claimed in his autobiography that he came up with the idea for building a game into a television set in the early '50s, while he was working at Loral Electronics in the Bronx. His superior at the time dismissed the idea, and Baer wouldn't revisit the concept until 1966, by which time he had joined the defence firm Sanders Associates in New Hampshire. While on a business trip to New York, the idea for how to make a game work on a television set popped into his mind. He jotted down a few notes dated September 1, 1966 — notes that would prove crucial many years later in various patent battles.

Baer instructed the technician Bob Tremblay to put together a proof-of-concept prototype called 'TV Game

017

017
Magnavox Odyssey Brown Box Prototype
1971

Unit #1,' which was based on vacuum tubes. He then showed it to the head of R&D at Sanders Associates, who gave him approval to keep on developing the project, even though it had little to do with the company's usual defence work. Indeed, the engineers on the project — including Bill Rusch and Bill Harrison — were often diverted away to work on high-priority defence-related contracts, forcing the project to periodically be put on hold.

By 1968, the team had created its seventh prototype, which they nicknamed the 'Brown Box' on account of the wood-effect vinyl stickers that covered it. Several ideas had been discarded along the way. Initially, Baer and the team had experimented with colour TV output and had considered adding a light-pen accessory for use with a quiz game, but both were ditched. They even experimented with a game that used a wooden pump handle on the top of the unit, and built a joystick with a golf ball on top for use with a golf game, but those, too, were abandoned. However, the core elements of what would later become the Odyssey were all in place, including its light gun, dial controllers and a selection of games, including *Tennis* and *Target Shooting*.

Now, they needed someone to license the technology. Initially, Sanders Associates pursued cable companies with the idea that they could sell the Brown Box as an accessory that might work in tandem with TV broadcasts. For example, the cable company could broadcast the overhead view of a tennis court, which could then provide a colourful background for a tennis video game. But the talks broke down, and instead Sanders approached US TV manufacturers, eventually signing an agreement with Magnavox in 1971.

Magnavox redesigned the Brown Box as the sleek Odyssey, although the components inside were relatively unchanged from the Brown Box prototype. However, the game cards concept was Magnavox's one significant addition — allowing the company to sell additional games (on the Brown Box, different games could be selected by simply using a switch). Initially, Magnavox called the console the Skill-O-Vision, but changed the name to Odyssey ahead of launch following a poor response to the Skill-O-Vision name in focus testing.

The Odyssey was initially sold at $99.95, the equivalent of over $700 in 2023, while the light gun accessory weighed in at $24.95. The high price and the fact that the Odyssey could only be purchased at Magnavox dealerships limited its reach. Nevertheless, the Odyssey sold an estimated 350,000 units between 1972 and its discontinuation in 1975, helped along by steep discounting in later years.

But the Odyssey's main legacy was a single game: *Table Tennis*. Reworked as *Pong* by Atari, it would have a monumental impact on the emerging games industry.

Let's Do the Odyssey (2)

In 1978, the Magnavox Odyssey was succeeded by the Magnavox Odyssey² — one of that console's many regional names. Sold for $179.99, the system would launch for the same price as the NES five years later. While it was a modest success, the system's library contained less than fifty games (Alien Invaders – Plus!, K.C. Munchkin!, and Freedom Fighters! being three of note), and it was a much less pioneering system than its predecessor.

018

019

020

021

018
Table Tennis (Game Card 1)
1972

019
Alien Invaders - Plus!
1980

020
K.C. Munchkin!
1981

021
Freedom Fighters!
1982

PONG.

The Magnavox Odyssey pretty much had the home console market to itself for the first couple of years after its release in 1972, but that was soon to change. As a result of the success of Atari's *Pong* arcade machine, manufacturers scrambled to bring *Pong* into the home, leading to the release of hundreds and hundreds of consoles that all played variations of a single game.

To set the scene: Nolan Bushnell and Ted Dabney formed the company Syzygy Engineering in 1971 and released *Computer Space*, the world's first commercially available arcade video game. It was based on *Spacewar!*, a shoot 'em up created on the PDP-1 computer at the Massachusetts Institute of Technology (MIT) in 1962 by a group of researchers including Steve Russell. *Spacewar!* was a two-player game in which players attempted to shoot each other's spaceships as they circled around the deadly gravity well of a star, and over the following decade, it was widely ported to computer systems at other universities.

But *Computer Space* was not a success. The game's complexity and steep learning curve made it inaccessible to the general public, most of whom would never have encountered a video game in their lives. Bushnell and Dabney needed a simpler game for their follow-up.

In 1972, Syzygy Engineering was renamed as Atari, and the company hired Al Alcorn as its first design engineer. Then, in May, Nolan Bushnell paid a visit to the Magnavox Profit Caravan at the Airport Marina Hotel in Burlingame, California, a trade gathering where the TV manufacturer Magnavox showed off its upcoming products. Among them was the Magnavox Odyssey, and Bushnell was taken by one game in particular: *Table Tennis*.

Bushnell has said that he had previously seen a version of electronic tennis while at university, and indeed, physicist William Higinbotham had created a tennis game in 1958 that was displayed on an oscilloscope. But Alcorn maintains that Bushnell got the idea for what would become *Pong* after seeing the Odyssey. Whatever the truth, Bushnell asked Alcorn to come up with an arcade game that used a ball and two paddles.

This decision would have far-reaching consequences. It was one thing to make a game based on *Spacewar!*, the code for which was in the public domain, but it was quite another to create a game based on the Odyssey's proprietary technology. Magnavox would later sue Atari for patent infringement, and Atari eventually settled for $1.5 million in 1976. Magnavox would go on to sue many other companies who had produced versions of *Table Tennis* over the next couple of decades too; Ralph Baer claims in his autobiography that these lawsuits ended up collecting close to $100 million for Magnavox and Sanders Associates. It seems plausible that Magnavox made more from lawsuits relating to the Odyssey than they did from selling the console itself.

Alcorn's *Pong* added several improvements to the Odyssey game. In *Table Tennis*, players could move their paddles back and forth as well as up and down, but Alcorn limited *Pong* to vertical movement to make the game simpler and more intuitive. He also added a scoring system and made it so that the ball gradually sped up over the course of a game, leading to exciting rallies. The Odyssey had a dedicated 'English' dial for adding side spin to the ball, but Alcorn switched this for a simpler, more elegant solution, whereby the ball ricocheted at different angles according to where it struck the paddle. A hit directly in the middle would send the ball straight back, but a hit towards the edge of the bat would cause the ball to ricochet at a sharper angle. Importantly, Alcorn also added sound, creating hypnotic beeps and boops as the ball bounces off the bats and the sides of the screen.

Whereas the Odyssey was an analogue machine, *Pong* was all digital. Alcorn created the arcade game using 66 TTL (transistor-transistor logic) microchips: simple chips that each contained a series of logic gates. The arcade prototype was famously placed in Andy Capp's Tavern in Sunnyvale, California, where it proved to be an instant hit. Sensing they had a winner on its hands, Atari decided to manufacture *Pong* itself rather than licensing it out, and the first *Pong* arcade machines began emerging into the wild towards the end of 1972.

Pong was rampantly copied pretty much from day one, and variants of the arcade machine (both licensed and unlicensed) soon started appearing around the world. In the US, Bally created *Crazy Foot* and Midway released *Winner*, both close cousins of *Pong*. In the UK, Alca struck a direct deal with the Boston-based manufacturer of *Pong* PCBs (printed circuit boards) and used them to create the arcade cabinet *Ping-Pong*. And in Japan, Sega released *Pong-Tron*, while Taito launched *Elepong*. Many more copies and variations of *Pong* would appear in arcades in the years to come.

Pretty soon, companies began thinking about how to bring *Pong* into the home. One of the earliest examples of a home *Pong* console is the VideoSport MK2, which — according to David Winter's excellent PONG-Story website — was sold in either late 1974 or early 1975 by a British retailer of television and Hi-Fi equipment called Henry's, which could potentially have been Henry's Radio Ltd. on Edgeware Road in London.

There are scant details on the system aside from a few pictures, which show a simple wood-effect box with two equally simple boxy controllers, each with two dials on top and a single button. However, we know that it used analogue circuits, just like the Magnavox Odyssey (although interestingly, it combined them with two TTL chips), and the system retailed at £34.72 plus VAT in 1975. The VideoSport MK2 played three *Pong*-style games, *Football*, *Tennis* and *Hole-in-the-Wall*, which users could select between with a dial. But like *Table Tennis* on the Odyssey, there was no scoring. Also like the Odyssey, players could move the paddles back and forth as well as up and down.

Another early entrant into the race to bring *Pong* into the home was Executive Games, a company in Massachusetts that made chess and backgammon sets, among other things. Executive Games released *TV Tennis* in 1975, a white plastic box with two cylinder-shaped controllers that somewhat resemble microphones, each with a dial on top. It was created by a group of students from MIT, and inside the box were around 27 microchips that replicated most of *Pong*'s functionality, although it lacked scoring. The system retailed for $69.95, and a February 1976 article in the Boston Sunday Globe noted that 12,000 systems had already been sold — and the firm had a backlog of orders for another 400,000.

A few other *Pong* home systems hit the market in 1975 as well. In Germany, the hearing-aid company Interton released the Video 2000, a system that closely resembled the Magnavox Odyssey in many ways, although its circuitry was based on microchips rather than analogue components. Like the Odyssey, it used cartridges (although they were called cassettes), and inside each one were various chips and components that added extra functions. For example, cassette #4, *Tennis*, was a simple version of *Table Tennis / Pong*, but cassette #5, *Super-Tennis*, added a scoring system through the addition of several more chips.

Other early entrants into the race to get *Pong* into homes included the Videomaster Home TV Game in the UK, the Zanussi Ping-O-Tronic in Italy, the Epoch TV Tennis Electrotennis in Japan and the FD-3000W from the Nashville, Tennessee-based company First Dimension. Magnavox joined in on the *Pong* craze by releasing a follow-up to the Odyssey called the Odyssey 100, which swapped the analogue circuitry for microchips and stripped out the cartridge system in favour of simply having two built-in games: *Tennis* and *Hockey*. The board-game components of the original Odyssey were dumped, along with the box-like controllers, which were replaced by dials on top of the console itself — three for each player, controlling vertical and horizontal movement as well as 'English' (side spin). A deluxe version, the Odyssey 200, was released at the same time and added a third game called *Smash*, which played like squash.

One thing that all of these early *Pong* consoles had in common was that they needed a large number of microchips and/or analogue components to replicate the functionality of *Pong*. As such, they were relatively expensive and complicated to produce. The next step would be to put everything on a single chip, something that Atari engineer Harold Lee had begun working on in late 1974.

Lee created the schematics for an LSI (large-scale integrated) chip that replicated all of the functions of *Pong*, including the scoreboard. In early 1975, Atari began pitching the idea of *Home Pong* to various US retailers. Eventually, they made a breakthrough with the Sears department store chain, which insisted that the product should initially be marketed under its own brand name, 'Sears Tele-Games,' although Atari had permission to release its own Atari-branded version later on. As such, *Tele-Games Pong* arrived in Sears department stores in November 1976 at a retail price of $98.95, and Atari's own-brand version — *Home Pong* — the following year.

But Atari wasn't the only company seeking to put *Pong* on a single chip. General Instrument (GI) created a chip called the AY-3-8500 that included four ball and paddle games and two target-shooting games, and other firms, including Texas Instruments, National Semiconductor and MOS Technology, all manufactured their own versions of *Pong* chips. Suddenly, pretty much anyone

Breakout!

Ever wonder what would happen if the Pong ball escaped the match? That's where the Atari-published platformers qomp and qomp2 come in. Developed by a four-person team, qomp wonders what the ball would get up to if it were to evade the paddles and keep ricocheting around a meticulously-designed world.

022

023

024

025

022
Pong
1972

023
Home Pong
1975

024
Coleco Telstar
1976

025
Color TV-Game 6
1977

026

027

026
Color TV-Game Block Kuzushi
1979

027
Computer TV-Game
1980

028
Arcade1Up Pong Head-2-Head Gaming Table
2021

could make their own *Pong* console by simply buying a few chips, and companies all over the world rushed to do exactly that.

The sheer number of *Pong* consoles produced is simply staggering. It's estimated that worldwide more than 900 different *Pong* systems were made by a huge range of manufacturers, many of which had the exact same chip inside. The GI AY-3-8500 chip was particularly successful, being used in at least 200 consoles, and GI kept up a steady release of successor chips that added more functions and new games.

Companies raced to release new variants of *Pong* in quick succession, adding slight changes to each console, such as variable difficulty levels, four-player support, extra games or colour TV output. In 1976 alone, Atari released *Home Pong*, *Pong Doubles*, *Super Pong* and *Super Pong Ten*, and it followed this up in 1977 with *Super Pong Pro-Am*, *Super Pong Pro-Am Ten*, *Ultra Pong* and *Ultra Pong Doubles*. Magnavox released nine different Odyssey consoles between 1975 and 1977 — the Odyssey 100, 200, 300, 400, 500, 2000, 3000 and 4000, as well as the 4305, which was a TV with a built-in console. All of them featured similar versions of ball and paddle games, with very little to differentiate between them.

The toy firm Coleco released an astonishing number of *Pong* consoles, beginning with the Telstar in 1976, which was followed by the Telstar Classic, Telstar Arcade, Telstar Alpha, Telstar Ranger, Telstar Colormatic, Telstar Deluxe, Telstar Regent, Telstar Galaxy, Telstar Marksman, Telstar Colortron, Telstar Gemini and Telstar Sportsman. The Telstar Arcade was a particularly interesting machine: triangular in shape, it featured *Pong* dials on one side, a gun on another and a steering wheel on the third. Four triangular cartridges were released for the system, each of which contained several games on a MOS Technology chip. In addition to the usual variants of *Pong*, there was a *Road Race* game and several different light-gun shooting games.

Numerous other US firms also released their own *Pong* consoles, including JCPenney, Hometronics, Philco and Radioshack, to name but a few. It was a similar story around the world, with companies in countries like Argentina, Australia, Austria, Belgium, Brazil, Canada, Denmark, Germany, France, Hong Kong, Hungary, Italy, Japan, Mexico, the Netherlands, South Korea, Spain and the UK all producing their own take on a *Pong* console.

Of course, it couldn't last. With so many companies rapidly producing consoles that were essentially the same, the market was soon saturated with machines, resulting in the little-remembered video game crash of 1977. Many of the companies which had dabbled in the video-game market quickly abandoned it, although a hardy few, such as Coleco, would stick around for the second generation.

The release of new *Pong* consoles slowed to a trickle from 1978 onwards, although they hung on in some countries. In the UK, Binatone's range of *Pong* consoles with their bright orange buttons is fondly remembered, and the company launched around half a dozen new *Pong* consoles throughout 1978. Nintendo released its first console, the Color TV-Game 6, in 1977, and followed this up with several more dedicated consoles that gradually moved away from *Pong* (including the Color TV Game Block Kuzushi), ending with the *Othello*-playing Computer TV Game in 1980. In the Soviet Union, meanwhile, the Ministry of the Electronics Industry produced the Turnir Pong console in 1978, which was manufactured until 1982 and was based around the ubiquitous GI AY-3-8500 chip.

Even though companies like GI were adding different games to their chips that slowly moved beyond the simple bats and balls of *Pong*, the very notion of having to buy a whole game console every time you wanted to play a new game was being superseded. Dedicated consoles would live on in the form of handheld LCD games, notably with Nintendo's Game & Watch series from 1980 onwards, but when it came to home consoles, interchangeable cartridges were the exciting new thing. The Fairchild Channel F introduced the idea of a programmable console fed with ROM game cartridges in 1976, and in doing so, it quietly kickstarted the second generation of consoles, which would eventually be dominated by the all-conquering Atari VCS.

028

Pong Lives On

Although we're well past the era of Pong being all the rage, you still can grab yourself a modern Pong 'console.' Released in 2021 by Arcade1Up, these boards are described as "instant conversation pieces." The company goes on to remark that "And YES, a clear cover top and control deck overlays are included, to protect from those accidental spills" — bringing a whole new meaning to Beer Pong.

THE STORY OF GENERATION 2.

words Van Burnham

By the end of the '70s, video games had become a global phenomenon. The unprecedented success of Tomohiro Nishikado's seminal arcade shooter *Space Invaders*, released by Taito in 1978, inspired companies across Japan to shift focus to games, creating such enduring industry icons as Capcom, Konami, and SNK. The following year, Atari introduced the vector classic *Asteroids* to staggering demand and officially kicked off what became known as the 'golden age of arcades' that has since defined early '80s culture.

Atari had launched a home version of its formative arcade hit *Pong* back in 1975, a simple black-and-white tennis game featuring a phosphorescent ball and paddles that connected to a standard television. The game was heavily indebted to Ralph Baer's pioneering Odyssey system, the first home gaming console released by Magnavox in 1972, which played *Table Tennis* and an array of similar, simple games utilising jumper cards and sundry accessories. *Home Pong* was originally sold at Sears and popularised what was then known as TV Games to the masses.

These primordial home gaming consoles were such a huge success that a flood of copycat systems were soon released by every electronics and toy company in the retail arena — nearly a thousand unique systems — including future players like Coleco, Commodore, and Nintendo. Even the Soviets had a knock-off *Pong* clone.

Then, in 1976, Fairchild Camera and Instrument took home gaming to the next level with the Video Entertainment System, later known as Channel F — the 'F' meaning 'Fun.' Led by engineer Gerald Anderson "Jerry" Lawson, recently appointed to direct the engineering of Fairchild's nascent video game division, the Channel F was the first system to utilise a microprocessor, the first to include directional joysticks, and the first to use programmable game cartridges. It was barely in colour, and the controllers were only a marginal improvement over Odyssey's clunky knob boxes. But, it was revolutionary enough to usher in the second generation of home consoles.

The first generation consisted of dedicated systems that essentially played one game, and that game was invariably a minimalist version of ping-pong. The addition of scoring, sound, and colour were, therefore, the greatest technological innovations of the era. There were a few dedicated racing games — Nintendo's *Racing 112* and Atari's *Stunt Cycle* being standouts — and shooting variants, but ball-and-paddle games were the defining genre.

The Odyssey had been able to play different games by utilising printed circuit boards that plugged into the console, altering the internal logic, but these 'game cards' did not store actual data and only served as a switch between built-in programs. There was no way to create new games for these early systems, but that changed with the introduction of Channel F.

Originally founded as Fairchild Aerial Camera Corporation in 1920 by Sherman Mills Fairchild, son of IBM chairman George Winthrop Fairchild, the company pioneered vertical photography and was integral to developing aerial mapping, radar, and reconnaissance technology used in the Second World War. Rebranded Fairchild Camera and Instrument, the company grew to include multiple divisions across aviation and imaging and launched Fairchild Semiconductor with the 'traitorous eight' in 1957 to manufacture silicon transistors and integrated circuits.

The mass proliferation of *Pong* clones in the mid-'70s had been possible thanks to the development of cheap ICs, specifically the AY-3-8500 'pong-on-a-chip' offered by General

photography Damien McFerran

27

029

030

031

032

029
Atari 2600
1977

030
Fairchild Channel F
1976

031
Bally Astrocade
1978

032
Magnavox Odyssey
1978

Instrument. Inspired by the success of the original arcade game, the chip was designed by Duncan Harrower (also the architect of the chipset later used for Mattel's Intellivision), who miraculously managed to reverse engineer and condense *Pong*'s sixty-six discrete chips into a single IC. General sold over 15 million chips in 1976 alone. But integrated circuits are only able to perform specific functions, and it would take more computing power to push games into the 8-bit era.

One of the first video games to utilise a microprocessor was Midway's *Gun Fight* arcade game, released in 1975. Adapted from Taito's *Western Gun*, an earlier design by the creator of *Space Invaders*, the US version of Tomohiro Nishikado's gun-slinging classic was re-engineered with the popular Intel 8080 chip by industry design contractor Dave Nutting Associates, who wanted to improve the graphics and gameplay. Microprocessors had been pioneered by Intel in 1971 with the 4-bit 4004, followed by the 8-bit 8008 the following year. Intel then introduced the enhanced 8080 ("eighty-eighty") programmable microprocessor in 1974, featuring a 2 MHz clock rate and 64 KB of memory. In addition to its historic role in video games, the chip is credited with booting the microcomputer industry as it was used for both the MITS Altair and IMSAI 8080, two of the first personal computers (the latter prominently featured in the Hollywood movie *WarGames*).

Fairchild had licensed the underlying technology of its new home video game system from Alpex, who'd demonstrated an 8080-based prototype to Jerry Lawson that utilised circuit boards with EPROM (Erasable Programmable Read-Only Memory) chips that plugged into the console, allowing novel games to be programmed for the system. Code-named Raven, the project was led by engineers Wallace Kirschner and Lawrence Haskell. These ROM-based boards evolved into the first fully-programmable modern game cartridges — what Fairchild dubbed a Videocart, the boards now encased in sun yellow moulded plastic — and would allow Channel F to play a library of more complex games like *Desert Fox* and *Space War*.

Fairchild's semiconductor division had also announced a new 8-bit microprocessor in 1974, the Fairchild F8 CPU, so Lawson's first challenge was converting the prototype's 8080 architecture to the F8 chipset. Lawson's team included engineer Ron Smith and industrial designer Nick Talesfore, who helped transform Raven's clunky keyboard control into a streamlined directional joystick. The design featured a ribbed shaft with a triangular knob that not only rotated, but could be pushed down or pulled up for action, as well as moved in multiple directions.

The redesigned system was the epitome of classic '70s style, featuring an angular casing of walnut wood grain and smoked plexiglass. It included a storage compartment to hold the two hardwired controllers and push-button switches evocative of a tape deck that could select from the built-in game programs — *Hockey* and *Tennis* — change the mode, adjust game times, or reset the system. Other innovations included a 'hold' button that could pause the on-screen action.

Programmers for the new system included Rick Mauer, who coded *Hangman*, *Pinball Challenge*, and *Pro Football*, and Jerry Lawson who developed the iconic *Space War*. Additional program designers included Brad Fuller, Michael Glass, Rich Olney, Vilas Munshi, Brad Reid-Selth, and Don Ruffcorn, among others. The library of games for the original Channel F grew to include twenty-one titles, with standouts being *Alien Invasion* and *Dodge It*.

The Channel F was released just in time for Christmas 1976 at a whopping price of $169.95 — more expensive than a scalped PS5 on eBay, equivalent to over $900 today — with Videocarts selling for $19.95 each. It was a solid success, selling over 350K units over its lifetime. But industry leader Atari would not be outpaced.

With the profits from *Pong*, Atari acquired Cyan Engineering back in 1973, an engineering consultancy first utilised to develop early arcade games like *Touch Me* and *Gran Trak 10*. But engineers Steve Mayer and Ron Milner also envisioned a microprocessor-based home console with interchangeable cartridges inspired by Atari's arcade hits. Housed in a former hospital building in Grass Valley, three hours east of Silicon Valley, the team began exploring their category killer in 1975.

Mayer and Milner began work on the first prototype of Atari's programmable console, working in concert with Al Alcorn (who designed the original *Pong*) back at Atari in Los Gatos. The team first put together a wish list of hardware components, contemplating the Motorola 6800, though the cost was prohibitive. However, the introduction of MOS Technology's 6502 at only $25 proved a better option. They met with MOS designer Chuck Peddle and proposed using his chip in Atari's new home console, settling on the soon-to-be-released 6507 CPU bundled with their 6532 RIOT (RAM I/O Timer) chip at a further reduced cost. A playable demo of *Tank* was developed on the test system as proof of concept; this game would later evolve into the ubiquitous *Combat*, the first pack-in cartridge.

Additional engineers were hired for the development team, including Berkeley grad Joe Decuir, who engineered a second prototype with a cartridge interface. His first contribution? The code name 'Stella.' He apprenticed with Jay Miner (who later founded Amiga), who created the TIA chip (Television Interface Adapter) to handle display graphics and audio.

Atari founder Nolan Bushnell also brought in Gene Landrum to consult on the new system. Landrum, who previously worked with the consumer products division of Fairchild developing Channel F and would later co-create

"Chuck E. Cheese" with Bushnell, recommended that it also feature an angular casing with a woodgrain finish appropriate for a living room or den. The design was conceived by Fred Thompson, working with a team of industrial designers, including Regan Cheng and Barney Huang — both moving from coin-op into the new consumer division — as well as Craig Asher, Roger Hector, and Pete Takaishi.

Doug Hardy, who had engineered the cartridge mechanism for Channel F, was recruited to Atari and worked with Thompson on the design. The iconic one-button joystick was developed by Kevin McKinsey based on an unused concept for a dedicated *Tank II* home console. A much-needed influx of capital from Atari's acquisition by Warner Communications in November 1976 helped fast-track development.

Now officially the Atari Video Computer System (VCS), the console was released for Christmas 1977 and sold upwards of 400K units in its first year alone. The system shipped with the original six-switch console — known as the "heavy six" for its thicker injection-moulded polyethylene — two detachable joystick controllers, paddle controllers, 9V power supply, RF switch, and *Combat* cartridge for $189.95. The first eight games available at launch were *Air-Sea Battle*, *Basic Math*, *Blackjack*, *Indy 500*, *Star Ship*, *Street Racer*, *Surround*, and *Video Olympics*.

In response, Fairchild changed the name of its console from VES (which sounded too similar) to Channel F to avoid any consumer confusion with the new system. Unfortunately, a defensive rebrand wasn't enough to bolster the increasingly-obsolete system. The overwhelming success of the Atari VCS, aided by a prime-time marketing blitz, catapulted video games further into mainstream consciousness.

Then, industry pioneer Magnavox hit back hard with a follow-up to the home console that started it all, Odyssey 2. The futuristic silver and black console featured an alphanumeric membrane keyboard — like a real computer — two hard wired controllers and game cartridges with built-in *handles*. It was stylish, sexy, and pure class. The Odyssey 2 had been developed internally by a team at the Fort Wayne HQ that included Magnavox engineering lead John Helms and hardware engineer Roberto Lenarducci, with oversight from original Odyssey creator Ralph Baer and Sanders Associates. The system was designed around the Intel 8048 CPU and featured 64 bytes of RAM.

The oversaturated, full-spectrum box art by graphic designers Ron Bradford and Steve Lehner gave the Odyssey 2 a slick '80s aesthetic to out-gloss Atari and Fairchild's fading '70s style. The bulk of the game library was developed by consultant Ed Averett, who championed the system as an employee for Intel and was paid only in royalties for his programming work. He coded a total of twenty-six of the forty-seven games released,

including launch titles *Take The Money and Run!* and *Speedway!/Spin-Out!/Crypto-Logic!*, the latter included with the system.

Fitness and casino giant Bally also released a new home console in 1978, the Bally Professional Arcade, later renamed Bally Computer System and, ultimately, Bally Astrocade. Designed by engineers at Midway in cooperation with Dave Nutting Associates — who also created the arcade legends *Sea Wolf* and *Gun Fight* — the system utilised the same display chip developed for their coin-op games. Originally announced as the "Bally Home Computer Library," the system was first available via mail order and later sold primarily in computer stores. It featured a Zilog Z80 CPU with a powerful multi-voice sound chip capable of an impressive range of synthesised sounds. It also showcased a calculator-sized keypad and had a fairly robust BASIC computing program by Jamie Fenton, *Bally BASIC*. The most unique components of Astrocade were its controllers, moulded after the gunstocks of Midway's *Gun Fight* arcade game, with trigger action and a rotating knob on top similar to Channel F. But it was also saddled with otherwise lacklustre games — which did no justice to *Gun Fight* or *Sea Wolf* — a staggering price of $299, and non-existent marketing, so it failed to gain any traction with consumers and died a painful death.

Then, in 1979, toy industry giant Mattel — who built their success on *Barbie* and *Hot Wheels* — entered the fray with Intellivision, a portmanteau for 'Intelligent Television.' The programmable home system was developed at Mattel Electronics in Hawthorne, a division established the previous year for its popular range of handheld electronic games, including *Mattel Football*.

The project was directed by Richard Chang, head of Mattel's design and development, who began exploring the idea of a video game system. Engineering was led by Dave Chandler, working in cooperation with Dave Rolfe at Pasadena-based APh Technological Consulting, who designed Intellivision's operating system (nicknamed "the executive") and launch games. By 1977 they had a working demo, developed in a windowless room at Mattel.

Utilising a new 16-bit microprocessor from General Instrument, who had created the original "pong chip" that fuelled the first generation, Mattel's new system would theoretically have twice the processing power of the Atari VCS. The CP-1600 chipset was developed by Duncan Harrower with Eric Bergman and Steve Main and was essentially a low-cost PDP-11.

The system itself, known as the Master Console, featured unique controllers that nested into the centre of the system. Instead of a traditional joystick, there was a membrane keypad for input, side buttons for action, and a pressure-sensitive directional disc for more precise control. Unique overlays for each game slid over the keypad for a more interactive game experience. Intellivision

033

034

035

036

033
Intellivision
1979

035
ColecoVision
1982

034
Emerson Arcadia 2001
1982

036
Atari 5200
1982

also used a side-loading cartridge slot for a more streamlined form.

The system was test marketed in Fresno in November 1979 with the first four games — *Armor Battle, Backgammon, Las Vegas Poker & Blackjack*, and *Math Fun* — and was released nationally in early 1980 with the addition of *Checkers, Major League Baseball, NBA Basketball*, and *NFL Football* – the first sports licensing deals for games. With its superior graphics and gameplay amplified by a bizarrely compelling advertising campaign featuring "famous author and gamesman" George Plimpton, Intellivision managed to command a respectable market share, even priced at a whopping $275.

Around this time, the first third-party software publishers began to appear, including Activision and Imagic, both companies formed by former program designers from Atari who were tired of not being credited or compensated equitably for their work. Previously, game cartridges were designed and released exclusively by the console manufacturer, but independent developers began to realise they could create and market their own games for popular systems. Atari then sued its defectors, claiming theft of trade secrets and non-disclosure violations. But Activision settled favourably — agreeing to pay royalties to Atari, thus legitimising the new model — and the floodgates opened. Dozens of new companies entered the industry to capitalize on the trend, and Activision went on to release enduring classics like *Kaboom!* and *Pitfall*.

By Christmas, Atari had sold over a million VCS systems, and it was looking unlikely that any competitor could keep pace, but Intellivision put up an impressive fight. Mattel attacked Atari, boasting about Intellivision's graphical fidelity and more realistic games. It was the first console war.

Fairchild responded with a redesigned and less expensive variant called the Channel F System II, now selling for only $99, but the console still struggled against the growing market share and superior gameplay of the VCS and Intellivision. Without an upgrade to its technology, the rudimentary games could not compete. Zircon acquired the rights to Fairchild's languishing console later that year and licensed it to manufacturers in Europe, but only six new titles were released for the system, and sales stalled.

In 1980, Atari licensed Taito's arcade hit *Space Invaders* for release on the Atari VCS, and the world changed. It was the first deal of its kind, and sales of the console quadrupled. Video games were now in Gold Rush territory, and everyone wanted in on the action.

Coleco had enjoyed success with its dedicated Telstar system back in 1976, and re-entered the gaming arena with the ColecoVision in 1982. Engineering was led by Eric Bromley with a directive from Coleco president Arnold Greenberg to create arcade-quality games for the home. Utilising the popular Z80 CPU, the microprocessor used in most video arcade games, they were able to closely mimic the sprites, graphics, and colours of the actual titles.

Previous attempts to port hit coin-op games for home consoles had fallen short, most notably Atari's lacklustre version of *Pac-Man* for the VCS — a famous failure that still managed to sell eight million copies. One of the biggest arcade obsessions of 1981 was Nintendo's *Donkey Kong*, and Coleco had managed to negotiate the licence to bundle the game with the new system.

The basic black console design was similar to the Intellivision with nested keypad controllers — featuring a joystick knob instead of a disc — with the cartridge slot on top and expansion slot at the front. It also had what felt like the biggest and heaviest power brick in history.

Retailing for $175, ColecoVision sold over half a million systems its first Christmas, mostly driven by the appeal of the *Donkey Kong* pack-in, which actually *looked* and *played* just like the original. Additional games available at launch included *Carnival, Cosmic Avenger, Lady Bug, Mouse Trap, Smurf: Rescue In Gargamel's Castle, Turbo, Venture*, and *Zaxxon*. Most were huge coin-op hits. For the arcade rats of the era, ColecoVision was perfection.

Coleco also released an impressive range of expansion modules, add-ons, and peripherals, including Expansion Module #1, which allowed you to play Atari 2600 games, Driving Controller aka Expansion Module #2 (for playing games like *Turbo*), Roller Controller (for playing *Slither*), and the Super Action Controller with a proper ball-top arcade joystick.

Also in 1982, General Computer Electronics introduced the Vectrex vector-based home console. Conceived and developed by John Ross at Smith Engineering with assistance from Gerry Karr, this system was unlike any other, in that it included a vertical 9-inch monochrome vector CRT display capable of playing arcade games like Cinematronics' *Star Castle* and *Space Wars* in flawless fidelity. The Vectrex featured a single control pad with a joystick that nested into the casing and included a built-in version of *Mine Storm*. The black and white graphics were enhanced

by colourful overlays that fit over the screen, similar to the original Odyssey. Priced at only $199, the launch was successful enough that GCE was acquired by Milton Bradley the following year.

Elsewhere, Emerson Radio Corporation also released the Arcadia 2001, which looked about four years out of date and lasted only eighteen months. The glut of consoles and low-quality games rushed to market to capitalize on Atari's success was beginning to take a toll; consumers were growing weary, and store shelves were crammed. Prices were slashed to clear surplus inventory, starting a downward spiral. Production of the Channel F was finally discontinued in 1983 due to slowing sales and an inability to compete with the more technologically advanced consoles that came after.

By the end of its lifecycle, the Odyssey 2 had sold over two million units, tied with ColecoVision behind Intellivision and VCS, later renamed the Atari 2600. All in, Intellivision sold three million Master Consoles, and by the end of Atari's epic production run — the longest in console history — the VCS / 2600 had sold 30 million units and become a cultural icon of the '80s.

Atari released a follow-up to the 2600, the Atari 5200 SuperSystem, with slightly improved graphics and controls, but it failed to capture the same imagination as its predecessor. By the end of 1983, the video game market was in freefall, losing billions and effectively crashing the second console generation. It wouldn't be until 1985 that the industry would regroup to start a new game.

037

038

Sought After Oddities

Although systems like the Vectrex or Gakken Compact have little relevance now, their unique hardware and small historical footprint have made them high-end curios for retro game collectors.

037
Vetrex
1982

038
Gakken Compact Vision TV Boy
1983

Cartridge Comparisons

From Nova Blast on Colecovision to Defender on Atari 2600, this was an era of interestingly-shaped cartridges — a bygone relic of a time before standardised media formats.

039

040

041

042

039
Utopia
1982

040
Tron: Deadly Discs
1982

041
Pac-Man
1982

042
Defender
1981

The second generation consoles not only featured myriad cartridge formats, but also many variable packaging strategies within their diverse libraries of games lost to time. Enjoy this tour back through the peculiar analogue world of selected games and box arts which highlight the breadth of these systems.

043

044

045

046

043
BurgerTime
1982

044
Nova Blast
1982

045
Space Invaders
1982

046
Super Breakout
1982

the story of generation 2.

ATARI 2600.

words *Lewis Packwood*

The Atari 2600 is by far the sweatiest console I've ever experienced. If you've played on one, you'll know *exactly* what I mean. Atari's iconic CX40 joysticks were made of a rubbery material that would become slicked in sweat within minutes of a session, causing your hands to helplessly slide off the stick as you desperately wrenched it back and forth in a game of *Space Invaders* or *Defender*.

First Released:
1977

Manufacturer:
Atari Inc.

Launch Price:
US $189.95

But people cherish those joysticks. You can find them emblazoned on every kind of merchandise you can think of — they even grace the spine of the UK's long-running Retro Gamer magazine. They are emblematic of a time when the games industry wasn't even an industry yet, a time when engineers were still working out what a console should be, a time when a ramshackle, laid-back Californian start-up somehow came to be synonymous with video gaming in the US. Atari's meteoric rise and precipitous fall is the stuff of legend, and the 2600 was both its crowning moment and its Achilles heel.

As a company, Atari had its roots in the arcade. Nolan Bushnell and Ted Dabney created the first commercial arcade video game in 1971 in the form of *Computer Space*, back when their firm was named Syzygy Engineering. But they got their first real taste of success the following year with *Pong*, created by Al Alcorn and released under the newly christened Atari name.

Pong became a phenomenon, spawning countless arcade copycats and later a slew of home consoles that mimicked its simple bat and ball gameplay. Hundreds of *Pong* consoles from a wide range of manufacturers were released in the mid-to-late '70s, quickly swamping the market. In the meantime, Atari followed up *Pong* with a brace of arcade hits, including *Tank* (1974, from Atari subsidiary Kee Games) and *Breakout* (1976), as well as some notable flops, such as the racing game *Gran Trak 10* (1974).

Atari released its first official *Home Pong* console in late 1975, first under the Sears Tele-games branding, and later under the Atari name. But the company had grander plans. Even before the release of *Home Pong*, work was underway to create a console with a programmable microprocessor at its heart, meaning it was able to play a variety of games rather than just the handful hard-coded into it. This console would eventually become known as the Atari 2600, but initially, it was called the Atari VCS, or Video Computer System.

Microprocessors were the hot new technology of the '70s, where all of the functions of a computer's central processing unit (CPU) were squished onto a single chip. The Intel 8008 emerged as one of the first microprocessors around 1972, and by 1975, the first microcomputers were being sold for home use — notably the Altair 8800 — which is often cited as kicking off the microcomputer revolution in the United States.

Atari initially approached Motorola about using its 6800 microprocessor, but the debut of the cheap yet powerful MOS 6502 chip in late 1975 instead saw Atari courting Motorola's arch-rivals MOS Technology (the 6502 was designed by a team led by Motorola defector Chuck Peddle). But even though the MOS 6502 was incredibly cheap for the time at around $25, Atari drove down costs further by going with the even cheaper MOS 6507 chip, a cut-down version of the 6502 that cost around $12. The main difference was that the 6507 could only address 8K of memory, rather than 64K — thus limiting the maximum size of the console's cartridges.

Development of what would become the Atari VCS was led by Steve Mayer and Ron Milner of Cyan Engineering, a Californian company that Atari purchased in 1974. The machine

photography *Damien McFerran*

047

048

was soon codenamed 'Stella' after the brand of bicycle owned by Joe Decuir, who became the third member of the team. The first prototype was completed by the end of 1975, and was able to run a version of Atari's *Tank* arcade game. The following year, Jay Miner created the Television Interface Adaptor (TIA), the console's graphics and sound chip (Miner would later go on to become one of the key designers of the Amiga line of computers).

The Atari engineers envisaged the machine playing simple games like *Pong* and *Tank*, so they only gave the console the ability to display five sprites at a time. This limitation — along with the 8K limit for cartridges — would come back to haunt Atari programmers further down the line when they were tasked with porting complex arcade games to the VCS. It took all of their ingenuity to come up with tricks to get around the console's limitations.

Atari desperately needed more cash to develop the console, so the company negotiated a deal which would see Warner Communications purchase the company in October 1976. Warner was able to supply the funds needed to make the VCS happen, but the deal would have enormous repercussions further down the line, resulting in Atari founder Nolan Bushnell being replaced as CEO by textile executive Ray Kassar in 1979.

The Atari VCS was finally revealed to the world on June 4, 1977, at the Las Vegas Consumer Electronics Show. By that point, a couple of rival firms had stolen a march on Atari, beating the VCS to market. The Fairchild Channel F debuted in November 1976 and was the first console to use interchangeable ROM-based cartridges. It was soon joined by the RCA Studio II in January 1977. But both of these consoles would soon fade into relative obscurity — the underpowered RCA Studio II was discontinued in 1978, and the Fairchild Channel F only ever managed a fraction of the sales of the Atari VCS, which would go on to stratospheric success. *Eventually.*

The original VCS came to be known as the 'Heavy Sixer' thanks to the six switches on its front and the heavy RF shielding inside. A lighter yet otherwise identical version followed in 1978, but the first real revision was in 1980, when the number of switches was reduced to four — although the console's characteristic woodgrain front was retained. The woodgrain was finally dropped in 1982 when the console was renamed the Atari 2600 and given an all-black makeover, which gave this model its nickname: Darth Vader. But the biggest redesign was in 1986 with the Atari 2600 Jr., a much smaller console with an angled front and a chrome strip featuring a rainbow stripe.

The VCS sold a respectable 350,000 units in 1977, even with its high price tag of $199 — the equivalent of around $1,014 in 2023. Yet this paled in comparison with the sales of cheap, dedicated consoles (machines that were hard-coded to play simple games like *Pong*) which topped seven million in 1977. Coleco alone sold 1.75 million units of its Telstar range.

However, the age of dedicated consoles was coming to an end. Retailers were forced to offer steep discounts on the machines as supply far outweighed demand during Christmas 1977 (something we'll see echoed in Atari's future). The market for dedicated consoles had basically collapsed by 1978, yet the reception for the Atari VCS remained lukewarm, with electronic games like Mattel's *Football* LCD handheld instead becoming the must-have Christmas gifts in the US. Sales of the

047
Atari VCS
1977

048
Atari 2600
1982

38

The Atari 2600 wasn't the original games console, but it was perhaps the first to explode into pop culture — its appearances in Ridley Scott's Blade Runner as a key example. Chaim Gartenberg wrote for The Verge that "After all, Scott was envisioning our future, and in 1982, imagining 2019 without Atari … was like filmmakers today imagining a future where Apple no longer exists in 40 years." Atari just stuck!

049

050

049
Sears Video Arcade II
1982

050
Atari 2600 Jr.
1986

VCS continued to tick along steadily, helped by a huge TV marketing campaign instigated by Kassar, but the console's fortunes only really turned around in 1980 thanks to one game: *Space Invaders*.

Space Invaders was such a huge hit on its release in Japan in 1978 that it reportedly led to a shortage of 100-yen coins in the country, and it was a similar arcade smash in the States. Atari secured the licence to port Taito's game to the VCS in late 1979, and it became an instant best-seller when it hit stores in early 1980. Atari sold over a million VCS consoles that year, bumping up the machine's install base to 2 million, with just over half of VCS owners buying a copy of *Space Invaders*.

The licensing of another company's game for home release was an unorthodox move at the time, when titles were usually produced in-house by the console maker. For its internally developed games, Atari had a strict policy that there should be no indication about which person made them, apparently to deter head-hunters from rival firms. One engineer who took exception to this was Warren Robinett, who coded a secret room into his seminal 1980 game *Adventure* that featured the text "Created by Warren Robinett." Steve Wright, the head of the VCS programming group, likened finding the room to an Easter egg hunt, and to this day, such hidden secrets are known as Easter eggs.

Other Atari engineers also got tired of toiling away in anonymity. Larry Kaplan, Bob Whitehead, David Crane and Alan Miller left Atari in 1979 after an internal memo revealed that the games they had made accounted for 60% of cartridge sales the previous year. When they asked Ray Kassar for royalty payments and credit to reflect their efforts, they were told they were "a dime a dozen" and that "anybody can do a cartridge," Kaplan recalled in a 1983 interview with InfoWorld.

Along with music executive Jim Levy, the four formed Activision and began producing cartridges for the Atari VCS, becoming the first-ever third-party developer. Atari wasn't happy about this and sued. The case was settled in 1982, with the court ordering that Activision should pay royalties to Atari, but the ruling otherwise legitimised the third-party model.

More and more people flocked to follow Activision's lead. Imagic was formed in 1981 by various defectors from Atari and Mattel, and released hits including *Atlantis*, *Cosmic Ark* and *Demon Attack*. The board-game firm Parker Brothers released an Atari VCS version of Konami's hit arcade title *Frogger* in 1982 that sold around four million copies. Activision's *Pitfall!*, an influential platformer created by David Crane, sold a similar number on its release in the same year.

The Atari VCS was absolutely flying by 1982, fed by arcade hits along with innovative, original titles like *Pitfall!* and *Yars' Revenge*. Ports of arcade behemoths such as *Donkey Kong*, *Defender*, *Asteroids* and *Centipede* each sold well over a million copies, and *Pac-Man* would become the best-selling Atari VCS game, eventually shifting over eight million cartridges. Atari had sold some ten million VCS consoles in the United States by 1982 and 12 million worldwide. However, the console remained only a minor success in the United Kingdom, where the focus was instead on microcomputers such as the ZX Spectrum and Commodore 64. In Japan, it all but disappeared without trace on its release there in 1979, and even a beautiful, Japanese-only redesign in the form of 1983's sleek Atari 2800 failed to change its fortunes.

atari 2600.

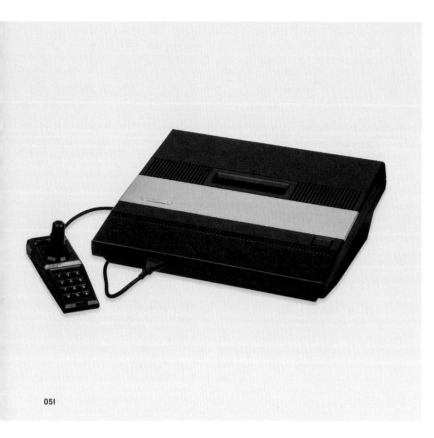

Past Being Prologue

Contemporary Atari has furthered its legacy with myriad pieces of new hardware, including the Atari VCS. But perhaps the most interesting is the Atari 2600+ — essentially a new 2600 that connects to modern TVs and accepts original 2600 cartridges. It's a brilliant, official solution to games preservation not dissimilar to the work done by third-party companies such as Analogue.

051

051
Atari 5200
1982

The VCS had a number of serious competitors by 1982, including the ColecoVision and Mattel's Intellivision, both of which offered superior graphics to the ageing VCS. Atari responded by releasing the Atari 5200 in 1982, re-naming the VCS to the Atari 2600 in the process. But the 5200 proved a flop, lacking backwards compatibility with 2600 games, and offering only a handful of previously released titles with moderate graphical improvements, such as *Super Breakout*. Incredibly, it also had even worse joysticks than the 2600.

Then came the so-called US video game crash of 1983. It had a number of causes, but perhaps chief among them were unrealistic expectations of growth coupled with market saturation. A slew of companies began making games for the 2600 in 1982, many of them poor quality, while Atari manufactured far too many cartridges for the Christmas season, after demand had outstripped supply in 1981. The poster child for the crash was *E.T.*, a costly licensed game that was hurriedly coded in just five weeks to meet the 1982 holiday sales deadline. Only around 1.5 million of the four million *E.T.* cartridges manufactured were sold; thousands of those remaining were buried in the New Mexico desert.

Atari had promised market growth of 50% in 1982 but only managed 10-15%. Spooked investors began with-drawing from the games industry, while excess game inventory was drastically marked down. Kassar was fired in 1983 after Atari reported losses of more than $530 million, and the following year, Warner sold Atari's console and computer division to Commodore founder Jack Tramiel.

The 2600 lived on, however. Although the number of games being released for the system tailed off dramatically after 1982, the console long outlasted its rivals, being manufactured right up until 1992, some 15 years after its debut. It's estimated it sold around 25 million units in total.

The Atari 2600 wasn't a perfect console by any means. It was underpowered compared to its rivals, its short-comings exposed in the flickering, flawed version of *Pac-Man*, while those joysticks remain a sweaty nightmare. Yet at the same time, those joysticks are iconic, and instantly recognisable, their image often used as shorthand for the very concept of retro gaming itself. The Atari 2600 may have been flawed, and the company that created it certainly was too, but it was the foundation stone of the US video game industry. It inspired a generation and forged a path that many others soon followed.

In modernity, a console will typically receive a standard controller and then a 'pro' variant of some kind. But for the most part, you won't experience the breadth of control options afforded by a system like Atari 2600 — a system with everything from a keyboard controller to a paddle controller, to something which more closely resembles an NES pad.

052

053

054

055

052
CX40 Joystick
1978

053
CX30-04 Paddle
1977

054
CX50 Keyboard Controller
1978

055
CX78 Power Control Pad
1987

atari 2600.

056

057

058

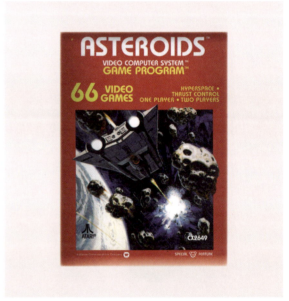

059

056
Pitfall!
1982

058
Defender
1981

057
Yars' Revenge
1982

059
Asteroids
1981

060

061

062

063

060
Centipede
1983

061
Pac-Man
1982

062
Super Breakout
1978

063
E.T. the Extra-Terrestrial
1982

atari 2600.

INTELLIVISION.

First Released:
1979

Manufacturer:
Mattel Electronics

Launch Price:
JP ¥48,800
US $275
UK £199

The '70s brought video games into our homes with systems that soon became part of everyday vernacular, like Atari, Nintendo, and Apple. It was an exciting time for electronics manufacturers to get in on the action too, with systems coming out from well-known companies such as Magnavox, Texas Instruments, and Mattel. Intellivision launched in 1979 and was touted as featuring the best graphics and sound design of all competing consoles. In 1983, a second model was released, which was more affordable, with longer cords for the controllers and a sleeker-looking design.

While the battle of the consoles was happening, a young engineer named Brian and his wife Pamela were moving from College Station, Texas, to Silicon Valley California, where Brian would work for Ampex Corporation on videotape research and development. It was hard for the young couple. They were fresh out of college, newlywed, away from home across the country with a new baby — roughing it on their own. They sought a supportive community with other young married couples and soon became good friends with San Francisco Giants shortstop Johnnie LeMaster and his wife Debbie.

Johnnie invited Brian over to his house many times to hang out with friends from the team. He had just bought a newfangled device called an Intellivision that had a great baseball game on it. He and his professional baseball teammates loved to play Intellivision baseball on their off days.

"I remember thinking these guys must really love baseball," Pamela recalls, "because when they weren't playing it in real life, they were playing it on a screen!" As an audio-video engineer, Brian was impressed with the quality of the Intellivision — and it was fun too. He kind of wanted one for himself, and he thought it'd be something fun to share with his young daughters as they grew older. But he and Pamela were hardly getting by. Such a luxury didn't seem wise. Just before Christmas of 1984, however,

he found an Intellivision II, the Intellivoice attachment, and a collection of several cartridges on sale and decided to buy it as a gift for his growing family.

Fast forward a few years. Brian and Pamela had moved to Nashville, Tennessee, and had their third daughter: me. I have a few memories of us playing the Intellivision in my dad's office at our first house in Nashville, but it wasn't until 1994 when we built my parents' current home — the home I grew up in — that the memories of the Intellivision really become vivid. My sisters and I got along well and shared our toys, clothes, and hobbies. One sister's room had all the books, and the other sister's room had all the dress-up accessories. But I was the lucky one with the small television, VCR, and Intellivision setup.

The console itself was light grey with black accents and red trim. The Intellivoice adapter came with the original Intellivision, so it sported the more '70s-looking faux wood with gold and black accents. The controllers were about the size of a cell phone today, with a nine-key number pad, a multi-directional thumb pad, and two buttons on either side, all attached to the console by a long spiral cord. Many games also came with a plastic overlay that slipped over the number pad to help identify controls for specific games. Dad kept the game cartridges, controller overlays, and extensive game manuals in a fake black alligator-skin cassette box, almost like a toolbox but with a red felt-covered liner to hold all of the cassette tapes — or in this case, game cartridges. The console plugged into the wall with a massive AC adapter which then attached to the TV with a coaxial cable. We had to tune the TV to channel three, turn on the console, and pop in a cartridge, waiting until we saw the title card for the game on the screen. Or, if the Intellivoice was connected, until we heard the distinct male voice saying, "Mattel Electronics presents..." Some games had music that played instead when the title card appeared to let us know that the cartridge was properly inserted. I can hear the *Frogger* theme now!

There were games we could play together (though often my two older sisters played and I watched), like *BurgerTime*, *Learning Fun*, and yes, *Baseball*. "It was the two-player games of football and baseball that followed conventional rules of each sport that made Intellivision unique," says my dad, "and the controls were very responsive and competitive. Some of these, like *BurgerTime*, could be played with only one player as well, so it was nice to play alone or with a friend." There were also lots of single-player games for the Intellivision like *Tron: Deadly Discs*, *Astrosmash*, and *Bomb Squad* that I could play by myself when my big sisters didn't want to be bothered by the youngest. Some of the buttons were a little sticky, especially with the overlay. If you played for too long, your thumbs would blister from the pad; and most games came with a manual that was difficult for a little kid like me to endure for long. But many of those games provided hours of Saturday morning fun throughout my childhood.

By far, though, my favourite game was called *Utopia*. This was a two-player simulation strategy game that required each player to maintain and develop an island. Every level spanned a season, so the first step of gameplay was to determine the length of each season and the number of seasons needed to complete the game. Each player started with a nest egg, and one of the first objectives was always to earn more money either by planting crops that would be rained on by passing showers or by building a fishing boat, venturing out into the ocean to hang in the middle of randomly-spawned schools of fish.

Using the instruction booklet (which began to fall apart after a decade or so), players would input codes on the number pad to build things on and for their island, and as they earned more, they could build more structures like houses, schools, or hospitals to increase their civilisation. Of course, though, even utopias have conflict. Natural disasters like storms or hurricanes could happen each season, and these could easily cause destruction. Pirate ships would also appear in the ocean and could destroy fishing boats. Players could even sabotage their competitors by blocking fishing boats or by directing rebels that might destroy structures or crops to an opponent's island. This cycle continued through each season until the end of the game, and the player with the highest net profit was the winner.

Growing up in the '90s and '00s, sure, I enjoyed my Intellivision. But when I started going to friends' houses and seeing the systems and games they had — like *Duck Hunt* and *Super Mario Bros.* on the NES, *Zelda* and *Paper Boy* on the Game Boy, *Perfect Dark* and *Pokémon Snap* on the Nintendo 64, *Final Fantasy VII* and *Tony Hawk* on the PS1 — I started to realise how dated my system actually was. No one else I knew had an Intellivision. So, when those friends came over to my house, the refrain became "Look at this silly thing that is older than I am!" Though I enjoyed *Utopia* and my Intellivision, I began to play it less and less.

Then in high school, I dated an avid gamer. He helped me see that it was actually really cool to have an Intellivision. It wasn't outdated; it was retro. He played games on a PC that he built (interestingly, the Intellivision positioned itself as a PC in its time, with the ill-fated Keyboard Component) and on his PS2. So he actually gave me his old PS1 — in 2003. Even though this was nearly ten years after its release, I was excited to have a system that felt so new compared to what I had grown up with! But I was surprised: a lot of our time together was spent playing games (or more accurately, again, him playing games and me watching), and I was shocked that he actually wanted to play Intellivision at my house — sometimes more than his old PS1 or even his new games on the PC or PS2! He helped me understand that this system left a strong legacy for others. To him, it was like experiencing history. I felt a growing sense of pride in my Intellivision again.

I started to do some research to understand the Intellivision legacy that my boyfriend was nerding out about. For one thing, the Intellivision was the only home console made by Mattel. As mentioned, the graphics and sound were especially

064

065

064
Utopia
1982

065
Intellivision
1979

066

067

068

069

066
Intellivision Controller
1979

068
Intellivoice Voice Synthesis Module
1982

067
Keyboard Component
1981

069
PlayCable Adapter
1981

noteworthy compared to the competition. In fact, "super graphics" were a large part of the marketing for several Intellivision games. These visuals were thanks to two then-new features. It was the first 16-bit console, and it was the first home console to use tile-based gameplay. The Intellivoice attachment was also the first of its kind as site Intellivsion Lives notes, and it gave an iconic quality to several of the games. *B-17 Bomber* and *Bomb Squad* especially would not have been the same without the Intellivoice. Though many players found the controller to be the worst aspect of the console as IGN's Craig Harris wrote, this directional thumb pad was an innovative choice combining a joystick and button in one. For these decisions and more, IGN ranked the Intellivision among the 25 best consoles of all time.

But I was especially surprised to see that *Utopia*, which I enjoyed the most, was hugely influential itself. I didn't think about it at the time, but I now realise that it was the first real-time strategy 'rags-to-riches' simulation game. Most games at this point were turn-based, but *Utopia* required players to make quick decisions simultaneously. It was also one of the first construction and management simulation (CMS) games, where the player starts out with limited resources and works to build an empire of some sort — a developed island in this case. Simulation and strategy are not often seen together in competitive gameplay, but here they were in *Utopia*. I soon learned that I was not the only one who loved this game. In 2004, GameSpy's William Cassidy inducted *Utopia* into its Hall of Fame as an "astonishingly detailed simulation." In 2010, GameSpot listed *Utopia* as "an unsung hero" of video game history, identifying it as a direct precursor to the Civilization and Sims franchises. Utopia is even in The Smithsonian! It was a winner in the travelling exhibition "The Art of Video Games," heralded as one of the most popular games.

Utopia and the Intellivision also sparked a personal legacy. As I mentioned, in high school, the boy I dated made video games a big part of my life. Not only did he give me his old PS1, he soon helped me buy a PS2 of my own, which I had always wanted. I played on the PC more too, and he introduced me to games that made me appreciate interactive storytelling and the beauty of worldbuilding. I began to notice a trend, however. I still gravitated towards simulation and CMS games. I played *Sim Safari* and the original *Sims*, and when I played MMOs with my boyfriend (especially *Everquest 2*, *Star Wars Galaxies*, and *World of Warcraft*), my favourite part by far was character creation.

In college, my gamer boyfriend and I parted ways, but I still had my Intellivision with me. I would show it off to friends, and we would laugh and still have lots of fun on the old console, even if the thumb pad was a bit sticky and we sometimes had to blow on the cartridges and hold our mouths just right when using the Intellivoice. And I kept gaming. With the rise of YouTube, I began to watch more Let's Plays and played more on the computer. I went to friends' apartments and continued the tradition of spectating better gamers play. By 2018, I was enjoying Twitch and even began streaming some content. All throughout this time, I still most enjoyed simulation and CMS games: The Sims series; *Don't Starve* and *Don't Starve Together*; *Animal Crossing*; *Stardew Valley* … I love a good RPG and enjoy platforming or party games too, but I always seem to go back to simulations. And I think it's all because of where I started: my love for *Utopia* on the Intellivision.

Obviously, the Intellivision eventually met its demise. In Mattel's 1982 10-K form, Christian Science Monitor's Norman Sklarewitz found, the company claimed to have control over nearly 20% of the gaming market and had made over $500 million in sales. So what happened? In 1982, nearly two million Intellivisions were sold, New York Times' Thomas C. Hayes reported in 1984, recapping the fate of the console. By 1983, prices of home electronics were dropping, increasing competition among home entertainment systems. Mattel showcased several new products at the June 1983 Consumer Electronics Show, but the response was underwhelming compared to their competitors — especially the Commodore 64. Mattel lost a lot of money, people were being laid off, and higher-ups began to be replaced by outsiders in a desperate effort to save the company. Development of the Intellivision III was cancelled, and while the Intellivision II had a massive price drop — sales still plummeted. Mattel decided to pivot to software development, and by the beginning of 1984, the remainder of all the programming staff had been laid off. Investors reached out to buy the rights to Intellivision, and in 1984, Intellivision Inc. was founded and changed to INTV Corporation, which continued to produce video games and toys. In 1990, due to licensing agreements with Nintendo and Sega, the Intellivision was discontinued. INTV filed for bankruptcy shortly after and closed entirely in 1991.

There have been repeated attempts to mine Intellivision for nostalgia in the decades since — to varying degrees of success. But my dad's original Intellivision II still works, as long as we have a coaxial adapter. Yes, the thumbpad is sticky, the overlays are slippery, the cartridges are dusty, and the manuals are falling apart; but it all still plays well. I now have two daughters, and my four-year-old is becoming increasingly interested in video games. The next time we visit Brian and Pamela's house — that is, Pop and Grammy's house — I might just pull out *Utopia* and see what my daughter thinks.

COLECOVISION.

When Coleco showed off the ColecoVision, for the first time at the 1982 New York Toy Fair and again at CES later that year, the reaction within the media was overwhelmingly positive. Many positioned the new console as a potential rival to Atari's dominance.

After all, the console was noticeably more powerful and adaptable than the other competitors on the market — the Atari 2600 and Mattel's Intellivision — boasting near-arcade perfect visuals and a modular design allowing for the introduction of various peripherals to further enhance the player experience.

The ColecoVision looked set to be a surefire hit, and in many ways, it was, shipping over 500,000 units before the end of 1982. However, between the miserable failure of Coleco's Adam computer in 1983 and the unbelievable success that it was finding elsewhere with the *Cabbage Patch Dolls* product line, the company made a drastic decision in 1985 to withdraw from the video game market and focus entirely on toys.

This has unfortunately caused the ColecoVision to be somewhat overlooked today, despite it having a significant impact on the video game industry. Not only did it bring the arcade experience home like never before, but it also played a part in the origins of both the Sega SG-1000 and the Nintendo Famicom — the first consoles from two of the most successful hardware manufacturers of all-time. To tell the incredible story of the ColecoVision in all its detail, we first have to recap Coleco's various ups and downs prior to the console's development.

In 1932, the businessman Maurice Greenberg founded the Connecticut Leather Company on 28 Market Street in Hartford, Connecticut. As the name suggests, the company started primarily as a supplier of leather-based goods, but over the next four decades, it would eventually diversify into everything from above ground swimming pools to toys to video games.

The company released its first-ever home video game console, the Coleco Telstar, in 1976, inspired by the success of *Pong*. This was a basic machine that included simple paddle-based games like *Hockey*, *Handball*, and *Tennis*. It was an instant success, selling approximately one million units in its first year. So, in 1977, Coleco had the ambitious idea to release eight more machines under the same branding. This turned out to be a terrible miscalculation.

Production issues, supply-chain problems, and a 60-day dock worker strike in the US prior to Christmas 1977 kept the Telstar off store shelves during the all-important season, resulting in huge losses for the company in the following year — as it had to sell its excess stock at a significantly reduced price. For the first time ever, the company's future was at risk. But eventually it managed to rebound in 1980, finding success in the burgeoning handheld electronic toy business with products like *Electronic Quarterback* and its *Head-to-Head* series of sports games.

It appeared to most people in the industry that Coleco had permanently withdrawn from the business of manufacturing video game consoles, based on its close call with the Telstar. However, behind the scenes, Eric Bromley (an engineer at Coleco) and the company's CEO Arnold Greenberg (Maurice's son) began discussions about potentially creating a new cartridge-based, arcade-quality video game system to rival Atari and Mattel.

The original design for the ColecoVision was planned to combine a Texas Instruments video chip and a sound chip from General Instrument, but was continuously shot down due to the cost of RAM and being unable to come up with a competitive price point. Then in 1981, Bromley happened to stumble across an article in

Barrels of Ports

While Donkey Kong was the marquee pack-in for the ColecoVision, it was far from the only home console version of Nintendo's megahit. Every system from Commodore 64 to Intellivision had a port to call its own — the Atari 2600 version being a famous iteration that actually hit the market two months prior to the game's release on ColecoVision. But that release was quite rudimentary. The ColecoVision port was much closer to arcade quality, a fact proudly advertised on the box.

070

071

070
Donkey Kong
Atari 2600
1982

071
Donkey Kong
ColecoVision
1982

the Wall Street Journal about how the price of RAM was decreasing, giving the company a newfound confidence to pursue the project. According to Greenberg in a news article from the time, the machine was created in just one year and ended up costing between $3-5 million to produce.

The ColecoVision's key selling point was its quality arcade-like visuals. In order to demonstrate this, Coleco needed a killer app — a pack-in title that everyone would want to play. As fate would have it, this turned out to be Nintendo's 1981 arcade classic *Donkey Kong*.

The story of how ColecoVision landed the *Donkey Kong* licence is now the stuff of legend. Ahead of the release of the original *Donkey Kong* in the West, Bromley was visiting Nintendo's Kyoto HQ to talk about potentially licensing some games when he accidentally stumbled across the arcade cabinet while searching for a bathroom. As Bromley has said, it was love at first sight, with the engineer immediately knowing that this was the game that needed to be packed in with every ColecoVision. Though, getting Nintendo to sign an official agreement proved to be anything but easy.

For starters, Nintendo's president Hiroshi Yamauchi, ever the businessman, asked Bromley for significantly more than the $5000 Coleco was paying for its other arcade licences, requesting $200,000 and a $2 per unit royalty for every ColecoVision sold. This seemed ridiculous at the time, but Bromley was confident that *Donkey Kong* would be a sales success. So, upon returning to Tokyo from Kyoto, he phoned up Arnold Greenberg to give him the good news and the bad, to which the CEO reportedly asked Bromley to tell him more about the mystery machine. Bromley told him that it was as good as *Pac-Man* and gave him the name of the cabinet, and remarkably, after a silence that seemed to last for hours, it was enough to convince Greenberg to wire him the necessary funds that same day. Over dinner, Bromley then negotiated a deal with Yamauchi via a translator and returned to the States with Nintendo's word and a napkin stating Coleco had the home console rights to *Donkey Kong*.

Bromley was obviously elated to have made the deal, but as time went on, he began to grow increasingly worried that he didn't have anything legally-binding in the eyes of US law. He tried to get Nintendo to sign a contract but was unsuccessful. Then, at an unspecified Consumer Electronics Show, the deal almost fell apart completely when Yamauchi's daughter Yoko let slip to the engineer that Atari had licensed the home computer rights to *Donkey Kong*, causing Bromley to panic that Coleco had been out-manoeuvred. Annoyed and potentially fearing for his job, Bromley called Yamauchi's room and desperately tried to convince Yoko of the ColecoVision's strengths over the Atari 2600, and in doing so, secured the home console rights all over again — though this time in a more official capacity.

The ColecoVision was publicly unveiled to the press at the 79th Annual Toy Fair in New York in 1982, where

Coleco announced 14 games for the system, including *Donkey Kong*, *Venture*, *Cosmic Avenger*, *Mouse Trap*, and *Lady Bug*. Speaking to the press, Greenberg called the machine a "third-generation" console, claiming that it was an "open-ended" machine and "state of the art." It later went on sale in North America in August 1982 (where it was typically sold for less than $200) and got some great reviews from early gaming publications like Electronic Games, who called it "the finest system we have ever seen for the home."

Coleco later partnered with CBS to bring the console to the UK and Australia the following year and even had plans for a Japanese launch too, signing an agreement with Sega to market a Sega-branded version of the console. But as history tells us, this didn't end up happening, with Sega instead opting to enter the home video game business for itself with the Sega SG-1000. This device ended up sharing more than a few similarities with the Coleco console, including the same processor, the same sound chip, and a similar video chip.

Following its release, Coleco continued to generate buzz, with the company announcing new games and additional modules for the ColecoVision (some of which sadly never released, like the Super Game Module and the Intellivision adapter). Perhaps the most useful of was the Coleco Expansion Module #1, a device which let people use their existing Atari 2600 cartridges on ColecoVision hardware.

The Coleco Expansion Module #1 rolled out onto store shelves in late 1982, and, as expected, Atari didn't take too kindly to the product's existence. It sued Coleco for patent infringement and unfair competition, seeking damages of more than $350 million, requesting an injunction against its manufacture and sale. In response, Coleco filed a countersuit, claiming that Atari was suing without merit and that it was in violation of antitrust law. The two looked set to go head-to-head in court, but by the following March, the disagreement appeared to be resolved with Atari licensing its patents to Coleco on a royalty basis instead.

Whereas its two main competitors — Mattel and Atari — struggled throughout the early months of 1983 due to the North American Video Game Crash, Coleco seemed to be doing well heading into the new year. The company's first quarter net profits nearly quadrupled and sales rose from $54.7 million to $180.2 million. Sources pinned these incredible results on the amazing success of the ColecoVision, and the future looked bright for Coleco heading into the rest of the year. But sadly, a high-profile failure would soon send the company's consumer electronics division crashing back to reality with a thud.

Released in late 1983 after a series of delays, the Coleco Adam (which promised to turn the ColecoVision into a 'powerful home computer') arrived with a huge wave of hype surrounding it. The hardware was propped up by an expensive marketing campaign consisting of television commercials and double-page ads in the leading computer magazines of the day. It was available to buy in two different versions, as either a standalone unit with a built-in ColecoVision system (available for roughly $700) or as an expansion module for the ColecoVision (priced at around $500).

Both were positioned as high-end, low-cost alternatives to the offerings from other companies like IBM, Apple, and Commodore. However, issues quickly arose with the design and development of the machine, with the two most egregious problems being the location of the power supply and the computer's ability to generate a strong enough magnetic wave upon launch to erase data packs sitting near or in its Data Drive.

To add to these problems, the Adam computer struggled to shift the 500,000 units the company had hoped for in 1983, with Coleco only delivering 95,000 units that year with a 10% return rate. This left the company with costly inventory and a lack of demand. Throughout 1984, the company tried to remedy the situation, releasing more and more peripherals and dropping the wholesale price to under $500, but it did little to reverse Adam's fortunes.

In January 1985, Coleco announced that it was discontinuing the computer and selling its remaining stock to an unnamed retailer below cost. As part of the same announcement, Coleco claimed that it would continue producing its ColecoVision unit (which was described as marginally profitable), but it was clear that the company was starting to lose interest in the video game market, swayed by the aforementioned phenomenal success of its *Cabbage Patch Dolls* toy line, which represented 80% of the company's total revenue in 1984. By the end of 1985, Coleco had sold much of its remaining ColecoVision inventory to retailers and planned to sell the remainder by the year's end. The ColecoVision was officially discontinued and the once revolutionary console was sadly put to rest.

In discussing the history of video games, the ColecoVision is often overlooked when people tend to talk about the major consoles from the early '80s. But this is clearly a mistake. The console may have not been as iconic as the Atari 2600 or had the longevity of the Intellivision, but made up for that in a number of ways. The system brought the experience of console gaming closer to the arcade than ever before and also ended up having a notable influence on both the SG-1000 and the Nintendo Famicom. It's safe to say that, if not for the ColecoVision, the video game industry would potentially be very different today. That alone demands its reappraisal.

A ColecoVision Education

While Atari 2600's library might be the second-gen selection best preserved in the modern era, the ColecoVision highlights like Rolloverture, Miner 49er, Sammy Lightfoot, Nova Blast, Squish 'Em Featuring Sam, Jumpman Junior, Sir Lancelot and more are available thanks to the ColecoVision Flashback collection.

072

073

074

075

072
BurgerTime
1982

073
Miner 2049er
1982

074
Sammy Lightfoot
1983

075
Sir Lancelot
1984

076

077

078

079

076
Rolloverture
1983

078
Jumpman Junior
1984

077
Nova Blast
1983

079
Squish 'Em Featuring Sam
1983

MY FIRST DAY AT ATARI.

words *Howard Scott Warshaw*

The birth of the new video game medium was incredibly alluring to true pioneers. We were blazing the trail of interactive entertainment and so many other life-altering innovations. Atari was the cauldron in which the dawning video game industry was truly forged. It was tumultuous, turbulent, nourishing and destabilising. All dominated by one sure rule: *when you expect things to make sense, you're losing touch with Atari.*

Atari was never about making sense. Atari was about making fun. It was about inventing things that never existed before in ways no one had ever imagined. It was not a sensible place; it was an outrageous place. It was an orgy of creativity and innovation, populated by the most engaging, accomplished and eccentric cast of characters I've ever known. Atari was the perfect place at the perfect time for inspired outcasts like me. And when my time at Atari ended (which it had to, since nothing so imbalanced can remain standing indefinitely), I knew it would never be equalled.

But what was it like to be there? Let's talk about my first day at Atari...

It's January 12, 1981, the second Monday of the year. My first day at Atari starts typically enough for a new job, but nothing could prepare me for the realities of the world I was entering.

Upon arrival, I see many of my brand new coworkers are just returning from the latest Consumer Electronics Show in Las Vegas. Stories of their exploits are hair-raising!

Back in the day, there was no E3. There was just the Consumer Electronics Show (or CES for short), and video games were simply the latest entry in a sea of click-flash-beep gimmickry. CES convened twice a year: Chicago in June and Vegas just after New Year's. Chicago was fun but Vegas was *amazing*. The idea that someone would turn us loose in Vegas (with an expense account) was incredible. Running around all day analysing the latest video games and electronic toys, that was our *professional obligation* for the trip. The rest of the time was focussed on 'allocating the expense account' for fun. Gambling, shows, great restaurants — and our only care was making sure we hung on to the receipts. CES in Vegas was magical. I mourned the fact I'd just missed this one, but I will dive deeply into the next three!

I head over to HR for orientation. They tell me about benefits and such, but nothing about what life at Atari is actually *like*. In retrospect, I don't think even they knew. Atari engineering was an entirely separate world. After watching the introductory video and filling out some perfunctory paperwork, I head back for whatever is next.

I sit down with Dennis Koble, my manager, and he asks me a question that will define my entire experience for the next several years. He says: "We have VCS or Home Computer. Which do you want to work on?" Months from now, with the gift of hindsight, this choice would be painfully obvious. But this is now, and I have no reason to prefer either; such is the plight of the newbie. So, I do what I usually do in situations like this: I answer the question with a question. "What's the dirtiest, ugliest, most primitive system you have here?" I hate moving from higher capability to lower capability systems, so I figure if I start at the bottom, I'll save myself anguish later. In life, most of our choices come down to one of two approaches: maximising pleasure or minimising pain. Since I cannot yet grasp the pleasure potential here, I choose the latter.

photography *Imogen May*

"OK, that's the VCS." Dennis assures me. And just like that, my fate is sealed. I'll be making console games.

Among the innumerable implications of my answer, the very first is seating location. The VCS department occupies the main quadrangle. Its main feature is a central hallway that cuts the world into an inner rectangle and an outer ring. The interior contains the labs where development systems live. The outer ring is for offices. People pencil out code in the office, then go into the lab where they test the code on a development system and figure out how to fix it. The hallway itself serves as a test track for all manner of racing or path-oriented games we might want to explore, as well as hosting the execution of many shenanigans, which are an integral part of life at Atari.

Dennis gets up from his desk and motions for me to follow. He takes me to an office that looks like a storage closet for desks, leaving precious little space for a person. I'm the third human assigned, apparently. "You'll be in here with Tod and Rob." That's Tod Frye and Rob Zdybel, two amazing characters who remain friends to this day. They would become formative people in my life. Yet at this moment, standing among the sea of desks, they remain unallocated neurons in my brain for a few hours more since neither is here now. I'm confident they exist because two of the desktops near the door have things on them. Grateful for the opportunity, I clutter a third with my things and continue the journey with Dennis. As we leave the office, I can't help wondering: *will Tod and Rob notice my things and contemplate my existence?*

As Dennis leads me around the department, I'm taking note of the faces. Some are familiar from my interviews, and some are new. He turns left through a doorway, and as I make the turn to follow, my eyes pop. It's one of the labs where games are made. All around the room, big televisions sit next to big black boxes. Interesting things are happening on every one of the TV screens. Some simple, some elaborate, but each with colours and motion and beeps and pings. It is hands down the coolest moment I've ever enjoyed in a workplace. In front of each station, seated on a tall stool, is an Atari game engineer. In this moment, I realise these people now have an additional designation in my mind: *colleagues.*

Standing here in this lab, for the first time in my life, I feel I've arrived. Right here, right now is precisely where I need to be. We walk around the lab, and Dennis is introducing me to the developers, but I'm not really taking it in. I'm too overwhelmed with pure joy!

After the lab, he shows me where supplies are kept, and who are the key admins to which I might turn in times of need. Finally, he hands me the standard starting package of documentation and floppy discs to use for my yet-to-be-assigned project. He assures me I'll have one soon and encourages me to explore coworkers and

documentation in the meantime. This whole introductory process is far less formal than my previous job at Hewlett-Packard. I don't have much basis for comparison, but this works fine for me. I'm not one to stand on formality, unless I'm jumping up and down trying to crush it.

Returning to my newly assigned desk, I reflect a bit on my day so far. It occurs to me that all those screens in the lab are video games soon to be released. Millions of people out there are eagerly anticipating this stuff. They can't wait to get their hands on it. I'm at the epicentre. This is broadcast media, and I'm in the 'studio.' The entertainer in me perks up, this is my chance to show them what I've got. I hope I've got something to show.

Sitting here in the office is a bit of a fishbowl experience. People pass by consistently, and my eye is drawn to each of them. Manual reading is best done without distraction, so I head downstairs to the cafeteria, which is empty since it isn't mealtime. The traffic is less frequent, and I'm feasting on new data.

After a while, Jim (one of the programmers) happens by and stops to chat. While we're talking, I can't help noticing there's something attached to one of the belt loops on his jeans. A second glance confirms it's an alligator clip, and judging by the discolouration on the tip, one that's been used recently as a roach clip.

Assuming he forgot about it, I point and say, "Hey, I think your roach clip is showing." Jim looks down at the clip, then smiles at me in a way that suggests how cute it is that the new guy thinks this could be an issue, "Oh, that's not a problem."

From the start, it was abundantly clear that marijuana had a real presence at Atari. Even during the interviews, people were feeling me out on the topic. But it's so blatant here that it's a new concept entirely. I'm beginning to realise I may need to recalibrate my sense of workplace propriety.

Jim asks me how I like it so far. I tell him I'm really digging it and looking forward to being here. Then he says, "Yeah, it's pretty good, but it isn't what it used to be. This place used to be amazing." Admittedly, I don't know much yet. Nonetheless, this statement feels odd to me. I cannot imagine a better work environment. But I know sometimes people lose sight of the forest for the trees and fail to notice how cool something is because it's become normal. I chalk it up to bourgeois entitlement, as I have no intention of ever taking this environment for granted. In my experience so far, Atari is beyond amazing, and no comment is going to change that.

After reading a while more, I head back up to VCS and continue my socialisation. I walk around the hallway, look around the labs and ask a few questions. Strike up a brief chat here and there about my background and

what game someone is currently developing. On one pass down the hallway, this happened: someone (presumably a game engineer) is walking in the opposite direction. As he passes, I notice he's making a series of sounds I cannot decipher. This is pre-cellphone, so he is not talking to anyone in particular, and I don't recognise the language at all. Stupefied, my eyes and ears are compelled to follow him down the hallway until he turns the corner and disappears. Apparently, seeing someone stupefied by this display is not that unusual, because another hallway passerby notices my quizzical expression and offers this unsolicited but welcome explanation: "Oh, he was raised with a twin, and they created their own language. He thinks out loud in it." Thankful for the explanation, a smile comes over my face. For no reason I can articulate, this makes perfect sense to me, and I feel more a part of everything for the knowledge. *I am so glad to be here right now.*

I return to my office and peer out the huge plate-glass window. The early nightfall of winter assures me that the end of my first day in the new world is fast approaching. I'm getting a few more pages of manual under my belt when Tod breezes into the office, the door closing shut in his wake. He produces a small plastic baggie whose contents appear green with purple sparkly streaks. He takes note of me and, with pure nonchalance, begins the most unforgettable exchange I'll ever have on my first day of a new job: "I'm going to smoke a joint now. If you don't want to be around this, you should leave."

I appreciate Tod's courtesy in offering me the choice and assure him leaving will not be necessary. In fact, I'd prefer to stay and join in, which is fine with him. Recalling my interview experience, I am prepared today with a joint of my own, freshly rolled this morning. *Isn't that part of everyone's pre-work ritual on the first day of a new job?* I reach into a pocket and produce my contribution, offering it to Tod. He gives me a look which could be either disinterest or disdain (but no hint of surprise whatsoever) and says, "No offence, but I'm going to smoke some *real* stuff here."

Apparently, my new office mate is a pot snob. As the newbie, who am I to argue? I'm here to learn. He opens the baggie, releasing a much sweeter aroma than I anticipated. He proceeds to roll up a joint rather adroitly, and we smoke it. Soon, it becomes clear to me I'm not dealing with a snob after all. *Tod is a connoisseur.* His stash is far better than mine. I realise I'm going to have to up my game on a variety of levels in this new job. After spending some time chatting most enjoyably with Tod, it was time to call it a day.

On the way home, I sift through my experience of the last ten hours. It's super exciting to be at the core of a magical engine, generating new kinds of entertainment that millions of people around the world are hotly anticipating. I'll get to see the games, play them, influence them and even create them on a daily basis.

I know that, for the first time in my life, I don't want to be somewhere else, or someone else, or do anything else. Finally, my foreseeable future is perfect just as it is. This is what makes Atari so remarkable. Something very special is going on here, and now I'm part of it, which is glorious!

It is also clear Atari will totally reset my concept (and expectations) of life in the workplace, much to the chagrin of a long series of future managers.

At the same time, Alligator-clip Jim's words are still ringing in my ears, "this place isn't what it used to be." Imagine showing up at your ideal job, and hearing people complaining how it was *so* great before, but now look at it. I'm thinking, "Yeah, look at this. It's a dream come true. WTF are you talking about!?!?"

It turns out I'd landed in the middle of a huge cultural transition. One with ominous ramifications for Atari, the game industry and the world of technology. What I'm not quite grasping yet is when people say, "It used to be better," what they mean is, "I don't like where management is heading." A new wind is blowing, less sympathetic to developer needs. I am too close, too new, and my eyes are too wide to see it. But I will come to understand the truth of it and, impossible as it seems now, I'll be singing the same tune soon enough.

I've stepped into a life-warp, wrapped in a reality quake. Atari will totally redefine my sense of who I am, where I'm going and what I need. Or perhaps Atari will simply enable me to finally hear the answers I've known all along. Either way, this is the first of over a thousand Atari days in a row, but I don't know that yet. In fact, at this point, I have no concept whatsoever of the extraordinary adventure ahead of me.

I do know this: I can't wait to come back tomorrow morning! I need that in my life. There weren't any days like this at Hewlett-Packard, but I'm feeling one right now and loving it.

And I know one other thing: I've finally found a home.

Howard Scott Warshaw is a video game pioneer. He created several of Atari's most famous and infamous products. Now the Silicon Valley Therapist, Howard shares his unique perspectives on the birth, death and resurrection of this incredible industry in the book 'Once Upon ATARI: How I made history by killing an industry'.

THE STORY OF GENERATION 3.

On July 15, 1983, in the skies over Japan, the war began. One launch, and simultaneously another. Nintendo had released the Famicom and Sega the SG-1000 — thrusting us all into the third video game generation. Melodramatic as that made it seem, July 15th was certainly an interesting date. Not only did Nintendo and Sega, future rivals, happen to both launch competing hardware on the same day, but an entire video game generation would be kicked off that aimed to correct all the issues of the previous.

The second video game generation was the Wild West era of video games. Anyone could make a console, game, or accessory, and just about every company did. The likes of Coca-Cola and Pepsi produced video games. Top dog, Atari, however was unable to corral the beast it had unleashed. The company failed to predict the value of anti-piracy measures, enforceable licensing agreements, and basic quality control of their brand.

Like the industry at large, Atari had miscalculated its target audience. Video games were seen as a fad, something to exist exclusively as the next big 3D glasses or smell-o-vision entertainment gimmick. Make a quick buck, move on, forget trying to keep people around. With so many bad games, confusing hardware, and downright poor business tactics, an extremely overloaded market crashed in the United States.

Meanwhile, in Japan, Nintendo was taking the country over with the Famicom. Sega would not see quite as much success, but it's worth noting that its history of releasing too much hardware started early. Sega also released the SC-3000 on the exact same day — why not start off being weird. Nintendo's success in its home territory was unparalleled, and the dream was to introduce the Famicom to the rest of the world. However, due to the crash, the timing just wasn't right. Nintendo waited, allowing games to be developed in Japan for a couple years, giving US markets a chance to heal.

Seeing an opening, Nintendo made a few changes to the design of its system — completely ditching the body of the Famicom, replacing it with the more boxy machine we got. The reason for this change was simple: the popularity of the VCR in the mid-'80s. This would ironically hurt the NES in the long run as the process of putting the cartridge in at an angle, then pushing it down, resulted in the system being highly unreliable as time marched on. In the moment of its creation, though, this was genius.

In 1985, Nintendo felt it was time to strike. After a few market and quality control changes before release, of course. To trial the system, Nintendo released the retooled NES only in New York City to see how it'd perform. The decision was made to launch 100,000 of what is now known as the 'test market' edition.

It was bundled with *Gyromite*, *Duck Hunt*, an NES Zapper light gun, and most importantly, a toy robot peripheral called R.O.B., short for Robotic Operating Buddy. This toy, odd as it seemed, was absolutely essential to the success of the NES. Remember, video games were seen as effectively junk in 1985. Piles of Atari-era carts littered stores and landfills. No one in their right mind would want a video game system, right? But if that video game system was disguised as a toy... then people were interested.

The NES was fundamentally marketed this way: as a toy with a brain that just so happened to be a home console. The logic was that R.O.B. would appeal to children, and get them hooked on games through R.O.B.-compatible software, like the aforementioned *Gyromite*. But that's not all. Remember, kids also had access to that NES Zapper and this *Duck Hunt*... thing (definitely not a video game). Soon enough, they were playing

Setting the Groundwork

As Sega's first home console, the SG-1000 is both incredibly important and doubtlessly overlooked. It lacks most of the touchstones that now define Sega and has a library of official titles which doesn't come anywhere close to 100 games in total. However, important Sega studios like Compile did stretch their legs here, and Flicky — a classic Sega arcade title whose eponymous character would later become a Sonic staple — did launch on the SG-1000! So in a circumspect way, even this platform has a Sonic game!

SG-1000
1983

PV-1000
1983

that too. But the NES still wasn't a video game system — certainly not. At least not yet.

One could argue that this was a bait-and-switch strategy, but it's hard to get mad about it: the switch was far better than the bait. And it worked — the console did extremely well in the test launch and received additional runs in Los Angeles, Chicago, and San Francisco in 1986 before its full national rollout. The system was a massive hit in the United States and Canada. To this day, it's fondly remembered as one of the most successful video game consoles in history. As an American who was largely conditioned to think that the NES' release was the greatest thing to ever happen since George Washington personally threw the British out with his own bare hands, I find the stories of the international launches (aside from Japan) to be fascinating.

Brazil only tends to get mentioned in a video game context for being an anomaly, and its NES launch is no exception. Nintendo's initial foray into this market was anything but smooth. Nintendo, well known for intellectual property protection, didn't react too well to how its content was handled there. It's standard for a publisher to provide local marketing assets when entering a new territory. But in Brazil's case, Nintendo didn't really bother — more or less leaving the country to its own devices. This resulted in not only a few odd releases and even more peculiar clone consoles.

When the NES (and especially Mario titles) launched in Brazil, having no official Nintendo brand materials to work with, the Brazilians devised their own marketing strategies. Outside of game stores, there would be people in what amounted to bad cosplay marketing the NES in an official capacity. Partly in response to this, Nintendo became more protective of its IP in general. Especially damning for Brazil in particular, Nintendo more or less decided to bail on the country. This would open the door for Sega to dominate there.

Meanwhile, in Europe, the NES was a borderline flop. While it certainly came out and found fans, even receiving a number of region-exclusive titles, the console simply wasn't the victory lap that it was in North America. It's hard for me to pinpoint why, but the narrative largely boils down to Sega simply doing a better job in that part of the world. Coupled with the fact that European markets were somewhat insulated from the video game crash, it's easy to find examples of things like the ZX Spectrum still flourishing. The idea of game console masquerading as a toy might have seemed almost insulting.

Despite isolated difficulties, the NES is an undeniable success and easily the winner of its generation. But why was Nintendo able to succeed where so many failed? It can't all be attributed to R.O.B., Nintendo made several business choices that proved to be even wiser. The company observed what had killed the Atari 2600

and its competitors, creating what is lovingly known as the 10-NES chip: a security chip in the NES that would help to prevent rampant piracy. Ironically, this chip was not present in the Famicom, hence why it was cloned so easily. To this day, Famiclones are *still* produced. There are even amusing stories about ones from countries the US and Japan wouldn't do business with (like the former Soviet Union and Cuba), but I digress.

Nintendo was also remarkably stringent about licensing agreements and quality control. Developers were bound by contracts with Nintendo that essentially required them to be exclusive partners with the company: work with us — and only us — or you can't have your games on the NES. This was monopolistic to say the least, but also incredibly effective. Developers in the US in particular couldn't risk supporting Sega or Atari if it meant burning a bridge with Nintendo.

Further, Nintendo wouldn't allow developers to produce more than five games a year for the NES. The resulting loophole saw developers establishing shell companies to release more titles. Konami, for example, made a company called Ultra Games for this exact reason. In a sense, the NES' success can be attributed to the cycle this mandate created. People developed games for the system because of its success, and it was a success because everyone *had* to develop for the NES. This phenomenon's potency just snowballed with time. Fortunately, this general practice would be disallowed a few years later.

However, despite Nintendo's then-monopolist policies, its philosophies were essential. Imagine a world where the NES flopped. Perhaps Nintendo dominates Japan, Commodore dominates Europe, and North America becomes a battleground. Maybe Atari tries again, or someone like Apple or Microsoft enters the fray earlier. The simple decisions and directives which guided NES, despite it being far from my favourite console, are hard to overvalue. There were essential hardware decisions — prior to the NES, we didn't even have a basic D-Pad, for instance.

But on a grander scale, Nintendo asserted the importance of focusing on all major economic regions when launching hardware — despite its isolated failures. To this day, the three major console manufacturers do that. Even Microsoft, who sees almost no pulse in Japan with the Xbox, persists. We have Nintendo to thank for making video games a unified global idea. If not for the company, we might have been forced to import obscure consoles to play their handful of games we've heard to be good. Nintendo made gaming a household concept and loomed large over the industry.

Parallel to this, Sega had a rocky go. Oh Sega, how I love you. But man, these times were just rough. As previously mentioned, Sega launched the SG-1000 and

SC-3000 to compete directly with Nintendo. Needless to say, it didn't work out. The SC-3000 was discontinued rather quickly, and the SG-1000 would be redesigned to stick around for about another ten minutes... until Sega did what it always does: make a new system. A Master System, you might say.

In October of 1985, as Nintendo was gearing up its US test markets for the NES, Sega was releasing the Sega Mark III. This was effectively the third iteration of the SG-1000 — in a manner of speaking. It was backwards compatible but also had better tech inside, allowing for newer exclusive games. The system did decently at best, and it was redesigned for an eventual release in the US, Europe, and Brazil.

We know this machine as the Sega Master System. Well, maybe you do. Most of my fellow Americans have never heard of it. The problem with the US release was that Nintendo so overwhelmingly dominated the space — it was almost impossible for Sega to get in. Almost all of the Master System's games had to be developed internally, and the console had very selective third-party support. The system was a technical leap above the NES, but the number of people who would ever notice was small.

However, this wouldn't be the case in other parts of the world. As NES dropped the ball in both Brazil and various parts of Europe (especially the UK), when visiting any retro game store in England, you'll have a hard time finding NES games. But *oh man* do they have Master System cartridges for days. The system was such a hit there that it even got a slim revision simply known as the Master System II. This revision would make its way to the US / Canada, though the Canadian release is more common.

Brazil is another conversation entirely. Due to the age of the system, the circumstances of its release, and tax laws in Brazil, the Sega Master System is, to this day 2023, still supported in Brazil. Yes, really, they still make new Master System content in an official capacity. This crowns the Sega Master System as the longest-lasting officially-supported system. Though, to be fair, this is at best true on a technicality, as new games and hardware are seldom, poorly done, and result from simple licensing agreements. But hey, Sega is still making consoles. Sort of.

The legacy of the Master System is largely over-shadowed by the NES I'm afraid. These days, it's best remembered in Europe as an interesting footnote in Sega history — at least in North America. At least it would live on through backwards compatibility in the Sega Genesis / Mega Drive, with the right adapter of course.

Good old Atari was in this third-gen mix too. We have Atari to thank for getting the ball rolling on the entire industry, but we simultaneously have them to

082

083

082	083
MSX	**Dina**
1983	1986

084

085

084
Super Cassette Vision
1984

085
Atari XEGS
1987

blame for running it into the ground. By the time of the crash, Atari had already released not one but two home consoles: the wildly successful Atari 2600, and the far less effective 5200.

Seeing the 5200's flaws, Atari attempted to correct them with the Atari 7800. Wanting to produce a more capable machine with a more reliable controller and backwards compatibility, it all sounded good on paper. Developed in 1983 and announced in 1984, it was happening. However, absolutely no one wanted a new console from Atari at that point in time. In an oddly wise move, Atari shelved the console until it felt the market had recovered. Once Nintendo fixed things, Atari was miraculously ready.

The system came out in 1986 in North America and 1987 in other regions. But Atari faced an unavoidable issue. While the system was indeed better than the 5200, it was a 1983 design. Atari didn't make any improvements at all in that time. The sound chip actually was straight up *exactly the same* as that of the 2600. Atari was effectively asking burned-out customers to buy antiquated tech that looked less fun and less capable than the system they already owned, all in service of getting slightly better versions of games they played on the 2600 almost a decade ago.

Not a great plan. But Atari somehow found a way to make the situation even worse. Despite wanting to make a controller that improved upon that of the 5200 (to be clear the company did), the controller released was still informed by an old arcade mentality. This would be corrected for the non-US releases though, as other regions got a controller in line with the NES', featuring a simple D-Pad. While I enjoy this system for what it is, from a simple business perspective, Atari just did it wrong. These days, the 7800 is largely remembered as a great way to play 2600 games.

It is worth noting that the third generation would ultimately consist of around 19 consoles — the legitimacy of some is debatable. Simply put, there are too many to visit in detail, but several of the lesser-known systems are interesting in their own right. The Casio PV-1000 — I have only ever seen this system once. Only released in Japan, it was recalled shortly after launch and never re-released. As a result, it's quite rare. But, it technically had a successor in the form of the Casio Loopy.

Speaking of region-exclusive consoles, Amstrad GX-4000 released exclusively in the UK with the legitimate intent of taking over the space that Nintendo failed to fill in England. This crashed and burned (literally) for a whole host of reasons — not least of which because Amstrad was unable to produce game cartridges due to a parts shortage, and the system's power supplies infamously had a tendency to blow up. Thanks, Amstrad!

The rest of the systems are largely edutainment -based, clone consoles, or failed spin-offs from Atari and Commodore. Many of these attempted to emulate Nintendo's business strategy in the US by presenting as toys first — I'm looking at you LJN Video Art, View-Master Interactive Vision, and Vtech Socrates!

Now, how is it possible for a generation with so many competitors to be remembered as only a two or three man race? I attribute this to many systems doing nothing more than hobbling out of the wild west console era. Due to how long production cycles were, it was essentially impossible for any of these failed machines to react in time to the collapsing environment around them. Those that made it to market were largely products of outdated thinking from companies just hoping to recoup any losses. And the others — these were born after the success of the Famicom / NES, hoping to trick people into thinking their platform was the next big toy.

The third video game generation is not one that I personally remember too well. It was the active generation at the time of my birth. I do, however, distinctly remember that the first video game console I ever saw was an NES. My cousins had brought it over to my house when I was perhaps only three. They played it, and I stared in awe as they tossed digital newspapers... guess the game. The second system I ever saw was, funnily enough, a Master System. A friend of mine sure did like *HangOn*, thus so did I. To keep it real though, I never knew anyone with a 7800 and wouldn't even know about it for probably another decade.

While I grew up on the fourth generation, I do have a historical fondness for the third. The things it brought to the table: the ideas, the norms, creativity — it is a generation to be respected. Amusingly, while the generation did technically have a lot of competitors, it's easy to reduce the field down to just the three. Perhaps the three most iconic dedicated video game console manufacturers in history. Oddly, this was the only time that the trio truly fought it out. The only time where a generation was effectively defined by them. I find that, in-and-of-itself, worth celebrating. Even if the contest was really one-sided.

The More the Merrier

While this console generation is defined primarily by a few key players, there continued to be a wide array of challengers in the space. From Amstrad and VTech to 8-bit computers like MSX, there were plenty of compelling machines during this time that didn't quite catch on like the NES. Sometimes, the also-rans are just as interesting to explore: systems like the Dina, Super Cassette Vision, Atari XEGS, and Action Max are worth researching!

086

087

088

089

086
Action Max
1987

088
VTech Socrates
1988

087
View-Master Interactive Vision
1988

089
Amstrad GX4000
1990

Nintendo
ENTERTAINMENT SYS
NES VERSION

NINTENDO ENTERTAINMENT SYSTEM.

words *John Szczepaniak*

What can be said about hardware whose legacy is now over 40 years old where, given its overwhelming popularity, it's almost impossible to read the entirety of the literature about it? Seemingly every scribe from every outlet has dissected and analysed the Family Computer and Nintendo Entertainment System in such microscopic detail; surely most of its mysteries have long been solved? Tasked with writing about such an iconic and clearly defined pop-culture phenomenon feels impossible, given my own introduction to it was so unorthodox.

First Released:
1983

Manufacturer:
Nintendo

Launch Price:
JP ¥14,800
US $199.00

My first Famicom / NES experience was in South Africa. My family was visiting friends; they'd emigrated from Hong Kong, and their son Kit showed me the new magical device his parents had acquired. First, we played a platformer where a guy in a loincloth collected fruit — the title screen had the Japanese kanji for *Takahashi Meijin no Boukenjima* (which we couldn't read), but the multi-cartridge label said *Adventure Island*. There was also *Ice Island*, which started you with the skateboard, and *Fire Island*, which gave you the skateboard *and* the fireball attack (these latter two were hacks.)

Historian Joshua Rogers has researched Nintendo's failed attempt at getting an official foothold in South Africa. It certainly existed, however briefly, but for children like Kit and myself, we were immersed in the bootleg scene. In Russia, they were called Dendy; in Brazil, it was Dynavision; and in China, a company called Subor had Jackie Chan endorsing its Xiao Bawang Education Computer.

In South Africa, we had several branded 'Famiclones,' including the Reggie's Entertainment System, but we just called them TV games — it was a strange mish-mash of cloned Japanese cartridges (many of them multi-carts), an esoteric array of system designs, plus imported American and British magazines. Seeing cartridges in-store was euphoric, as hundreds of pastel-coloured rectangles hinted at the worlds within. The labels were usually the original Japanese, but equally as often, they were bizarre custom-made enigmas. To this day, I still don't know which game was represented by a semi-naked anime girl's backside, and I was too shy to ask.

South Africa, in general, would have seemed strange to many. December is summer; television and films often showed us as the bad guys (alongside Russians and nondescript South Americans); and *Super Mario Bros. 8* was popular at school. Also, lions *totally* wandered our backyards. My first inkling that I was experiencing things differently to the global mainstream was reading a US magazine which had a quiz about the number of games in the Mario series. They claimed there were three 8-bit titles. They had to be wrong, because I absolutely knew the true number was eight entries on the Famicom / NES. Many years later, I would ascertain that the eighth game we all played was actually just a hacked reskin of *Don Doko Don 2*. In fairness to my younger self, the magazine had also neglected to account for the *Yume Koujou: Doki Doki Panic* discrepancy: the Japanese *Super Mario Bros. 2* became *Lost Levels* in America, while the second localised game was imported back into Japan under the name *Super Mario USA*. So, officially, there were *four* mainline Mario instalments on the system. Plus hacked reskins, of course.

This sense of mystery surrounding TV games didn't end after emigrating to England, nor did it dissipate when discovering the World Wide Web in later years. If anything, the nascent Web brought more mystery, as enthusiasts around the globe shared a mixture of personal anecdotes and pure fabrication. Discovering that *Ice Climber* was censored outside of Japan; that the real *Final Fantasy II* was actually a NES game; that *Snake's Revenge* wasn't the real sequel to *Metal Gear*; that there was an alternate Star Wars game in Japan in which Darth Vader

photography *Damien McFerran*

was a scorpion; that there were official Sega arcade ports on it; and that *Metroid* contained more 'secret rooms' than anyone imagined... Nintendo's system clearly had hidden depths.

One enthusiast's attempts to chart the entirety of *Metroid*'s rooms, accessed via the wall glitch, stands out in my memories. His acolytes would share discoveries as if deciphering ancient sacred texts, each on the verge of glimpsing the face of God. Secrets they believed were promised by Nintendo to only the most devout players. Most people would only ever experience a tiny percentage of the game, but they knew its true depth. Eventually, it was explained that these so-called hidden areas were actually just the result of how *Metroid*'s programming loaded ROM data, and accessing places which were out-of-bounds caused junk data to be loaded, to put it simply.

The leader's reaction was emotionally charged and, in a fit of apostasy, they deleted all of their work and discoveries. They spoke like someone who had believed a lie and was then forced to accept an uncomfortable truth. I can no longer recall this person's name, nor the site, but their passion for exploration and words has remained with me for decades. They described players as astronauts leaping into the great unknown when searching for these secrets. This feeling pervaded everything. From *Super Mario Bros. 8* through all of the above examples, everything about this 8-bit machine seemed to exude unfathomable weirdness. So many mysteries which I wanted to solve. This desperate yearning to understand the unknown would define my life, as I became an investigative journalist and later — inadvertently — a historian.

As I would discover, the Famicom and NES are repositories of innumerable minutiae. The Famicom actually started with square buttons, not round ones. For its entire first year, none of its games had any sort of screen scrolling. Curious licensing deals and anonymous contract work (*it's contractors all the way down!*). The fact Galoob shot first in a series of court cases against Nintendo over the Game Genie, not the other way around. Also, the dark underbelly of the machine, as stories of Nintendo's monopolistic behaviours emerged, describing the company's attempt to bully or coerce retailers, developers, and publishers. And then the games themselves, over one thousand officially licensed titles plus many more unlicensed.

So many details, half lost, increasingly forgotten as those of us who grew up with it slowly age.

Thus, it came to be that roughly 25 years after my formative first encounter, I was living in Tokyo for three months, interviewing over 80 Japanese game developers for a trilogy of books in an attempt to unravel as many mysteries as possible. There were countless captivating stories about the Famicom and NES, and so many developers saying they had no idea anyone outside of Japan liked their games. For you, the readers, these games were tiny windows into a foreign culture on the other side of the world, enchanting adventures that, for some, would chart the trajectory of their careers. But for the men and women creating them, there was little realisation of such everlasting impact.

One of the first interviewees was Ryuichi Nishizawa of Westone, who created the original *Wonder Boy*, later reskinned by Hudson as *Adventure Island*. He described development in a rented apartment where, on the veranda, someone had left a skateboard. Nishizawa would fool around with it, leading to the skateboard in the game. For me, meeting Nishizawa was more significant than meeting Shigeru Miyamoto. It was somewhat melancholy when he revealed he never gets recognised by the public, despite influencing a generation. He also described creating *Jaws* for the NES in two months with absolutely no oversight process. We had pork cutlet for lunch, and there was an amusing stand-off as we each vied to pay the bill.

Later was Michitaka Tsuruta, an old friend of Nishizawa, who described the Famicom conversion of *Bomb Jack*. He said they removed licensed music tracks since, although the cost was only a few yen per cartridge, the profit ratio was justifiably higher with arcade PCBs. He also shared design documents for *Solomon's Key*, showing changes for the NES port, and also its console sequel, *Fire 'n' Ice*. Tsuruta revealed the time travelling in *Super*

090

091

090
Famicom
1983

091
Nintendo Entertainment System
1985

Star Force was because he and a colleague had seen *Back to the Future* at the cinema.

A trip to Hokkaido allowed an interview with Takashi Takebe, the seventh employee of Hudson. He worked with Toshiyuki Takahashi, who became the mascot for *Adventure Island;* he said turning some middle-aged man into an idol was "unexpectedly successful." Takebe revealed he visited London in 1982 so Hudson could expand into the ZX Spectrum market (a British microcomputer with BASIC interpreter). It's nice to think that the spirit of Sir Clive Sinclair would influence his subsequent work. Hudson became the first third-party developer for Nintendo, and Takebe would create Family BASIC, *Princess Tomato in the Salad Kingdom*, port *Lode Runner* to the NES, and port *Super Mario Bros.* to the PC-88 computer (with wacky results).

Keiji Inafune believed that Capcom's success with its Mega Man series was because the team didn't resist the NES architecture, instead allowing its limitations to guide their creativity. That, and his boss Akira Kitamura was a harsh taskmaster! He also talked about how, from *Mega Man 2* onwards, they had Japanese children submitting boss designs.

During my great odyssey, former Nintendo president Hiroshi Yamauchi, the godfather of the system, passed away, forever locking away any stories. While I never interviewed the legend himself, I did speak with those who knew him. Henk Rogers, of *Tetris* fame, remembered befriending Yamauchi and creating the only Famicom game he likely ever played (*Igo*). Manabu Yamana meanwhile recounted being awestruck while attending meetings at a teahouse and hearing Yamauchi's impassioned calls for another *Dragon Quest*. Yamana also sketched the expensive development environment Nintendo provided Chunsoft, and described how he helmed later Dragon Quest entries, converting them to Dragon Warrior for America (Enix worried the head/body proportions would not be appealing).

Yoshio Kiya of Falcom gave detailed accounts of creating *Legacy of the Wizard*, expressing pride that in a 1989 issue of Nintendo Power, it was ranked higher than *Dragon Warrior*. To facilitate such a complicated map, he designed and printed out each screen, arranging them in place. Pochi was immune to attack because who would want to hurt an adorable family pet? Kiya also recalled the anger of Richard Garriott upon seeing Falcom had plagiarised *Ultima III*'s artwork.

Tokihiro Naito described how the Nintendo version of *Hydlide* sold a million copies, while its combined sales on eight Japanese computer formats only matched this. Although derided by critics, *Hydlide* was an important early evolution in action-RPGs and represented a shift towards console dominance.

Takashi Tokita of Square expressed the excitement of making a game based on the *Aliens* film, even though the Famicom Disk System version went unreleased (it was eventually leaked). He was horrified when I showed him the racist graphics in *Square no Tom Sawyer* — and insisted that while he drew Tom, a colleague drew Jim! He reminisced about befriending Nasir Gebelli, who programmed both Rad Racer titles and the first three Final Fantasy games.

Takayuki Hirono of Compile detailed the programming of *Zanac*, also exploring the strengths of the NES over the TurboGrafx-16 (replicating the audio like a human beatbox). He says the protagonist in

092

093

The Guardian Legend came about because he'd always preferred strong female characters — he then opened a folder with over 20 pages of original design documents!

Kouji Yokota gave insight into why the Famicom version of *Megami Tensei* was an RPG while the computer versions were action: Telenet and Atlus both agreed to adapt the novel into a genre uncommon for that hardware. Would we have the Persona series today if they'd instead followed trends?

One of the biggest interviews was with Professor Yoshihiro Kishimoto, formerly of Namco. He talked about creating *Pac-Land* and the Famista series (R.B.I Baseball), the late Shouichi Fukatani, who set up Namco's programming environment, and how Haruhisa Udagawa reverse-engineered Nintendo's hardware to port *Galaxian* secretly, which ultimately gained them a more favourable third-party license. He also gave me a list of Namco staff and their games, saying the company didn't want staff credited and imploring that I make it public. Importantly, Kishimoto was behind Namco's *Star Wars* with its bizarre animal versions of Darth Vader. He lamented the difficulty of trying to recreate such an iconic film on such limited hardware, claiming that in the end, they just copied A*lex Kidd in Miracle World*. And the transformations? He admits it's a mystery why the licensor allowed them to get away with it!

After returning home, my investigations continued. For example, when researching the Game Genie, designed by Codemasters and published by Galoob, I interviewed four key people, including engineer Ted Carron. They described how this family-run company, operating from a small British farm, ended up playing at the same table as the corporate giants. Going through the "Lewis Galoob Toys v. Nintendo of America" court papers revealed that Galoob initiated court proceedings — not Nintendo — by filing an injunction to prevent Nintendo from changing its own hardware design.

I also spoke with the Rozner brothers in America, who described trying to remake *Mega Man* for DOS, and even porting the original arcade *Street Fighter* to the NES, all for Capcom USA, though *Street Fighter* never came to market. Meanwhile, Masahiro "Mitch" Ueno, programmer for *Metal Gear* on the NES, had since left Japan for America. He spoke English and described doing the conversion in only three months, how management wanted the opening jungle to differentiate it from the MSX2 original, and how not having access to Konami's VRC4 chip meant he had to replace the end-boss with a giant computer.

Today, every Famicom and every NES game is catalogued, photographed, scanned, archived, and preserved. Experts have disassembled the code, patched in corrections, and translated Japanese games to English and English into everything else. Even the bootleg scene is better documented, with the *Resident Evil*, *Final Fantasy VII*, and other fan demakes meticulously documented. Unreleased games continue to be found and shared. Forty years later, we're still talking about this remarkable system. We also still haven't solved all its mysteries.

092
Famicom Disk System
1986

093
NES-101
1993

The Disk System Difference

Released in 1986, the Famicom Disk System add-on allowed for more ambitious game design, thanks to its use of bespoke floppy disks. Marquee games like Metroid were designed with the FDS in mind, featuring a save system which was only possible due to the disk format. When retooled for NES, the game was overhauled with a password system due to the restraints of cartridges. Many compromises were made when bringing titles overseas, as the Disk System never released beyond Japan.

Now You're Playing With Power!

From the NES Zapper and the NES Advantage to the Power Glove and the Power Pad, the NES had no shortage of interesting hardware peripherals. The hardware itself saw one major revision during this era too, the NES-101, more commonly known as the NES top loader.

094

095

096

097

094
NES Zapper
1984

095
NES Advantage
1987

096
Power Pad
1988

097
Power Glove
1989

nintendo entertainment system.

A Forgotten Nintendo Gem

The Mysterious Murasame Castle is an often overlooked NES gem — one which seldom gets the attention of marquee titles like Mega Man 2, Ninja Gaiden, or Kirby's Adventure. Considered to be The Legend of Zelda's 'sister game,' Murasame Castle re-uses a lot of its bones in a fresh and even more action-oriented title.

098

099

100

101

102

103

104

105

106

107

108

109

098
Mario Bros.
1983

099
Duck Hunt
1984

100
Tetris
1984

101
Ice Climber
1985

102
Metroid
1986

103
The Mysterious Murasame Castle 1986

104
The Legend of Zelda
1986

105
Final Fantasy
1987

106
Ninja Gaiden
1988

107
Rockman 2 (Mega Man 2)
1988

108
Super Mario Bros. 3
1991

109
Kirby's Adventure
1993

74

Although R.O.B. was pivotal in selling the NES, he soon entered a period of relative obscurity. It wasn't until being featured as an unlockable character in Mario Kart DS, and then as a newcomer in Super Smash Bros. Brawl, that the little robot's stock began to rise again. These days, he's a staple Nintendo character!

110

110
R.O.B.
1985

nintendo entertainment system.

FAMICLONE DREAMS.

words *Suhaila Karim*

It's the early '90s. Two brothers and their little sister sit around a Pegasus Mark 3 gaming console. Over the years, many battles will be fought and won — some sorely lost — around that console and many consoles to come. The competitive nature of all three siblings would always inevitably bring out that inner demon that'd have them screaming, "You *cheated*!" repeatedly, often at the little sister that neither brother could ever bear losing to. But on this particular day, they sat around a brand new game: *FIFA*. In a football obsessed family, this was the Holy Grail. And so began the quest for that ever-elusive first goal (and all important bragging rights) on a console notoriously difficult to master. Would it be one of the brothers? Or would it be me, the little sister, that finally netted it? Or perhaps, was the Pegasus going to have the last laugh?

Where the Pegasus Mark 3 — with its little winking boy logo, his cap askew, tongue sticking out, doing a double peace sign — came from, or how we got the multicarts for it, has always been a complete mystery to me. I was too young (about eight or nine at the time) and didn't inquire. I didn't care, really. I was just excited we had a console at all and that I got to play! We'd had an Atari before that, but as sibling legend would have it, one of us had broken it. The *who* of it has been lost to time with adamant denials from all three of us. And so, in came the Pegasus. It came with two controllers, a light gun and one multicart. It was simply a gaming Nirvana. I never knew that one little cartridge could hold so much. We were spoiled for choice.

Back then, none of us even had a concept of what bootleg was. Certainly not my tech challenged parents. They must've just seen a cheap console with an all-in-one cartridge and grabbed the opportunity. It'll keep us busy for hours? Say less — that's all they needed to know. There was a game for every mood: from *Super Mario Bros.* to *Contra*, *Duck Hunt* to *Tetris*, *Donkey Kong* to *Arkanoid*, and everything in-between, with *almost* everything purposefully mis-named in true bootleg fashion. And we played them all. Well, those that'd work. We did have our favourites that we always went back to, though.

The Pegasus itself posed its own challenges. Not only was the console temper-amental — having to be switched on and off several times after mid-game freezes — the controllers were their own trial by fire. The directional buttons were hard to press, and the right buttons tended to stick… not to mention the ports (including that of the power cord) were a loose fit so any extraneous action pulled them out. And as everyone knows, there is simply no way to play anything while staying absolutely still. The light gun somehow never aimed straight either. It always seemed counterintuitive to shoot at ducks from an obscure angle, but we diligently did so all the same. And the graphics quality on our old and infirm TV was, for lack of a better word, shit… yet somehow still the greatest I'd ever seen. Despite all these off-putting obstacles, none were insurmountable. In fact, if anything, they added to the fun. They bolstered our competitive natures, because if we won, we had overcome the Pegasus itself. We beat more than just the game.

My brothers were well established in the world by the time I came along. Seven and five years older than me, the last thing they wanted to do was have their little sis-ter following them around. That, of course, never stopped me from doing just that. Or, from doing everything they did — whether it was playing football wherever there was enough space for it, roughly riding our bikes down hills, or playing video games. We were sporty in every aspect of our lives — gaming included. The advantage video games had over everything else though: they were stationary. My siblings couldn't leave me

art *Hannah Kwan Cosselmon*

behind. They were stuck with me, for better or worse. They acted like they hated it, but deep down I knew they didn't mind because they always, reluctantly, gave me a go.

What they had not anticipated was that I'd eventually actually get good. And so, in our little and extremely messy TV room (that doubled as our gaming room), with VHS and cartridges strewn everywhere and wires haphazardly set up, we played. And we conquered. Not every game was multiplayer, and we quickly learned how to tag-team certain games so that we all got a chance to play. If one of us couldn't complete a stage, another one would step in to tackle it. As much as we hated to admit any one of us was better — we fought, cried, cursed and burned kingdoms down while playing multiplayer games — we were a rare unified force when playing on the same side.

One day, we got back from school and there was a new multicart waiting for us, with a plethora of fresh games. As sacred as you hold some games, you never really realise just how tired you are of a title until you're presented with a new one. Or in this case, new *ones*. The titles that caught all our eyes were *Pro Wrestling* and the first ever FIFA game, called *Soccer* on the multicart. FIFA above all others awoke something in us that no other game had. Football constantly orbited our lives. We all played it competitively, we all watched it fervently. And we all had one thing in mind when seeing the multicart: winning the first match.

Looking back now, I couldn't tell you exactly how long it had actually taken. What could have easily been nothing more than just a few weeks of brief after school sessions and weekend marathons *felt* like months of our fellowship journeying through Bedlam to Mount Doom. Everything that could have gone wrong went wrong. The ageing Pegasus was more temperamental than ever... not helped by the fact that we were not exactly the gentlest of care takers. Mid-game freezes were happening more regularly, the controllers were maddeningly re-sistant when attempting any nimble and instinctual plays. The game itself wasn't exactly conducive to that either. Even simply running with a player put ridiculous amounts of pressure on everyone's thumbs.

Not to mention the new cartridge had to be inserted multiple times over, just to get the console to read it. And once we *finally* got it to work, the real struggle began. The actual gameplay. Anything that felt like it should've been easy was exasperating. It was all the more frustrating thanks to constant shit talking and the echoing screams of legitimate tackles or frantic (albeit game-saving) fouls that re-sulted in inconsolable arguments and vows of merciless revenge being made. Any belief we had in our winning chances was quickly and unceremoniously extinguished, replaced with a more... humble mission. The goal was simple, to get just that: a goal. And with every agonising attempt, we got closer.

Over the course of our struggles however, we'd take much needed breaks — if just to give our minds and thumbs respite, playing other games on the multicart. During one of these so-called intervals of downtime, a round of *Pro Wrestling* matches was, for some inexpli-cable reason, started. And as with everything we did, tempers flared, passions ran high and during one particular fight, through a series of frantically and randomly pressed buttons, I eliminated one of my brothers. The ensuing "you *cheated!!*" meltdown sent one of the con-trollers crashing to the ground, injuring it. I say injured because while

111
Nt Mini Noir
2020

112
RetroUSB AVS
2016

it still *technically* worked, it was never the same since and would sporadically cut out or make phantom commands on its own without us pushing any buttons. And so playing against each other was effectively nullified. It was an unfair disadvantage for anyone who had to use the damaged controller. Now it was us versus the computer. And a game already hard to master was made even harder.

We took it in turns. Like a game of reverse Russian Roulette. A draw meant you got another go, a loss meant the next person got to play. And with every round, each one of us got closer. Despite being united in our goal, that didn't stem the tide of inevitable and irritating backseating: "*you should have passed it!*" "*Why didn't you shoot?!*" "*Down the line! Down the line!*" Every game felt like a World Cup final, to the tune of the Pegasus whirring louder as it worked overtime. The closer we got, the more reluctant each of us was to relinquish the controller. "*But I had it this time!*" would be the recurring warcry, believing the momentum was finally favourable and giving up the chance to ride the wave meant losing that spark.

Calluses began forming while every attempt was met with a half cheer that quickly turned to a groan. The one surviving controller was almost injured itself when I managed to hit the post and sent the controller flying from reflexive shock, saved only by my brother's quick thinking and faster reflexes. Then on one unremarkably ordinary day, it happened. After its customary on and off ritual, we sat around the Pegasus like we always did, passing the controller back and forth like we always did. It was my eldest brother's turn when it happened. Brazil versus Argentina (it was always Brazil versus Argentina – only who played as who changed). Argentina was my elder brother's team, still is. He took up the usual spot right in front of the TV and began to play.

The game was no different than any other. It was furious, stressful and full of backseat playing. But determination lined my brother's face — like it always did. By half time, he was down 2-0. But that didn't matter. There was still a second half to play. By now, we were all (as usual) leaning towards the TV barking instructions as the little unrecognisable players meandered their way around the field, when he found himself with space inside the D. With a poise none of us possessed, he kept his cool and slotted in the first goal scored on our Pegasus.

What happened next was sheer pandemonium. We all jumped to our feet cheering louder than the occasion really called for, but we didn't care, the duck was finally broken. In the ensuing celebrations however, with little consideration for the haphazardly cluttered wiring around the console, a foot snagged on the Pegasus' power cord, yanking it suddenly free of the console. A deafening pause fell upon us all as the room was suddenly and abruptly plunged into an aggressive silence. We all froze.

If there's one thing in my childhood that I'm likely to never forget, it's the silent exchange of looks that went round the room in that split-second, as a ripple of murderous rage built within my brother as he puzzled out who the offender was. As I stood closest to the console, his ire fell on me. At once, I saw his eyes grow with accusation, even though we all stood around the console. But guilt by proximity seemed the only proof needed. And before I could get the words out that it wasn't me, that it could have really been any one of us, we were *racing* through the house. I may have been closest to the console, but I was also closest to the door. Without a glance backwards I hauled ass across the upstairs landing, down the flight of stairs, through a hallway and into the kitchen. I ran for my very life looking for the safety and protection of my mother's shield, to which I arrived just in time!

Amid all the chaos, "*she did it on purpose!*" and "*I'll never forgive you!*" flew with mad abandon, as I pleaded my innocence. *If* it had been me, *if!,* then I can genuinely say it had been a truly innocuous accident. We all look back on it now (and over the many years since) with affection and laughter, but back then, every single emotion was so acutely felt. All over a simple, unassuming console.

It was more than just a console though. The Pegasus contained memories. Some memories have, with count-less hours passed, inevitably faded — some vaguely come to the surface whenever I see an old clip and picture of one of the games we used to play, filling me with the purest nostalgia and itch to find all those old games again. But there are precious few memories — core memories — that still remain beautifully vivid. Like snapshots in time. Every console we ever had, from then till now, holds with it *the* core memory of its very own, that I'll forever cherish.

High-End Excellence

Famiclone systems still exist in a manner of speaking, but they now exist for the sake of high-end collectors looking for the most premium experience. Systems like the Nt Mini and RetroUSB play your original cartridges while offering immense quality-of-life enhancements for modern TVs. That all comes at a premium, though!

79

CUTTING TIME.

words *Alicia Haddick*

We all strive for perfection. It's human nature. The quest to achieve this ideal is tantalising and desirable in part because it seems so impossible. It's a paradox too: if you were, somehow, to achieve this inhuman level of perfection, what's next?

The word perfect gets thrown around a lot in the games space, even when it's clearly an exaggeration of the truth. If you play well in a multiplayer shooter, it was a perfect match — even if you died, took damage, or made a mistake. If you enjoy a game's story, you might say that's perfect... conveniently forgetting the boring section that almost made you stop playing. That console you played in those formative childhood years, with all its associated memories? They just don't make them like they used to.

Super Mario Bros. is an interesting example of gaming 'perfection.' If the prior examples of assigned perfection are personal and subjective — often defined by nostalgia or bias — this is an example of an entire industry and community giving a game the objective title of indisputable perfection. Whether we talk about its iconic music or innovative level design which remains a masterclass decades later, this is a game where even those without rose-tinted glasses marvel at its achievements.

And, in the world of speedrunning, *Super Mario Bros.* is one of a select few games wherein the idea of achieving true perfection is a tangible reality. Speedrunning, for those less familiar, is the act of mastering a game, learning its glitches and tricks, all in order to beat it with the fastest time possible. It's something that has grown from a niche hobby to an alternative way of play, complete with its own community-run marathons like Games Done Quick that raise millions for charity every year.

Beginning with the early arcade days and their high score chasing, gaming has always been infused with an air of competition. Speedrunning simply applies that concept to a mad dash under the pressure of a stopwatch. This makes speedrunning, in its purest form, a dedication to the pursuit of perfection. Those who speedrun put hundreds, if not thousands, of hours into games they love in the hopes of achieving this dream. It's a solitary task, but one rarely performed alone — like-minded players with similar goals cheer each other on and share discoveries. The more popular the game, the larger that community.

Of course, when we speak of big speedrun communities, it shouldn't be a surprise that *Super Mario Bros.* has one of the largest in the world. It's an iconic game, featuring one of the most recognisable mascot characters of any medium. It's simple but hides complexity underneath the surface for those chasing the fastest times. During the rise of speedrunning in the early-'00s across the message boards and record adjudicators like Speed Demos Archive and Twin Galaxies, *Super Mario Bros.* was an obvious choice for people to set their sights on.

While it's likely that kids and adults whittled away the hours in private challenging themselves to complete *Super Mario Bros.* quickly as soon as it hit store shelves, tracking such achievements was all but impossible. The earliest verified record for *Super Mario Bros.* Any% (a speedrun category where the goal is simply to finish the game as fast as possible without consideration for how much of the game you complete, opposed to a 100% run for instance) was performed by Aaron Collins in 2003, clocking in at 5:25. This time was later refined over the course of heated discussions in thousands-strong forum posts. "Is it possible to grab the plant a little higher too?" asks Frezy_man in 2006, watching a 5:05 run from once-World Record holder andrewg, while others shared personal runs or offered advice of their own. This was at a time during, and also just before, the early days

photography *Damien McFerran*

of YouTube, where runs were recorded primarily on VHS, trust and camaraderie being the ultimate adjudicators.

While few runners are still around from these early years, Tompa is one who remembers it fondly — although at the time, their interests lay not with *Super Mario Bros.* but another beloved childhood game. "Back in 2002-2003, I was curious how fast I could beat *Link's Awakening* for the Game Boy, so I sat down at home and managed to get a time of around 1:15:00. Then I found Speed Demos Archive about a year-and-a-half later, and I started watching everything! I thought it was amazing to see everyone's skills."

Joining the community there and on TASVideos — a site dedicated to Tool-Assisted Speedruns (TAS), inhumanly-optimised speedruns that could only be performed by computers — they got to meet other runners who shared a passion for *Super Mario Bros. 3*. Recalling a story from early 2010, Tompa noted, "Some people at the time were working on a new TAS for the Warpless category, but I wasn't as good at it, at the time. Then, I found a new strat in one of the levels and they let me join in the project."

Since then, community is the reason why they've stuck with speedrunning. That 2010 Warpless TAS culminated in a 47:04, a time later refined to a sleeker 46:20 — another community effort Tompa assisted with. Since taking part in that initial TAS, Tompa has helped test new human-viable strategies for improving records, turning acquaintances into close friends along the way.

The rise of streaming and YouTube led to an explosion of *Mario* speedrunning activity, and more people started to become active in it. Kosmic is known today as a former World Record holder in the Any% category, including being the first person to finish the game with a legendary, near-TAS time of 4:55 in 2018. Kosmic got into *Mario* speedrunning through SpeedrunsLive, a site with the necessary tools to assist people in racing other speedrunners. They started speedrunning *The Legend of Zelda: Ocarina of Time*, but eventually became interested in *Mario* after joining community races on a regular basis in around 2011.

"Back then, it was really just a fun hobby that I did after school," Kosmic explained. "There were some people in the race who got around six minutes, and I kept thinking I would like to be able to beat the game that fast, but nothing crazy or more ambitious. In my personal best videos from the time, I'd get times like 5:10 or 5:08 and each time say I was probably done."

For a time, that was the case. Time was more limited as Kosmic reached college and served a religious mission, but they were able to keep in touch with friends even as their dedication to the game decreased. Returning to the community, people celebrated Kosmic as a future record

holder. "Back when I was just racing, we would be in Skype groups. Even if I was just doing attempts on my own, I would sit on a Skype call and talk," they recalled. "That definitely helped a lot. I don't think I would do it nearly as much if it was all just a lone endeavour, you know? I feel like you need a community. If I was just alone on an island [playing], I don't know if I would still be as interested."

Nowadays, even those who don't participate themselves are fascinated by the world of *Super Mario Bros.* speedrunning that they see through online videos, watching as this iconic game is whittled down with precision in a matter of minutes. While not as active a runner of *Super Mario Bros.* today, Kosmic regularly makes YouTube videos on the game and its race for the perfect run, explaining the mechanical intricacies and theory behind these records in detail. Such intrigue surrounds the game that new records are often picked up by major news outlets, and videos of these runs typically receive view counts in the millions.

By the time content creation and speedrunning hit the mainstream in the mid-2010s, the Any% run had already become massively optimised, with the record having dropped less than three seconds since 2015. The ease of access to online video massively improved awareness and respect for the endeavour, and a greater effort was put into cataloguing the history of this and other titles. Another runner known as Bismuth published videos that explored what the theoretical human limit could be, while SummoningSalt created videos chronologising the world record history of the NES titles.

Work like this brought more people into the fold. "I found out about speedrunning in August 2017 when I stumbled upon SummoningSalt's content and watched his video on the history of *Super Mario Bros.*," noted GTAce, another runner. From there they started getting involved in the community and later began speedrunning. For WolfAeterni, their interest came from French runners commentating and discussing the magnitude of Kosmic's 4:57, and the ever-approaching human limit of *Super Mario Bros.* speedrunning.

When the game first released in 1985, neither developers nor fans could have imagined what was to follow. That the game would go on to sell over 40 million copies and receive countless re-releases, that a small group of players would take advantage of the coding tricks in the pursuit of speedrunning perfection. Yet that's now something runners are ever-so close to achieving. With a record of 4:54 by Niftski in September 2023, the run is just 22 frames away from the theoretical best possible time, based on current knowledge. While there's a chance that the human limit could go lower with further optimisation, those in the community find this idea unlikely.

While other speedrunning categories for *Super Mario Bros.*, such as Warpless, have more optimisation to go,

we've reached a point almost four decades following the game's release where achieving perfection may no longer be an exaggeration. After decades of new tricks, glitches, and the growth of a large community collaboratively pursuing a single goal, it is now mere milliseconds away.

In that time, friendships have formed, lives have been changed, and history has been made. So what comes next? Even if those frames are shaved off, the community will likely never truly disappear. Indeed, it appears to be the last thing on anyone's mind at this point. For many in the space, the record is an obvious goal that they all want to see come to fruition. But it's also a bonus on top of an experience that's already been life-changing for everyone.

"I posted a couple runs before I joined Discord or anything like that," admitted Nebula_Composer. Despite keeping the community at arms length at first, they're glad to have changed their mind. "It's one of the best communities I've ever joined, honestly. Everyone's just wonderful."

To say that speedrunning is purely the pursuit of perfection — the pursuit of that fastest time — is to overlook the true joy of speedrunning. From personal experience and from speaking with other runners, the highs aren't the temporary thrill of a new personal best or discovery. It's about the pride felt sharing that record with a friend, hearing them become overjoyed by your victory. It's about meeting the person who taught you how to clip through walls in real life for the very first time, watching them send a gutter ball when you two go bowling.

As another runner, Mars02, put it, "If I were the only person playing these games, I would have quit a long time ago. Speedrunning to me is more than just beating *Mario* as fast as possible. It gives me something to do when I'm bored, or when I want to hang out and chill with online friends. It's so much more than time in a video game."

It's no different than how we remember pre-internet gaming, the afternoons spent playing the hot new title with a childhood friend, huddled together on the living room floor. You're seeking victory, you're striving for a goal — but years later, did reaching the credits really matter? Or was simply reaching that summit with your friend what you remember most fondly?

Super Mario Bros. is 22 frames away from a perfect run. The 'perfect' video game almost has its perfect speedrun. If that's achieved, don't expect this community to go anywhere. Just as *Super Mario Bros.* has endured well beyond the 8-bit era, the challenge of speedrunning it, and the friends you can make while doing so, will never truly go away. Perfection in speedrunning has already been achieved. It's been around us the whole time.

113

114

Mushroom Kingdom Mad Dashes

Not only are Super Mario Bros. and Super Mario Bros. 3 popular speedrun games, but Super Mario 64 is arguably the most iconic of all-time. Its glitch-filled 16-Star category is a particular favourite with a massive presence in livestream communities. Fast-paged, glitch-filled, and full of iconic strategies, Super Mario 64 speedrunning is simply a crowd-pleaser.

113
Super Mario Bros.
NES
1985

114
Super Mario Bros.
Famicom
1985

cutting time.

SEGA MASTER SYSTEM.

words Kurt Kalata

When I was five years old, I received the Sega Master System as a gift from an older relative. He was an appliance salesman and had gotten it as a freebie, and since his teenage son had no interest in the machine, it was passed on to me. My family had an Atari 2600 as well as an Atari 400 computer, and I regularly played games on these with my father. But the Master System was the first that I called my own, which I bought games for with my own meagre allowance, and which I vigorously defended against the overwhelming juggernaut that was Nintendo.

First Released:
1985

Manufacturer:
Sega

Launch Price:
JP ¥16,800
US $199.99
UK £99

My imagination was captured just by the screenshots in the catalogues and posters included in the game packages. I coloured my own pictures of the title screen from *Wonder Boy*, because I thought the characters were cute. I doodled pictures of the Dobkeratops monster from *R-Type*, because that thing looked scary and incredible. All of the stories in my second-grade composition class were based on Sega games I'd read about, somehow tying together *Double Dragon* with St. Patrick's Day and delivering a four-page novelization of *Alex Kidd in Miracle World*.

This was in 1986, back when the 8-bit console war was first beginning in the United States. But, even as a child without much greater awareness, it felt like Sega was the underdog. Most of the other kids in my class had an NES, so I only knew a few to trade games with. None of the local video stores rented out Sega titles either, so I had no other way to try games before I bought them.

My father was a mail carrier, and sometimes he would bring home issues of the Nintendo Fun Club (which were considered bulk advertisements and would otherwise be disposed of if undeliverable, just to make it clear that he wasn't *stealing* mail). I didn't have an NES, since my parents wouldn't let me have more than one system, but it was fascinating to read about all the games I couldn't play. Still, I thought, *why didn't Sega have something like this?* So, I took some school composition paper, stole a stamp, and wrote Sega a letter.

Several weeks later Sega wrote back, with a thick stack of papers detailing cheats and strategies for every game currently available. It also turned out there *was* a newsletter called Sega Challenge, and they put me on the mailing list. Finally, I had some way to learn about new Sega games beyond looking at the sparse and often puzzling cover artwork. Through this catalogue, you could also order video tapes with game footage, which I convinced my father to do since there was no other way to see these games in action.

I had received a handful of games along with the Master System, one of my favourites being *Black Belt*. Here was this karate dude who could punch enemies so intensely that they shattered across the screen! The multi-layer parallax scrolling was incredible, as were the boss fights, which used an entirely different set of larger sprites for more focussed duelling.

What I wouldn't know for many years was that this game was based on the manga and anime series *Fist of the North Star* in Japan. While a massive success in its homeland throughout the '80s (and to the present day), it hadn't been localised in English at the time, so the licence was dropped when the game came to North America, and nearly all of the graphics were changed. Yet some elements remained — like the way the final boss cryptically turned to stone when defeated, a leftover from ultimate villain Raoh's final moments in the original story. And, of course, the enemies exploding and the fancy super attacks when defeating bosses still remained. It made me a *Fist of the North Star*

photography Damien McFerran

fan at the tender age of five, even though I wouldn't even know what it was until decades later.

The other game that I had an odd affection for was *Ghost House*. As a little vampire-looking kid, your goal was to find all of the keys in a haunted mansion then kill all of the Draculas found in coffins that were also lying about. It was made for the 'Sega Card' format, which was cheaper to manufacture since it used less memory, but *Ghost House* had plenty of tricks buried in that 64kb of ROM. Jumping in front of candles summoned a knife flung at you from off-screen, which you could jump on and capture. Blank picture frames could be used to warp between the areas. One of the enemies was this enormous red ball with legs that bounced about and spat fire as you drew close. This is what defined Sega to me as a child: unusual mechanics that led to hidden discoveries, and captivating character designs that were scary as well as charming.

The next Christmas, I asked for *Alex Kidd in Miracle World*. Alex Kidd was the burgeoning mascot of the Master System, a face to put up against the Mario Bros. and the goliath that was Nintendo. While its controls are slippery and its hit detection is unforgiving, it's a far more ambitious adventure than the title it was attempting to outclass. It had money and shops where you could purchase items, rideable vehicles like a helicopter and a motorcycle, an inventory screen with a world map that tied the levels together, and characters that told a stronger story than "Our Princess is in another castle!"

I also received *Zillion* as a birthday present a few months later. Why I got this particular game — I have no idea. American Master System covers were typically vague, and the only thing on this front cover was the image of a boring computer. It was also *far* too complicated for a six-year-old, offering an enormous labyrinth to map and explore. But it was one of those adventures that felt big and exciting and scary. Over the years, I eventually got a greater understanding of how it worked — the codes, the keycards, the level layout — and it became one of my favourite titles.

Much like *Black Belt*, *Zillion* was an anime tie-in, which was also associated with a light gun whose design is basically the same as the Master System Light Phaser. But *Zillion* kept its licence for international release, probably because Sega co-produced it in Japan. Several years later, I discovered a *Zillion* VHS tape at a Suncoast video, and its existence blew my mind. It was $30 for a single episode and completely unaffordable for a kid, but once I got a job and eBay came about, I bought all of them. Later, Viz released a Blu-Ray set with the complete series, with disc artwork that mimicked Master System cartridges. They *really* knew who they were selling it to.

I received *Double Dragon* as a birthday gift as well, which was one of the only games I could play co-op with my four-year-old little brother. It was also one of the first games that introduced me to the concept of console wars. At the time, Nintendo had a rather unscrupulous rule that third-party developers who produced games for its popular NES could not make games for rival systems. This didn't mean that games couldn't appear on multiple systems, though, as Sega often bought the rights from other companies and ported the games in-house. The Master System was supposedly more powerful from a technical standpoint, and *Double Dragon* was one of the few games that appeared on both systems, so you could directly compare them. In this case, the NES version didn't support two-player co-op for some reason, but the Master System version did — so to me, this was the obvious winner. *Sega had won!* But the market (and my classmates) did not care.

Incidentally, there were a few other notable third-party games in different territories. In North America, Parker Brothers brought out ports of computer games like *Where in the World is Carmen Sandiego*, *King's Quest*, and *Montzema's Revenge*, while Activision brought us *Rampage*. In Japan, Tecmo stealthily brought out a few Sega Mark III (the Japanese version of the Master System) games under their Salio label, which were arcade ports like *Argos no Senshi* (*Rygar*) and *Solomon's Key*. Ultimately, this didn't do much to loosen Nintendo's stranglehold on the market.

Golvellius: The Valley of Doom was the closest the Master System had at the time to *The Legend of Zelda*. Even though it wears its inspiration on its sleeve, *Golvellius* still advanced the action-RPG formula in significant ways. The visuals were cleaner, player progression was less opaque, and it featured cool items that let you walk over water or fly over pits. The game also ended on a cliffhanger, where the hero Kelesis, the rescued princess Rena, and the reformed boss Golvellius set off on new adventures – but thirty-five years later, we have yet to see how this journey plays out. My personal quest is to obtain the *Golvellius* licence and make this sequel myself.

Phantasy Star was a game I was enamoured with thanks to the aforementioned VHS preview tape. The opening cutscene, the colourful battles and enormous animated creatures, the full-screen first-person dungeon crawling with smooth movement... it was incredible! Unfortunately, I didn't get to play it as a kid, probably because it was $70 — which was at least $20 more expensive than most other games.

Along with *Miracle Warriors*, *Phantasy Star* was one of the first Japanese RPGs released in North America. While the genre was exploding in popularity in Japan on the Famicom, games like *Dragon Warrior* and *Final Fantasy* wouldn't be released in English for a few more years, making Sega quite the risk taker for localising these games first. Even though *Phantasy Star* was obviously based on these other titles, visually, it knocks pretty much every 8-bit Famicom RPG right out of the water.

Names Around the World

The '80s and early '90s were the time of regionally particular naming conventions for home consoles. Both Nintendo and Sega famously employed different names for their marquee systems across regions — often pairing these with unique hardware designs as well. The Master System is no exception, first released as the Mark III before getting a complete makeover when it left Japan in 1986. We'd have to wait until the fifth generation for consoles to adopt global names as standard.

115
Sega Mark III
1985

116
Sega Master System
1986

117
Sega Master System II
1990

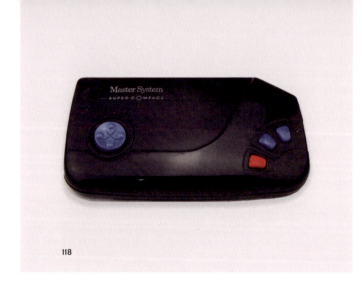

A Halfhearted Hybrid

The Master System Super Compact, launched exclusively in South America, came out nearly a decade after the Mark III — releasing in 1994. Its big gimmick was its ability to run on batteries and connect to a TV wirelessly over the airwaves. As such, it's an oddly portable console albeit one that still required a TV to use, thus falling short of the truly portable Sega Genesis companion, the Nomad.

118
Master System Super Compact
1994

One birthday, I received a set of Sega 3D Glasses. These plugged into the system itself and powered shutters that gave a 3D effect without the red-blue artefacts seen with typical red-blue anaglyph glasses. It wasn't a bad effect, but the few games that used it — the awkward *Maze Hunter 3D*, the choppy *Space Harrier 3D* — didn't impress much. The frames were also incredibly fragile, as they didn't survive long in a household of pre-adolescent boys. Even so, the peripheral added immeasurably to the allure of the console and, seeing as Nintendo's own take on the concept never left Japan, gave me more bragging rights around my NES-owning friends.

Alex Kidd: The Lost Stars was a straightforward platforming experience compared to its more ambitious predecessor, and I later learned that it was a port of an arcade game that never seemed to have left Japan. A friend bought it, so I didn't need to buy it myself. But I did get the next game, *High-Tech World*, an amusing example of cross-promotional synergy, as Alex needed to escape his boring life to get to an official Sega-branded arcade to play *OutRun*. Half of it was an adventure game, as you explored a Japanese castle to look for map pieces or walked around town solving obtuse puzzles. The other half was a challenging but basic platformer where you fought off ninjas. The game looked and felt nothing like its predecessors; I later learned that this was yet another game based on a Japanese anime — this time the mediaeval comedy *Anmitsu Hime*, with Alex Kidd hastily inserted as the main character. I still played and beat it, but it certainly gave the impression that Sega had no idea what to do with the character.

The final game I got for the Master System in Christmas 1989 was *Wonder Boy: The Dragon's Trap*, an appropriate sendoff considering it's one of the best titles on the system. Picking up directly at the end of the previous game, *Wonder Boy in Monster Land*, this entry allowed you to take on several different animal forms, each with their own abilities, and featured an open-ended world filled to the brim with secrets to explore and return to — a mean feat when you consider the term 'Metroidvania' hadn't even been coined at this point. Like other games developed by Westone, it's filled with attractive characters and fantastic music that kept me entranced for quite some time.

And yet, even then, I could feel that time had basically run out for the Master System. The Genesis had been released a few months prior, and all of the magazines made it clear that Sega was shifting its efforts to the more powerful 16-bit system. I couldn't remotely afford it and the library was still small. So instead, I scraped together the remaining Christmas money to purchase an NES, leaving the Genesis for a few years down the road.

When the internet expanded in the late '90s and I discovered emulators, it was fascinating revisiting the Master System. Not only could I return to titles I'd missed — like *Fantasy Zone*, *Aztec Adventure*, and, of course, *Phantasy Star* — I learned that the system had a whole second life in PAL territories, leaving me to play catchup with previously unknown classics like *Power Strike 2* and *Ninja Gaiden*, several Sonic the Hedgehog games (some of which had made it over to North America on the smaller Game Gear, since the systems shared similar hardware) and even some curiously decent licensed games, like *Jurassic Park* and *Home Alone*.

The history books show that Nintendo won this chapter of the console war — both financially and culturally — which unfortunately means that the Master System isn't really given its due, particularly in North America and Japan where it floundered. But it was a system filled with colourful characters and adventurous mechanics. It was an utterly foundational piece of hardware in my own personal development as a gamer. While the Master System's library lacked the refinement of Nintendo's, it had a strong sense of identity that still defines Sega even decades later.

119

120

121

119
SegaScope 3D
1987

120
Rygar
1988

121
Solomon's Key
1988

122

123

124

125

126

127

128

129

130

131

132

133

122
Alex Kidd in Miracle World
1986

123
R-Type
1987

124
Black Belt
1986

125
Double Dragon
1988

126
**King's Quest: Quest for
the Crown** 1989

127
Rampage
1989

128
Golvellius: Valley of Doom
1987

129
Phantasy Star
1987

130
**Miracle Warriors: Seal of
the Dark Lord** 1987

131
Alex Kidd: The Lost Stars
1986

132
Alex Kidd: High-Tech World
1987

133
**Wonder Boy III:
The Dragon's Trap** 1989

The Master System might've been replaced by the Mega Drive in most parts of the world, but the console kept chugging along in South America well after the release of its successor. In fact, Sonic Blast was ported from Game Gear to Master System for the Brazilian market in 1997. That's three years after the Sega Saturn launched!

134

135

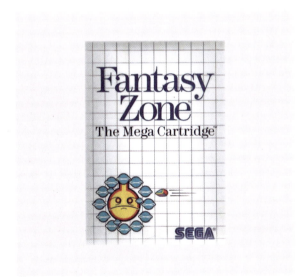

136

137

134
Sonic the Hedgehog
1991

135
Sonic Blast
1997

136
Fantasy Zone
1986

137
Power Strike II
1993

ATARI 7800.

words Rees "Ctrl-Alt-Rees" Stephenson

First Released:
1986

Manufacturer:
Atari Inc.

Launch Price:
US $79.95

The development and eventual release of the Atari 7800 is a twisted tale indeed. The console wasn't even designed by Atari — and that's just the beginning. We haven't even gotten to the part where the consoles sat gathering dust on warehouse shelves for over two years, during a time when the home video game industry was innovating at a rather rapid pace. But let's start at the beginning.

Massachusetts-based GCC, or General Computer Corporation, made its name in the industry developing modification kits for existing arcade games. Founded in 1981 by a ragtag band of MIT dropouts under the leadership of Steve Golson, perhaps its most famous product was *Crazy Otto*, an unauthorised enhancement kit for *Pac-Man*, which Midway later purchased and released as official sequel *Ms. Pac-Man* in 1982.

More relevant to the Atari story, however, is GCC's *Missile Command* hack, released as *Super Missile Attack* in 1981 — just one year after the original cabinet started to appear in arcades. This hard-as-nails take on an already challenging formula saw the number of cities the player defended double to six, while also adding additional enemies. *Super Missile Attack* was sold as an unofficial upgrade to Atari's existing cabinets that could be purchased for $295 and easily fitted by arcade operators. It proved to be an instant hit, providing players with a new challenge and an associated boost in revenue for the arcades themselves.

Atari, perhaps understandably, wasn't especially pleased with GCC's reverse engineering of its technology — not to mention the use of its trademarks in marketing the game. A lawsuit was duly filed, and Golson (claiming that he literally had nothing to lose) outmanoeuvred Atari at every turn, keeping his product on sale thanks to minor technicalities. Sensing that the suit was going nowhere and growing tired of throwing good money after bad, Atari eventually

settled out of court. The result? A big legal bill for Atari, and a $1.2 million, two-year contract developing Atari-branded hardware and software for the plucky startup.

This arrangement turned out to be very fruitful indeed for both parties, resulting in the arcade games *Food Fight* and *Quantum* — as well as the unreleased top-down shooter *Nightmare*. On the console side, GCC handled the official Atari 2600 ports of *Ms. Pac-Man* and *Centipede*, not to mention over half of the cartridges for Atari's 5200 console, released in 1982. But it was the 5200's successor where GCC's team would really make its mark at Atari, developing not only a slew of launch titles but the actual hardware itself.

Coleco's ColecoVision console had already been on the market for a year and offered arcade-quality ports of *Donkey Kong*, *BurgerTime*, *Zaxxon*, *Galaxian*, and a whole lot more, and it was making Atari's 2600 console look very long in the tooth. The Atari 5200 had been released to a lukewarm reception, being based on the company's 8-bit computer technology from 1977, and was widely criticised for its poor controllers and lack of compatibility with the older 2600's huge library of titles.

So, up against a tight, self-imposed deadline and an uncertain market that was growing weary of its rehashed offerings, Atari would depart from tradition and task the outside contractor with the design of their new 7800 "ProSystem." Work began in earnest in 1983, with GCC opting to use Atari's SALLY CPU, a modified version of the popular MOS 6502 8-bit processor used in its 400/800 computers and the console's predecessor. Clocked at 1.79MHz, the console's processing power would — in theory — be on par with Nintendo's Famicom, which used a similar Ricoh-designed 6502-based CPU running at the same clock speed. Of course, the Famicom would later be released outside of Japan as the Nintendo Entertainment System, becoming a very large thorn in Atari's side. But that's a story for another time.

photography Damien McFerran

Diminishing Library Returns

With nearly 500 games, the Atari 2600 library is quite significant. Its successors, however, only have libraries a fraction of that size. Atari 5200 only has 69 exclusive games, and the Atari 7800 has ten less than that. Backwards compatibility truly was key to keeping 7800 players happy.

138

139

140

141

138
Ballblazer
1988

139
Choplifter
1987

140
Ninja Golf
1990

141
Alien Brigade
1991

The real technical marvel of the 7800 was GCC's custom graphics chip, known as MARIA. This did away with Atari's outdated notions of 'players' and 'missiles' in favour of raster-based Display List graphics, allowing for hundreds of independent sprites at resolutions of up to 320x200, with 25 simultaneous colours per line from a palette of 256. The chip also supported DMA, allowing it to bypass the CPU and access the RAM directly at 7.16MHz, allowing for high-speed rendering.

Learning from the lessons of the failed 5200, Atari also insisted that the 7800 be backwards compatible with the existing library of 2600 games, facilitated by the 2600's Television Interface Adapter (TIA) chip that would also be integrated into the design. This proved to be a double-edged sword. While the original chip could be used to offer essentially 100% hardware-based backwards compatibility (an industry first), GCC also found itself leaning on it for sound, which was inferior to the POKEY chip used in Atari's 8-bit computers, the 5200, and indeed many of its arcade games — something of a backwards step in an otherwise forward-thinking console.

In addition to primitive audio, the TIA chip also offered an easy way for GCC's engineers to access the controller ports in 7800 mode, saving some development time, with the downside being that any access would reduce the CPU's clock speed from 1.79MHz to 1.19MHz. Of course, with MARIA's DMA support, clever programming meant that this could be done while graphics were being drawn independently. So, in reality, this didn't prove to be a problem.

The console shell design was based on Atari's lesser-known 2800 console, a very brief foray into the Japanese market with a facelifted 2600. It was a sleek and modern black affair with metal highlights and rounded corners in line with the company's aesthetics of the time. The stage was set for the console launch of the decade — but there was a hitch that resulted in Atari's stock of 7800 consoles gathering dust in a warehouse for an entire two years before going on sale.

It certainly wasn't GCC's fault, who did indeed stick to its side of the deal and got the 7800's hardware finished on time, as per the contract. An initial production run was manufactured and ready for release by May 1984, when the console was officially announced at that year's Summer CES, with limited stock sold in Atari's California test market.

Unfortunately for the 7800 (and perhaps even more so for GCC) Atari's owner, Warner Communications, was in the process of selling the entire operation to Commodore founder Jack Tramiel's newly-formed Tramel Technologies for $240M — a deal that closed in July of the same year. All projects were put on hold by the new owners while their commercial viability was reevaluated. This also meant that GCC wasn't paid for its work on the 7800 until the following May, a whole year later.

With the launch finally given Jack Tramiel's personal approval in mid-1986 — two years later than initially planned — the new console emerged into a very different market to the one in which it was conceived. Nintendo's NES and Sega's Master System were well established, and both public as well as supplier trust in the Atari brand was at an all-time low as a result of unsubstantiated marketing bluster, broken promises, and very public financial troubles.

While receiving somewhat subdued praise for its solid graphics, contemporary reviewers did pick up on the 7800's poor sound and even poorer lineup of launch titles – *Asteroids*, *Centipede*, *Dig Dug*, *Food Fight*, *Joust*, *Ms. Pac-Man*, *Pole Position II*, and *Robotron: 2084*. While in hindsight these are considered solid arcade conversions, in mid-1986, they were very much old hat. Especially when put toe-to-toe with innovative new console-focussed games from Nintendo and Sega.

With only two more titles to follow for the remainder of 1986 (*Galaga* and *Xevious*, more old arcade conversions) and three for the entirety of 1987 (*Choplifter*, *Karateka* and *One-on-One Basketball*), it was clear to anyone who was paying attention that Atari wasn't fully committed to the new console and was just clearing old stock to prop up its home computer business — headlined by 1985's ST — where the Tramiels' real interests lay.

As for the 7800's underwhelming audio capabilities, GCC had made provision for this, adding extra data lines to the cartridge interface, allowing developers to include additional chips, including the audio variety. Two games took advantage of this and were released with POKEY sound chips inside: *Ballblazer* and *Commando*, later releases from 1988 and 1989 respectively, and these really show what the system could have been capable of if it had included this hardware from the outset. Golson's team had also undertaken some initial development work on a low-cost sound chip specifically designed to take advantage of this capability, known as GUMBY, but souring relations with Atari led to the project being canned before it came to fruition.

They had also developed a novel 'high score' cartridge, which reached the prototype stage. In the days before battery-backed save functionality, this piggyback cartridge offered players the ability to save up to five high scores per game. This was supported by the initial launch lineup — also developed by GCC — but was dropped by the Tramiels and never saw a public release, although Atari historian Curt Vendel did bring it to production in limited numbers in 2000. Modern gamers can take advantage of its functionality in various 7800 emulators.

So, what became of the General Computer Corporation? Well, after its successful stint working under Atari, it branched out into hardware peripherals for home computers, developing the highly successful HyperDrive

internal hard drive for the original Macintosh — a machine that didn't even offer a hard drive interface. Delivering on its now well-established technical prowess, GCC's HyperDrive offered data transfer speeds over seven times higher than Apple's own hardware, by interfacing directly with that machine's CPU. It continued to sell other peripherals, including laser printers, until 2015.

In total, 59 games were commercially released for the Atari 7800 before it was officially discontinued in 1992. Twelve of these were from GCC's initial batch, and the vast majority of the console's overall library was published by Atari itself. The 7800 incorporated a 'lockout chip' similar to Nintendo's infamous CIC, which meant that any releases had to be authorised and issued with a digital signature by Atari. Unfortunately, poor relations with third-party developers meant that there was little enthusiasm to jump through this particular hurdle to release games for the console.

It's a shame, as there are some real gems among its library and even a few games that can't be experienced anywhere else. Take the somewhat odd cult classic *Ninja Golf*, for instance, a unique combination of side-scrolling beat 'em up and (you guessed it) golf.

142

143

142
Atari 7800 ProSystem (NTSC)
1986

143
Atari 7800 ProSystem (PAL)
1987

Later releases like the excellent light gun game *Alien Brigade* — one of five on the system and another exclusive to the 7800 — a port of Lucasfilm's futuristic sports game *Ballblazer*, and top-down scrolling shooter *Commando* are well worth checking out too, as are many of the arcade conversions on the system.

Other personal highlights include *Scrapyard Dog*, a challenging platformer which later received a port to the Lynx with additional levels, and the exclusive *Midnight Mutants*, an interesting horror-themed free-roaming isometric game. One of the last official releases on the system, *Midnight Mutants*, for some inexplicable reason, stars the character of Grandpa Munster from the '60s sitcom of the same name, despite having no other connection to the series whatsoever.

The 7800 is also an excellent way to enjoy 2600 games via its plug-and-play backwards compatibility, and as with many of these classic consoles, there is also a very active modern homebrew scene. Today, the 7800 is still a relatively inexpensive console to pick up and collect for, despite its age and relative obscurity. Boxed examples and even sealed games regularly appear on online auction sites at lower prices than the 2600, 5200 (which wasn't released outside the US), and Jaguar equivalents. Although the console was originally RF only, it can easily be modified to add composite and S-Video output for connection to more modern displays or even for a sharper output on a CRT for a more authentic experience and access to those light gun games.

The original US version of the 7800 was bundled with 2 CX-24 "Pro-Line" joysticks (also available separately) with the later European release bundling Atari's answer to the NES and Master System joypads. This two-button affair, dubbed the CX-78, features a detachable thumbstick and was never officially released in the USA. Also available was the XG-1 light gun, a pack-in with the Atari XE Game System console and also available separately, although increasingly rare to find these days, especially in working condition.

Rounding off the international variant lineup is the Australian release, which for reasons known only to Atari itself, came bundled with a relabelled '32-in-1' cartridge, developed for the release of the Atari 2600 Jr. This only contained more primitive 2600 games and didn't showcase what the new console had to offer.

Early revisions of the 7800 include an expansion port, and it was rumoured that this was intended to be used to control a laserdisc player, as *Dragon's Lair* was popular in the arcades during the console's development. This was dropped from the second production run onwards, as no software was released to take advantage of it — a fitting note to encapsulate a curious, out of time machine from Atari and GCC.

Advertisement Antics

There is no shortage of garish advertising strategy across games history, and Atari 7800 had some pretty 'remarkable' slogans in its print campaigns. With huge taglines like "Pick A Fight After School" and "Viewer Aggression Is Advised," there's little doubt that Atari really wanted you to buy into the action-filled edginess of the 7800.

144

145

146

147

148

149

144	145	146
Food Fight	**Dig Dug**	**Joust**
1986	1986	1986
147	148	149
Karateka	**Robotron: 2084**	**Commando**
1987	1986	1989

COMMODORE 64.

words Jonathon Greenall

First Released:
1982

Manufacturer:
Commodore Business
Machines

Launch Price:
US $595

When the history of the second and third generation of game consoles is discussed, people often jump from the video game crash straight to the NES, omitting everything in-between. They act like games just stopped for a few years. But this is far from the truth. In fact, the home microcomputer segment of the industry weathered the crash, even growing in popularity while consoles floundered in the wake of the Atari-induced collapse. In the US, this segment was dominated by the Commodore 64, but it wasn't alone. There were loads of other microcomputers on the market, and many amassed large dedicated fanbases, becoming home to era-defining games.

It can be debated if microcomputers are game consoles in the traditional sense. After all, the systems were heavily marketed as business and productivity machines. But many users, especially younger ones, exclusively used their home microcomputers to play games. Plus, games comprised the vast majority of software released for them. So, even if they are not technically consoles, they are the forefathers of the modern PC gaming community, making them historic machines in their own right.

The term microcomputer started to enter the popular vocabulary in the '70s with the birth of the Intel 4004, the first commercially-produced microprocessor. The Intel 4004 revolutionised computing, quickly decreasing the size of computers and making them cheaper to manufacture. Because of this, many companies started to offer pre-made computers and self-assembly computer kits, with the Altair 8800 being considered the first truly successful home computer. Although, the Altair's price limited its reach. When it launched in 1974, the pre-assembled model retailed for $600 and the kit was priced at $400.

However, things would quickly change as the '70s continued and the '80s began, as more and more companies entered the market. But of all the home microcomputers, the Commodore 64 (named after the 64 kilobytes of RAM it had) would quickly become the most recognisable, especially in America. Released in 1982, it was far from Commodore International's first attempt at a home microcomputer, as the firm had previously released two other successful home computers, the Commodore PET in 1977 and the VIC-20 in 1980.

Commodore did two clever things with the Commodore 64 which helped the machine stand out against its competitors and become the legendary system we know today. For one, the C64 was available in general electronics stores, toy stores, and department stores in the US. Previously, home computers had been relegated to specialist stores or mail order, massively limiting their reach. Plus, computers being only in these stores led to many seeing them as a niche hobby product rather than a helpful and accessible tool for the general public. Likewise, Commodore's acquisition of chipmaker MOS Technology brought construction costs down dramatically, allowing the company to offer the C64 for $595 at launch in the US. Plus, the console had several price cuts early in its life, falling to around $250 by May 1983, undercutting many other similar machines on the American market.

Commodore's hardware also helped its sales, as the original C64 model came with some helpful and interesting features that set it apart. One such feature was the machine's two game ports, allowing various controllers and peripherals to be plugged into it directly. It also featured a cassette interface that could be used to hook up the Datassette peripheral, a serial port that allowed users to attach a disk drive and an Expansion Port, meaning software could be loaded from cassette tapes, floppy disks, or cartridges, making it amazingly versatile. The system also came with the now-legendary MOS Technology SID chip, a sound chip that allowed talented developers to give their games high-quality and memorable synthesiser music.

photography Damien McFerran

As the '80s continued, the microcomputer market grew, but the C64 remained America's most popular machine. Its status led to more coders making software for it, and the massive amount of available software convinced users to buy a C64 over its competitors — establishing a loop that helped cement the C64 as America's microcomputer of choice.

Over the C64's lifespan, Commodore would release new C64 spin-offs using the same architecture. This included 1983's Commodore Educator 64, a variant aimed at schools that featured a C64 and monitor in a single case. In 1984, this was followed by the Commodore SX-64, a portable C64 and monitor combination. Commodore also tried to follow up the C64 several times as the decade progressed, but none of the new machines were able to match the success of the C64. This included 1984's Commodore 16, a computer made to compete with lower-cost computers and replace Commodore's earlier Vic-20 machine. A more advanced version with 64 KB of RAM and built-in office software was also released, dubbed the Commodore Plus/4, but neither made a massive impact. Commodore tried again the following year with the Commodore 128, a machine with 128 KB of RAM, two CPUs, and the ability to run the CP/M operating system, alongside many other improvements. However, despite good reviews, it couldn't unseat the C64.

Commodore would also release the Amiga line of computers, starting with the Amiga 1000 in 1985. Acting as a wholly separate platform from the C64, Amiga computers were famous for their graphics and sound, and the line quickly gained a large, devoted fanbase. However, the Amiga line never matched the popularity of the C64.

Across the Atlantic Ocean in Europe, microcomputers also went through a boom period, especially in the UK. However, the landscape was very different for several reasons. In the early '80s, the British public service broadcaster, the BBC, believed computers would become a core part of modern life and business. Thus, it launched a massive computer literacy project to familiarise the public with them. To make computing more accessible, the BBC teamed up with manufacturer Acorn to launch the BBC Micro in December 1981. The BBC aimed to make the Micro as cheap as possible, with the 16 KB Model A machine retailing for only £235 at launch. However, this low price tag was controversial at the time, as some critics believed that the BBC was unfairly manipulating the market by entering the field with such a low-priced machine.

As part of this literacy initiative, the BBC launched *The Computer Programme* in 1982, a television show that promoted microcomputers and taught viewers how to use them. This show was popular and got a sequel in 1983, called *Making the Most of the Micro*. Then *Micro Live*, another microcomputer-focussed show, would launch in 1984 and run until 1987 — showing just how mainstream microcomputers became over the decade.

So, when the Commodore 64 launched in 1982, it got to ride this wave of popularity. Much like in America, the C64 quickly became popular with users and developed a dedicated fanbase despite the European microcomputer market being more crowded. But, despite this popularity, the C64 failed to become the UK's most popular microcomputer. Another machine overtook it: the ZX Spectrum.

Also released in 1982, the ZX Spectrum sold over five million total units during its lifetime. A big reason for the Spectrum's success was its price point. While Commodore had aimed to make the C64 cheap, Sinclair Research (the creators of the Spectrum) took this to a whole new level, with the 16 KB version retailing for £125 and the bigger 48 KB version costing £175. In 1983, these prices were slashed to £99 and £129, making the Spectrum a highly accessible computer for hardcore computer hobbyists and those just looking to dip their toes into the water.

Because of their accessibility and features, a vibrant home coder culture formed. The Commodore 64 and other similar microcomputers came installed with dialects of the BASIC (Beginners' All-purpose Symbolic Instruction Code) programming language and BASIC interpreters that let the machines run code written in these dialects. This is because, rather than seeing a graphical UI when you booted one of these machines up, you would be presented with a command line and would have to use BASIC to find and load your software. This meant the machine's inner workings were always visible, and users would pick up coding concepts passively while using the system. This captured many users' imaginations and encouraged them to dig deeper and see what else they could do, leading to many experimenting with advanced game design.

As everything in BASIC is handled via code, type-in games became common in magazines and books. The publications would include a complete transcription of the game's code, and the user would transcribe that into their machine's BASIC compiler and run it. This meant that — unlike the other consoles of the era which required access to a dev kit — all you needed to make a game on a microcomputer was the computer itself. This meant that many young people were able to visit this development world without having to invest a lot of money upfront, kicking off a boom of basement coders who would program for fun in their free time, with many moving up to more complex languages as their skills developed.

Another boon for home microcomputers — especially the BBC Micro, Spectrum, and C64 — was that they could all load software from a cassette tape. While this limited size and meant games took a long time to load, the format came with several massive advantages. The biggest was the price. In the early '80s, there were few data storage options and the available ones were expensive. Cassette tapes, on the other hand, were cheap to fabricate. Because they were the de facto home format

150

151

for music, large-scale manufacturing, mastering, and distribution networks already existed for them, bringing the price down even further. In mid-1983, most new cassette-based home computer games were retailing for under £10, with bigger name titles rarely pushing past the £20 price point. Due to higher production costs, cartridge-based console games cost a lot more. At the same point in 1983, Atari 2600 titles retailed for £25 to £30, and when the NES landed in 1985, its newest Game Paks cost anywhere from $30 to $50. The cassette format also benefited microcomputer hobbyists because tape made it easy to share software with friends. Most microcomputers that read from cassettes could also write to them. Blank cassettes were carried by most stores and were decently affordable. It was feasible to code a game and give it to someone else, who could then copy and pass it along to others.

This ease of duplication led to the formation of many small distributors, dubbed Software Houses. These Houses would operate via mail order, promoting their software catalogues via magazine advertisements. Rather than having in-house coders, many of these Software Houses had an open submission process. Any aspiring developer could mail the company a tape with their program on it, and if the Software House liked it enough, they would buy the game, add it to their catalogue, and distribute it.

Eventually, some of these houses would offer games in traditional retail stores and build internal coding teams, becoming the equivalent of modern publishers, and allowing many bedroom coders to go full-time. However, this environment did have a few flaws, and stories of consumers and programmers not getting what they were promised are far from uncommon. It was such an issue that, in 1983, the magazine CVG ran a column featuring reader complaints about various mail-order software publishers, saying that "Cheques cashed and programs not delivered seems to be the biggest problem area in the home computer industry's reputation."

While they were not without their issues, the microcomputer scene and Software Houses that sprung from it left a lasting mark on the games industry as, due to the ease of entry, many legendary creators made their name in this space. Plus, many microcomputer-focussed Software Houses would become, or be absorbed into, some of modern gaming's most well-known studios.

Two of the most notable developers who started on microcomputers are Tim and Chris Stamper, who, after spending time as arcade developers, formed the publisher Ultimate Play the Game in 1982. Ultimate Play the Game would design and publish popular home computer games, including *Sabre Wulf* and the massively influential *Knight Lore*. In 1985, seeing the then-new Famicom as the next logical step in gaming, the Stampers formed a new company called Rare, which would become one of the most widely praised studios in gaming history.

150
Commodore 64
1982

151
Commodore 64C
1986

commodore 64.

The Commodore 64 family had no shortage of interesting inclusions, from the 64C to the Commodore MAX and the 65. The Europe-exclusive Commodore 64 Games System retooled the existing C64 hardware into a cartridge-based home console — but a fairly unsuccessful one. Released in 1990, Nintendo and Sega were already battling for this space, elbowing Commodore out of the console business.

152

152
Commodore 64 Games System
1990

Another famous studio to come from this era of gaming is DMA Design Limited, a studio formed in 1987 by David Jones, Russell Kay, Steve Hammond, and Mike Dailly, who had first met at the Kingsway Amateur Computer Club in Dundee. In 1988, the studio released its first game, *Menace*, on the C64, Commodore Amiga, and Atari ST. The studio would release several more games for home computers before hitting the big time with the release of *Lemmings* in 1991. First released on the Amiga, *Lemmings* would get ported to many other home computers, including ZX Spectrum, Amstrad CPC, and the C64. It would also arrive on MS-DOS and consoles, becoming one of the most famous titles in the world. But DMA Design Limited would become even more legendary in 1997 when it released *Grand Theft Auto*, and then, in 2002, took on the modern name of Rockstar Studios.

But the Commodore 64 was more than a starting point. Its fantastic hardware and the era's creative freedom meant it was home to some wildly innovative titles that spawned entirely new genres. One such example is *Little Computer People*, a life simulator that tasked the player with caring for one of the titular inhabitants. The game was praised for its unique premise, one massively enhanced by the documentation remaining mostly in kayfabe, acting as if the digital people were real beings living within the user's machine. It was a massive influence on *The Sims*, which would come out 15 years later. During interviews, Will Wright would acknowledge *Little Computer People* and say he got many of its developers to give him feedback while working on *The Sims*.

Another notable title was Sid Meier's *Pirates!* which arrived on the C64 in 1985 before being ported to many other systems. One of the earliest sandbox games, this randomised pirate adventure was massively ahead of the curve, throwing players into a world of adventure and treasure. *Pirates!* also marked another milestone as it was the first game developed by Meier to feature his name in the title, kicking off one of the most recognisable meta-franchises ever seen. There was also 1987's *Maniac Mansion*, designed by Ron Gilbert and Gary Winnick. This game quickly cemented itself as a classic upon release due to its off-kilter sense of humour and engaging puzzles.

But nothing is forever when it comes to technology, and things would start to turn sour in the latter half of the '80s. The price of IBM Personal Computers and PC-compatible devices dropped massively, making them more affordable for home users. Commodore would try to enter this market, beginning with the Commodore PC 5 in 1984, which, like all the other Commodore PC-compatible machines, couldn't use C64 or Amiga software due to the vast differences between the platforms. While the Commodore brand was beloved, these machines failed to make an impact, often blending into the crowd of other PC-compatibles available at the time.

By the time the '90s began, PC-compatible became the format of choice for most users, causing the C64's growth to halt. Software continued to be released for the machine, but it was clear that its days were numbered. On top of this, game consoles had once again become popular. Systems like the Sega Genesis, the NES, and later the SNES reached new heights thanks to their popular and heavily marketed games.

Commodore attempted to transform the C64 into a fully-fledged games console with the European-exclusive Commodore 64 Games System in 1990. Designed to compete with the NES, it aimed for a more console-like experience with a new body design and cartridge-only interface. However, this final machine was a massive flop, especially as many existing C64 carts were unplayable due to the console not having a keyboard. In early 1994, Commodore announced the C64 would be discontinued in 1995. But in April of 1994, the company filed for bankruptcy, ending the production of the machine early. Despite its official production ending, the C64 has maintained a cult following, and even today there are active websites and groups dedicated to the computer.

The C64 and its brethren are an essential chapter of console history. Not only did they outsell their console counterparts in some regions, but they also marked a major technological milestone, one that would turn computers from a hobby to a standard part of every home. The open nature of these consoles allowed many legendary devs to forge new genres and gameplay styles, many of which would transform the industry in years to come.

Given that the C64 was a computer foremost, it's no surprise that the system had an array of associated peripherals — from floppy disk and cassette drives (such as the 1541 or 1530 Datasette respectively) to a printer and mouse.

153

154

155

156

153
Commodore MAX
1982

155
Commodore 128
1985

154
Commodore Educator 64
1983

156
Commodore 65
1985

commodore 64.

Games as Far as the Eye Can See

The bustling development community for C64 was almost unfathomably big, with homebrew titles releasing well into the twenty-first century. Looking at this wealth of software, Lucasfilm Games' titles including Maniac Mansion and Zak McKracken are certainly some of the platform's marquee releases, joined by the likes of IK+ and Sid Meier's Pirates!

157

158

159

160

157
Commodore 1541
1982

158
Commodore 1530 Datasette
1978

159
Commodore MPS 802
1984

160
Commodore Mouse
1986

161

162

163

164

161
Maniac Mansion
1987

162
Pirates!
1987

163
IK+
1987

164
Zak McKracken and the Alien Mindbenders
1988

THE STORY OF GENERATION 4.

Nintendo's Famicom, released in 1983, was the decisive winner of the Japanese 8-bit wars. It had faced competitors like Epoch's Super Cassette Vision and both Sega's SG-1000 and Mark III / Master System, still coming out on top, thanks in no small part to its robust third-party support. But technology evolved quickly in the '80s, and there was still plenty of money to be made — even if it meant taking on the giant that was Nintendo.

The first volley came from Hudson, one of Nintendo's early third-party publishers who had reaped many benefits from the Famicom's success and wanted a bigger piece of the action. Since it was a software company, it teamed up with NEC, one of the leading manufacturers of Japanese personal computers, to create a new console called the PC Engine. The joint venture ended up coming at a good time, since NEC had been mulling over creating its own CD-ROM-based system but lacked any knowledge of the video game marketplace to make it happen — something that Hudson was well versed in. However, a CD-ROM-based console would prove to be too expensive. Instead, they would initially release a console that used credit card-sized media — dubbed HuCards — to keep costs low, and eventually introduce the CD-ROM as an add-on later down the line.

While it ultimately wouldn't emerge the victor, the PC Engine marked the opening salvo of what would become one the most hotly contested console wars in memory. The system used a 16-bit graphic chipset which was able to display 482 colours out of a palette of 512, which afforded richer, more vibrant visuals. However, the console's CPU, the HuC6280, was based on the 8-bit 6502 processor — albeit a more powerful offering than anything seen by its competitors. Debate continues to rage on PC Engine's status in the 16-bit console wars.

The Field Clears

Starting in the fourth generation, the number of entrants in the console race began to slim. Market leaders became clear, setting up the most iconic scuffle between systems in the medium's history.

The PC Engine was released in Japan in the fall of 1987, with early games including *Bikkuriman World* (a port of Westone's *Wonder Boy in Monster Land* arcade game using characters from the popular Bikkuriman sticker series), *Kato-chan Ken-chan* (a humorous platformer starring two Japanese comedians) and *The Kung Fu* (a martial arts brawler with enormous sprites). Compared to Famicom games, these titles looked utterly remarkable, and the PC Engine quickly amassed a passionate following in its homeland.

Sega wasn't far behind with the Mega Drive, later known as the Genesis in North America. Neither the SG-1000 nor Mark III / Master System were particularly popular in Japan, but Sega was still a strong brand name, particularly when it came to the arcades. Leveraging this expertise in its new hardware, the Mega Drive used a 68000 CPU and other hardware similar to the System-16 arcade board. However, some cuts had to be made to keep costs under control, reducing its on-screen colours to 64 and lowering its CPU speed to 7.6 MHz.

The Mega Drive was released in Japan at the close of 1988, about a whole year after the PC Engine. Its two launch games, *Space Harrier II* and *Super Thunder Blade*, were based on popular arcade games. In their coin-op guise, both used fancy sprite scaling effects to create the impression of moving in a 3D space — a feature that had to be cut from the Mega Drive versions as the console lacked the same powerful scaling hardware. This resulted in choppy gameplay that hardly showed off the power of the new system. A month later came *Altered Beast*, another port of an arcade game. Although, since it was a side-scrolling beat-em-up, it played much stronger into the Mega Drive's strengths.

Even with the new competitors offering stronger hardware, Nintendo was still on the top of the world with the Famicom. The strong install base of the system — along with developers who consistently pushed it to its limits — meant Nintendo was in no rush to leap into the new generation. But eventually, it relented with the Super Famicom.

The Super Famicom used a custom 65C816 compatible CPU running at 3.58 MHz, making it slower than its competition. But what it lacked in CPU power it more than made up for elsewhere, with a GPU that allowed 256 colours out of a 32,768 palette, along with impressive transparency effects. It also included a graphics feature called Mode 7, which allowed for background scaling and rotation capabilities — effects that were put to great use to show off the fancy new system.

It also marked a new evolution in sound hardware. The PC Engine primarily used pulse sound generation (PSG), similar to the NES, while the Mega Drive used a combination of FM synthesis and PSG. The Super Famicom, however, featured the custom SPC700 chip from Sony, which allowed for fully sample-based music. Instead of a computer mimicking various instruments, composers could use custom samples of actual instruments to create a more realistic sound.

The Super Famicom launched in Japan in late fall 1990. Coming so late in the game meant that Nintendo had the technical edge over its competitors, at least when it came to cartridge games. It launched with *Super Mario World*, a continuation of its massively popular Super Mario Bros. series, along with *F-Zero*, a futuristic racing game that showed off those fancy Mode 7 effects. Later in the year came early works from longtime third-party developers, like Capcom's *Final Fight* and Konami's *Gradius III*.

The system launches were a little bit different around the world. In North America, the PC Engine had been renamed the TurboGrafx-16, and came out in late summer 1989, while the Mega Drive was now called the Genesis and released at about the same time. While the PC Engine had a whole year's lead on the Mega Drive in Japan, in the West, they were released on equal footing. What's more, Sega had bigger name recognition over NEC or Hudson in North America, giving the company a small but notable advantage. The Super Famicom — rechristened the Super Nintendo Entertainment System (SNES) — didn't arrive in North America until fall 1991, about a year after its Japanese launch.

Meanwhile in Europe, NEC was too busy focusing on the North American market, and while the TurboGrafx-16 was planned for European launch, it never officially made it out — making its way only through grey markets. The Mega Drive kept its Japanese name and came out at the close of 1990, with the SNES launching in the spring of 1992. While the Master System was a flop in North America, it had found greater success in many European countries, which put Sega at a better starting point. Indeed, Sega marketed the Master System alongside the Mega Drive as a cheaper alternative to its pricier 16-bit console and continued to develop games exclusively for PAL territories.

Outside of the main trio of 16-bit consoles was Neo Geo. It was the creation of SNK, a Japanese company that had a few minor arcade hits like *Ikari Warriors*, *Athena*, and *Psycho Soldier*. SNK wanted to create a cartridge-based system that would allow arcade owners to easily swap out games or allow multiple games in a single cabinet, rather than dealing with pricey customised arcade boards. Due to this modular design, SNK decided to release a console version alongside it. To keep the markets separate, games were released in slightly different cartridge formats – MVS (Multi Video System) in arcades, and AES (Advanced Entertainment System) for consumers. While they were not directly compatible (outside of using third-party converters), the ROM chips inside were identical.

Since it was designed first and foremost for arcade games, the Neo Geo hardware was far beyond other 16-bit consoles. The core chipset is similar to the Mega Drive, with a 68000 running at the faster clock speed of 12 MHz — but it can feature 4096 on-screen colours, which, along with other graphical tricks, made its games look so much richer than those seen on other 16-bit consoles. The games were also much larger in size — the average 16-bit console game in the early '90s was 4 Mb, whereas early Neo Geo games like *Magician Lord* bragged about its 46 Mb, over ten times larger. Of course, all of this came with a price. In North America, the AES launched at $649 and most games were about $200, making a single game cost as much as an entire 16-bit console. Obviously, this put it outside of the price range of most regular consumers, so these games were either only found in specialty stores or through mail order services.

By 1992, the stage was set for all the major players of the console war. Sega's first big victory was the creation of Sonic the Hedgehog. The company had a few mascots in the Master System era, including the block-busting monkey boy Alex Kidd, but he was never as popular as Nintendo's Mario. On the other hand, Sonic was immediately appealing; the kind of character that could appear in toys and cartoons. It didn't hurt that his initial game was excellent, too, with enormous levels and fast action that showed off the power of the Mega Drive. The American promotional division coined the term "Blast Processing" as to why Sonic could move so fast, and while some interpreted this as a reference to the Mega Drive CPU's faster clock speed, in reality, it was little more than meaningless marketing speak. NEC and Hudson tried the same thing with Bonk, known as PC Genjin in Japan, who was a bald caveman who fought off dinosaurs with his enormous head. He was a likeable character and his games were

decent, but they were no match for Mario or Sonic. This was a time when mascots could win (or lose) the war.

Nintendo had a lot of forward momentum thanks to the NES. The first-party line-up of games was consistently strong, particularly in franchises like The Legend of Zelda with *A Link to the Past*. Big names like Capcom and Konami strongly supported the SNES, as did Square and Enix, the developers of Final Fantasy and Dragon Quest, two of the biggest names in RPGs. To combat this, Sega made inroads with Western third-party publishers like Electronic Arts, while bolstering its own American software studios. This allowed for a more diverse library that catered specifically to American audiences, especially when it came to sports games. Additionally, Nintendo's iron grip on third-party publishers began to slip as legal challenges in the US caused the company to loosen their anti-competition clauses. This, along with Sega's success in North America and Europe, attracted other companies to lend their support. Suddenly, companies had two solid and profitable options when it came to releasing games.

The most important title that factored into the third-party equation was Capcom's *Street Fighter II*, the immensely popular fighting game that started a tremendous boom across arcades around the globe. While Capcom had licensed out some of its arcade games to other developers — both the Mega Drive and the short-lived PC Engine successor SuperGrafx got ports of *Ghouls 'n Ghosts*, for example — it only *directly* supported Nintendo's consoles. And since *Street Fighter II* was initially exclusive to the SNES, that made it the obvious choice for those who wanted the red-hot arcade experience at home.

But, not long after, Capcom eventually struck a deal with Sega to bring some of its biggest names over to the Mega Drive, and that meant console exclusivity for *Street Fighter II* was tossed out the window, removing one of the SNES' big advantages. The PC Engine also saw its own *Street Fighter II* port, though this remained Japan-only.

The Neo Geo found its own niche within the fighting game boom, first with *Fatal Fury*, then with later titles like *Art of Fighting*, *Samurai Shodown*, *World Heroes*, and *The King of Fighters*. Ports of these games made their way to the Mega Drive and SNES, but they were always compromised in some way due to the hardware differences. But with the Neo Geo, gamers could have the same experience at home as the arcades... as long as they could afford it, anyway. The console remained an outside bet, but one that ironically delivered the definitive coin-op experience at home.

But *Street Fighter II* wasn't the only fighting game on the block, with Midway's *Mortal Kombat* also finding incredible success, particularly in America. The home

The games industry has always toyed with the idea of consoles being multi-purpose entertainment centres. The LaserActive is one such example: a device that not only plays games, but also LaserDiscs, CDs, and more. The Wondermega is a Sega system with a similar philosophy, bundling a Master System and Sega CD into one unit. It was an experimental time, one that also saw Nintendo innovate with a TV-like philosophy of broadcasting games to the SNES at certain times via the Satellaview add-on.

165

166

165
Wondermega
1993

166
LaserActive
1993

167

168

Edutainment Oddities

The concept of edutainment software has been part of the medium since its early days. However, Sega really leaned into the notion with the release of the Sega Pico which even had an original Sonic the Hedgehog game. It received a successor decades later in the form of the Advanced Pico Beena.

167
Sega Pico
1993

168
Advanced Pico Beena
2008

ports were published by Acclaim, who enthusiastically supported both the Mega Drive and SNES, so there was no threat of console exclusivity. However, *Mortal Kombat* was known for its astounding gore, where combatants could murder each other with brutal Fatality moves, tearing their heads off or ripping their spines out. Sega had a lax attitude towards violence, so Mega Drive owners could get the same gory experience at home — if they entered an easily obtainable cheat code. On the other hand, Nintendo still had a family-friendly image to protect, resulting in a *Mortal Kombat* port that removed most of its most violent moves, even changing the red blood to white 'sweat.' Unsurprisingly, the Mega Drive version trounced the SNES version in sales and another milestone in the 16-bit console war was reached.

Nintendo was more than a little sore from this thrashing, and in retaliation, brought Sega's violent games in front of the US Congress in 1993. This moral panic was meant to damage Sega's reputation, but it actually bolstered the Genesis' rebellious image of being the more mature console, where all of the adults played their games, compared to the so-called kiddie games on the SNES. By this point, the industry was setting up a rating system that indicated the games' mature content, eventually evolving into the ESRB (and other similar organisations around the world), which also opened the doors for games aimed at older audiences. At any rate, Nintendo learned its lesson, and *Mortal Kombat II* was released uncensored on all platforms. The SNES version, with its technical superiority and now having all of its intended violence, outsold the Genesis version by a fair margin.

One smaller campaign waged within the 16-bit console wars involved the nascent CD-ROM format. The PC Engine was always developed with the CD format in mind, and in 1989 came the CD-ROM2 attachment, bringing with it a new wave of software. A CD-ROM could hold about 650 Mb of data, which was several orders of magnitude more than what could be held on a HuCard or cartridge. With so much space, most of that went to high-quality music, voice acting, and animated cutscenes. This was particularly popular in Japan with RPGs, like Hudson's comical Tengai Makyou series, which basically gave the player their own long-form playable anime series.

While CDs weren't initially part of Sega's plan, the pressure to compete eventually propelled the company to release its own attachment, the Mega CD (known as the Sega CD in North America). In Japan, it attempted to compete with the PC Engine with RPGs like Game Arts' *Lunar: The Silver Star*, as well as anime tie-ins like *Record of Lodoss War* and *Urusei Yatsura*. Most of these wouldn't fly in North America, so instead, the focus was put on FMV titles. Hasbro had previously experimented with interactive video for its unreleased VHS-based Nemo console, with its two titles, *Night Trap* and *Sewer Shark*, resurrected for the Sega CD. It was a cool novelty, but like the LaserDisc arcade games of the '80s, their playability (and thus, their appeal) was limited. Outside of these FMV games, what was left were mostly just marginally enhanced versions of games that could have appeared on cartridge — hardly enough to get the audience to lay down the extra money for the add-on.

Nintendo also plotted its own CD-ROM device with the help of Sony. Nintendo got cold feet after concerns that the deal would turn Sony into a deadly rival and backed out, signing a similar agreement with Dutch firm Philips, which never resulted in any hardware (but did give us some rather suspect Philips CD-i outings for Mario and Zelda). However, this broken deal came back to haunt Nintendo a few years later, as Sony had whetted its appetite for the console market and would create the best-selling PlayStation as a way of getting revenge.

SNK also created its own CD-ROM platform, appropriately dubbed the Neo Geo CD. This wasn't an add-on like the other systems, but rather a standalone console that played its own games. The high price of the Neo Geo was always a sticking point, but the console was substantially cheaper than an AES system, and CD-ROMs could be sold at the same price point as other games, costing only a fraction of their cartridge counterparts. But this with its own set of compromises, like enormously long load times. The system stayed alive through the 32-bit era, but at that point, the PlayStation and Saturn could deliver experiences reasonably similar to the Neo Geo CD, and eventually, it went out of production.

By 1994, console developers were releasing their 32-bit consoles, and the 16-bit war was coming to a close. In the American marketplace, the TurboGrafx-16 floundered in third place. Many of its games were popular in the Japanese market but had little appeal to Americans at the time, and software was reduced to a trickle in 1995. While the Genesis and SNES had been neck-and-neck through most of the Western 16-bit console wars, the decisive blow for Nintendo came from *Donkey Kong Country*, an impressive title from British developer Rare. Computer-rendered animation was suddenly all the rage, and here was a game that used it to breathe new life into Nintendo's 16-bit cartridge-based platform. It was a tremendous seller and was followed up by two more sequels before transitioning to the Nintendo 64, the company's next machine.

Things played out a little differently in Japan. Nintendo was the clear winner of the generation, in no small thanks to both its strong first-party offerings as well as its immense RPG library. The PC Engine came in second, no doubt

111

due to its early entry in the marketplace as well as its many shoot-em-ups and anime-themed CD-ROM games. The Mega Drive ended up in last place, as Sega could never quite take the advantage over the other two the same way it could in North America and Europe. However, it did cultivate a group of hardcore fans that called themselves 'Mega Drivers' and adored the system for its library of impressive action-platformers like Treasure's *Gunstar Heroes* and *Alien Soldier*. The loyalty of these fans — alongside Sega's continued presence in arcades — would build hype for its CD-based successor, the Saturn.

SNK and the Neo Geo continued along, completely separate from its other console competitors. It stayed alive in the arcades, with most of the mid-to-late '90s output consisting of more fighting games alongside popular run-and-gun series Metal Slug. However, the devotion to 2D arcade games lasted until 2001, when the company went bankrupt and changed its name to Playmore, releasing a few more games until officially retiring the platform in 2004.

It was a tough fight, but the competitors chugged along. NEC followed up with the PC-FX, which embraced the full motion video fad to its detriment, resulting in an early failure. Sega continued along with the Saturn, and Nintendo carried forward with the Nintendo 64. But the biggest disruption would come from newcomer Sony, who would leverage its tremendous experience with consumer electronics to bring the world the PlayStation. While the 16-bit console war had many notable flashpoints, what followed next was totally unexpected: a newcomer would shake the very foundations of the industry, putting Nintendo and Sega firmly in the shade.

169

169
Sonic the Hedgehog's Gameworld
1994

While Nintendo's arcade games did appear on other platforms in the early console generations, that trend quickly ended. That is, save for rare exception — including a set of Nintendo titles which remain exclusive to the Philips CD-i. It was a peculiar machine with suitably peculiar controllers (such as the mouse, Commander, and Roller controllers). Nintendo doesn't acknowledge these games, perhaps for good reason. The CD-i Mario and Zelda games are infamously bad, marring the reputations of these marquee series. Nonetheless, they remain a fascinating part of games history.

170

171

172

173

170
CD-i
1990

172
CD-i "Commander" remote control
Unknown

171
CD-i Mouse
Unknown

173
CD-i "Roller" controller
Unknown

the story of generation 4.

174

175

176

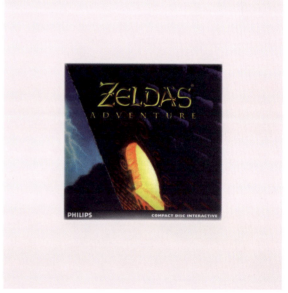

177

174
Hotel Mario
1994

176
Zelda: The Wand of Gamelon
1993

175
Link: The Faces of Evil
1993

177
Zelda's Adventure
1994

178

179

180

181

178
PC Engine
1987

179
Mega Drive
1988

180
Super Famicom
1990

181
Satellaview
1995

PC ENGINE.

words Julian Rignall

First Released:
1987

Manufacturer:
NEC Home Electronics

Launch Price:
JP ¥24,800
US $199
UK £199

I remember first reading about the PC Engine in Tony Takoushi's 'Mean Machines' column in Computer & Video Games (CVG) magazine. At that point, I was working at ZZAP! 64 magazine, which was focussed solely on the Commodore 64. However, being a super hardcore gamer, I was always interested in hearing about new systems and their games. Especially ones from other countries — and Tony had a knack for digging up cool stuff from beyond Blighty's shores.

Most of what he covered was NES and Master System fare, which was appealing to me since I'd bought both those machines the moment they were launched in the UK during the summer of the previous year. However, in May 1988, Tony really hit a home run. Somehow, he'd got hold of a PC Engine very shortly after its end-of-prior-year Japanese release and wrote a piece about it. Tony's writing style was bombastic and hyperbolic, to say the least, so I always read his prose through 'pinch-of-salt' lenses. And while he ranted and raved about this miraculous new console he'd just received fresh off a boat from Japan, I could sense that this wasn't just his usual puffery. This little PC Engine thing sounded like the real deal; a dedicated gaming machine that could truly deliver the goods.

To cut a long story short, just a few months after reading his piece, I'd jumped ship from ZZAP! and joined CVG. I'd become increasingly unhappy with my former employer, as what I really wanted to do was write about the new consoles I was seeing and playing at the time. Literally five minutes after first arriving at CVG's dusty, musty old London office, I'd dived into the even-more-rank games room so I could locate and play the PC Engine — which I knew had a fantastic version of *R-Type* because Tony had written another hyperbole-infused piece about it while I was in the process of moving from Ludlow in Shropshire (where I previously lived) to Brighton on the south coast. I was unbelievably excited to play it — and I was not disappointed.

It's important to remember that *R-Type* was still a relatively new coin-op at the time, so seeing what felt like a pixel-perfect conversion running on the system was an absolute revelation; it instantly elevated the PC Engine to legendary status in my eyes.

As the weeks and months went by and we acquired more of its games, the PC Engine's legend continued to grow. Original titles like *Victory Run*, *Alien Crush*, *World Court Tennis*, and *The Legendary Axe* made it abundantly clear that this bijou system was able to punch well, well above its diminutive weight — and top-quality arcade conversions like *Galaga '90*, *Space Harrier*, *Fantasy Zone*, *Dragon Spirit*, and *Vigilante* cemented it as an absolute must-have for any arcade fan. The PC Engine just felt like something from the future, making the ageing 8-bit home computers that most gamers were using during this period look painfully antiquated.

My head was certainly turned. I was a huge arcade fan, so the PC Engine's seemingly endless parade of hit ports was massively appealing to me. Not only were many of them astonishingly good, but they also often knocked their European-developed equivalents on the UK's domestic systems into a cocked hat. It wasn't long before I was evangelising the system to anyone and everyone who'd listen. And you know what? Some people did.

The prospect of this machine from Japan, with its range of knockout games, was tantalising. Its lack of official availability made it feel all so damn cool and exclusive, like it was some kind of forbidden gaming fruit. As interest began to build, enterprising importers stepped in and started to bring systems to the UK. At first, it was sporadic, but soon, PC Engines began to arrive in greater numbers. Not massive shipments, but certainly more than enough for the machine to become hot gossip among gamers across the country — and plenty for NEC's UK division to feel compelled to place advertisements in magazines warning people not to buy an imported PC Engine because

photography Damien McFerran

these had no warranty — a move which dissuaded absolutely nobody.

At this juncture, you could buy a native PC Engine for use with TVs that were able to display an NTSC picture, but most early systems sold were PAL-modded — usually by some enterprising young boffin cobbling together components bought from Tandy and Maplins using his dad's soldering iron. Later, SCART-modded PC Engines became the *choice de jour* since they offered absolutely top-tier picture quality.

While the number of PC Engines that were eventually shipped to the UK was dwarfed by the millions of Sega and Nintendo systems that were subsequently sold there, the impact NEC's little white wonder had on the British gaming public was immense.

This was the system that heralded what would become the hugely vibrant British 'grey import' scene of the late '80s and early '90s. It blazed the trail and busted down the doors that Mega Drive and Super Nintendo's consoles would subsequently pour through. And most certainly, do not underestimate how it was essentially the bridgehead for British console gaming. While the Master System and NES were slowly beginning to make headway in the UK in the late '80s, they weren't exactly fearsome competition for computers like the Amiga and Atari ST that we all expected would inherit the gaming market as players transitioned from 8-bit to 16-bit machines. Suddenly, that future seemed not so certain.

Consoles had always been somewhat specialist machines in the UK. While you could buy all the classic first and second-generation systems in the early '80s, they were not only very expensive but also released at a time of great economic hardship in the UK. These premium-priced systems and their extremely expensive games were luxuries for the few.

As the British economy picked up through the mid-'80s, the US Video Game Crash of 1983 that had essentially taken out most console makers essentially handed the gaming market to the 'right-place-right-time-right-price' home micros from Sinclair, Commodore, and Amstrad that were launched during this period. Their immense success resulted in the British gaming market being dominated by them — consoles basically fell out of fashion. And by the late '80s, the general consensus was that the dominance of home computers would continue into the next generation.

But then the PC Engine appeared seemingly out of absolutely nowhere, offering pretty much 16-bit quality console gaming at a considerably lower price than the still expensive 16-bit computers. Suddenly, console gaming started to become fashionable again. Not immediately, of course. But this was the moment when the tide began to turn. The PC Engine represented the tip of the console spear that pierced the heart of the British computer games market and whose killing blow was thrust home by the weight of the Mega Drive, SNES, and eventually, PlayStation consoles that followed it. By the mid-'90s, Britons were console gamers.

And while all that was happening, the PC Engine's star that had shone so very, very brightly during those early import days unfortunately began to lose its lustre. Not for those who'd experienced the machine's many delights, but certainly in the eyes of the emerging young gamers of the era who soon forgot about it as Sega and Nintendo geared up for their impending 16-bit console wars, whose games and marketing messages subsequently dominated the media.

Unfortunately, NEC decided to launch the PC Engine in the US before Europe — which is easy to understand, considering the size of the US market. The trouble was that NEC not only built awareness for the system from scratch with the all-new (and somewhat underwhelming) TurboGrafx-16 branding, but it would also unwisely retool the console body to a larger, fresh-air-filled size because US gamers assumed that a little console equalled crap performance. All of that required time at a point when Sega and Nintendo were running away with the market.

The really weird US selection of games also didn't help. I heard from a reliable source that the person at NEC US who was responsible for the TurboGrafx-16's software lineup simply gave the games to her eight-year-old son and chose the ones he liked. Perhaps that's apocryphal, but either way, NEC's marketing always felt a bit off. The software selection was questionable, the machine just didn't seem as cool as its rivals, and ultimately, it got clobbered and its lunch money taken by Sega and Nintendo.

And once that had happened, NEC got cold feet about a mass-market European PC Engine release, leaving the system to become a cool, niche specialist item highly prized among those in the know — while the same companies that had demolished it in the US rolled into Europe and between them dominated that territory, too.

However, while the PC Engine was never the great commercial success I think it could have been, it is nevertheless an absolutely cracking little machine — and it had so many cool features. It had the first-ever CD-ROM drive, in 1988 no less! That was so far ahead of its time. It also had a bunch of weird variants, of which the pumped-up SuperGrafx (released to combat the arrival of Sega's Mega Drive in Japan which only has five exclusive games to its name) was always my favourite. A complete and utter boondoggle, but what a great-looking system it was!

Oh, and of course, there was the portable Turbo-Express — or 'the Darth Vader of handhelds' as I used to refer to mine. That really was one of the coolest video game systems I'd ever owned. Being able to play PC

While the Sega Mega Drive's 32X and CD hardware add-ons are the most famous examples of modular hardware expansions during the fourth generation — they're far from the only ones. The TurboGrafx environment had plenty of its own. First there was the CD-ROM unit, which earned the TurboGrafx the title of first console with CD-ROM capabilities. Then, there was the TurboDuo, a suped-up machine which combined the base HuCard-reading system with the CD-ROM expansion and a bit more horsepower.

182

183

184

185

182
PC Engine
1987

184
TurboGrafx-CD
1989

183
TurboGrafx-16
1989

185
TurboDuo
1992

186

187

188

Engine games on the train home was fantastic… even if I couldn't read the text on its tiny screen and had to pile batteries into it like a stoker shovelling coal into an express steam train.

But it's the games that really made the system, and the PC Engine really does have some absolute belters. *R-Type*, of course, is a system standout then and now; a true gem among the machine's embarrassment of arcade conversion riches. Ultimately, the PC Engine is a fabulous period showcase of mid-to-late '80s coin-op classics. I don't need to reel them off. If you know, you know. If you don't, Google and enlighten yourself.

The PC Engine also has plenty of original greats. The vertically-scrolling shooter *Gunhed* was a massive favourite of mine back in the day. The *Devil* and *Alien Crush* pinball games are exceptionally well-designed and heaps of fun to play. *Bomberman* was a huge CVG favourite. Hooking up a multitap for five simultaneous players was a massive laugh and some of the greatest office gaming I've ever experienced. And *Parasol Stars* remains one of my most beloved games on the system; the weird and somewhat unsung third entry in the *Bubble Bobble* series.

The PC Engine really is a terrific machine. A proper 'bucket list' gaming system. A console whose diminutive size belies its impact on gaming. I've always wondered what might have happened had NEC been savvier and either launched the PC Engine themselves or – probably more smartly – assigned distribution rights to a knowledgeable European video game publisher at some point in the late '80s. How would that have affected the gaming market and changed history? NEC would have been in on the ground floor a good year or two before Nintendo and Sega's 16-bit systems arrived. I really think that would have shaken things up. Would it have completely changed the eventual pecking order of things? Difficult to tell. But it would certainly have made things interesting. And I *really* would have loved to have seen it!

186
Alien Crush
1988

187
R-Type
1988

188
Victory Run
1987

189

More Ways to Play

The TurboExpress handheld offered yet another way to experience NEC's library, as this little machine was able to play all of TurboGrafx-16's HuCards. It was a sophisticated machine but it failed to make a dent in its portable competitors' market share. In 2020, Konami brought the TurboGrafx-16 library to another new form factor, this time stepping into the realm of mini consoles. Boasting a robust library of built-in games and modern affordances, it was a great throwback to the NEC heyday.

189
PC Engine Mini
2020

190
TurboExpress
1990

190

191

192

193

194

191
World Court Tennis
1988

192
The Legendary Axe
1988

193
Galaga '90
1988

194
Space Harrier
1988

195

196

197

198

195
Fantasy Zone
1988

196
Dragon Spirit
1988

197
Vigilante
1989

198
Bonk's Adventure
1989

123

SEGA MEGA DRIVE.

First Released:
1988

Manufacturer:
Sega

Launch Price:
JP ¥21,000
US $189.99
UK £189.99

Before I discovered the Sega Mega Drive — or Genesis, as it's known in North America — I barely realised that video games came from anywhere but the West. Sure, I'd owned a *Donkey Kong II* Game & Watch as a young child and was aware of arcade games like *Space Invaders*, *Pole Position* and *Pac-Man*, but I had no idea where they were created. To my pre-teenage mind, these were simply products that rolled out of the same factory located in some huge, sprawling North American city. I mean, look at games like *OutRun* and *After Burner* — those could only be dreamt up by American minds, right?

This all changed dramatically when my dad — who is himself a keen gamer, even to this day — informed me that, for Christmas 1990, I would be getting a shiny new video game console produced by a company called Sega. Leafing through magazines such as Computer & Video Games and Advanced Computer Entertainment (or ACE, for short) gave me a degree of forewarning of what this would entail, but nothing could prepare me for that fateful festival morning when my outlook on gaming (and, one could hyperbolically argue, my entire life) would alter irrevocably.

I knew I was getting some kind of gaming system, and my exposure to my dad's beloved Atari ST (not to mention the 1989 Hollywood movie *The Wizard*, a VHS favourite which was famously described by one critic as a 100-minute Nintendo commercial) gave me at least some idea of the delights that would soon be mine. However, on Christmas day, I got an unexpected shock when I tore off the gaudy wrapping paper to expose the shiny new Mega Drive console within. Both it and its games were Japanese in origin.

This really wrong-footed the 11-year-old me, who, as we've established, had a painfully limited view of the global gaming market. While the game boxes and instructions featured a small amount of English, the majority of the text was utterly incomprehensible. Thankfully, most of the early Mega Drive titles had relatively little in the way of text

to read, so the language barrier wasn't an issue. But it nonetheless caused a degree of consternation when relatives visited. They simply couldn't fathom why all of the packaging was in a foreign language, nor could they grasp how or why I was so invested in this unfamiliar and alien lump of plastic.

I have to admit that, as the confusion surrounding the origins of the console evaporated, it was replaced by a keen appreciation for the exotic nature of the Mega Drive and its library; these were items that weren't intended to be used in the United Kingdom. My dad had used what was commonly known as a 'grey importer' — someone who brought foreign products into the country and sold them through unofficial distribution channels.

The grey import market in the UK had exploded with the arrival of the Japan-only NEC PC Engine in 1987, triggering a groundswell of interest from hardcore players who craved arcade-quality games in the home. Sega's Mega Drive launched in Japan in 1989 and rode this wave of interest and demand; opening up a video game magazine during this period would reveal a wealth of independent and mail order companies, all selling imported consoles and software which were months (if not years) away from an official release in the region. If they got an official release at all.

By the time my Mega Drive arrived in Santa's bulging sack at the close of 1990, the console had already been released in North America and the United Kingdom, so it's not as though I were part of a super-exclusive club. I was a year too late for that. However, the console's official UK release — courtesy of Virgin Games, Sega's UK distributor — had only taken place that September and was therefore quite recent. So it still gave me a certain degree of enviable credibility, especially when you consider that most of my friends were still playing on their ZX Spectrums or Sega Master Systems. Add to the fact that I owned the much cooler-looking Japanese model of the console (albeit one which had been hastily modified by the

Chilli Dog Check-In

Thanks to its stratospheric success and cunning marketing like 'Blast Processing' Sega effectively has history convinced that Sonic the Hedgehog and its meteoric sequels were always a part of the Mega Drive story. But that's not the case! Launched in 1991, Sonic's first outing was ostensibly a relaunch for the machine and the moment when Genesis really started doing what Nintendidn't.

199

200

199
Sega Mega Drive
1988

200
Sega Genesis
1989

aforementioned grey importer to run on a PAL television), and there was definitely a sense that I was operating on another level compared to the vast majority of British Sega fans. I must have been insufferable.

Given that I was a keen reader of magazines like C&VG and Mean Machines — both of which enthusiastically covered import releases with little regard for Sega's official plans when it came to distributing Mega Drive software in the country — I quickly became a keen consumer of Japanese games. Not only did it mean I was months ahead of the curve when it came to getting my hands on these titles, but I also benefited from superior cover artwork, full-colour manuals and an overall feeling of intense smugness whenever the topic of the latest video games was up for discussion in the school playground.

Sega's output on the console was mind-blowing, especially if you were a keen arcade-goer at the time. *Golden Axe*, for example, not only looked and played almost identically to the coin-op original, but it even included extra levels and a two-player duel mode. *Ghouls 'n Ghosts* — a Capcom title which was ported to the console by Sega itself — had one of the most beautiful cover images I'd ever seen and played fantastically. Even games like *Super Monaco GP*, which lacked the sprite-scaling visuals of its arcade parent, still managed to shine in the home thanks to consumer-focussed modes, such as the ability to compete in an entire Formula One season.

My first year with the console was mesmerising. *Thunder Force II* gave me one of the first tastes of the 'shmup' genre I would come to adore, while *ESWAT*'s music had such an impact on my young, still-developing brain that snatches of its soundtrack continue to live rent-free in my head, even after all these years. *Herzog Zwei* — a game so obtuse that the store my father purchased the Mega Drive from basically bundled it in for free — ironically turned out to be one of our most-played titles in those opening twelve months. One of the earliest examples of a real-time strategy game, it would keep me and my dad glued to the screen for hours at a time, and, even today, feels like a near-perfect video game. Meanwhile, Capcom's *Strider* further illustrated the Mega Drive's potency when it came to arcade-to-console conversions, and arguably looks better than the coin-op, in my humble opinion.

While the Mega Drive wasn't the first console to be available on import in the UK, it certainly felt to me like the one which made the biggest impression. This was partly due to Sega's lackadaisical approach to region locking, at least in the very early days. With a handful of exceptions, many early Mega Drive releases would work on any console, regardless of its origin. The only thing preventing people from playing Japanese games on their North American or European Mega Drives was the fact that cartridges from Japan were different in design to their Western equivalents. Therefore they wouldn't slot into non-Japanese Mega Drive systems without a pass-through converter cart or cosmetic surgery (the extreme option, but one that more people seemed to resort to more often than you'd think, given the large number of butchered Japanese carts on eBay these days).

This meant that players had access to a wide selection of games from different regions, and these were quite often sold for less than the official versions in the United Kingdom. This consumer freedom resulted in some unexpected side effects, at least in the town where I grew up. I was taken aback one day when visiting my local 'corner shop' to find a rack of Japanese Mega Drive games for rental, including the recently-released *Golden Axe II*. Around the same time, Ubisoft inked a deal which would allow it to officially distribute a handful of Japanese games in the UK, selling them alongside a converter cartridge to ensure compatibility. This was the level of market penetration grey imports achieved before Sega introduced more robust region protection around 1993, taking the wind out of the grey import sector — at least for a while.

The combination of amazing games, gorgeous Japanese artwork and access to titles ahead of their official release turned me into a particular kind of player. While I would happily purchase PAL hardware and software on occasion (there was, after all, little chance of me enjoying a text-heavy RPG unless I picked up the localised version), my main focus was on Japanese imports. Even when the PlayStation, N64 and Saturn came along, I either paid to get my console chipped so it could run Japanese games or, in more extreme cases (as I did with my Saturn), would eventually trade in my PAL hardware for a Japanese system — a choice which was made somewhat easier by the fact that the Saturn was woefully under-supported in the West when compared to its homeland.

This wasn't merely down to my desire for better packaging and faster releases, either. As any PAL-region gamer alive during this period will attest, we were very often given a bum deal when it came to NTSC-to-PAL conversions. Because the PAL TV standard has more lines on the screen (576 visible lines compared to NTSC's 480), many games were often 'letterboxed' because companies couldn't be bothered to adapt them to fill the entire display. Also, PAL runs at 50Hz while NTSC runs at 60Hz, so PAL games would almost always run slower (around 17.5% slower, in fact) than their North American and Japanese counterparts. Some firms would go the extra mile to optimise their titles for PAL release, but this was the exception rather than the rule during the 16 and 32-bit eras.

By importing Japanese or North American hardware and software, not only did you get the previously explained advantages of quicker releases and better artwork, but you also benefited from full-screen, full-speed games — another reason to feel impossibly self-satisfied when in the company of other PAL region players.

All of this cultivated in me a snobbish, almost dismissive attitude towards localised PAL software. I avoided it whenever possible. As the decade progressed, I found myself paying extortionate prices for the latest Japanese games. When *Street Fighter II* arrived on the SNES in Japan, advertisements in magazines were hawking it for well over £100, while the PlayStation and Saturn, upon their Japanese releases at the end of 1994, were being offered for two or even three times their eventual UK recommended retail price.

For me, the import buying bubble burst not long after the release of another Sega console, the Dreamcast. I managed to get the hardware for a relatively low price, thanks largely to the fact that, at the time, it was selling sluggishly in its native Japan, and consoles were in abundance. However, games still cost a lot — especially if you wanted them as close to their Japanese release as possible as I did — and essential items like home-made RPG SCART cables were selling for eye-watering figures despite their terrible quality. However, by the time the PlayStation 2 arrived on the scene, importing was becoming less appealing to me. Release schedules for PAL regions were improving, and you didn't have to wait years for games to hit the UK. Likewise, packaging was (generally) getting better, and many games were either optimised for PAL systems or came with 60Hz options built-in, so if you had a TV capable of supporting it, you could enjoy the same full-screen, full-speed experience as NTSC players.

Today, I still dabble in Japanese games from time to time, thanks mostly to the fact that Sony, Nintendo and Microsoft have all but eradicated the concept of regional lock-outs for their current-generation consoles. However, the homogenization of the global gaming market means that the benefits aren't as pronounced these days. Indeed, box design for Nintendo Switch games is practically identical across all regions, save for text. With uniformity comes familiarity, but also a sad lack of identity.

Even so, I still hold a candle for the console that started it all for me: the Mega Drive. Today, I continue to collect Japanese games for it whenever possible, which has led to some rather confused looks from the in-laws when they ask what I'd like for Christmas each year (I'm not sure anyone else in the UK had the Japanese version of *OutRunners* on their festive wish list back in 2018, but I sure did). Just looking at all those lovely multi-coloured box spines fills me with nostalgic joy. There aren't many console collections which look as good on a shelf as they do on a TV, but the Mega Drive certainly comes close.

Modular Mania

The Sega Mega Drive is one of the most modular home consoles ever created, thanks to its Mega CD and 32X add-ons. There were several iterations of the Mega CD to fit the various Mega Drive hardware iterations around the globe — as the system famously had differently-shaped hardware from region to region. To throw further complications into the mix, the system received two major redesigns across its life, in the form of the Mega Drive II and the lesser-known Genesis 3.

201

202

201
Sega Mega Drive II
1993

202
Sega Genesis 3
1998

203

204

205

206

203
Sega Genesis Mega-CD 1
1991

204
Sega Genesis Mega-CD 2
1993

205
Sega Genesis 32X
1994

206
Sega Genesis Nomad
1995

207

208

209

210

211

212

213

214

215

216

217

218

207
Golden Axe
1989

208
Super Monaco GP
1990

209
Ghouls 'n Ghosts
1989

210
ESWAT: City Under Siege
1990

211
Herzog Zwei
1989

212
Golden Axe II
1992

213
**Street Fighter II: Special
Championship Edition** 1993

214
OutRunners
1994

215
Streets of Rage II
1993

216
Sonic the Hedgehog 3
1994

217
Ecco the Dolphin
1992

218
Ristar
1995

The Sega Mega Drive library is clearly Sega's favoured collection. Its games have been re-released countless times across Xbox 360 and PS4 alike, bundled into Nintendo's various Virtual Console solutions, launched across a pair of Mini consoles, and remastered. From the classics, like Sonic the Hedgehog 3 and Ecco the Dolphin, to the obscure — many Mega Drive games are readily available no matter your platform. Even the likes of Night Trap are accessible today. Check these games out!

219

220

221

222

219
Knuckles' Chaotix
1995

220
Virtua Fighter
1995

221
Night Trap
1992

222
Snatcher
1994

sega mega drive.

131

SNES.

words Alana Hagues

Flicking the sturdy 'on' switch, I sat cross-legged on the floor in front of the TV. My tiny hands gripped the controller, fascinated by the red, blue, green, and yellow buttons. I ran my thumb over them before being caught off guard by a soft coin sound from the speakers.

There it was: "Nintendo Presents" in white writing on a black screen, accompanied by that famous sound. Then, a burst of colour, jolly chiptune music, and a little red plumber running across the screen, red shell in his hands.

First Released:
1990

Manufacturer:
Nintendo

Launch Price:
JP ¥25,000
US $199
UK £150

It all started with that sound of a coin. Since there was no start-up screen on the SNES (known as the Super Famicom in Japan), I've always associated *Super Mario World's* coin "dink" with the console. The two things are intrinsically linked to me — maybe not just because *Super Mario World* is still, today, my favourite Mario platformer, but because of *when* I got my very first SNES.

Video games have been one of the only constants in my life; their presence permeates every significant moment. The SNES came into my life when I wasn't doing well. None of my family were. My grandfather passed away over a year before, and my parents were going through a divorce. I experienced these two events through a glass pane of video games: a coping mechanism of burying myself in digital worlds, trying to suppress and understand the emotional changes around me simultaneously. I was getting away from the tears, the screaming and shouting, or sometimes unhealthily unleashing my anger or burying my feelings.

Getting the SNES felt different from any other retro console. To pay for divorce proceedings and to keep us afloat, my mum had to sell so much of our life, including old game consoles we had stuffed in the loft. Years of history, life, and love, handed off or sold for the sake of paperwork. But, importantly, it kept a roof over my and my brother's heads. We could carry on as best as possible, coping how we did — we were just kids, but at least we were safe.

As the dust settled over a tumultuous 18 months, my mum slowly amassed these old consoles again. She had to sacrifice these belongings, these pieces of her, to get by, but she'd taken notice of the minutes and hours I was pouring into holding a controller. And she wanted to give back some joy after a period of unrest.

In 2004, the SNES already had a tremendous reputation. I'd grown up around video games, which meant I was fully aware of the weight this console's legacy held. I might have been over a decade late to it, but even next to the shiny 3D worlds I could explore on the PlayStation, PlayStation 2, GameCube, and Xbox, the 16-bit machine burned bright. It was strangely comforting to have something that important on the shelf, tucked snugly next to its distant relative, the GameCube.

Flicking that 'on' switch on for the first time was a relief, like lifting a weight from my mum and my shoulders. Something as simple as the coin sound from *Super Mario World*, the explosion of 16-bit colours that illuminated the screen, and the jingle emanating from the speakers, brought a smile to my face and lit up my eyes.

Super Mario World felt magical, even over ten years after its launch. I'd played and loved many Mario games before. Still, Dinosaur Land's inviting palette, the introduction of Yoshi, and locations such as Donut Plains and Chocolate Mountain felt positively liberating. *Super Mario Sunshine* might have been the Mario hotness then, but I wouldn't trade my jaunt through the dinosaur world for a summer vacation.

photography Damien McFerran

A View of the Future

The Satellaview was a Super Famicom add-on which allowed owners to play broadcasted games. During set windows of time, Satellaview titles were beamed into your home like TV shows. You could tune into a 16-bit remake of The Legend of Zelda (NES) called BS The Legend of Zelda or an original Fire Emblem game called BS Fire Emblem: Archanean War Chronicles. There are over 70 Satellaview titles, and the majority have been lost to time — foreshadowing the limited-availability fate that'd befall Super Mario Bros. 35 on Nintendo Switch.

223

224

225

226

223
Super Nintendo Entertainment System Control Set
1992

225
Satellaview
1995

224
Super Nintendo Entertainment System
1991

226
Super Nintendo Entertainment System Jr.
1997

It was doubly special because this was also a piece of my mum's history. She'd played the game before with my older brother, and now she was watching me do the same things — watching me run and jump and bob along as the drums beat in time with Yoshi's footsteps. Back in 1992, video games were her escape and a way to spend quality time with her kids. Getting it back in 2004, after struggling for so long, she was giving a piece of herself. And even if she didn't use words, I think she wanted me to use the SNES to explore the possibilities, magic, and freedom video games could give us.

The coin may have been the first flicker of the flame, but it was picking up the Feather that opened a whole new world to me. Look, Tanooki Mario is cool and all, but what about giving Mario a yellow cape? The simplicity reminded me of the times I'd be home alone with my dad, and I'd tie a tablecloth around my neck and pretend to fly. But in Dinosaur Land, you really can soar with a cape. That liberating joy of running along a flat surface and then leaping into the sky so Mario could glide through the levels? It was unmatched. It still is.

The Feather was like picking a padlocked door inside my heart. In the years before, I'd played video games because I liked playing them — they were fun and engaging and made my brain tick in a whole new way. But *Super Mario World* and the SNES taught me that video games could be more than escapism or a hobby — they were a way to free myself and think for myself. They could make you a better person and could teach you things about yourself you didn't know.

Yes, a 16-bit platformer did have that effect on me. But it only grew from there. *The Legend of Zelda: A Link to the Past*, a game from one of my mum's favourite series, was the first Zelda game that really clicked for me. Controlling the little green hero and pushing through enemies to free Zelda in those opening hours are the embodiment of the Triforce of Courage — I had to brave corridors of enemies and sneak around in order to save someone important. And I had to embrace that bravery again to travel trepidatiously through the Dark World.

But Link's journey between the Light and Dark is also a story about the importance of history and of your elders. Rescuing the descendents of the Seven Sages was a monumental task for little old me, but those 'links to the past' in-game were crucial to me realising about the importance of my links to the past in real life — and the link between my mother, me and video games.

Going back to Mario, *Super Mario World 2: Yoshi's Island*'s pastel world was my gateway for learning how to care. Look, we might complain about Baby Mario crying every time he gets taken from Yoshi's back, but the panic I felt every time he floated away in a bubble was overwhelming. I'd scramble around, make silly mistakes, and more often than not have to start the level again. I knew I

had to protect that little Baby Mario at all costs. As such, video games don't just teach you about respecting the past — they also teach you to care for those who need it and protect the future.

There were plenty of other things the Super NES taught and showed me. Take *Super Mario Kart*, *F-Zero*, and *Star Fox* — three Nintendo franchises that started on the SNES and pushed polygonal visuals on the 16-bit console to their limits, thanks to Mode 7 and the Super FX chip. It doesn't matter if you've seen 3D visuals or overworlds before, Mode 7 is like a telescopic roller coaster ride in these games. Pixel art in 3D? Who would've thought!

Mario Paint, on the other hand, is a lot simpler to deduce — and more than just a tool to colour Mario-themed pictures with. It was the *only* way I could make music. Both my dad and brother can play plenty of musical instruments, but despite having piano fingers, I can't tune a recorder — unless you give me *Mario Paint*'s mouse and mousepad. There are no limits on the SNES, at least in my eyes.

But my true love was always RPGs. Europe's RPG library was much more limited, but *Secret of Mana* and *Terranigma* are two of the most precious gifts my mum ever gave me. Games like *Chrono Trigger*, *Super Mario RPG*, and even the SNES Final Fantasy titles eluded me until much later, but I'd argue the lessons I learned through these two games have been more valuable than any other.

Secret of Mana was one of the few Squaresoft games to make it into Europe, and it was also the rare game in which I could play *with* my mum rather than against. It wasn't about winning a race or getting the KO — it was about working together to save the world. And what a magical world *Secret of Mana's* is: bright, verdant, and blossoming, full of colours and sounds I'd never seen or heard before. We *had* to protect it.

You can't go off the screen without your second player, and you have to work together to dive into the menus and use magic or items. While my mum started teaching me the ropes of playing in tandem, I soon adjusted to the squeaks of the Ring Menu and learned how to be more patient and *help* the party. Controlling Purim (appropriately named after me in my playthrough), I was in charge of healing up my mum's main character, and there were times when my button presses were the difference between life and death in-game. I never wanted to leave that beautiful world which taught me about the joys of helping and working together.

Quintet's *Terranigma*, then, is an entirely different beast. *Secret of Mana* embodies the spirit of adventure, whereas *Terranigma* tackles grief, religion, human nature, and creation. You're not just saving the world in *Terranigma* — you're rebuilding it. And that requires a very different mindset than just 'dethroning' God or some all-powerful

227

228

227
Super Metroid
1995

228
Donkey Kong Country 2: Diddy's Kong Quest
1995

being. It requires a mix of all of those things I've talked about already: care, courage, freedom, and ambition.

It's also not just any world — it's Earth. The Surface is Earth as we know it. Africa, America, Asia — places I knew appeared on the screen in pixelated beauty, and these scenes, as the world slowly came back to life, showed me a new layer of beauty in the world. The importance of small moments that we should hold dearly. Those recreations of the real world as they're reborn have stuck with me.

Something as small as buying an old game console for your kid, then, is anything *but* small. It's strange to think that there's a timeline where I never got my hands on this little grey box, or at least I did, but under very different circumstances. But I wouldn't want that. The SNES was a gift from my mum, someone who perhaps didn't emote or couldn't be emotional, attempting to be emotional by sharing a piece of her with me through a video game console. The coins my mum had spent in real life allowed me to experience the joy of collecting those little 16-bit discs of gold, and the experiences I got in the process were invaluable. Even next to those sixth-generation consoles, the 3D visuals couldn't dull the magic that 16-bit pixel art created on our TV.

I've felt like that ever since. I snapped up rereleases and digital downloads of SNES games like *EarthBound*, *Chrono Trigger*, *Final Fantasy VI*, and more because I knew they were amazing and had something to say. And to me, that's precisely what makes the Super Nintendo stand out — everything on that console *has something to say*. Video games are there to teach us things about ourselves and the world, and there are ways we can use them to make ourselves better people. I've always known that about books and films and art, but it took the Super Nintendo for me to realise that games were capable of the same thing. The 16-bit console gave me a new lens to see the medium through, and it's why I am where I am today.

While the Super Nintendo came to me during a tough time, playing with 'Super' power told me I could get through anything, that I could do anything. You can fly with a cape and surpass all the odds. You can be a woman, fight terrifying space creatures, and save an entire planet. You can change the course of history to save the world you love, and you can even push through the apocalypse and end a crazed god's reign of terror.

Every single time I sit down to play a Super Nintendo game, I feel a mix of childlike joy, wonder, awe, and emotion. So you could say there's a lot wrapped up in that little console for me. If I'd never been gifted that system, or experienced and felt the effort my mum put into sharing that part of her life with me… well, I don't want to think about what an SNES-less world would be like. Nowadays, all it takes to make me happy are 256 colours, 16-bit visuals, and a Nintendo S-SMP sound chip.

229

230

231

229
Super Scope
1992

230
Super Game Boy
1994

231
Super NES Mouse
1992

A Lifetime of Excellent Adventures

Whether you were a day 1 SNES adopter, you picked up a Control Set, or you jumped in late with a revised Jr. model, there was always something fantastic to play on SNES. Super Mario World and F-Zero made for an exceptional launch. From there the library just kept growing, right up through the release of the N64! Late-gen games like Super Metroid, Donkey Kong Country 2 and 3, as well as Kirby Super Star were absolute gems. You could even enjoy some light gun action with the Super Scope or play portable titles on the big screen with the Super Game Boy accessory.

232

233

234

235

232
Super Mario World
1990

233
Super Mario World 2: Yoshi's Island
1995

234
The Legend of Zelda: A Link to the Past
1992

235
Secret of Mana
1993

236

237

238

239

236
Chrono Trigger
1995

237
Star Fox
1993

238
F-Zero
1990

239
Kirby Super Star
1996

THE TRAGEDY OF SELLING HARDWARE.

words *Billy Ludt*

We fit our Super Nintendo Entertainment System and all of our games in a little plastic bin and hopped in our dad's pickup truck. My brother, my dad and I sat side-by-side on the front seat of this rusted heap of a vehicle with the bin on our laps, the matte grey cartridges jostling together as we rolled over bumps in the road. I'd pull one out of the group, and they all sang hollow plastic tones in response. I felt the grain of the controller shell and how it contrasted with its smooth face and shoulder buttons.

Our destination was a now-defunct FuncoLand somewhere in Northeast Ohio. We stood under the fluorescent lights and passed the plastic bin over the reinforced glass counter that was worn and scraped by countless similar transactions. The store clerk, now faceless and nameless with passing time, gave a paltry offer on what we brought: twenty games, two controllers and a console. That, plus our meagre allowance, was just enough money to buy a PS one, the smaller, off-white version of Sony's foray into home gaming consoles. We reached the sticker price and didn't know about sales tax, so our dad begrudgingly forked over a few bucks to cover the remaining cost.

When you lose something, you hope that it will somehow find its way back to you, because its departure was unintentional. When you sell something, it immediately changes hands and the optimistic mystery of its fate is swept away by a desire to exchange something you once loved for something entirely new and unfamiliar. We were hypnotised by the PlayStation after visiting a family friend. We sat in their dark basement and watched them play games with graphics that we'd seen only in arcades. They popped a rock CD into the console and showed us its audio visualiser and spirographic lines burst onto the screen to the beat of the music. We agreed that it was worth having this machine that was unbound by the confines of cartridges.

Our parents wouldn't pay for another console, so we paid up with what we had. We exited FuncoLand into the shopping mall parking lot after exchanging known quantities for the chance at new possibilities, rendered in new fidelity, stored at a larger capacity, with three-dimensional environments and characters running at frame rates that kept pace with your inputs. The voices that spoke from our tube television would no longer sound modulated. The next console generation promised bigger and bolder games — and two analog sticks.

But our excitement for this new gam-ing machine was misguided. We were seduced by features that were novelties incapable of maintaining our adolescent attention spans. There were games we loved on the PS one, but in hindsight they had a nascent polygonal design that resembled sheets of latex stretched over a wire frame model.

What we abandoned was a gaming console with a more realised visual style. The Super Nintendo certainly wasn't as graphically powerful as the PS one, but it was built on a legacy of pixel animation. The Nintendo Entertainment System, Atari consoles and its other predecessors had a limited colour palette and the SNES was an incremental advancement in that right, but it had titles that felt more optimised for the hardware, especially visually.

I certainly couldn't articulate these feelings as a seven-year-old turning in our SNES. I was excited by what the PS one offered, and I stared at the instruction booklet for *Spyro The Dragon* the entire ride home in that rusted pickup, wondering what awaited us when we finally booted up this new gaming system.

I quickly realised that I truly missed our SNES, and there was no chance it would return to us. It was a miracle that we had one in the first place.

art *Hannah Kwan Cosslemon*

CHRISTMAS 1997

Despite being a northern state, Ohio has rarely had a White Christmas, at least in the region where I grew up. This holiday was no different. Some snow did fall overnight, but our lawn was still green and the grass poked through this light blanket of snow that melted swiftly underfoot. It was dust compared to the snowfall our cousins visiting from Colorado experienced in the Rockies. This White-Green Christmas arrived slowly, just like they did for many years, time lengthened by that excitement at what would materialise under the tree. This was before the holiday lost its wonder and turned into two days of travelling between households for separate family celebrations.

This was one of the last holidays before our parents divorced.

Neither of our parents came from families of great means, yet for a long time, our house was the biggest I'd ever seen. They saved enough money and built it from designs my mom devised herself in the country, set back in a wooded clearing.

That Christmas morning, we kids sat on the floor with the tree pressed against the panoramic walls of our living room. The sun hadn't risen yet and the room was washed in gold light from the tree and kaleidoscopic wrapping paper beamed from just beneath its lowest branches. We had scoured the Toys "R" Us catalogue in prior months, and past all of the dinosaurs and Nerf footballs, beyond the Play-Doh and the Lazer Tag blasters, further than the Power Rangers and Star Wars action figures was the SNES.

Despite my seemingly insurmountable excitement, the sun did rise and our parents roused from their beds with it. My brother and I, and our cousins, tore into the wrapping paper as soon as we were able, pushing through the adults' delays of coffee and cooking. From the largest box under the tree addressed to both me and my brother was the SNES, the first game console in the house that belonged to us kids. It was a bundle that came with a pack-in copy of the fighting game *Killer Instinct* and a CD of its soundtrack appropriately named *Killer Cuts*. My brother received the arcade racing game *Top Gear* and I got the infuriating platformer *Disney's The Jungle Book*.

Right after we unveiled our SNES, our cousins unwrapped a Nintendo 64, the more expensive and more modern console of the time, but we didn't care. We had our very own video game system. All of our previous time playing video games was in arcades or at friends' houses. They were something I pined for and even dreamed of. I would lay in bed and imagine what was contained within those cartridges, gleaning as much as I could from catalogues and TV commercials

Our cousins set up their N64 in the living room and we packed up our SNES and headed downstairs. We had a TV and an old couch in dire need of reupholstering set up in the corner of our unfinished basement. If you sat on it wrong, you'd slip between the cushions and land with a shock on a wooden slat. My brother pushed his copy of *Top Gear* into the slot of that grey console and slid the purple power button up. We didn't know we were about to hear possibly the finest music ever penned for a racing game. Rotating, percussive notes rang out from a black screen and I thought they must have been played on precious gems fashioned into instruments, not notes programmed onto an in-console sound chip. Moments later, he was cutting sharp turns and passing opponents at breakneck speeds framed by a background of a city skyline rising out of the horizon.

I saw the screen and nothing else, and I wished I could push through the glass and leap into that landscape that was built pixel by pixel and now displayed in front of us. It might as well have been magic, because I didn't know how it was possible to make something like this — and to be honest, I still don't.

The fact that the SNES was there was a feat, and it took some convincing that we could have it. Our mom thought that playing video games would turn us into cellar-dwelling creatures that fed on high scores and the glow of television. She was partially correct — our eyes often bloodshot from sitting too close to the screen. But it also ignited a lifelong love for games and a realisation that the harrowing moments of adolescence can be softened with a controller in hand.

LOST PROGRESS

Even the most obtuse solutions to puzzles in video games still made more sense than the dynamics of adult relationships. The challenges these SNES games presented often required greater dexterity than I could muster as a child barely half a decade old, so I pushed against the proverbial wall of progress an inch at a time. That didn't stop me from wanting to clear every CC class in *Super Mario Kart* as Toad, just so I could stand on the winner's podium and watch that cork burst off the bottle and spiral through the air before blasting into a giant Cheep Cheep balloon. I beamed when I eked out victory over a robot master in *Mega Man X*, thrusting my hand into the air in unison with X as he teleported back to the stage selection screen. The theme from the Sewer Surfin' stage in *Teenage Mutant Ninja Turtles: Turtles in Time* still gets stuck in my head from our countless attempts to clear it. When our dad moved to his new place, we would play *Killer Instinct*, but neither my brother nor I could beat him when he selected Orchid.

The memories I can recall from that age feel like elastic stretching from one image to the next. Sitting on the floor as a family, passing the controller between the

four of us, taking turns on lives in *Super Mario All-Stars* and *Jungle Strike*. Then falling to the same floor as a family, watching my mother sob and my father get in his truck and drive away. Those moments are punctuated by memories of pixelated characters moving across a screen. I could not grasp the reality of divorce, but I could press a button to make someone jump over a gap.

Memories from that age are pulled from a dusty sleeve and replayed in soft focus, with the same fuzzy static pulsing from the screen as the CRT you played games on as a kid. You pause and pass a hand over the glass and feel your hair stand up on end as the screen crackles in response, your fingers obscuring the pixels composing landscapes. I don't know how many times I played a particular game or another. Those memories are lost and replaced by the desire to revisit those titles — to remind myself that it wasn't all strife back then. I derived a lot of joy from the escape these games provided, and it isn't necessary or healthy to hope it could all be like it once was.

As much as I tried, I don't believe I was able to complete any game in our collection. It wasn't for lack of effort — I spent many warm summer days on that perilous basement couch playing the SNES. There was still so much to see that I wasn't able to. It wasn't feasible for my brother and I to get back what we had sold. Cracks had formed in our parents' relationship long before either of us was born. We were thrust into a world and home that only we knew, and it couldn't be fully understood by anybody outside of it. We moved through the years, peering into the dynamics of other parents with other children, and I catalogued their marital status as well as what game console they had hooked up to their television. I sat on the floor with friends at their houses, playing games, shoving aside piles of mess, listening to parents argue from other rooms, keeping my eyes fixed on the screen to push against that wall together, because the progress was inconsequential, harmless, stimulating, fulfilling.

For however long we had a Super Nintendo, we loved it. For however long we had a single family unit, perhaps we loved it, too. So, my brother and I pushed our collection over the counter and walked into that night wondering about the possibilities contained within these new games.

I wanted to see something newer and take a step closer to the latest console generation, but I still had an emotional attachment to the games I owned before the exchange. Loss in life is inevitable, and it isn't always within our control. And we lost our save files that night, as well. Too much reflection can reveal moments of lost potential. But video games are not static in operation or production. As an adult with an endless backlog of games, it's unrealistic to expect that you'd explore every inch of every game you own. The past remains the present for games, and next time we'll recognise that we love what we have, even if we desire to see something shiny and new.

Matters of Format

The jump to CD technology from cartridges in the fifth generation was essential. The Nintendo 64's continued use of cartridges was one of its distinct weaknesses — resulting in a loss of third-party series to PlayStation, including Final Fantasy.

240

241

240
Super Mario Kart
1992

241
Spyro the Dragon
1998

the tragedy of selling hardware.

NEO GEO.

My personal journey with the Neo Geo is one I'm sure many can relate to. Unless you were rich enough to afford one at launch — when they were twice the price of a Super Nintendo and each game cost the same as a Mega Drive — your relationship with SNK's "arcade at home" console was one defined by insatiable desire and longing.

First Released:
1998

Manufacturer:
SNK

Launch Price:
JP	¥58,000
US	$649.99
UK	£280

Neo Geo games weren't simply watered-down and compromised conversions of arcade titles, as was the case on Sega and Nintendo's home consoles, *they were the arcade titles*. While cartridges for the Neo Geo AES (Advanced Entertainment System) and Neo Geo MVS (Multi Video System) were not physically cross-compatible, the software contained on them was identical.

I first discovered the Neo Geo AES in May 1996, six years into the system's life. In 1990, when it launched as a way to play Neo Geo MVS arcade games at home, I was just eight years old and still trading C64 tapes in the school playground. SNK's high-end luxury console just wasn't part of our world. The 'rich' kids had a Master System (or, later, a SNES) and I don't remember Violet Berlin or Dominik Diamond ever talking about Samurai Shodown on the telly (they may well have done, though).

All this was about to change with the debut of a game that hit me with all the force of a "ROCKET LAWNCHAIR!" to the face. Aged 14, I picked up issue 7 of MAXIMUM magazine, attracted by the bold image of *Super Mario 64* on the cover. The N64 represented the most exciting vision of the future to me, and this mag was packed with screenshots and passionate descriptions I could pore over in anticipation of that 3D future. I had no idea that its contents would, in fact, reignite my love of 2D.

Tucked away in the centre of the magazine was a preview of a game I'd never heard of, for a system I also didn't know anything about. The game was *Metal Slug*

on the Neo Geo. The team at MAXIMUM crammed an astonishing 42 screenshots into just four pages and still left enough room to spell out how blown away they were by this incredible creation — a run 'n' gun action game that allowed you to hop into a tank that could unbelievably jump between platforms, with easily had the most gorgeous 2D graphics I'd ever seen.

Even in stills, the expertly-captured screenshots conveyed a vivid sense of movement, like an epic action movie paused at the critical moment. The first screen in the article showed a wooden structure being blown apart by an explosion. The bamboo scaffold, held together at the joints with bits of rope you could actually see, was beginning to break apart in the chaos, with individual sprites flying off at oblique angles. Exploding clouds of fire blotted the air while, caught in the blast, an unlucky soldier flailed his arms, mouth wide open with a visible scream as he fell from where he once stood. No other game I knew had incidental animations like this, which so perfectly captured a kinetic sense of movement. I instantly felt this was something not possible on the consoles I'd played before.

Over the next few weeks, I became fixated on the article, my one and only source of information on this wondrous new game. On the way to school, I would carry the issue with me and became an expert at walking without looking where I was going, as I took every chance to re-consume the text and re-inspect every screenshot. I read with keen interest about some of the little visual touches the God-like developers at Nazca had added, like the soldiers you catch sleeping on deckchairs before mercilessly blasting them away.

I was starting to become obsessed with the idea of playing *Metal Slug* and finding out what else the Neo Geo had to offer, but it would be two long years before that wish was granted. When I graduated from high school and started going to college, I found myself taking the bus into the city of Wakefield, where I made friends with the

staff of a local games store, who in turn told me about Playland, a life-changing arcade filled with every great '90s arcade game imaginable.

It's here that I first played The King Of Fighters. This crossover series featured characters from both *Fatal Fury* and *Art Of Fighting*, with a roster of playable fighters so large that you could spend months figuring out which combination of three to take into a team battle. And by the time you had it all worked out, they'd release another entry in the series, adding new characters, new moves and more beautifully drawn backgrounds. King Of Fighters became a great annual tradition, and the only thing fiercer than its combat was the debate over which year's game was the best.

It's in this same arcade that I finally got to play *Metal Slug*, and I wasn't disappointed. Here, I learned that its unparalleled visual excellence was matched by finely-crafted game design; sublime run 'n' gun action that struck a perfect balance between challenge and spectacle. When I wasn't at college, you'd often find me in a dark corner of the arcade, alone with *Metal Slug*, trying to make it to the end of each stage on a single credit or rescuing as many boxer-short-wearing hostages as possible. Sometimes, I'd play until I'd blown my bus fare on just one more try. It was worth the long walk home!

For a while, I felt sure that the arcades would be my main source of Neo Geo goodness. Yes, many SNK games did get home conversions on other systems. But there always seemed to be compromises, like missing frames or poor loading times. Not every system could run them 'arcade perfect,' and even the mighty Sega Saturn needed help. Its unique port of *King Of Fighters '95* required both a cartridge *and* CD to play. My beloved *Metal Slug* had been released for PlayStation and Saturn, but only in Japan, and the Saturn version needed a RAM cartridge to run properly. Besides, even if I could play these games on other systems, I didn't necessarily want to. There was something about the mystique of a real Neo Geo that made playing on this elusive system so attractive. And, soon enough, I would find myself in possession of one.

That same games shop I'd been hanging around in had an awesome window display where the staff would showcase the most exciting items that their coolest customers had traded in. One day, I walked past, and there it was: an actual Neo Geo AES complete with an arcade stick and one single, enormous cartridge. The game was *King Of The Monsters*, a fighting game with giant kaiju battling over tiny, destructible cities. But that didn't matter right now. The cartridge could have been a Mahjong game or a horse racing sim for all I cared. All that stood between me and the console of my dreams was a single pane of glass and an unbelievable £50 asking price. I traded in a few unwanted games and proudly walked home with an arcade system under my arm!

I took the Neo Geo back to my grandparents' house and placed it on the kitchen counter to plug into their portable TV. The console was so large it took up almost the entire surface, which only made it seem more special. For the next few weeks, I camped there, creating a personal arcade where once only cups of tea were made. I played *King Of The Monsters* so much I could have become an EVO master, all the while dreaming that I might one day add a *Samurai Shodown II* or a *Neo Turf Masters* or a *Crossed Swords* to the kitchen arcade.

Over the next few months, I'd walk by that shop window, hoping to find more Neo Geo games that I could add to my collection of one. It never happened, and as much as I loved the idea of finally owning this object of desire, the allure of other games and systems would eventually win out, and my prized possession was reluctantly traded in.

For now, I'd make do with playing SNK's games on other systems. *Real Bout Special* was pretty good on Saturn, and soon *Metal Slug X* would come to PlayStation, even getting a UK release. But the more I played these great games, the more the desire for a Neo Geo remained.

Many years would pass before I'd own an AES again, and in that time, it would become much easier and cheaper to play SNK's best games on other hardware via emulation, compilations or digital distribution. But in 2016, when a friend came into possession of one of the best Neo Geo collections I've ever seen, I found myself round his house in a flash and ready to spend.

My mate had bought a job lot from someone who had given it all up in a move to America, and his collection was jaw-dropping! It had three separate AES consoles, several sticks, Neo Geo CD pads, and an envious number of rarities like *Mark Of The Wolves*, *SNK Vs Capcom* and *Matrimelee*. He'd struck gold! There was no way I could afford the big ticket items, but since he'd bought everything in a bundle, he was able to offer me one console and a couple of early games at a bargain price. He didn't have to ask me twice. He didn't have to ask me once!

This was finally the opportunity I'd never quite had as a cash-strapped youngster. I could build up a little collection of my own, slowly and carefully using disposable income to assemble a cross-section of the select games from each genre.

I'd need several fighting games, of course. On the surface, the Neo Geo is about 70% near-identical looking fighters, but the more time you spend with them, the more you'll find a place in your heart for each. *Fatal Fury* was SNK's answer to *Street Fighter*, fronted by a guy in a red jacket and matching baseball cap, so you knew how cool it was. Of its multiple sequels, I most loved *Real Bout 2*, but they're all worth playing. Then there's the *Art Of Fighting* trilogy, with its heavy emphasis on

A Trio of Confusing Machines

The Neo Geo AES and MVS are easily confused, given that they play the same games. The MVS (Multi Video System) is a cabinet purchased by arcades that used even more expensive MVS cartridges whose difference comes down to their unique pin connectors, essentially preventing relatively cheaper AES games from being used in their place. The Neo Geo AES (Advanced Entertainment System) is the home console iteration of the arcade tech. The Neo Geo CD also plays the same games just off CDs instead of cartridges.

242
Neo Geo AES
1991

243
Neo Geo CD
1994

244
Neo Geo MVS
1990

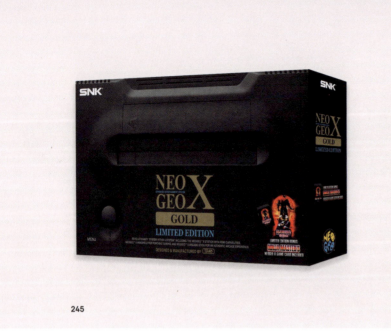

A Hybrid Experiment

*Released in 2012, the Neo
Geo X was a hybrid device
which came pre-loaded with
nearly two dozen classic
Neo Geo games and could
be docked to a TV for use
with a Neo Geo X-branded
fight stick. Three dozen
games were released for
the X in total between the
pre-installed selection and
game cards sold separately.
Unfortunately, discord
between its manufacturer
Tommo and SNK boiled
over in late 2013, with SNK
attempting to pull Tommo's
license — culminating in an
ugly public dispute.*

245
Neo Geo X
2012

story and fighters who would take visible damage during
fights, their clothes torn and their faces bruised. I picked
up a couple King Of Fighters — *96* and *2000*. I like how
classy and celebratory these games are; their exceptional
production values and presentation make them feel like
a special event, as though your favourite fighting game
characters got dressed up to go to the Oscars... but then
beat the crap out of each other.

Samurai Shodown offers bloody and brutal duels in
ancient Japan, with sprite scaling effects to underscore
the drama with impressive crash zooms. I like Ukyo the
samurai, who can deal deadly slashes while simultane-
ously slicing an apple in midair. Meanwhile, its spiritual
counterpart, *The Last Blade*, feels more considered and
methodical to play, featuring postcard-like backgrounds
that seem disrespectful to sully with your blade.

Outside of fighting games, there's more variety
than you might think. Shoot-'em-ups, racing games,
sports and more, all with that loud, oversized swagger
that defines the system. *Pulstar* is Neo Geo's answer to
R-Type with gorgeously rendered sprites. *Thrash Rally*
is a fun top-down racer with great incidental details like
soaring birds or screen-spanning trains. The Sengoku
trilogy offers scrolling beat-'em-up action with magical
transformations and a dude in a cowboy hat. What's not
to like, right?

When the AES launched, the NES was still dominant.
But by 2004, when its final official cart was released, we
were all playing *Halo 2* online. What a lifespan it had. For
fourteen years, it remained the pinnacle of 2D arcade
action and is still unofficially supported today. I've since
added *Xeno Crisis* to my collection, a superb homebrew
shooter that feels right at home next to a fan-made copy
of the excellent *Shock Troopers* that's been converted
from MVS to run on AES. I also picked up *Neo Drift Out*,
an arcade-only racer recently brought to AES by retro
specialists PixelHeart. It's kind of cool to buy brand-new
carts today and get a taste of how early adopters must
have felt.

I could never afford my favourite Neo Geo game, of
course. Even by the end of the nineties, *Metal Slug* was
selling for well over £1,000 and goes for multiple times
that now, if you can even find someone to sell you one.
The inner circles of the hardcore Neo Geo community are
like a clandestine club, and when it comes to buying the
rarest games, deep pockets alone won't grant you the
secret handshake.

I did, however, pay a reasonable amount for a man on
the internet to get another man in France to create a fully
working reproduction of *Metal Slug*. This still cost more
than most people would be willing to spend on a single
game, but it looks and feels so close to the real thing I had
to have one as the centrepiece of my collection. Not just
for its symbolic value but also for its tactile quality. That
feeling you can't get by playing emulated. The physical
sensation of ceremoniously opening the clamshell case,
plugging the ludicrously-sized cartridge into the console,
sitting back with an authentic arcade stick and bathing
in the glow of a CRT television to experience the very
best of 2D gaming's heyday.

To those who love it most, Neo Geo is more than a
console. It's an obsession, one that begins long before
many have even seen the system and can only be satisfied
once a certain number of cartridges are in their hands.

How many cartridges? Maybe just one more.

246

247

248

249

246
Metal Slug
1996

247
NAM-1975
1990

248
Blazing Star
1998

249
Neo Turf Masters
1996

Arcade All-Timers

Despite the Neo Geo AES having a small library, the system has countless bona fide classics. Some, like Neo Bomberman or Metal Slug 3, belong to long-standing franchises, and even Garou: Mark of the Wolves (which may be an unfamiliar name) features Smash Bros alum, Terry Bogard! But dig even deeper into Twinkle Star Sprites, Cyber-Lip, Cross Swords, Aggressors of Dark Kombat, Blazing Star, and NAM-1975, and you'll find some true arcade must-plays.

250

251

252

253

250
Garou: Mark of the Wolves
1999

251
Metal Slug 3
2001

252
Twinkle Star Sprites
1996

253
Neo Bomberman
1997

254

255

256

257

254
Fatal Fury: King of Fighters
1991

256
Cyber-Lip
1991

255
Crossed Swords
1991

257
Aggressors of Dark Kombat
1994

THE STORY OF GENERATION 5.

words Lewis Packwood

It's unlikely that we'll ever again see such a dramatic leap between console generations as what we witnessed at the dawn of the 32-bit era. The jump between 8-bit consoles like the NES and the 16-bit systems that followed was certainly impressive, offering huge improvements to the range of colours and sprites on display — not to mention neat tricks like the stunning Mode 7 scaling of the Super NES. But the 32-bit consoles ushered in the age of 3D graphics, and nothing would ever be the same.

I was lucky enough to receive a Sony PlayStation as a sixteenth birthday gift not long after its launch in Europe in September 1995, and I remember being blown away when I turned it on for the first time. Here, on my home TV, was *Ridge Racer*: a game that represented the cutting edge of arcade technology. Over the previous few years, arcade racing games had evolved from the cartoony sprites of 1986's *OutRun* to the plain, sluggishly moving polygons of 1989's *Hard Drivin'*. By comparison, *Ridge Racer*'s stunningly fast, fully-textured 3D graphics felt like they'd been beamed in from the future. And now, that achingly impressive arcade game was on my home TV, and it looked the *same*.

In hindsight, of course, it wasn't quite identical. Sacrifices had to be made to squeeze Namco's racer onto the PlayStation, including a reduction to the frame rate. But after years of living with watered-down home console ports of arcade hits, often with drastically simplified graphics and missing features, the PlayStation port of *Ridge Racer* felt like a revelation. The power of the arcade was now in our homes. In fact, it was even better than in some ways: the PlayStation version of *Ridge Racer* added extras like reversed tracks and more cars.

Players and developers alike rushed to embrace 3D in the '90s, with games such as *Resident Evil* and *Tomb Raider* pushing technical boundaries and representing a decisive break from the flat worlds of the previous generation. In fact, 2D games felt like old hat with the arrival of the PlayStation. The 2D platformer *Rayman* seemed like an anomaly in the PlayStation's 3D-dominated launch line-up, and the game's 1999 sequel would belatedly embrace 3D. It was only much later that developers and players would realise what had been lost in the rush towards the third dimension, with indie games such as *Axiom Verge* celebrating the beautiful pixel art past. But in the '90s, anything that wasn't 3D was given short shrift by the press and players alike. UK magazine Computer & Video Games sniffily dismissed *Rayman* as a "jazzed up 16-bit title" featuring "old ideas in the emperor's new clothes."

Sony's PlayStation would go on to utterly dominate what later came to be regarded as the fifth generation of consoles, eventually selling over 102 million units (including sales of the revised PS one edition from 2000). Nintendo had to settle for a distant second place with just under 33 million Nintendo 64s sold, and Sega would take an embittered third position, not even breaking the 10 million sales barrier with its Saturn — marking a precipitous fall for the console maker that had seen such success with the 16-bit Mega Drive.

But no one could have foreseen Sony's monumental rise at the start of the '90s, at which point the company was only a minor player in the games industry with just a handful of titles released under its Imagesoft publishing label. The start of the fifth console generation was messy and exciting, as new consoles were announced with startling regularity, and companies rushed to take advantage of emerging technologies like CD-ROM. It felt like *anything* could happen back then. And it usually did, often with calamitous results.

CD-ROM drives had started to find their way into game consoles in the fourth generation with machines like the Philips CD-i and Sega Mega-CD, but by the fifth generation,

photography Damien McFerran

258

259

258
Atrai Jaguar
1993

259
Sega Saturn
1994

154

CD drives had become standard (with a couple of notable exceptions). CD-ROMs offered vastly more storage than cartridges, with the added bonus that they were much cheaper to manufacture. The downside was that the loading times could be interminable.

One of the first 32-bit consoles to emerge was the Japanese-exclusive FM Towns Marty, where the FM stands for Fujitsu Micro. Released in February 1993, it was based on Fujitsu's FM Towns home computer and was backwards compatible with all FM Towns games, featuring both a 3.5-inch floppy disk drive as well as a CD one. Charmingly, there was also a microphone port on the front for karaoke.

The Marty didn't last long, though. Its high launch price of ¥98,000 — equivalent to around $800 in February 1993, or more than $1,600 in 2023 — meant it barely made an impact on the market. The following year, Fujitsu released the FM Towns Marty 2 (which was essentially the same console but in grey rather than white) at a more reasonable price of ¥66,000, but it failed to turn the Marty's fortunes around, and the console was soon discontinued. Nowadays, its rarity means the Marty is much sought after by collectors — particularly the FM Towns Car Marty, a variant with a built-in navigation system for use in cars.

Other early entrants in the fifth generation fared similarly badly. Commodore copied Fujitsu's trick by turning one of its home computers into a CD-based console, again with disastrous results. The Amiga CD32 launched in Europe in late 1993, and was essentially a reskinned Amiga 1200 computer without a keyboard. Like the Marty, its game library mostly consisted of home computer conversions, with few exclusives to call its own. The console was a last-gasp effort from Commodore to stave off bankruptcy after years of mismanagement, but it failed dismally, and the company went under in 1994.

There were more casualties. The Japanese-exclusive PC-FX, a successor to NEC's popular PC Engine consoles, was released in late 1994 but struggled to gain a foothold in the market owing to its high price and lack of a dedicated 3D graphics chip. Bandai's budget-priced Playdia appeared at around the same time and then disappeared almost immediately, with Bandai making the bizarre decision to base the console around an 8-bit processor. The Casio Loopy from 1995, another Japanese exclusive, also sank quickly: the novelty of its built-in sticker printer failing to gain much attention.

Probably the highest-profile failure was the 3DO Interactive Multiplayer, the brainchild of Electronic Arts founder Trip Hawkins. Hawkins set up The 3DO Company with the idea of creating a video game standard, a bit like VHS. His company would provide the license for making 3DO consoles, and any manufacturer could sign up to produce one, while The 3DO Company collected a small royalty of around $3 on each game sold — much lower than the royalty rates for Nintendo and Sega at the time. One of the first companies to sign up was Matsushita, owner of the Panasonic brand, and later, Sanyo and GoldStar both produced their own 3DO models. Toshiba, Samsung and AT&T also signed on, but ultimately didn't manufacture the machines.

The 3DO hardware was designed by Dave Needle and RJ Mical, who had previously helped to create the Amiga computer line, and it made for an impressive piece of tech when it was revealed to the world at the US Consumer Electronics Show in 1992. But by the time the machine was launched in the United States in October 1993, some of the 3DO's thunder had been stolen by Nintendo, Sega and Atari, who had all announced their next-generation consoles earlier that year. In fact, the Atari Jaguar would launch just a month after the 3DO.

But the biggest problem was the price. The clunkily-named Panasonic FZ-1 REAL 3DO Interactive Multiplayer would have set you back a whopping $699.99 at launch, the equivalent of over $1,400 today (for comparison, the price of the Super NES had dropped to just $99.99 in 1993). To make matters worse, only one game was available at launch: the futuristic racer *Crash 'N Burn*, Crystal Dynamics' debut title. The developer would eventually go on to great things with the Legacy of Kain and Tomb Raider franchises, but at the time, it was an unknown quantity, and *Crash 'N Burn* was by no means a killer app.

The idea of a video game standard sounded good on paper, and it even had some precedent with the MSX computers of the '80s. But it meant that manufacturers like Panasonic had to make a profit on the hardware they made, rather than selling it at cost or even at a loss and then making the money back from game royalties. As such, the initial price of the 3DO was astronomical for the time. Although within six months, it had come down to a slightly more reasonable $499.95, and by December 1994, it had dropped again to $399.95.

By that point, however, the 3DO had lost the initiative, and although more games had begun to arrive (the 3DO library would eventually boast some 200 titles), there were few exclusives — and those that *were* unique to the 3DO often later made their way to the PlayStation as well, such as *Gex* and *Return Fire*. The 3DO Company tried to win back favour by announcing the M2 Accelerator in late 1994, initially billed as a powerful add-on for the 3DO and later as a standalone successor console. However, the M2 project never came to fruition. Between 1996 and 1997, The 3DO Company sold off its hardware to Samsung and reinvented itself as a software developer.

Atari had a similarly torrid time with its Jaguar console. By the early '90s, Atari had become considered something of an also-ran in the console wars, with its 7800 and XEGS consoles failing to make much of an

impact and the Lynx handheld losing out to the Nintendo Game Boy and Sega Game Gear. Atari planned to fight back with a 32-bit console called the Panther, but at the same time, it was developing a 64-bit successor called the Jaguar. However, work on the Jaguar proceeded ahead of schedule, so the Panther was ditched in favour of releasing the Jaguar into test markets in New York and San Francisco in November 1993, with a wider launch across the United States and beyond in 1994.

The Jaguar had a much more favourable price point than the 3DO at $249, but it had the same lack of games in its early days, and those that did appear were of questionable quality. The pack-in title *Cybermorph* resembled an open-world version of *Star Fox* on the 16-bit Super NES, with similarly simple, untextured polygons, leaving many to doubt the Jaguar's claim of 64-bit power. The machine contained two 32-bit chips named Tom and Jerry, where one was mostly used for graphics and the other for sound, and both were hooked up to a Motorola 68000 processor, the same chip used in the Atari ST computers. Technically, the Jaguar is a 64-bit machine since the Tom chip has a 64-bit data bus, but in practice, it was horribly difficult for programmers to use the machine to its full potential, and it was still woefully underpowered compared to the later Saturn and PlayStation.

Other early titles for the Jaguar were similarly underwhelming, like the much-maligned horizontal shooter *Trevor McFur in the Crescent Galaxy*. The console eventually managed to accrue a handful of decent games by the end of 1994, including *Tempest 2000* by Jeff Minter, excellent ports of *Wolfenstein 3D* and *Doom*, and the impressive *Aliens vs Predator* from Rebellion Software — the closest thing the Jaguar had to a killer app. But the machine was held back by the limited storage capacity of cartridges: something that Atari promised to fix with a CD drive add-on, along with a VR headset developed by UK company Virtuality. The Jaguar CD did eventually arrive in late 1995, but by then, the machine was in its death throes. The VR headset was cancelled, and Atari abandoned the console in November 1995 after selling approximately 125,000 units.

With upstart competitors falling left, right and centre, the fifth generation seemed like it would end up being a straight fight between Sega and Nintendo, the champions of the previous round. But in November 1993, Sony shocked the games industry by announcing it was entering the ring with its own next-generation console. This remarkable turn of events was set in motion by a decision made by Nintendo a couple of years earlier, a decision that would ultimately come back to haunt the company.

At the end of the '80s, Nintendo and Sony had been working together on a CD-ROM add-on for the Super NES, along with a combined console called the PlayStation (similar to how Sharp released the Twin Famicom, which combined the Famicom and Famicom Disk System into one machine). Sony engineer Ken Kutaragi — who had previously designed the S-SMP sound chip for the Super NES — was in charge of the project.

However, the deal reached a sticking point when Sony insisted on taking a cut from every title released on the machine's 'Super Disc' format, which Sony had developed. Matters came to a head at the 1991 Consumer Electronics Show, when Sony publicly revealed it was working on the SNES CD-ROM for the first time. The following day, in a brazen act of betrayal, Nintendo announced it was instead partnering with Philips for the SNES CD add-on. The higher-ups at Sony were furious.

Ultimately, the SNES CD-ROM never materialised, although Philips did end up producing Mario and Zelda games for its ill-fated CD-i system. However, Sony's humiliation by Nintendo convinced Kutaragi, with support from Sony CEO Norio Ohga, to press forward in developing Sony's own console.

Tantalisingly, there was almost a tie-up between Sega and Sony in the wake of the failed Nintendo deal. Former Sega R&D head Hideki Sato recalled in a 2018 interview that the then Sega chairman Isao Okawa met with Ohga in late 1992 to discuss joining forces to beat Nintendo, and Sato also talked separately with Kutaragi — ultimately leading to a meeting between Sega president Hayao Nakayama and Ohga. However, Ohga wouldn't commit to a deal at the meeting, and Sega's concerns about being sidelined by a much bigger company meant the discussions didn't go any further.

Separately, former Sega of America head Tom Kalinske was working with Sony Computer Entertainment president Olaf Olafsson on creating Sony games for the Sega CD, a relationship that led to discussions about teaming up to produce hardware. Kalinske recalled in a 2022 interview that Sony had agreed to the move in principle, but Kalinske's boss in Japan, Nakayama, vetoed it.

Trip Hawkins also approached Sony to ask whether the company would be interested in manufacturing 3DO consoles but was rebuffed. Presumably, by that point, Sony's plans to make its own console were well underway.

Nintendo had announced 'Project Reality' in the middle of 1993, whereby the company was teaming up with Silicon Graphics to make its next console. Silicon Graphics was the top dog when it came to CGI at the time, with its workstations providing the pioneering visual effects in *Jurassic Park*. This was exciting news, but Nintendo's console was still years away. In the meantime, it was to be a battle between Sega and Sony, whose consoles were pegged to come out at almost the same time in 1994.

Sony lacked its own in-house developers, so it quickly went about courting the major third-party studios,

260

Don't Judge a Console By Its box

The Japanese Nintendo 64 packaging (pictured here) features a distinct and vibrant design — but don't be fooled. Inside is the same grey N64 that we got around the world. The one difference: Japanese N64 cartridges have a unique back plate, so the console has a region-specific cartridge slot. With a tri-wing screwdriver though, you can remove the back of a Japanese cart, screw on an American one, and play the game on your local machine.

261

Mini Modernity

The PlayStation Classic, released in 2018, was a plug-and-play device with pre-loaded games similar to Nintendo's NES and SNES Classic systems. The PlayStation Classic is unique, though, in that it's the only fifth generation mini system, making it the most 'modern' console to receive such treatment!

260
Nintendo 64
1996

261
PlayStation
1994

with Capcom and Namco proving particularly important partners. The latter would provide the PlayStation's killer launch title in the form of *Ridge Racer*, later joined by the stunning 3D beat 'em up *Tekken*, while Capcom's *Resident Evil* would become a phenomenon on its release in 1996. Developers were suitably impressed by the PlayStation's incredible 3D capabilities, with the famous T-Rex demo turning heads. To bolster its in-house development, Sony bought the Liverpool-based studio Psygnosis in 1993, and the UK company not only helped to improve the PlayStation development kit, it also provided key launch titles in the form of *WipEout* and *Destruction Derby* (the latter developed by Newcastle-based Reflections).

Meanwhile, Sega made an almost unbelievable series of errors, some of which can be attributed to the frosty relations between Sega of America and Sega Japan. After painstakingly carving out a huge slice of market share for the Mega Drive in the US, Sega of America wanted to prioritise extending the Mega Drive's lifespan with the Mega-CD and 32X add-ons. But in Japan, where the Mega Drive had a much smaller market share, the Sega parent company wanted to focus on the Saturn. In the end, both things happened, with disastrous results.

The Mega-CD and 32X were only ever purchased by a fraction of Mega Drive owners, meaning third-party studios had little incentive to develop titles for this tiny market, and thus, these add-ons remained starved of games. Even worse, news of the upcoming Saturn had emerged before the 32X's launch. Many would-be purchasers held back, leaving many who had bought one wondering whether it was such a good deal. In the end, the 32X launched just six months before the Saturn in the US. In Japan, it actually launched several weeks *after*.

The development of the Saturn was similarly chaotic. Initially, it was envisaged that it would run cartridge games as well as CD ones, and there was also going to be a separate, cheaper version of the console called Jupiter, which would only have a cartridge slot. But Jupiter was scrapped, and Sega decided to focus on CD games for the Saturn (although the console retains a vestigial cartridge slot, which is chiefly used for backup RAM cartridges). There was even talk of yet another console — Neptune — which would have combined the Mega Drive and 32X into one machine, but this was quickly shelved.

The Saturn was originally concepted as something of a 2D powerhouse, but the reveal of the PlayStation spooked Sega into beefing up the Saturn's 3D capabilities at the last moment. The result was a machine that was capable of producing some stunning 2D games but that still fell slightly short of the PlayStation when it came to 3D. Like the Jaguar, it was also a tricky machine to program for, thanks to its twin Hitachi SH-2 processors. In a feature for the February 1995 issue of Next Generation, Sega's star designer Yu Suzuki said it would be preferable to have a single, fast processor and that most program-

mers would only be able to eke out about one and a half times the speed you'd get from a single SH-2 processor. For *Virtua Fighter*, his team had managed to get this up to 1.8 times by using assembly code rather than C.

The Saturn's Japanese launch on November 22nd, 1994 was initially promising, with the initial shipment of 200,000 units selling out on the first day, and with *Virtua Fighter* proving particularly popular. For the first few months, the console remained neck and neck with the PlayStation, which launched just a couple of weeks later on December 3rd, 1994, priced around ¥5,000 cheaper at ¥39,800. But then came the US launch and Sega's undoing.

Under pressure from Sega Japan, Tom Kalinske announced a surprise September launch of the Sega Saturn at a price of $399 during his presentation at the E3 conference in May 1995. Then it was Sony's turn to take to the stage. Steve Race, a former Sega executive who had since become head of Sony Computer Entertainment of America, simply strode up to the lectern, said the words 'two nine nine,' and walked off. The room erupted. The $299 selling price meant Sony was taking a huge loss on every PlayStation sold, but it had undercut its greatest rival by a full $100.

Saturn's surprise US launch also backfired spectacularly for Sega, angering retailers who hadn't been let in on the plans and causing the KB Toys chain to refuse to stock the console altogether. In addition, it meant the Saturn launched with a meagre line-up of games, most third-party titles still slated for release later in the year. The PlayStation left the Saturn in the dust on its US launch in September 1995. It was a similar story in Europe: by November of that year, the PlayStation was outselling the Saturn by three-to-one in the UK. The Saturn would go on to host some fantastic games, like *Panzer Dragoon Saga*, *Radiant Silvergun*, *NiGHTS Into Dreams* and *Guardian Heroes*, but it never really recovered from that disastrous start.

And what of Nintendo? Its Project Reality console was rechristened as the Ultra 64 in the middle of 1994 and then rebranded again to the Nintendo 64, with tentative plans for a worldwide launch towards the end of 1995 — a full year after the debut of the Saturn and PlayStation. But the console was delayed to April 1996, and then that was changed to a Japan-only launch in June, with the US launch following in September and Europe having to wait until March 1997 for the long-delayed console. By that point, the PlayStation had carved out an unassailable lead.

But the Nintendo 64 had an ace in the form of launch title *Super Mario 64*. It was quickly hailed as one of the all-time greats, showing how platformers could be expertly translated into 3D, and it provided a compelling reason to purchase the Nintendo console. The Nintendo 64 also made analogue controls standard, something that was

262

263

264

soon copied by other manufacturers, along with the N64's innovative addition of four controller ports. Indeed, those four ports were crucial for the console's brilliant range of multiplayer titles, including *Mario Kart 64*, *Super Smash Bros.* and Rare's fantastic 1997 first-person shooter *GoldenEye 007*. The launch of *The Legend of Zelda: Ocarina of Time* in 1998 also marked a pivotal moment in the games industry, with many aspects of this seminal game being copied in years to come, including its lock-on targeting.

However, although the Nintendo 64 hosted a number of truly astounding games, it lacked third-party support, partly because of Nintendo's decision to stick with cartridges rather than adopt the CD format. This meant porting games from other consoles was difficult due to the lack of memory — there was a maximum of 64MB for N64 cartridges versus 660MB for CDs. Indeed, this lack of memory motivated Square's decision to release *Final Fantasy VII* on PlayStation, even though all of the previous *Final Fantasy* games had appeared on Nintendo consoles.

Nintendo's reasoning for adopting cartridges was that they provided instant loading and were much less prone to piracy, but they were also more expensive to manufacture — a cost reflected in the higher price of Nintendo 64 games compared with those on PlayStation. Ultimately, the number of games released on the Nintendo 64 (around 400) versus the number released on PlayStation (nearly 5,000 in Japan alone) neatly reflects the outcome of that decision.

The PlayStation would emerge as the clear winner of the fifth console generation, with Sony unseating the old guard and assuming a dominant position in the games industry, which it maintains to this day. It was a period of unprecedented advances and upheaval, with gaming making the messy and marvellous transition to 3D, while storied companies like Atari and Sega withered away. Above all, it was a thrilling time to be a video game fan.

Top of the Charts

Virtua Fighter 2, Gran Turismo, and Super Mario 64 were the best-selling games on Saturn, PlayStation, and Nintendo 64 respectively. Although Super Mario 64 was the system's crowning commercial achievement, that's a bit like giving such an honour to Wii Sports, or any other iconic pack-in game. The best-selling non-bundled N64 title is Super Smash Bros.

262
Virtua Fighter 2
1995

263
Gran Turismo
1997

264
Super Mario 64
1996

3DO INTERACTIVE MULTIPLAYER.

words Jason Shields

Many consider the 3DO Interactive Multiplayer a divisive system in the history of console gaming. With a high price point, lack of exclusive titles, fierce competition, and minimal third-party support, the 32-bit system almost immediately became a lost relic in the fifth generation of console hardware. Its unfortunate path shares similarities to other forgotten consoles of the era, such as the Atari Jaguar and the Amiga CD32. Right out of the gate, things seemed amiss, with the 3DO Interactive Multiplayer being awarded the Worst Console Launch of 1993 by Electronic Gaming Monthly. To gamers at the time, it was not a positive sign for the future of the 3DO. While many would like to forget its tumultuous past, its catalogue of obscure and often irreverent games makes this system an artefact of console gaming history that should be embraced and not forgotten. With its experimental approach, powerful hardware, internal save states, and 8-player local multiplayer, the 3DO has influenced many of its console descendants, and some may be surprised to learn about its impact and long-lasting effect on a particular gaming subgenre.

The 3DO Interactive Multiplayer was initially introduced to the US market in October 1993, with Europe and Japan receiving the console in June and March 1994. The release was heavily publicised, with advertisements prominent in typical gaming magazines like Electronic Gaming Monthly, GamePro, and Edge. In 1994, the 3DO company went as far as embarking on a seven-city mall tour as a marketing campaign to introduce the console to the public. The system was poised to be a revolutionary entertainment device, offering gamers one of the first 32-bit machines to hit the retail shelves. The 3DO company, spearheaded by Electronic Arts founder and CEO Trip Hawkins, would be among the first to move away from cartridge-based games. The 3DO Interactive Multiplayer would exclusively use CDs, following in the footsteps of the Philips CD-i and FM Towns Marty. The 3DO's initial price was astronomical at the time, costing $699.99 USD (£399 GBP). Only previous competitors, such as the SNK Neo Geo ($649.99 USD) and the Philips CD-i ($699.99 USD), had dared to enter the burgeoning interactive game market at such a high price point.

Nevertheless, Trip Hawkins was confident in his new system. Existing designs created by Dave Needle and R. J. Mical were expanded upon to produce the hardware. The 3DO would mark their third collaboration, as the two had previously worked on the Amiga 1000 and the poorly marketed Atari Lynx. By 1993, David and R.J. had proven their prowess and capabilities to the game industry, with many at the time believing that the 3DO would be the next true evolution in console gaming. Unfortunately, not everything went as planned.

It would be difficult to suggest that the North American release went smoothly, as the 3DO only came with a single launch title due to developers struggling with the newly released hardware. The launch title, unfortunately named *Crash 'n Burn*, would later draw parallels with the console's enigmatic legacy. To make matters worse, initial shipments to retailers were relatively small in North America, with approximately 30,000 units sold in the first two months of launch. The lack of product would lead to notable shortages and poor reception in the press. However, the system would see moderate success with its launch in Japan, selling 70,000 units.

Surprisingly, in its short lifespan of three years, the 3DO produced over 250 games worldwide. Many of which I remember fondly. The system offered excellent arcade ports like *Super Street Fighter II Turbo* and *Samurai Showdown*, in addition to some questionable FMV 'classics' such as *Supreme Warrior*, *Snow Job*, and *Psychic Detective*. However, the small library of console-exclusive titles allowed the system to develop a cult following over the past decades. Such titles as *Advanced Dungeons & Dragons: Slayer*, *Blade Force*,

photography Damien McFerran

Doctor Hauzer, Escape From Monster Manor, Jurassic Park Interactive, Twisted: The Game Show, and *Way of the Warrior* have continued to resonate — for better or worse — with gamers today. However, one 3DO-exclusive game in the simulation genre has always intrigued me.

In the '90s, as a youth, I was often captivated by the emerging game genre of management and construction simulation. While I did not own a PC at the time, I would always relish the opportunity to play titles like *Caesar, SimCity 2000,* and *Pizza Tycoon* on my older cousin's computer when visiting their home during the holidays. This passion for the genre would later lead me to import obscure Japanese PlayStation titles such as *Burger Burger, Theme Aquarium,* and *The Conveni: Ano Machi wo Dokusen Seyo.* However, out of the endless English and Japanese construction sims I had played during that decade, I would argue that one of the most impactful is the 3DO exclusive design simulation game, *The Life Stage: Virtual House,* a long-forgotten but oddly influential title in gaming history.

I encountered *The Life Stage: Virtual House* for the first time when I was renting a 3DO game system from my local video store in central Canada during summer break in 1995. With a sizable down deposit from my parents, the system came with one controller and three game rentals. It was immediately evident that *The Life Stage: Virtual House* significantly contrasted the other two games I had rented. It was not as sharp-tongued and fast-paced as the now infamous *Gex* or as perplexing and frustrating as the cyberpunk point-and-click adventure game starring Dennis Hopper, *Hell.* In retrospect, some of these titles are an odd selection for a ten-year-old kid to rent, but the availability of 3DO games was minimal at the time as the console only became available in Canada in the fall of 1994, nearly a full year after the American release.

The Life Stage: Virtual House was not advertised as a ground-breaking, action-packed adventure, and the box art was a confusing plethora of neon shapes perched behind an anthropomorphic 3DO console that was seemingly raising its CGI-rendered hands in unfettered excitement. The game itself was a slow-paced, understated, and oddly revolutionary early title for the 3DO. It felt surreal and out of place, a unique experiment in what one could consider a video game in 1993. I suspect I resonated with this title as this was not my first time playing a game that revolved solely around architectural and interior design.

The 1988 *Vtech Socrates* ($130 USD launch price) was the only video game system they allowed at my daycare growing up; this was due to the cartridge-based console marketing itself as an educational system for children. Of the few titles the daycare owned, The game *CAD Professor* always stuck out to me. *CAD Professor* was quite advanced in its functionality and graphics compared to others on the system. The title offered four games

based on architectural, interior, textile, and fashion design. The interior design portion was the most interesting of the bunch. It was quite rudimentary but would provide the player with a room shown in an isometric view in which you could plan the placement of furniture, appliances, and other objects. The interface needed to be polished, with extensive draw times, clunky controls, and unintuitive UI. For many years at that daycare, we would produce substandard designs unsuitable for inhabitance, using the tedious yet playfully coloured interface. Even as a youth, I hoped that a better option would be available one day, but I always felt this style of game would never return to game consoles. It was surprising to find out that the newly released 3DO would finally provide a fully 3D immersive simulation of residential and commercial interior design, expanding on the creative experience the *Vtech Socrates* had provided in my formative years.

Developed by Microcabin, *The Life Stage: Virtual House* would be released exclusively on the 3DO in North America in 1993 ($59.95 USD) and released in Japan the following year. It remains an unusual title that could only emerge during the transitory years of console gaming. The shift from 2D sprites to 3D polygons was in full effect, and 3DO needed to flex its ability to produce fully 3D games at an early stage in the console's life cycle. Considering these factors, one can only assume that Japanese developer Microcabin, in conjunction with Panasonic (Matsushita), decided that player-driven architectural design would be the best way to showcase the power of the 3DO. No other console game in 1993 could allow you to create fully traversable 3D spaces with applied textures and 3D objects to create life-like or surreal interior environments. The game was a novel idea but a risky venture catering only to a niche market on a console with a low adoption rate.

Nonetheless, the game was distributed in both Japan and North America, so the 3DO company must have had confidence in Microcabin's work. This title actively encouraged gamers to feel like a faux-Le Corbusier from the comfort of their couches, and at the time, it surpassed anything I had seen before on a console system for user-oriented creation using polygonal 3D space. It made the previous 2D iterations of this concept seem dated and rudimentary. It seems absurd now, but allowing players to build the architectural shell of structures and select the placement of doors, windows, and other components was a very forward-thinking concept at the time. While a seemingly complex title to navigate at first, once familiarised with the menus and load times, the game has incredible depth for a 1993 release. Surfaces such as floors, walls, and ceilings can be quickly customised using a variety of textures like paper, brick, clay, metal, stone, and wood.

Once you have designed and placed your architectural shell, the interior mode offers expanded options such as furniture and electronic appliance placement, kitchen

casework creation, and bathroom fittings customisation, allowing flexibility in your desired design concepts. Some electronics, such as televisions, stereos, and computers, are interactive. Accessories such as coat hangers, dryers, telephones, safety railings, and books can be inserted into the interiors, providing a sense of realism to each player's space, something that would become more prevalent in future through series like Animal Crossing, or *Stardew Valley*. If interior design is not your forte, the game comes preloaded with eight demo rooms the developers created. This feature allows you to freely navigate eight pre-designed spaces in first-person mode, ranging from basic homes, an apartment complex, a log cabin, an office, an RPG-style dungeon, and a surreal psychedelic space titled "?" that I would absolutely recommend you take a stroll through.

Considering this title was initially released in 1994, what it accomplished with its 3D graphics was impressive, and I believe the game did achieve its goal of showcasing the power of the 3DO. Unfortunately, a game where you design and explore a house in 3D is a tough sell, no matter the region, market, or gaming generation. Like other early 3DO titles, it was readily available at launch but became increasingly difficult to locate due to its poor sales and early cycle release. Admittedly, The title suffered from slow loading, poor FPS, a lack of music, and a control pad that was difficult to navigate. However, this was pretty typical for *most* 3D console games in the mid-90s. *The Life Stage: Virtual House* still had some of the shortcomings of its predecessor, *CAD Professor*, but no system besides a high-end PC could offer such an immersive experience at the time.

These exciting moments of obscure exclusive games and hardware superiority in the console market would be short-lived for the 3DO, as the Sega Saturn and Sony PlayStation would be released less than two years later in 1995. With their increased capabilities, brand notoriety, and additional third-party support, it became evident to most that the 3DO company could no longer compete. Unless you lived during this time, it is hard to explain how quickly the hype diminished for the console. A mere 15 months after I had first rented the system, it appeared destined for the discount bin, with production and development discontinuing sometime in late 1996. However, as things seemed like they were coming to an end for the console, the 3DO company quickly announced a successor.

First proposed as a chip add-on for the existing 3DO console, the Panasonic M2, designed in collaboration again with Dave Needle and R. J. Mical, would eventually be announced as a new standalone console system with an intended release date of 1997. Due to many internal and external factors, the console never went to market. Panasonic sold the technology to its parent company, Matsushita, which would eventually shift the M2's target market toward professional industries instead of home gamers. The M2 technology would, however, appear in some arcade games such as *Tobe! Polystars* and *Total Vice*. However, even six years later, the legacy of Microcabin's *The Life Stage: Virtual House* must have continued to resonate with the executives at Matsushita. A second attempt at architectural and interior design simulation would surprisingly reappear on their M2 technology, this time used exclusively in Japanese Kiosks.

In 2021, a full copy of *VizHouse v1.41* for the 3DO M2 was released online by video game preservationist Video Game Esoterica. *VizHouse* is strikingly similar to *The Life Stage: Virtual House*; it feels and appears much like a vastly improved sequel. Increased framerate, better graphics, faster loading times, and a sleeker UI are all welcomed improvements. Unfortunately, very few copies are available, so the likelihood of playing this architectural oddity is relatively small for most. However, its mere existence further emphasises *The Life Stage: Virtual House's* influence on the gaming industry.

Many would ask why this game is important. Why should we care about an obscure title that offers no gameplay? *The Life Stage: Virtual House* remains an interesting example of the 3DO company's willingness to explore conceptual ideas, introduce new console gaming ideologies, and push boundaries of 3D spatial customisation and representation not previously experienced on game consoles. In the decades since then, architectural construction and interior design have become increasingly prevalent in contemporary games. The Harvest Moon series, the Animal Crossing series, *Final Fantasy XIV*, and many others make 3D architectural design and home customisation a critical gameplay feature to provide players with a sense of identity and connection to home within their virtual worlds. The Sims series and *Second Life* are likely the most recognised of these games, where architectural design and interior environment creation play a crucial role in creating an immersive life simulation.

With a vast array of titles leveraging this concept in the subsequent years since 1993, one must remember that *The Life Stage: Virtual House* was the first console game to implement 3D interior design in a profound and detailed manner, and the 3DO system was the first home console to implement and market it to the masses. Although the 3DO may not have succeeded in its goal of console dominance, it has supplied many of us with memories of a console that desired to look outside the boundaries of typical gaming. It was a console that did not always follow the mainstream trends at the time. Personally, the 3DO provided me with my first 32-bit experience, and in the summer of 1995, it truly did seem revolutionary. It showed me the possibility of 3D room-building on a console and introduced the idea of using gaming consoles to simulate architectural design and immersive life-like experiences. Many years and console generations later, I would go on to pursue a Master's Degree in interior design, and one can only think of the influence this game and many of the others mentioned may have had on my trajectory.

ЛATARI®

INTERACTIVE MULTIMEDIA

ATARI JAGUAR .

words *Darryl Still*

When I started gaming as a kid in the late '70s — via the standard routes of *Pong* through an Intellivision console and *Pac-Man* in the local arcade — you didn't have a console; you had an *Atari*.

First Released:
1993

Manufacturer:
IBM

Launch Price:
JP ¥29,800
US $249.99
UK £199.99

Even if it was an Intellivision, back then, people played 'Atari' in the same way you'd 'Hoover' your carpet even if you were using a Dyson vacuum cleaner. It just became the standard name for the activity (and was later replaced as that standard by 'Nintendo' and even later 'PlayStation,' even if you had a Sega Mega Drive or Xbox).

Atari was the generic name because Atari got there first with the VCS game system in 1977. The year after punk rock started my love of music, Atari started my love of gaming.

So it was a thrill for me, eleven years later, when I started to work for the company in the UK headquarters in Slough. I had spent the previous four years working for two game publishers in the Reading area in a variety of roles. I joined Atari on 8/8/88. My starting role was as a Product Manager for the Atari ST, and, as befits my start date, I stayed at the company for eight years, eventually becoming Marketing Manager for the UK and finally for Europe.

In 1988, the Atari ST was in its early days and became a massively successful computer system — especially in the UK, where it became, despite the best-laid plans of many in Atari management in the USA, a fully-rounded gaming system. This was driven by the UK office and our strategy, but to understand its impact requires a little further history and context.

From 1977 onwards, the Atari VCS became the introductory console for many gamers. It had a huge catalogue of games — some very rudimentary, just a series of lines and beeps with the most basic of sprite graphics. By the time I joined in 1988, it had sold over 30 million units and was still selling. In 1982, Atari introduced the Atari 5200 and renamed the VCS the 2600. The 5200 was based upon the company's line of 8-bit computers. The initial lack of games hindered the 5200, as did its incompatibility with 2600 games. Sales totalled just one million units, and the product was withdrawn just two years after launch and replaced by the 7800, which was derived from VCS technology and was backwards compatible with 2600 games.

In 1984, Warner Brothers — which had acquired the company in 1976 — sold it to computer entrepreneur Jack Tramiel and a whole new Atari was created. Initially, the only change was that the Fuji mountain logo which had always sat proudly atop the Atari name was moved to the left of the name, running lengthwise. Tramiel, however, was a home computer man and *not* a console man, and whilst he initially fiddled with the console range — pushing the 7800 and in 1987 introducing the Atari XEGS, a whole new console system — computers remaining his focus (the XEGS, for example, was based upon the 65XE computer range and included a keyboard for the first time, hybridising the console and PC business). It won a whole host of design awards for its lovely pastel shade buttons and click-and-add peripherals. Design awards were pretty much all it won, though, and it proved wholly unsuccessful against the Nintendo NES and Sega Master System, which were introduced at the same time. The feeling was that this was always a temporary product, and the company's focus was fully behind the 16-bit ST system and beyond to 32-bit technology.

So, the Atari I joined in 1988 had a chaotic range that was changing fast. The 2600 was still selling through mail order catalogues at a very low price and in good numbers but with no development of new titles. The 7800 was listed alongside it, but the higher price was a turn-off to consumers. The XEGS had failed to find any market at all, and was being

photography *Damien McFerran*

Doomed To Repeat Itself

'Can it run DOOM' is one of the go-to gaming jokes — and for good reason. id Software has been asking this question since 1993, bringing DOOM to every platform under the sun including Atari Jaguar. Across all its home console, portable, and mobile iterations, there are 20 unique ports of the game!

265

266

267

268

269

270

265
Cybermorph
1993

266
Alien vs. Predator
1994

267
Tempest 2000
1994

268
DOOM
1994

269
Wolfenstein 3D
1994

270
Fever Pitch Soccer
1995

phased out. Whilst using the 2600 as a cash cow, the company was now totally focussed on the Atari ST home computer and, in effect, had no separate above-the-line console division whatsoever. However, Atari's research and development team was working on a new console project aimed at replacing the 7800, codenamed Panther, and there was a handheld project in the offing that eventually became the Lynx.

Over the next five years, between 1989 and 1994, the ST went head-to-head with the Commodore Amiga (ironically, from Tramiel's old company) for domination of the UK gaming market. Atari initially won the battle, but the release of the mass-market Amiga 500 turned the tide. With the home computer market starting to slip out of its grasp, Atari had another rethink and made the decision to return to its previous stronghold: it picked game consoles over home computers.

First up was the Atari Lynx, a full-colour handheld game console. It was a lovely product to be involved with, but never entirely took off the way it should, considering how much better than the huge-selling Nintendo Game Boy it was. Initial design issues were fixed by the lighter (but less robust) Lynx II, but one issue remained constant: it was a battery eater. Even so, having the Lynx running alongside the ST kept Atari's hand in the 'pure' games market and enthused the development sector. Internally, we waited patiently for news from the R&D team about the upcoming Panther system.

Development was not happening directly in Atari's Sunnyvale headquarters. Leonard Tramiel's team was historically focussed on the continuing ST line: the Stacy, ST Book, Portfolio, TT and Falcon. The Panther came from the UK, from Flare in Cambridge, who had previously worked for both Sinclair and Amstrad. Flare was, at the time, involved in the technology of video game cabinets, but in 1989, Atari contracted its chief designer, Martin Brennan, to complete and implement the chip design of the codenamed Panther — a 16-bit console based initially on ST technology.

Martin Brennan and his colleague at Flare, John Mathieson, firmly believed they could do better than Panther, moving to the level above what Nintendo and Sega were producing in the Super NES and Genesis / Mega Drive consoles. Convinced, Atari provided the funding for Flare II, and such was the speed of development on the new system that in 1991, Atari cancelled the development of the Panther and focussed all efforts on the Jaguar.

Rumours started circulating about a 64-bit system from Atari in 1992, and we finally started to get some exposure within the office thanks to some development kits ready for showcasing to key development studios in the UK. Atari unveiled the Jaguar at the Consumer Electronics Show in June 1993 to much buzz and excitement — but it was already causing controversy over the claim that it was a 64-bit console. Going head-to-head with Electronic Arts founder Chip Hawkins' 32-bit 3DO machine, a PR war ensued.

Powered by two custom 32-bit processors named Tom and Jerry, with a Motorola 68000 alongside, it was certainly a very powerful machine. Atari's claim that 2x32-bit chips running in parallel on a 64-bit bus used by the 'blitter' chip equalled a 64-bit system was disputed by many and is still a subject of debate to this day. Atari, however, did not hold back and jumped straight in with the memorable tagline "Do the Math" (already alienating UK customers — and marketing folk — who wanted to add an 's' to the phrase to make it proper Queen's English). Tech journalists claimed that if Sega used the same counting methodology, the company could claim its Saturn system to be 112-bit. Irrespective of this, all these systems were impressive and powerful, and the battle was won and lost in two key areas: supply and software.

By all accounts, the Jaguar was not easy to develop for. Earlier in 1993, as Atari hurtled towards an earlier-than-expected release date to make up for the demise of the ST and Lynx systems, game development studios struggled to keep up. Many of the best titles came from UK studios, but unfortunately, some of the early releases from US firms got nowhere near showing the power of the console or convincing the press or consumers that it was *truly* the next generation. Titles like *Trevor McFur in the Crescent Galaxy* were derisory releases, at best.

Cybermorph, which was bundled with the console at launch, was more impressive in its creativity. Developed by UK Studio Attention to Detail — who had worked with Brennan and Mathieson on Flare's unreleased Konix console — it looked to David Braben's 3D landscape design from *Zarch* for inspiration. Visually, it was striking, especially compared to what was being achieved on the 16-bit platforms of the period, but its gameplay was restricted by time and cartridge size restrictions.

The system was officially launched in the US on November 22, 1993, at $249.99, initially just in New York and San Francisco. A half-a-million dollar manufacturing deal with IBM was in place, but only 17,000 units were reported to have sold in this 'test' period, with no units arriving in Europe whatsoever. The Nationwide US release six months later was still troubled by a lack of titles, especially when compared to the 3DO, which had a more impressive launch library — thanks to Hawkins leveraging his Electronic Arts contacts and influence. We approached EA Sports in Europe to develop a version of *FIFA*, their best-selling soccer game, for Jaguar but were turned down. I am still slightly suspicious that there were more reasons than just user sales behind this. So, we were restricted to developing and releasing *Fever Pitch* as our lead soccer title. Produced by myself and Steve Fitton, even I am prepared to admit it was hardly my greatest hour.

167

271

272

Even so, Europe was responsible for some of the strongest Jaguar titles. Take *Alien vs Predator* from Rebellion as an example. The first entry in what would become a massive franchise, it was simply groundbreaking. A first-person shooter with built-in tension and atmosphere as much as action, this was one of the strongest Jaguar titles in terms of critical reaction, and I believe one of the best-selling. Also from Europe, from the amazing Jeff Minter of Llamasoft, was *Tempest 2000*, a remake of a '80s arcade machine brought totally up to date with a stunning soundtrack. It is probably the most captivating game available on Jaguar, and worth buying the console for alone.

I travelled with Jeff from the UK to the New York launch of Jaguar in November, and took him, accidentally, to a British pub in Washington Square that is a replica of the pub The Slaughtered Lamb from the movie, *An American Werewolf in London*. As a self-professed lover of all things ovine and woolly, Jeff found this a very distressing experience, and we made our exits early. Thankfully, this didn't stop him from supporting the console with future games!

With Bill Rehbock now running the development side of the business, first-person shooters such as *Doom* and *Wolfenstein 3D* showed that Jaguar was well-suited for the genre. Apart from the aforementioned less-than-impressive port of *Fever Pitch*, I personally worked on other titles. The first was *Attack of the Mutant Penguins*, on which I worked with Wayne Smithson of Sunrise Games from their pitch and produced it alongside Alistair Bodin, who later worked on PlayStation for Sony and Xbox for Microsoft. At the time, Alistair and I were the sole representatives of the European development department at Atari, and *Mutant Penguins* was our first official release. I still feel it is very underrated. Original in design (albeit slightly inspired by *Lemmings*), it is colourful, fun and very lively. Mark Robinson and Paul Hoggart were also key to the development.

I also began work with Caspian Software on a game called *Zero 5*, which had stunning graphics and would have potentially been one of the best titles for the system had it been released early enough — but the Jaguar itself was being beset by issues elsewhere. Quite simply, it was not being received well within the US, and whilst we had created quite a buzz and had a significant order for it in Europe for its first official Christmas, we just could not get the supply of the units to fulfil demand. There were rumours of problems at IBM with the supply of some chips and components. Meanwhile, Atari had quickly developed and released a CD drive to counter the 3DO, but hardly had any CD games to put behind it, and so relied on music and movies to promote it. However, when the player was placed atop the console and the lid lifted, it looked distressingly like a toilet with its seat raised. Not an easy sell!

273

274

275

Keen to find a foothold somewhere, Atari tried other ventures, including a deal with UK firm Virtuality for what would have been one of the first at-home virtual reality headsets ever produced. I clearly remember the prototype helmet being brought into our Slough office and standing in a small, square room feeling thoroughly ill as it failed every single motion sickness test that staff were put through. It looked amazing but was probably a health risk — it was decades ahead of its time.

In December of 1994, Atari Europe had received just 25,000 units of the Jaguar and the consumer fury from parents who could not get the gaming console their child dearly wanted. One turned up to our Slough office with her dustbin and emptied the contents of it in our reception area. This single incident was indicative of the problem. If they couldn't get little Johnny his first choice, he could not go without — so he opened somebody else's console on Christmas morning. The Jaguar was essentially dead. In the narrow window of opportunity when we actually had demand for it, we were simply unable to supply the product.

By the time 1995 arrived and Sony and Sega had entered the market with their PlayStation and Saturn consoles, the writing was on the wall. Atari dropped the price of Jaguar to $149 in 1995, but sales did not pick up. Throughout the year, the company suffered layoffs but continued to work on the last few Jaguar products. *Zero 5*, which I was working on, was still being developed when I left the company in early 1996, and it was eventually released in a somewhat unfinished state by Telegames. It was one of the last official releases for the console before Atari entered a reverse takeover with JTS corporation and essentially abandoned the Jaguar later that year.

In line with all things eight in my Atari career, I was the eighth-from-last person to leave the UK office as I took up a position at Electronic Arts, then I worked again with Bill Rehbock at Nvidia before forming my own publishing company. Jaguar is a footnote in my own career, but the machine remains a staple of the retro gaming scene, and I have recently sold and signed my own personal units on eBay at a nice little profit.

There's clearly still some love for the Jaguar, in spite of its manifold failures.

273
Atari Jaguar Controller
1993

274
Atari Jaguar ProController
1995

275
Atari Jaguar VR
1995

Certainly Diminutive

The ill-fated Jaguar CD add-on, released in 1995, only received 13 games during its official lifespan. Of those, Atari itself published half, with the remaining split almost entirely between ReadySoft and Telegames. Another underutilised bit of Jaguar hardware was the ProController, whose added buttons beyond that of the standard controller were seldom used.

atari jaguar.

SEGA SATURN.

words James Mielke

The Sega Saturn was my first serious gaming console. By *serious*, I mean I put down real money to buy a Japanese version so that I could play all the latest imports, instead of waiting for these games to (sometimes) get published in North America.

First Released:
1994

Manufacturer:
Sega

Launch Price:
US $399
JP ¥44,800
UK £399.99

Although I grew up with games, at first with the phone-like 'Radio Shack Electronic TV Scoreboard Pong' and assorted Game & Watch handhelds sent to me by my relatives in Japan, the Sega Saturn arrived around the time I started having disposable income as a young adult. I had an Atari 2600 and whatever garbageware I could afford at the time (usually dollar carts at the local thrift shop), a NES that I saved up for by working a part-time job for two months, and a Genesis that I only ever had about five games for. I skipped the Sega CD and the 32X at the time, so the Saturn was the one where I gambled on the library to come and jumped into head-first, buying the latest games with hard-earned money from my bartending job and freelance illustration gigs, savouring every exciting new game I took home with me. *Almost.*

Like any console, there were duds. *Deadalus* (*Robotica*) single-handedly introduced me to the concept of motion sickness. I bought it one day and returned it the next. All that gyroscopic headbobbing put me out within minutes of playing it. *Myst* bored me terribly, because I couldn't figure out what needed doing.

However, WARP's groundbreaking horror *Myst*-like *D* was significantly more interesting. *Virtua Fighter* and *Virtua Fighter Remix* were brilliant, of course — so was *Daytona USA*, environmental draw-in and all. *Clockwork Knight* was cute, as was its superior sequel. Later down the line, *Saturn Bomberman* blew me away (no pun intended). To me, it remains the true peak of the franchise — the soundtrack is a sublime slice of drum n' drum-infused electronica.

Of all the launch window titles, the real gem was *Panzer Dragoon*. I was at my favourite import shop on 40th Street and 7th Avenue in NYC when I saw the sandworms jump out of the ground in the game's rolling demo. I was sold. I said, "GIVE ME THAT!" and walked out of the store, impossibly excited about the game I'd just purchased. *Panzer* was tough, but the soundtrack, the stark cinematics, the unique dragon design, the 'us against the world' vibes all conspired to make this the game worth owning a Saturn for.

I couldn't believe I was playing these titles at home. After all of those hot launch games, Sega followed with Saturn ports of its still-peerless arcade portfolio. *Sega Rally, Virtua Cop, Fighting Vipers,* and *Fighters Megamix* emerged, alongside the best arcade ports of Capcom's 2D fighting roster, bolstered by stellar 2D shooters like *Soukyugurentai, Radiant Silvergun,* and *Thunder Force V*. The Saturn was a hardcore gamer's dream console in the late '90s. The problem, though, was that Sega was doing most of the heavy lifting internally.

Third-party support was lacklustre, leaving most Saturn owners waiting for first-party releases with little sustenance in between. The buzz of the shiny new Saturn was only temporary, as it was quickly overshadowed and outpaced by the PlayStation, followed by the Nintendo 64. As games like *Final Fantasy VII, Resident Evil, Wipeout 2097,* and *Super Mario 64* as well as *Wave Race 64* released on their respective platforms in a steady cadence, it became harder and harder to watch the already soft support for Saturn dwindle in the West.

Only the first chapter in the three-part *Shining Force III* trilogy was ever localised, while games like *Deep Fear* were only released in Europe. Meanwhile, other masterpieces like *Panzer Dragoon Saga* were printed in agonisingly limited numbers. Outside of Japan,

photography Damien McFerran

276

277

276
Sega Saturn Model 1
1994

277
Sega Saturn Model 2
Japan, 1996

172

where *AZEL Panzer Dragoon RPG* (the game's Japanese title) was released in ample quantities, the 1.8 million or so Saturn owners in North America had to scramble to pick up one of the less than 20,000 copies of *Panzer Dragoon Saga* that Sega made available. Europe had it worse, with Sega supposedly only ever printing 1,000 copies of the game for an install base of around a million. The late '90s (and, to be fair, also the early '00s) were a very hard time to be a Sega fan. How did the company fumble the ball so badly, when its previous system — the Mega Drive — had fought with Nintendo for worldwide dominance?

Released in Japan in 1994, Sega's Saturn was originally conceived as the ultimate 2D gaming powerhouse; an admirable conceit, but also entirely out of sync with the impending trend of 3D games to come. After the heyday of the Mega Drive, Sega completely failed to read the room, releasing a series of misfires designed to carry the momentum of its 16-bit dominance forward with add-ons and also-rans like the Sega CD, Sega Nomad, and the 32X. While the Sega CD (and, to some extent, the 3DO) ushered in the dubious wave of full-motion video games, it was never a mass market concern. The Nomad was a battery-gobbling handheld that was ahead of its time, and the 32X was a halfway house between the current and next generations. None of these set the table for Saturn, Sega's true successor to the Mega Drive, and when it did emerge, it suffered a troubled and dysfunctional launch.

The first problem was the hardware itself. Word on the street prior to Saturn's launch was that a senior director at Sega Japan got a whiff of the PlayStation's 3D-focussed hardware specs and panicked, forcing the Saturn team to add a second video display processor (VDP) in an effort to better match up with Sony's impending console. The truth wasn't that far off, and surely the added VDP resulted in a better piece of hardware. But the ad-hoc nature of the console made it a complex machine for most to develop for, and inelegant results were often the norm.

Next to the PlayStation's carefully considered 3D capabilities — which could generate 90,000 polygons with transparencies, light sourcing, and textures — the Saturn had to fake it, with developers utilising innovative techniques to manipulate the system's strengths, namely generating sprites and bitmaps, to simulate polygons and 3D space. It took creative thinking by clever developers to get the best results out of the hardware.

Camelot Software Planning, developers of the *Shining Force III* trilogy, found clever ways to maximise the Saturn hardware for their game, funnelling data through the system's powerful but under-utilised Yamaha YMF292 sound chip to load battles at high speeds usually associated with cartridge-based games. Meanwhile, Sega's internal development team, Team Andromeda, made use of Saturn's 2D prowess to produce stunning 3D effects not even PlayStation could emulate. By layering separate 2D textures in parallel with each other, *Panzer Dragoon Zwei* achieved stunning water effects not possible on the 3D-focussed PlayStation.

However, for every hard-won graphical victory, Sega kept getting in its own way when it came to marketing. Although the Saturn was initially quite successful in Japan, Sega's American HQ attempted to outmanoeuvre Sony's PlayStation with a surprise launch of the Saturn that excluded certain retailers in favour of others, angering those outlets who, in turn, refused to carry the system at all, paving the way for PlayStation to assert itself at launch.

It's a real shame because, in hindsight, the Saturn really was a hardcore gamer's best friend. Heaps of games showcased the 2D prowess that the Saturn was designed for. Arcade-perfect ports of Capcom and SNK's near-complete 2D fighting rosters called Saturn home, even if some of them required a RAM-boosting plug-in cart, like *Cyberbots: Full Metal Madness*, *Marvel Super Heroes*, and *The King Of Fighters '97*. Other games, like the gorgeous platformer *Keio Yugekitai*, Atlus' *Princess Crown*, Irem's *In The Hunt*, and Treasure's *Guardian Heroes*, showcased everything great about Saturn's mastery of 2D gaming.

Perhaps most significantly, though, despite all of the brilliant 2D things the Saturn could do, Sega failed to deliver the hero the console most desperately needed: Sonic the Hedgehog. *Sonic X-treme* — a game originally designed to follow *Sonic & Knuckles* — was supposed to be that hope. But instead of saving the day, it would languish in development hell for years, moving from Genesis to 32X and, ultimately, to Saturn. The long, troubled story came to a predictable and disappointing end when *X-treme* was cancelled in 1997. Sonic's main presence on Saturn was the ironically-named *Sonic 3D Blast*, a game which was not really 3D, nor a blast. Developed by Traveller's Tales in the U.K., *3D Blast* was an isometric platformer that was neither the 2D Sonic people identified with nor the 3D platformer *Sonic Adventure* for Dreamcast would be.

Sonic 3D Blast was poorly positioned to compete with PlayStation's own platforming success in *Crash Bandicoot*, and offered no counter to Nintendo's breathtaking *Super Mario 64*. Instead, Sega's contribution to the 3D platformer space — complete with a bespoke analog controller — was an esoteric curiosity called *NiGHTS Into Dreams*.

Developed by Sonic Team, directed by original Sonic character designer Naoto Ohshima, and designed by long-time Sega veteran Takashi Iizuka, *NiGHTS Into Dreams* was a gorgeous, evocative game with a thrilling electronic soundtrack. But as a new IP designed to compete with Nintendo's domineering plumber, *NiGHTS* failed to ignite the masses. Although it boasted a memorable cast and storyline — along with the innovative 'Nightopian' system

173

278

278
Sega NetLink
1996

(which would return, transformed, in the likes of *Phantasy Star Online*'s Mag system, and *Sonic Adventure*'s Chao system) – *NiGHTS*' time attack gameplay appealed primarily to hardcore Sega fans and Sonic Team fans, but not the general public — a win the Saturn so badly needed.

It also didn't help Sega's battle with the RPG-strong PlayStation that all of the Saturn's acclaimed, exclusive role-playing games were left behind in Japan (or, in some painful instances, ported to PlayStation instead, as was the case with *Grandia*). This meant that games like Sega's incredibly successful anime steampunk strategy RPG, *Sakura Wars*, never saw an English release. While Working Design's legendarily lengthy localisation of *Magic Knight Rayearth* finally saw release as the Saturn's final North American launch in late 1998, this was the end of the road for the Saturn, leaving the console battle to Sony and Nintendo while Sega prepared Saturn's successor, the Dreamcast. But even the hype and excitement of Sega's Windows CE-powered Dreamcast couldn't put a dent in Sony's unstoppable momentum with PlayStation and PlayStation 2. By 2001, Sega had abandoned the hardware business entirely to focus on its transition to life as a third-party software developer.

Despite all of this, in hindsight, Saturn is one of the highlights of the golden era of video games. It, along with Nintendo's GameCube, were the last of the breed of barely connected consoles that weren't tasked with doing double duty as home entertainment centres. No DVD players, no Netflix apps — these were *pure* video game machines (if you don't count Saturn's ability to play seldom-used VCDs, that is).

Saturn's legendary status also rests on the fact that most of its original games — with some exceptions, of course — have never been ported to newer consoles. Although select Saturn games like *DecAthlete Collection*, *Dragon Force*, *Fighting Vipers*, and *Last Bronx* saw a brief revival in the Sega Ages 2500 series, plenty of other titles, like *Burning Rangers*, *Panzer Dragoon Saga*, *Fighters Megamix* and others, have never resurfaced. To find original copies in good condition nowadays will cost you a small fortune, too, exacerbated by the fact that most of the late-era Saturn catalogue was printed in pitifully small batches.

Entire books could be written about how the gaming landscape today could be markedly different had Sega only made some tactical adjustments to its mid-'90s game plan. What happens if Saturn launches with a 3D Sonic game or is more developer-friendly? What if it kept Electronic Arts as close to the fold as the company had in the Mega Drive days and didn't completely lose them by the time the Dreamcast rolled out? Could PlayStation have been anything but as inevitable as it seems now, or would the N64 capture everyone's imagination with Mario's great 3D adventure? We'll never know. What *is* known is that Sega squandered all of the momentum built with the Mega Drive, which meant that Saturn was left to the connoisseurs while PlayStation made sweet gaming music for the masses.

For this writer, however, the Saturn was — and still remains — the *definitive* gaming machine. While I can finally play Treasure's *Radiant Silvergun* on something modern *and* portable thanks to its Switch port, it's not the same as playing in its original form. I also loved small details like *NiGHTS*' little Easter eggs, like calendar-based menu screens, and collecting all of that game's Nightopians. While I have parted with some of my collection through the years, I've kept the core of the best Saturn games intact, and you'll have to bury the system with me. For my money, it offered pure, undistilled gaming with a software library unlike any other console out there.

The fact that it failed to sell even a fraction of what the PlayStation did only makes its brilliance all the more precious.

279

280

281

282

279
Virtua Stick
1994

280
Virtua Gun
1995

281
Arcade Racer
1995

282
Saturn Keyboard
1996

A Sonic Solution

While the Sega Saturn did not receive a fully-fledged 3D Sonic platformer, it did receive the compilation disc Sonic Jam. In addition to remastered versions of the Mega Drive titles, this package featured a wealth of bonus material accessed through a 3D platforming hub world complete with small challenges. It offered a minute glimpse into an alternate timeline where Sonic made his way into 3D a generation sooner.

283

284

285

286

287

288

289

290

291

283
D
1995

284
Virtua Fighter
1994

285
Clockwork Knight
1994

286
Saturn Bomberman
1996

287
Panzer Dragoon
1995

288
Sega Rally
1995

289
Virtua Cop
1995

290
In The Hunt
1995

291
Shining Force III
1997

292

293

294

295

296

297

298

299

300

292
Deep Fear
1998

293
Radiant Silvergun
1998

294
Panzer Dragoon Saga
1998

295
Cyberbots: Full Metal Madness
1997

296
Princess Crown
1997

297
Guardian Heroes
1996

298
Sonic Jam
1997

299
NiGHTS Into Dreams
1996

300
Magic Knight Rayearth
1995

PLAYSTATION.

words Robert Ramsey

I was introduced to the wonderful world of gaming through the power of the original PlayStation: a console that defied expectations. Thinking back on it now, it was a rather strange-looking grey box, wasn't it? Not necessarily appealing in terms of immediate aesthetic design beyond its asymmetric buttons and large disc cover (that opened up with a satisfying click), it had a certain charm nonetheless. Fortunately, the console wasn't defined by its sense of style — its games solidified Sony's place in the industry.

First Released:
1994

Manufacturer:
Sony Electronics

Launch Price:
JP ¥39,800
US $299
UK £299

The PS1's library is jaw-droppingly vast. When I got my own as a Christmas present, several years after its initial launch, there was simply no going back. Gaming captured my imagination unlike anything else I had experienced as a kid, but my engagement developed gradually.

For years, I'd just keep myself entertained with the likes of *Tekken* and *Crash Bandicoot* — relatively straightforward games that were a fun distraction for 15-to-30 minutes, maybe an hour if I was really in the zone. Initially, sitting down in front of my PlayStation wasn't much different from grabbing my action figures. But as I got a bit older and started reading the Official UK PlayStation Magazine on a monthly basis, something changed.

There was a distinct desire to go deeper; I would gawk at gory screenshots of *Resident Evil 2* and be left utterly mesmerised by *Metal Gear Solid* — a game I watched my friend play through from start to finish after school. I didn't really understand any of it, but there was a robot ninja and Psycho Mantis knew what was on your memory card. That was more than enough to push me into broadening my horizons.

The release of the PS2 in 2000 (the same year that Sony released the redesigned PS One) completely passed me by, as I was still knee-deep in exploring the many PS1 games that my now-adolescent brain could comprehend. But there was one specific series that struck a chord like no other. A potent combination of teenage angst and the stark realisation that (*gasp*) video games could tell emotionally engaging stories, Final Fantasy altered my perspective forever.

The covers of Final Fantasy titles always intrigued me: just fancy black text on a white background. There was a pretentiousness to it — what does Final Fantasy think it is, not even slapping a character on the front of the box? *And* it uses Roman numerals instead of numbers? I used to look at these covers in my local games shop and dismiss them almost immediately, but once again, the Official PlayStation Magazine was responsible for opening my eyes.

Reading those old mags, you couldn't help but notice that the top 100 PlayStation games list — a consistent feature found near the back of each issue — was flush with Final Fantasy. They had to be doing *something* right, I thought. One day, having saved up my pocket money, I took the plunge and plucked *Final Fantasy VIII* from the shop shelf. I'm not exactly sure why I was drawn to *VIII*, but I do remember being fascinated by the fact that its cover (previously deemed pretentious) featured a man and woman sharing a loving embrace. A rarity, I suppose, when it comes to box art. In hindsight, I couldn't have chosen a more angst-ridden starting point, but the story of Squall and his stunted emotions really hit home.

It felt like *Final Fantasy VIII* had everything: a near-incomprehensible plot (which, to my young teenage mind, meant that it *must* be cool and mature), endearing characters, and an initial school-like setting — how relatable! And perhaps most importantly, there was romance. At this point, actual love stories were alien to me, but the advent of puberty had, of course, forced an underlying interest. Needless to say, I became enraptured by *Final Fantasy VIII*, and because of that, my perspective on gaming as a whole was elevated to entirely new heights.

I was desperate to relive the emotional investment and thrill of *Final Fantasy VIII*, and so naturally, my next port of call was *Final Fantasy VII*. *This* was the game that everyone

photography Damien McFerran

301

302

301
PlayStation
1994

302
PS One
2000

gushed over, the one perched right on the peak of that all-important top 100 PlayStation games list. Fortunately, I stumbled across the classic going cheap in my soon-to-be shuttered local shop (at the mercy of the impending and extremely corporate GAME store), and I picked it up without a second thought.

Admittedly, it took a couple of weeks for me to come around to *Final Fantasy VII*. Its blocky character models looked so primitive after spending goodness knows how many hours with *Final Fantasy VIII*'s correctly-proportioned cast, but as is often the case with a quality RPG, it was the storytelling that won me over. Another brooding protagonist with a cool sword? *Check*. Another whimsical love interest? *Check*. Another engrossing fantasy world filled to the brim with adventure? *The biggest check imaginable*.

I adored *Final Fantasy VII*. At this point, I had played through a number of RPGs and the genre was fast becoming my favourite of the bunch — but Cloud Strife and the gang went above and beyond expectations. It marked the first time that I truly came to appreciate what we now broadly refer to as gameplay. The entire experience is layered with systems and mechanics that align in harmony, from unleashing limit breaks in battle to unlocking impressive mini-games that add to the texture of the overall adventure.

The thing is, I had purposefully missed out on a lot of what its successor, *Final Fantasy VIII*, had to offer. I dabbled in Triple Triad — the title's collectable card game — but never felt the urge to try and master it. Likewise, I struggled to fully comprehend the highly customisable but undeniably tedious draw system, which sees you 'draw' magic from enemies in order to bolster your party's stats.

However, with *Final Fantasy VII*, I felt compelled to see *everything*, and that's almost certainly a result of its immaculate design. But in an era where the internet wasn't readily accessible to me (the *horror*), this thirst for in-game knowledge meant that I'd have to track down physical guides and comb the 'cheat' sections of unofficial magazines. I must have spent weeks, potentially months, putting together what was essentially an archive of *Final Fantasy VII* information — complete with classic GameFAQs guides — which were printed out using ink that was bought specifically for homework purposes.

Final Fantasy VII triggered something in my brain which has been active ever since. To this day, I still see it as a benchmark for what an RPG can offer in terms of design, structure, and, indeed, storytelling. It's no exaggeration to say that it helped shape my view of what makes a game *good*. And with that conclusion, I very slowly (but very surely) began to realise that I was a *massive* weeb.

I had watched my fair share of the Pokémon anime as a kid like everyone did, and I had gone through a serious Digimon phase back in primary school. But it wasn't until I got deeply immersed in games like *Final Fantasy VII* that I thought to myself, "you know, Japan might be onto something." It wasn't long before I was streaming episodes of *Naruto* via a dreadful dialup internet connection (the bitrate must have been unfathomable) and buying up *Dragon Ball* manga volumes in order to kickstart a collection that continues to this day.

I would rent *Neon Genesis Evangelion* DVDs from the local library's shockingly robust (and weirdly adult) Japanese animation section and purchase old *Gundam Wing* VHS tapes for pennies. I fully embraced all of the teen-targeted Japanese entertainment that I could get my hands on, and this newfound fascination could be traced straight back to Final Fantasy, and, by extension, PlayStation. Here we are two decades later, and all of these interests have stuck with me.

Unsurprisingly, my foray into Final Fantasy wasn't just a gateway into broader Japanese entertainment; it pushed me into trying my luck with other Japanese games, RPGs especially. We're talking about *niche* releases here, and across the PS2 and Nintendo GameCube, I bought *so many* duds. Almost immediately, deep-dive research on my next potential purchase became a necessity. Part of the problem was that I was *still* using those formative Final Fantasy games as my main point of reference. I was *expecting* these obscure Japanese titles to stand alongside true classics. I must have been mad.

However, every now and then, I'd just stumble upon an absolute gem. By sheer chance, I was out shopping for a game on the day that Dragon Quest made its grand debut in Europe with its *eighth* instalment, subtitled *Journey of the Cursed King*. How could anyone resist that incredible box art (inked by *Dragon Ball* creator Akira Toriyama, no less) despite knowing next to nothing about the franchise? I snapped it up on the spot, and it remains one of my all-time favourites.

It was a similar story with *Persona 3*, although I'd been keeping tabs on that one through the magic of the internet. I have a crystal clear memory of sheepishly entering the aforementioned GAME (traitor!), walking up to the counter, and asking if they had *Shin Megami Tensei Persona 3* in stock on launch day — except I was so embarrassed at the prospect of speaking Japanese words that I pretended not to know the full name.

"Do you have *Shin... Shin Mega...* something? I think it's out today."

"Oh, *Persona 3*?" replied the guy behind the counter, with zero hesitation.

He revealed that they'd only been sent five copies: three of them were pre-orders, and one had been sold earlier. I'm pretty sure I paid a sickening amount

of money to snag that last (at least, by my cheapskate student standards), but *Persona 3* was worth the sacrifice. It was a title that melded an effortless anime art style with tightly-designed RPG gameplay. And that jazz-inspired soundtrack! I'd never heard anything like it in a video game. For a long time, I thought *Persona 3* was the coolest thing on the planet.

On that note, part of me misses the days of rolling the dice on a genuinely unknown Japanese entity. We live in an age where a single Google search will tell you absolutely everything that you need to know about an album, book, movie, show, or game. It's been literal decades since I strolled into a physical shop and trawled the stands for something I haven't already heard of. In some ways, that's a positive — I don't want to think about how much money I must have wasted as a youth — but it does feel like that sense of discovery has been lost to time. Or maybe that's just the nostalgia talking.

Speaking of which, nostalgia is an incredibly powerful tool. I've probably played through the opening two hours of *Final Fantasy VII* about 1,000 times, and it's not just the perfect plot pacing or Midgar's iconic atmosphere that calls me back. It's that desire to *feel* what I felt all those years ago, even just for a moment. I don't necessarily think that's unhealthy or *weird*, for lack of a better word. Everyone has something they'd like to experience again for the first time.

I see the original PlayStation as much more than just a console and a means of casual entertainment. When I picked up a PS1 controller for the first time to play *Tekken 2* with my older cousins, I couldn't have possibly imagined how that strange-looking grey box would impact my life. Here I am, roughly four console generations later, making a living by writing about video games. Specifically, PlayStation video games. *Incredible.*

Tethered Together

The PlayStation has no shortage of interesting peripherals, like the Analog Joystick. But, its most intriguing accessory is the PocketStation. This is a diminutive device that, like Dreamcast's Visual Memory Unit, pulls double duty as a memory card and micro-portable that downloaded games from the PS1 and compatible software. These LCD companion devices were phased out over time, but their spirit remained — the DS and Wii could interface together for various gameplay features, as could the PS Vita and PlayStation 3 or PlayStation 4.

303

304

303
Dragon Quest VIII
2004

304
Persona 3
2006

182

305

306

307

308

305
PlayStation Memory Card
1994

306
PocketStation
1999

307
PlayStation Analog Joystick
1996

308
PlayStation Mouse
1994

183

309

310

311

312

313 314

309
Crash Bandicoot
1996

310
Tekken 3
1998

311
Resident Evil 2
1998

312
Final Fantasy VII
1997

313
Final Fantasy VIII
1999

314
Final Fantasy IX
2000

The PlayStation cultivated an incredibly diverse library of games from the serious to the silly. New characters like PaRappa were born, franchises like Mega Man and Castlevania were taken to new and ambitious heights, and series like Tomb Raider, Twisted Metal, Ape Escape, and Dino Crisis were pioneered. And of course, you had Final Fantasy at the top of that catalogue with XII, XIII, and IX on the same system.

315

316

317

318

319

320

321

322

323

315
Mega Man Legends
1997

316
Castlevania: Symphony of the Night
1997

317
Twisted Metal
1995

318
Ape Escape
1999

319
Metal Gear Solid
1998

320
Dino Crisis
1999

321
Spyro the Dragon
1998

322
Tomb Raider
1996

323
PaRappa The Rapper
1996

playstation.

AN ODE TO PS1 KIOSKS.

words *Sara Heritage*

IT'S SEPTEMBER 1995.

I'm not here yet.

The hazy dawn of 'mainstream gaming' has begun to bleed out across the UK's bitter morning sky. It's a sunrise welcomed by the quiet melodies of the early-morning Nickelodeon cartoons you coyly pretend you've outgrown, the smell of slightly charred toast you made yourself in the air, and the sight of new PlayStation consoles flying off Woolworths' shelves.

This is a brand-new era. New games. New memories, with old friends.

The PS1, that iconic grey box, invites this new dawn in, heralding an era where pixels would bow to polygons and edgy gaming magazines would flirt with the idea that this, surely, is the most realistic that video games will ever be.

As the sun climbs steadily throughout the '90s, the PS1 stays at the tip of counterculture's tongue. For young adults, flush with disposable income for the first time in their lives, the PlayStation 1 was the thing to have. The console had revolutionised gaming from a secluded teenage pastime for 'losers' into a legitimate, alternative experience, imbued with a rebellious flair. *Street Racer*'s immersive racetracks become the talk of the skatepark, and *THAT* moment in Final Fantasy lives eternally in the walls of teenage girls' bedrooms, amidst spilt neon nail polish and discarded kandi bracelets.

Sony was growing up.

This lost generation, who had cut their teeth on Sega's Mega Drive and Nintendo's SNES but had since outgrown their pixelated past, presented the brand with an opportunity to tap into a new market. The PS1 demo kiosk would prove to be the perfect way for Sony to embed itself in this countercultural movement.

Enter Geoff Glendenning, an ambitious Product Manager at PlayStation, who would soon become its Head of Marketing. His love for PlayStation and underground UK rave culture influenced one of the most iconic youth campaigns in gaming history.

"In the early '90s," he reminisced to The Guardian, "club culture started to become more mass market, but the impetus was still coming from the underground, from key individuals and tribes. What it showed me was that you had to identify and build relationships with those opinion-formers — the DJs, the music industry, the fashion industry, the underground media."

Glendenning's vision for the future of gaming pulsed through the UK's underground subculture like an entrancing synth beat. In 1995, visitors to London's hallowed Ministry of Sound were greeted with strobe lights, flowing drinks, and PlayStation's new 'Chill Out' room: a small space taken over by ten PS1 consoles and TVs. Demo kiosks, if you will. Young men and women could lose themselves in PlayStation's new worlds, with a DualShock in one hand and a drink in the other. High-octane titles such as *Tekken*, *Ridge Racer*, and *WipEout* were the dealer's choice — the ideal backdrop to the night's frenetic, glowing ambience.

Forget the family-friendly Mario or the primitive Pac-Man. PlayStation was cool. These PS1 demo kiosks were electrifying experiences that set the console ablaze with popularity among this demographic.

photography *Imogen May*

"PlayStation took the age of the average gamer from about 14 to about 23," says Glendenning. "It made games cool, it made them part of popular youth culture — people were no longer embarrassed to admit they played them."

The campaign wove the brand naturally into the fabric of authentic youth culture, expanding to over 52 dedicated PlayStation rooms in clubs across the UK alone, giving countless young men and women their first taste of gaming.

Speaking to Video Games Chronicle, he said: "When you talk about brand positioning, and you pay an agency millions, they'll say they think you should associate your brand with one particular area of culture. Whereas video games cross over into so many different areas of culture; it gave us a licence to work within board sports, hip-hop culture, graffiti, B-boying, snowboarding, surfing, inline skating, snakeboarding, sky-surfing and the like. You've got to have the credibility to be there in the first place, but also the work that you do is important. It isn't so much about 'stick your logo here,' sponsor something and move on; it's about approaching and supporting areas of youth culture."

Looking at the snapshots of those hazy nights spent playing on PlayStation, of gaming memories frozen in time within a single moment, I find myself adrift in nostalgia's murky waters, longing for an era I never knew.

The enigmatic charm of PlayStation's demo kiosks left an imprint on an entire generation of gaming fans, and their impact does not end here.

IT'S SEPTEMBER 2001.

I'm four years old.

By this point, the PlayStation had revolutionised gaming.

The PS1's successor — the PlayStation 2 — has been out for a few months now. The younger generation, with their ears finely tuned to the whispers of the older, achingly cool kids, had already picked up on PlayStation's allure. At this point, console gaming was a bonafide sensation, igniting the fervent fires of a moral panic that surrounded the hobby.

But the PlayStation 2, whilst singed by the discourse, found itself embedded in nearly every British family home as an affordable bastion of entertainment. DVDs spun in its tray like a magician's trick, CDs serenaded the senses, and it even dipped its toes into the waters of online and local co-op multiplayer with the likes of *Pro Evolution Soccer* and *TimeSplitters*.

As the allure of the new and gleaming PlayStation 2 console took centre stage, the majority of the faithful

PS1 demo kiosks were left to rot in the shadows, perhaps gathering dust in some forgotten storage locker.

However, not all was lost.

In the early '00s, some PS1 demo kiosks were saved. A far cry from the thumping techno rhythms that danced throughout the halls of the Ministry of Sound, some PS1 demo kiosks would make the soft play areas of British chain pubs their new home. These institutions, their purse strings tight, could not afford the latest tech offered by the PlayStation 2. But these loyal retail kiosks were about to convert an entirely new generation of young gaming fans into dedicated PlayStation enthusiasts.

IT'S SEPTEMBER 2003.

I'm six years old.

The sun beats down on rubber tarmac playgrounds, hot to the touch. Pint-sized adventurers descend upon the playgrounds of quintessential British pubs, basking in those golden rays of early '00s warmth.

Inside, the air is thick with the familiar smell of cigarette smoke and stale beer. As the sun fades, the playful screams from outside fall away, replaced by the slurred promises of "just one more drink" leaving parents' mouths. The blinking lights and spinning wheels of fruit machines, a mainstay of the British pub, fill the hazy indoor air, drowning out the quiet snores of kids tucked up under coats on a bed made from two chairs.

At the very back of the pub sits a young girl on a borrowed barstool, glued to an old and dusty PS1 demo kiosk. She held a DualShock controller in her hands, its buttons worn away from years of anonymous adventures.

A maternal voice, tinged with hints of urging, beckoned her to venture toward the soft play area, a more familiar kind of adventure. A mother and her daughter playing together — a picture-perfect, 'normal' childhood would've surely distracted both from reality for a short time, as 'reality' sat by the bar with clenched fists and another drink.

But the girl would always return to the console, playing through the same levels over and over again, lit only by the fuzzy glow from the CRT. The games may have been reset when the pub's doors closed, but the stories lived forever in her mind as she shared them with her friends on the playground at school.

Childhood, for her, felt like an experience viewed through a window, not dissimilar to a third-person camera faithfully tracking her every step. The frenzied collect-a-thons of *Spyro the Dragon* and the web-slinging adventures of *Spider-Man* were a distraction from the confusing demands of school politics and the tumult of home life.

IT'S SEPTEMBER 2023.

I'm twenty-six years old.

I'm writing this on my birthday.

As the golden hour of gaming kiosks fades to a star-flecked twilight, I sit at my desk and remember a childhood, twenty years in the past, spent in British pubs playing on those PS1 demo kiosks.

I remember a girl with brown pigtails sitting next to me and helping me find those elusive final few gems in *Spyro the Dragon* late into the evening before her dad drunkenly pulled her away by the collar. Soon enough, I would meet a similar fate.

I remember two boys donning matching *Big Bang Theory* shirts mocking me for playing *Rugrats: Search for Reptar* because it wasn't a 'real game' and that "girls don't play games anyway."

I remember missing the birthday cake from a class party of a boy called Callum when I was nine-years-old because I was so wrapped up in playing *Spider-Man*. Nobody noticed I wasn't there. Everyone went home without me.

Today, I'm a creative working on PlayStation campaigns and a freelance games journalist, content in the company of my friends and the stability of my life. I'm acutely aware that my journey to this point, my current life, owes a great debt to those long evenings spent engrossed in the PS1 demo kiosks, tucked away at the rear of quintessential British pubs. But occasionally, I catch the smell of that same stale beer and I feel my feet falter for a moment, peeling off the same sodden, patterned carpets.

Sometimes I feel like I've never left that borrowed barstool.

Don't get me wrong — amidst all the complexities, these childhood memories are still tinged with happiness. It's a joy to think about how all those PS1 demo kiosks, something I thought was just a personal memory lost to time, left an indelible mark on an entire generation of the games industry. Recently, I dived back onto Twitter to see if anyone else out there shared my recollections of those quaint pub demo kiosks, and my heart swelled as a choir of voices joined me in a nostalgia-laden chorus.

Jacob Woodward, a fellow games journalist mused:

"Being born in 1994, the early '00s were prime time for my formative gaming experiences. The PS1 demo stations that were placed in pubs across the country were a big part of that. One in particular that was near my house was a place called The Stable Gate which had a play area attached, similar to a small Wacky Warehouse.

324

325

324
Disney's Hercules
1997

325
Tarzan
1999

an ode to ps1 kiosks.

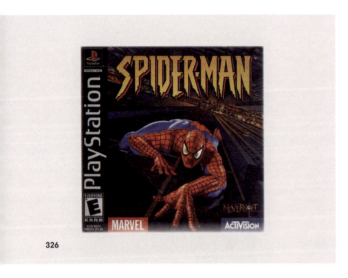

Whatever Insomniac's Spider Can

Although the Insomniac Games Spider-Man titles have since come to define the web-swinger's interactive endeavours, there are a host of great Spidey titles that came before. Activision released several on PS3 and Xbox 360, but the PS1 Spider-Man title from Neversoft is worthy of special attention. IGN even rated it as one of the 10 best Spider-Man games — after the release of 2023's Spider-Man 2, no less!

326
Spider-Man
2000

This was *the* place for birthday parties, and what did it have inside? A PS1 demo station. My fondest memories of this was playing *Disney's Hercules* for pretty much the duration of many parties that were had there. *Disney's Tarzan* was also around in that era which I got to play from time to time, but I always gravitated toward *Hercules* for some reason. It's a game I sometimes go back to, to this day. I wish these stations were still around but sadly it seems they've been lost to time!"

Swathed in nostalgia, I reconnected with an old friend, Oli Hope, the Video Manager at GGRecon. He regaled me with recollections of a peculiar PS1 demo kiosk nestled within a nearby chain soft play area, its screen adorned with the web-swinging prowess of *Spider-Man*.

Then, there was Brett Claxton, my sweet friend and Creative Strategist at Heaven Media. He conjured vague memories of a locale in his youth boasting a Charlie Chalk-themed play area with PS1 demo kiosks.

To end, I brought it back to the beginning. As I was telling my dear childhood friends about my latest ramblings, Harrison reminded me of how some memories stick with you as you grow older.

"Back in the day, my brother and I didn't have a game console at home, so we'd hop over to our friends' places to get our gaming fix. But there was another adventure waiting for us right in town. I can't recall the exact shop or its location, but what I do remember vividly is spending endless weekends there with my brother, engrossed in the world of *Crash Bandicoot*. It's funny how that memory has stuck with me while others have faded into obscurity. We'd stand side by side, grabbing sweets and snacks, and losing ourselves in the chaos of the game until we either wore out our welcome or were summoned back home. My brother and I didn't always get on either when we were younger, but *Crash Bandicoot* had this magical ability to defuse any arguments between us, making it a cherished part of our childhood.

"And then, as if he could sense how much we loved it, our dad decided to gift us a PlayStation 2 for Christmas a few years later. It was, without a doubt, the best Christmas ever. From that moment on, *Star Wars Battlefront*'s split-screen battles became an integral part of our lives."

The PlayStation 1 demo kiosk, that unsung, overlooked hero of countless gaming stories, quietly weaves between the threads of history that wove our games industry into what it is today. To think about the landscape today without their contribution is unimaginable.

In an era tarnished by a relentless cost-of-living crisis, where latest-gen consoles remain an elusive luxury for many, I can't help but think about the accessibility that demo kiosks offered to so many people. How many eager young hands grabbed for the very controller I had held? What stories wore those symbol buttons away so much? How many kids sat on that same borrowed barstool?

I guess I'll never know.

Too Many to Count

The PS1 is synonymous with childhood for so many, as we enjoyed series like Driver or Tony Hawk's Pro Skater — franchises which began on the platform. It was a time of prolific sequels too, as Crash Team Racing was both the series' first spin-off and the fourth game in the series (all on the same platform). Add in beloved oddities like Worms Armageddon, and you have a near endless selection of games to enjoy across PS1's more than 4,000 titles.

327

328

329

330

327
Driver
1999

328
Tony Hawk's Pro Skater
1999

329
Crash Team Racing
1999

330
Worms Armageddon
1999

TWILIGHT TRANSLATIONS.

words Brogan Chattin

For English speaking audiences, the Sony PlayStation had a robust catalogue that offered experiences which its competitors struggled to compete against. It had excellent multi-disc RPGs with epic stories and demanding memory usage that a Nintendo 64 couldn't rival. It had goofy platformers featuring Gobbos or sentient primates, and high production horror masterpieces that pushed their genre forward.

Sean Seanson is a Youtuber that covers obscure games and regularly returns to the PlayStation library. Sean's channel has dozens of hours of PlayStation videos alone, and his enthusiasm for the console is essential to the identity of his work. It's infectious, whether he's talking about *Incredible Crisis* or *Gamera 2000*.

Sean explained why the system is so special to him, remarking that "the PlayStation's library is almost like a bottomless pit of creativity and strange ideas.There are over 4,000 unique games released for the platform which is an absolutely incredible amount when you think about it. And considering how popular and influential this console is, there's still so much that people don't know about it." That is due to myriad factors, such as marketing and business decisions which dissuaded localisation efforts and often kept exciting catalogue titles away from certain regions.

The relationship between cultural sensitivity and market forces become delicately intertwined when it comes to localising a game for the West. As a result, many PS1 games are almost impossible to play now, simply because they've never been translated. If director Bong Joon-Ho was right about film subtitles being an infamous one-inch barrier to a wider appreciation of that medium, the same is perhaps true of games — the effort of localising and then experiencing that video game might just be a mountain for devs and players alike.

For years, an independent translator named Hilltop has been working on translating Sony titles for the PlayStation and PlayStation 2. They are one of many in a community of modders who translate games that were never localised (and sometimes, some that were). The motivation to take on these sorts of projects often stems from a combination of personal ambition, time, and passion. "I've been gaming for as long as I can remember," Hilltop said. "Most of my earliest memories are about me and my family huddled around an NES playing *Mario*. I didn't start doing translations until I found myself unemployed and with a lot of spare time during COVID, though."

For Hilltop, what's most exciting is the opportunity to show people something they've never experienced before. "These works may have not found great success at the time, but here in 2023, these games look and feel fresh, and we have a chance to give them a second life by bringing them to a new audience." Hilltop's translations include some unique picks. *Dr. Slump* is an adaptation of an Akira Toriyama manga with beautiful texture work and animation similar to *Mega Man Legends*. *Aconcagua* is an impressive cinematic effort that combines adventure game elements with *Resident Evil* and *Parasite Eve* fixed-camera gameplay. *Harmful Park* is a fun take on the cute-'em-up genre mostly represented in cultural memory by *Parodius*.

These games aren't novelties, though. They represent a large part of the system's true identity. Playing *b.l.u.e. Legend of Water* and hearing its music for the first time feels instantly familiar, in an uncanny sense. It's a deep sea diving game that may not break any barriers, but instead advocates for beauty and aesthetics clearly, making it an essential PlayStation experience.

photography Damien McFerran

One particularly interesting translation in Hilltop's catalogue is *Racing Lagoon*. This game, published by Square, combines standard role-playing and street racing. Its style and gameplay influences has cultivated a community to this day with people sharing builds on Discord servers. "*Racing Lagoon* is an absolutely fantastic video game and unique like a gemstone. Yet it was absolutely hammered by reviewers at the time who simply didn't 'get it.' They thought a racing RPG was pointless, 'why wouldn't you play Gran Turismo or Final Fantasy instead of this middle ground?' But now that people have finally tasted it, it's almost like a curse. It gave them an itch that nothing else can scratch — Final Fantasy and Gran Turismo simply don't have it," Hilltop said.

Stories of influence and innovation can be found elsewhere in the canon of translated games too. In 1994, FromSoft made the first King's Field game, an early ancestor to the now-juggernaut Soulsborne genre. This first title was never localised officially, but as of 2006 John David Osborne provided a translation for the PlayStation 1 classic. It's an essential first-person dungeon crawling title — if not because of how good it is on its own — for the legacy it carried onwards. Similar translations of classic dungeon crawlers such as the PlayStation versions of *Ultima Underworld* (translated by Gertius) and Sting Entertainment's *Baroque* (translated by one Plissken) continue to be workshopped and released. These hard-working translators are adding more PlayStation games for you to experience, unbound by time.

This sort of work is largely a team effort even when a single person does the majority of the work themselves. Exporters, debug tools, and other programs are essential for many of these projects. Hilltop credits a single document by *Policenauts* translator Slowbeef as a tool that allowed him to understand the work required for the *Dr. Slump* project... which was a game full of proprietary encryption algorithms and a whole bunch of other words that make heads spin. Hilltop has also worked with Cargodin before, who translates games and song lyrics on his blog. From SnowyAria to people who have been in the practice for actual decades such as Esperknight — there's a rich community of translation personalities and a history of fan development to explore.

But why do so many dedicate themselves to the PlayStation? Why any console, for that matter? "Don't get me wrong, I love the PlayStation 1," Hilltop remarked. "I love its games, its music, its aesthetics, the creativity in its burgeoning 3D titles, but it's not *cool* to like PlayStation, you know? It's almost a given, since it's so ubiquitous. On the other side, you have a lot of people who exclusively work on Nintendo titles because of how much their games have meant to them, and because SNES hacking in particular is friendly territory for a hacker trying to break in."

Hilltop cites practical reasons for translating any console game. How many tools and retractable footsteps are there for newer hackers? Is there an audience? The latter is a foregone conclusion. People are eager for new experiences and have gone far in supporting Hilltop and other translators in their endeavours. They playtest on real hardware and provide consistent financial support or ongoing feedback. The internet facilitates direct connections between artists and their audience.

It's a two-way street for Hilltop. "Having an audience I can connect with has helped tremendously. The entire time I've been doing this, I actually did not possess any convenient means to play my translations on real PS1 hardware. Being able to reach out for testers has helped keep the patches hardware compatible. And of course, it's incredible to see the vast amount of people who come to these games not just to play them, but to create content and share them on social media."

This showcase of passion is one of the best ways to communicate the importance of art and preservation. It's easier to care about a game when someone has poured their enthusiasm into it and brought it to you, rather than just stumbling upon said game in isolation. It's like making a playlist for your best friend.

Sean Seanson's Youtube work embodies this — Sean has both a passion to learn and a passion to show. "So much of what I know about video games is thanks to the great work of writers and video makers, who helped to educate me about the history and wider world of video games. So my videos are a way to both satisfy my own curiosity and have a creative way to help teach others about them, because I think there's a lot we can learn from some of these older games. If they help to inspire creatives or even just give somebody a fun new game to check out, then I feel like I'm at least doing my part."

Sean, and creators like him, become the gateway for many curious enthusiasts who want to learn more about games history, so perhaps creators also shape the future identity of a console too. "I think when you see how the elements of [PlayStation's] visuals and sound are still popular today (PSX-style horror, PSX D&B / Jungle mixes), its influence on people goes further than just the games. The PlayStation is a *vibe*, as the kids would say, and I think it's something that will continue to resonate with fans both old and new throughout the years," Sean said.

These voices also showcase the importance of the internet and less-than-official channels for wider cultural understanding. "[I'd] go to a video game store, or rental place, pick out a game and that was that," Sean explained. "Across certain parts of Europe, Asia, and South America, they were getting games from family members and markets and ending up with all sorts of strange games from across the globe. So games that are maybe quite obscure and unusual to a Western audience might end up being a well-known classic to the kids who got all their games from the local market."

The most fan translations are purely labours of love from dedicated teams who want to share amazing region-locked experiences. However, as Legends of Localization reported, a few fan translations have become more than that! One example they cite is the RPG Ys: The Oath in Felghana, which was translated by fans. That script was then licensed by XSEED for use in the PSP and PC versions of the game.

331

When a console's identity is only defined by how its parent company advertises it, we become region-locked. We think of Kirby's furrowed brow when we think of the Pink Puffball in the States, but Kiry's demeanour is quite different in Japan. Developers and publishers often decide that elements of their catalogue aren't worth the financial risk in certain parts of the world, or they craft various marketing schemes that change design intent to fit their target audience. There are two forces that ultimately determine a console's identity: the marketing machine and the fans who want to play. Each is deeply informed by the other, but often the gaming industry strives to control the conversation.

These companies have a financial incentive to dictate the image of the past, or to forget it entirely. This is why community-driven preservation is essential. "Please consider playing [a fan translated game]," Hilltop said as our conversation concluded. "And consider supporting the people creating them. It is no easy task to create a fan translation and they are no lesser than any 'official' work. The pool of games that never left Japan are some of the most interesting relics of the era and absolutely deserve your time and attention."

When Sony released the PlayStation Classic as a retro revival product in 2018, the game list was wildly different depending on the region. The US PlayStation Classic included the original American release of *Revelations: Persona*, along with all of its questionable localisation choices. I think of that title when I look at Hilltop's disdain for the word 'official.' How many official translations of *Symphony of the Night* exist now? Games are collaborative works, and a translation in any medium requires its own artistic liberties. A console or game's identity has to live beyond the purview of marketing — in the hands of people willing to have a conversation. The very book you're reading in your hands is part of the effort to have this ongoing conversation. Consoles may die in the eyes of their manufacturers, but we ensure that their twilight remains eternal.

332

331
Harmful Park
1997

332
Racing Lagoon
1999

twilight translations.

NINTENDO 64.

words Gavin Lane

Let's begin with a truism, something we can all agree on: Motorcycles are cool. The reasons are many, but perhaps the best of them has nothing to do with the thrill of rapid acceleration, the unrivalled sense of freedom, or donning form-fitting leather on a daily basis. It's something you don't find out until you've got your licence and get out there alone on the road: Bikers nod at each other as they pass.

First Released:
1996

Manufacturer:
Nintendo

Launch Price:
US $199
JP ¥25,000
UK £250

It doesn't matter what you're riding; you are part of the club and deserving of a head-tilt. This tiny gesture acknowledges a kindred spirit, a fellow traveller who sacrifices comfort and risks loneliness in search of a better mode of existence, maybe even a higher truth. These days, that's what being a Nintendo 64 fan feels like.

Okay, 'higher truth' might be pushing it — but as the years pass, N64 fans feel like a declining demographic, and crossing paths with someone who doesn't instantly run off a list of caveats feels like an event. Bring up Nintendo's 64-bit SNES successor in gaming conversation, and eyes tend to glaze over. Typically, you're met with polite smiles or, occasionally, downright hostility when you wax lyrical about the beautiful machine... and not just from stalwart PlayStation fans.

"What were they thinking with that controller, though, eh?"
"Sticking with carts killed that console."
"Oof, shame it didn't have any games!"

These are the criticisms commonly levelled at a platform which, in many ways, birthed modern gaming as we know it. It's not that they aren't valid — they definitely are — but they don't reflect my experience with the console at all. It's strange hearing it treated as an outcast in Nintendo's canon. Beyond the acknowledgement of a few token classics, it seems nobody cares all that much.

Nintendo's market share declined as Sony claimed the hearts and minds of the PlayStation generation, and Microsoft's arrival in 2001 meant that, despite huge success, Nintendo has never regained the overwhelming console market dominance it enjoyed with the NES and Super NES. Perhaps it's this which has tarnished the N64's reputation to the extent that it gets thrown in with the also-rans; not enough of a failure to garner Dreamcast-style underdog adoration, yet still a harbinger of disappointment. For someone who was switched nto Nintendo thanks to this console, it's *baffling*.

I was on the cusp of teendom in the late '90s. I had dipped my toe in the NES pool earlier in the decade, but it was the N64 that had me Bob-ombing into the world of Nintendo. The console's idiosyncrasies — its stately yet sensual form, its kaleidoscope of controller colours, its host of peripheral 'Paks' — give it more character than the grey, business-like plastic suggests. As an object to slide a thick cartridge into with a satisfying clunk, I instantly loved the thing.

Laying eyes on a *GoldenEye* demo kiosk for the very first time, it was clear that the future had arrived and I *had to* be a part of it. I was there, before twin-stick controls became the default, when the precision of that spindly stick protruding from the centre prong felt like advanced alien tech.

I was there when gently buzzing CRT TV screens softened sharp polygons and repeating textures into uncannily realistic-looking — or *feeling* — environments.

photography Damien McFerran

I was there when the growling feedback of a Rumble Pak transformed the haptic gaming experience, when the nascent field of 3D console gaming was fizzing with possibilities, when Nintendo took players (and developers) by the hand and showed everyone how it should be done. Gaming felt impossibly exciting in the late-1990s, and I was there for it.

Perhaps that's just it. Did you *have to* be there?

The recent re-release of *GoldenEye* (a game which sold over eight million copies and which, incredibly, remained officially playable only on Nintendo 64 for nearly a quarter of a century) highlighted one thing very clearly for me: a generational gulf between those who played and loved it at launch — fuelled by fierce affection and muscle memory — and practically *everyone* else. Even players who understood its historical impact and appreciated, intellectually, its design elegance and effectiveness struggled to enjoy the game 25 years on.

And then it struck me: this isn't just GoldenEye's story; *it's the story of the Nintendo 64 itself.*

This console and its library, relics of an era of incredible promise, are tougher to appreciate after decades of their innovations being so thoroughly co-opted, refined, and resold. Perhaps more than any other mainstream console, the N64 remains a peculiar specimen to everyone but those who, through the blind lottery of their birth date, just happened to be around back when Britpop, Girl Power, New Labour, and the Euro '96 England squad made it feel like *anything* was possible.

What makes the N64 so impenetrable to so many? Honestly, it's all the controller's fault.

As an instrument to help players explore their first 3D environments, the N64's unusual-looking pad was a sophisticated tool. That is, once you understood that only two of its 'prongs' are used at any one time. When you realised you could ignore the left third of the pad and just hold it at an angle, it felt natural. However, confusing the player from the very beginning doesn't make a good first impression.

The N64 controller is a perfect physical manifestation of the transitional, experimental phase in which the gaming industry found itself in the mid-1990s as the first burgeoning steps into 3D space were taken. Its analogue and haptic innovations became industry standards, yet they were presented in a non-standard configuration which still manages to bewilder.

For anyone who grew up with twin-stick controls, the N64 pad is an alienation device that forces you *out* of the experience. The C-buttons are a poor substitute for a second stick, and modern gamers instinctually reach for one to manipulate the camera in practically any 3D space. If you weren't there at the time to internalise these inputs with software specifically designed for them, the N64's buttons and single stick feel impossibly archaic.

Worse still, the inputs stubbornly refuse to be mapped comfortably to a modern twin-stick pad. Try playing any of the N64 games on Switch with a Pro Controller and, while it varies per game, even the great ones become unintuitive and awkward. If you're thinking of playing an N64 game *without* an N64 pad, just don't bother. Decades later, the three-pronged controller continues to confuse and confound, presenting a barrier to entry that's actively damaging the console's legacy by putting off curious new players from discovering its library for the first time. Future inductee numbers for our dwindling N64 Motorcycle Club aren't looking healthy.

To be absolutely clear, I *adore* the N64 pad, with its ludicrous surplus of plastic, its spectrum of colour variants, its bizarre array of peripherals you could slap in the back, and even its largely ignored D-Pad. But, again, *I was there.*

I was there to play the system's genre-defining games before they defined their genres. Discounting *Sonic 3D Blast* for narrative's sake, *Super Mario 64* was, essentially, my first 3D platforming experience. *Ocarina of Time* was my first Zelda. Those two titles and *GoldenEye* wrote the book on 3D game design principles with regard to mechanics, environments, controls, and objectives. That holy software trinity alone should make a Nintendo 64 mandatory in any civilised game-playing household. Delete the rest of the library, and the console's existence is justified with just those three.

But there were so many others. I wandered dreamily through the fairytale worlds of *Banjo-Kazooie*, just one of Rareware's 64-bit classics, and one that trumps *Super Mario 64* for atmosphere and visuals. The Smash Bros. series debuted on N64, memorably using a child's toybox as a framing device to explain and excuse Samus beating the living crap out of Mario. My local multiplayer heart belonged to *Mario Kart 64* and *GoldenEye*, though. The system's four controller ports made split-screen racing and deathmatches a breeze in the days before competitive play went online, another oft-overlooked aspect of the console's legacy.

I was there to ride the waves around Dolphin Park and marvel at the realism of its swelling waters. Most of us PAL-territory paupers didn't know what we were missing compared to our NTSC brethren – the slower, letterboxed *Wave Race 64* we played still felt like magic. I experienced the blistering speed and balls-out metal of *F-Zero X*, a twitchily precise racer that felt like nothing I'd ever played.

Lylat Wars (or *Star Fox 64*, if you prefer) offered cinematic rail shooting and is perhaps the best advertisement

In Japan, the ill-fated Nintendo 64 Disk Drive clipped onto the N64, allowing for online functionality and the magnetic disk format games. It never caught on. Many titles planned for 64DD disks were retooled for N64 carts, resulting in a very small library of 64DD-exclusive titles. N64 reached China's shores via the plug-and-play iQue Player, whose design circumvented the government's console ban and brought a selection of top-tier titles digitally to the Middle Kingdom during the early-to-mid 2000s. The N64 had some exceptional limited edition systems as well, such as the Hey You, Pikachu! tie-in design.

333

334

335

336

333
Nintendo 64
1996

335
Nintendo 64 Disk Drive
1999

334
Nintendo 64 [Pikachu Edition]
1996

336
iQue Player
2003

nintendo 64.

The Complete Package

The N64 and its controller were designed for modular expansion through various 'Paks' which slotted into the system or its gamepad. Perhaps the most interesting is among the least utilised: the N64 Bio Sensor. Sold only in Japan with Tetris 64, this oddity monitored the player's heart rate during gameplay and perhaps inspired the cancelled Vitality Sensor for the Wii. The system had some other interesting peripherals as well, like the N64 Mouse and Voice Recognition Unit (notably used for Hey You, Pikachu).

337

338

339

340

341

342

337
Nintendo 64 Bio Sensor
1998

338
Nintendo 64 Expansion Pak
1998

339
Nintendo 64 Rumble Pak
1997

340
Voice Recognition Unit
2000

341
Nintendo 64 Transfer Pak
1998

342
Nintendo 64 Mouse
1999

for the Rumble Pak and still a high-water mark for the series. It felt all the more potent back when *Independence Day* was a contemporary filmic nod, and also when George Lucas was gearing up for his return to the Star Wars universe. I was there to play *Rogue Squadron* and *Episode I: Racer* — the pick of the Star Wars console offerings when *Phantom Menace* fever gripped the planet for the first half of 1999.

Back on Planet Earth, Konami's ISS series delivered the best console version of the beautiful game at the time, and wrestling game developers are still trying to recapture the spirit of *WWF No Mercy* even today. *1080° Snowboarding* offered a deep, beautifully subtle take on extreme sports — all the rage at the turn of the millennium — while on the other side of the mountain, Racdym's wonderful *Snowboard Kids* brought Mario Kart-style shenanigans to the slopes.

N64 got plenty of top-tier racers, from serious stuff like *F-1 World Grand Prix* to *Diddy Kong Racing*, and an excellent version of *WipEout* with a suffix you'll *never* guess. Appending *64* to the end of any old title or port might seem uninspired, but it avoids confusion with other platforms (apologies to Commodore fans) and sidesteps the tiresome word soup we gamers wade through these days. Give me a '64' over a *Retribution* or an *Origins* any day of the week.

Camelot's excellent *Mario Golf* kicked off the plumber's enduring series of tiny-ball-hitting games proper, one of several Mario spin-offs that took flight in the 64-bit era. He also began hosting parties and tennis tournaments and turned two-dimensional again in *Paper Mario*, a rare RPG on a system with few to its name following a developer exodus to PlayStation. Metroid fans never got a 64-bit entry, either, and 2D platformers, in general, were few and far between. And despite a small handful of contenders, the N64 doesn't have a truly great 1v1 fighter — a shame when you consider those six face buttons on the right and imagine what a *Street Fighter 64* might have looked like.

There were gaps, then, and N64's total number of software releases worldwide stands at just a fraction of the PS1 library: fewer than 400 versus nearly 8,000. Yet the quality shone through, even towards the end of the console's life, with late-cycle arrivals such as Rare's *GoldenEye* follow-up *Perfect Dark*, the adults-only comedy curio *Conker's Bad Fur Day*, the underrated *Excitebike 64* (hey, motorcycles are cool, remember?), and the sublime *Ocarina* follow-up *Majora's Mask* continuing to deliver into the 21st century.

Despite genre gaps, the N64 library offered so much quality, and I was there for it all. I repeat that over and over, not as some badge of honour or derisive gong to highlight my superior gamer breeding, but to emphasise that, sadly, I think you *had* to be there for this one — more so than any other system.

With hindsight, yes, *obviously* Nintendo's draconian licencing agreements and election to stick with the expensive cartridge format are big factors in how we perceive the N64 these days. Despite my love for it, I concede that the controller was a mistake, inasmuch as it confused people from the jump. And those early polygonal visuals, designed to be viewed on television screens that simply aren't made anymore, can be an acquired taste.

It's the destiny of every gaming system to be speedily superseded, for successors to arrive that dazzle with their technical superiority and flashy functions — there's nothing surprising about that. Typically, a few generations' worth of distance leads to a calm critical reappraisal, away from the foetid fumes of console warriors which inevitably seep into contemporary 'discourse.' I don't see that for the N64, though.

For lesser-known consoles that barely made a splash in the mainstream, it's unfortunate but understandable that they go unloved outside of dedicated fan and collector circles. But with every year that passes, this stirring, industry-shaping system seems to become more 'cult.' Sure, *Ocarina*, *Mario 64*, *GoldenEye* — individually, those games are in precisely zero danger of being overlooked or undervalued. But the joyously awkward transitional console that hosted them? It feels like its mindshare is on the decline.

As a fan, that's concerning... but as tribal and childish as it sounds, it's also quite *nice*. The club I first joined when devouring issues of N64 Magazine is becoming more exclusive, and I got in on the ground floor. Ultimately, the Nintendo 64's legacy can be felt in almost every modern 3D game you care to name. But the curvy system itself remains my personal favourite — a trailblazer with real character and a software suite that shaped all that followed.

And while it doesn't happen as often as I'd like, an approving nod from a fellow '64er when we pass on the highway will forever be a thrill.

343

344

345

346

343
Goldeneye 007
1997

344
Super Smash Bros.
1999

345
The Legend of Zelda: Ocarina of Time
1998

346
Wave Race 64
1996

347

348

349

350

347
F-Zero X
1998

349
Sin and Punishment
2000

348
Star Fox 64
1997

350
Banjo-Kazooie
1998

SIN AND PUNISHMENT

Developer:
Treasure, Nintendo R&D1

Publisher
Nintendo

Release Year:
2000

Available on:
N64, Nintendo Switch Online

No title pushes the N64 like Treasure's blistering rail shoot-er. With an ambitious presentation and one meticulously constructed set piece after another, *Sin and Punishment* is an endlessly replayable and spectacular title at the pinnacle of its genre. With multiple difficulties and about a one-hour playtime, this title encourages gradual, sat-isfying improvement.

351

352

351
Sin and Punishment Cartridge
2000 (Japan)

352
Sin and Punishment
2000 (Japan)

RAKUGAKIDS

Developer:
Konami Computer Entertainment Kobe

Publisher
Konami

Release Year:
1998

Available on:
N64

The Nintendo 64 is not known for its fighting games, aside from *Super Smash Bros*. However, Konami's 2D fighter *Rakugakids* is certainly worth a look and stands as perhaps the best animated title on the platform. With exceptionally whimsical art direction, *Rakugakids* isn't just an enjoyable fighter, it's one of N64's most visually-timeless games.

353

354

353
Rakugakids
1998 (Japan)

354
Rakugakids
1998 (Europe)

WAVE RACE 64

Developer:
Nintendo EAD

Publisher
Nintendo

Release Year:
1996

Available on:
N64, Nintendo Switch Online

The Nintendo 64 has no shortage of excellent racing games, but the likes of *Mario Kart 64*, *Diddy Kong Racing*, and *F-Zero X* always hog the spotlight. *Wave Race 64* deserves to be in conversation with these other classics — even though it might look like some variety of shovelware jetski game today! Don't let its licensed rides fool you: this is a brilliant aquatic racer. With some of the most impressive water physics of all-time and rock-solid mechanics, *Wave Race 64* remains a must-play.

355

356

355
Wave Race 64
1996 (America)

356
Wave Race 64
1996 (Japan)

JET FORCE GEMINI

Developer:
Rare

Publisher
Rare

Release Year:
1996

Available on:
N64, Nintendo Switch Online
Xbox One, Xbox Series X|S (*Rare Replay*)

Rare's library of games is synonymous with Nintendo 64 — best remembered for titles including *Banjo-Kazooie* and *Goldeneye 007*. But Rare's output on the platform didn't stop there. *Jet Force Gemini* is a must-play too, a third-person shooter with sci-fi stylings which takes a bit of time to get to grips with. Once you can rock with its controls, this community favourite is worth adventuring through.

357

358

357
Jet Force Gemini
1996 (Japan)

358
Jet Force Gemini
1996 (America)

THE STORY OF GENERATION 6.

words *Liam Triforce*

After the Saturn failed to captivate an international audience, Sega had to pivot despite the Saturn's success in Japan. The Dreamcast was the company's last bastion — a glorious final gambit in the console space and the sixth generation's unforgettable kickoff.

Launched in 1998, the Dreamcast shipped alongside Sonic Team's belated answer to *Super Mario 64*: *Sonic Adventure*. It was a smash hit and a great game in its own right. Though it was inspired by the concepts *Mario 64* established, the game was not beholden to them. *Sonic Adventure* featured linear action stages and open-ended, explorable worlds as a method of managing pacing and just having fun with each character's abilities. Really though, its best feature was the Chao Garden. Raising these little creatures gave me more incentive to replay action stages for animals and rings, so that I could increase their attributes for the Chao Races. Even though the game's sequel had the more robust Chao Garden, I still have fond memories of how the first tied the entire game's feedback loop together. With so much gameplay variety, a touching story, and a killer soundtrack, *Sonic Adventure* seemed like it was about to usher in Sega's silver age.

The Dreamcast had several innovative features that would foreshadow trends in the sixth generation, but it also had features that remain unique to the console itself. It was the first to feature a built-in modem for online functionality in games, making the Dreamcast capable of online multiplayer and downloadable content — the latter of which wouldn't become industry standard until the *seventh* generation. Online multiplayer began with Sonic Team's own *ChuChu Rocket*, a hectic four-player multiplayer game in which you attempt to escort as many mice as possible to your rocket while avoiding cats. Whether online or playing locally, the game was a blast and remains one of the studio's most unique projects. Sonic Team kept things going with *Phantasy Star Online*, a full-featured landmark MMO, and one of the first for a home console, opposed to home computers. Also hailing from that realm, Raster Productions ported id Software's *Quake III Arena* to the console, creating a beautiful console port of one of the best multiplayer shooters ever made.

Part memory card, part second screen, and part micro handheld, the Dreamcast's Visual Memory Unit (VMU) remains a distinct piece of hardware which you slotted into the controller. Not only could you save games onto it, but the device sometimes acted as a supplement to the TV gameplay, and other times you could remove it from the controller to play mini-games. In *Sonic Adventure* and its sequel, for example, you could download a Chao of your choice to the VMU and raise it on the go.

The Dreamcast had a fantastic library of high-quality games which extended far beyond Sonic. We had *Skies of Arcadia* and *Shenmue*, as well as oddball titles like the ever-fascinating, questionably named *Seaman* — narrated by the late, great Leonard Nimoy. *Jet Set Radio* in particular was emblematic of the era that the Dreamcast existed in. It delivered a liberating tale of freedom, coupled with an engaging trick system that hinged on those arcade-style player improvement and replayability philosophies, just like a lot of Sega's best games. The better you got, the more satisfying the flow of momentum and graffiti would be. It was evocative of the larger culture, and it gave the illustrious Hideki Naganuma his breakthrough in video game composing. The console was also home to fantastic console ports of arcade classics, like *Crazy Taxi, Street Fighter 3, Power Stone, Ikaruga, Dead or Alive 2, Capcom vs. SNK, Marvel vs. Capcom,* and so many more. In particular, the Dreamcast version of *SoulCalibur* remains one of the highest-rated games on Metacritic — and for good reason.

photography *Damien McFerran*

359

360

361

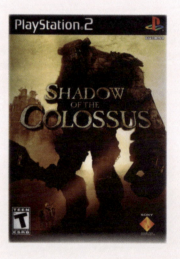

362

359
Super Mario Sunshine
2002

361
ChuChu Rocket
1999

360
Resident Evil 4
2005

362
Shadow of the Colossus
2005

Sadly, the Dreamcast's success would be short-lived. The anticipation for Sony's PlayStation 2 overshadowed the Dreamcast in the end. Between PS1's high install base, the features PS2 promised, and its DVD functionality — this new console was not only a device that promised high-quality games. There was a legacy behind it, and tantalising, affordable multimedia capabilities in tow. It was nearly impossible for the Dreamcast to keep up once the PS2 launched in 2000. Though support for the console continued from certain third-party developers, Sega discontinued the console in 2001, with *Sonic Adventure 2* being the last game released for the system. This was a fitting 'sayonara' to both the console and Sega itself as the world knew it back then, as the company soon pivoted to third-party development.

Though I haven't mentioned every game here, the Dreamcast was home to countless hidden gems and usually had the highest-quality versions of multiplatform games. It feels like Dreamcast's library is a time capsule of that point in Sega's history, in which its creative teams were throwing things at the wall just to see what'd stick, and I admire that ambition in the face of such overwhelming pressure to perform. It's symbolic of how pressure *can* breed creativity.

But as Sega exited the arena with the Dreamcast, Microsoft threw its hat in the ring with its very own console. The original Xbox was powerful — managing to garner a lot of support over the course of its life. But *none* of that would have happened without *Halo: Combat Evolved*.

However, this marquee series got off to a rocky start. Despite financial difficulties, a scattered sense of direction, a strict schedule, and the responsibility of a flagship title for an unproven console, *Halo* developer Bungie persevered. The game changed genres and perspectives throughout development, and its reception during E3 2001 was lukewarm at best. *Halo* didn't seem like it'd be a hit, but when it launched with the Xbox on November 15, 2001, the first-person shooter genre — as well as the world as we know it — were both shaken to their core.

Halo: Combat Evolved redefined core FPS mechanics and structural conventions, just as *The Legend of Zelda: Ocarina of Time* had for action-adventure games before it. The two weapon limit, a regenerating health system, and linear progression in level design alongside stellar narrative presentation all became staples of the genre. Moreover, the scope of its levels and battles were unlike anything we had ever seen, all heightened by Martin O'Donnell's brilliant score — giving players goosebumps as they fought back against the Covenant and stormed enemy bases in Warthogs. There really wasn't anything like *Combat Evolved* when it released, and the game sent shockwaves through the industry. But Bungie was just getting started.

In developing *Halo 2*, Bungie wanted online multiplayer over Xbox Live to be a major focus. The first game had system-link play for large-scale multiplayer battles, but very few actually got to experience that. I think most would agree that Big Team Battles on Blood Gulch provided us with some of *Halo*'s best multiplayer memories, and Bungie wanted to deliver those experiences to a global community of players.

Halo 2's online multiplayer accomplished this goal, setting industry standards in the process. The idea of playlist-based matchmaking, allowing you to matchmake for specific game modes, as well as being able to form a party with people on your friends list and queuing together, were both novel features at the time that quickly were adopted by all other online multiplayer games to follow. Both Halo's arena multiplayer, as well as the scope of its battles, were successfully brought worldwide. It was a magical time.

Halo 2's marketing led to it becoming a blockbuster release, one of the most remarkable in video game history, with the excitement being felt around the globe — regardless of whether or not you had even played the first game. And, the beautiful experience of sharing multiplayer matches with friends and strangers alike paved the way for how we experience multiplayer today. Its campaign may have been truncated by a rushed development period, but the gargantuan impact it had on players led to Halo becoming a household name, and the Xbox being synonymous with it. More than that, though — *Halo* brought people together, which I feel is the true essence of video games, distilled into a magnificent first-person shooter.

Microsoft's closest sales competitor was the Nintendo GameCube — but both consoles were indisputably smoked by PS2. Despite that though, Nintendo still maintained a strong focus on quality games, just as the Dreamcast did. The uniqueness of its library more than made up for its lack of apparent system-sellers. *Pikmin* was a great RTS that actively involved you in its action, forcing you to acclimate to your surroundings and repair your ship before time ran out. And yes, your time *could* run out before you escape. *Mario Kart: Double Dash!!* was a great game in its own right thanks to the possibilities afforded to you via its two-player kart racing system, and the strategies you could employ by hanging on to items for later. *Super Mario Sunshine* wasn't necessarily attempting to be a direct follow-up to something as colossally impactful as *Mario 64*, and was more so concerned with trying to set itself apart. Its gameplay was dynamic thanks to F.L.U.D.D.'s strong capabilities, and cleaning each level became integral to its gameplay, and it was wonderfully satisfying to do this while exploring a cohesive island resort. That distinctiveness extends to *The Legend of Zelda: The Wind Waker,* which featured a dramatic shift in art style from *Ocarina of Time* and *Majora's Mask* — for good reason. Its art style harmonised with its story about letting go of the past and forging your own path to the future, with those that derided its style proving the game's point altogether, and reflecting

Ganondorf's uncharacteristically... human desires. It was a brilliant game.

Several GameCube games would go on to be regarded as some of the best in their genre. *F-Zero GX* remains the latest 3D entry in the series, with it being seemingly impossible to surpass in terms of quality. Its speed and control are exquisite to experience, and its high level of difficulty ensures replayability *and* a high skill ceiling in competitive multiplayer. The game was developed by Amusement Vision, who previously released *Super Monkey Ball* and its sequel on the console, two of the greatest party games ever made thanks to their precise controls, imaginative level design, and excellent mini-games. Though the system wasn't home to many RPGS, it did have some worth noting. *Tales of Symphonia* was a 4-player co-op action-RPG, and a great one at that. *Paper Mario: The Thousand-Year Door* is one of the greatest RPGs ever made, full stop, for its character writing, battle system, unique visual style, and pacing. As for fighting games, *Super Smash Bros. Melee* became a smash hit, but its surprise competitive scene allowed it to have a second life as players dug into its unintentional mechanics. It blossomed into something beautiful in its own right.

Some GameCube games went on to become incredibly influential across the industry, particularly *Resident Evil 4*. The game popularised the over-the-shoulder camera angle seen in countless third-person shooters today, but that only scratches the surface of why it was genius. The intro sequence alone established both how the flow of action and horror would be interwoven throughout the entirety of the game's runtime, and the game never relents in its surprises and anxiety-inducing game design. *Metroid Prime* is another key example of bold invention on the platform, and a title often cited by contemporary developers as being formative in their creative process. The GameCube may have fallen short of its competition due to lacklustre online capabilities, its proprietary miniDVD format, and weak third-party support, but the console is fondly remembered for its library nonetheless, and its unwavering focus on the games.

But PlayStation 2 dominated the market, and it enjoyed support long after the PlayStation 3 was released — with the final PS2 game being released a week before the PlayStation 4's launch in 2013. You have *Pro Evolution Soccer 2014* to thank for that.

While the PlayStation 2's status as an entry-level DVD player was critical in its early success, like GameCube, its focus was really on games. The PlayStation 2 had something for everyone. If you liked RPGs, you had them in spades. Platformers? Jak and Daxter, Ratchet and Clank, and Sly Cooper headlined the system, but there were plenty more if you dug deeper. Fighting games? Tekken and arcade ports were plentiful. And if you were a fan of the weird and wild, there were plenty of niche games too. *Katamari Damacy* comes to mind.

The PS2 had variety thanks to its extensive third-party support, built on relationships established during the PS1 days. Most importantly, the PS2 ushered in an era of more sophisticated, mature storytelling and gameplay, with its best games being representative of the medium becoming a respected form of entertainment and art. *Metal Gear Solid 2: Sons of Liberty*'s narrative was ahead of its time, addressing socio-political and philosophical themes, some pertaining to the advancement of technology in the twenty-first century. Its themes of artificial intelligence, fabricated news, political conspiracy, social engineering, and freedom of thought have only become *more* relevant in recent years. *Silent Hill 2* was another Konami benchmark, which dealt with serious themes of abuse, guilt, lust, and love, all through a psychological horror lens.

Many PlayStation 2 games left a massive impact on culture, but *Grand Theft Auto* is the poster child for this truth. *Grand Theft Auto III* laid the blueprint for open-world action-adventure games to come — "The Legend of Zelda meets *Goodfellas*," as described by Rockstar's Sam Houser when speaking to IGN. Its direct sequel, *GTA: Vice City*, actually starred Ray Liotta himself as the no-bullshit criminal Tommy Vercetti, in a fish-out-of-water crime caper set within a '80s Miami-inspired city. The third series entry on PS2, *San Andreas*, kicked things up a notch in both the scope of its world and narrative, as it told a gripping tale of brotherhood and ambition, against a satirical backdrop of the real-life '90s crack epidemic, the police corruption scandal and Los Angeles riots. These games established Rockstar as a dominant force in the industry, and with every major *Grand Theft Auto* instalment came groundbreaking design decisions that informed the medium going forward. This also became the series' turning point into the cultural juggernaut that it now is, led by characters and satire that both resonated and provoked in equal measure.

To me though, the greatest PlayStation 2 games were those made by Team Ico, a studio led by designer and auteur Fumito Ueda. While its first game, *Ico,* wasn't a huge hit upon release, a cult following was quickly formed. *Ico* was a masterpiece, simply put. It managed to tell a compelling story of cooperation between a boy Ico and a girl Yorda through gameplay primarily. Yorda is taller than Ico and can Ico when finding himself stuck, while Ico needs to defend Yorda to avoid her being taken away by the Queen. They *need* each other, in every sense. It goes to show how effective games could be as a storytelling medium, as the emotional impact of its narrative is sewn into its design effortlessly.

Naughty Dog's Neil Druckmann, whose games went on to define the seventh generation, cited *Ico* as an influence on the gameplay and relationship-building between Joel and Ellie in *The Last of Us*, when speaking to The New Yorker. *The Legend of Zelda: Twilight Princess*' visual direction took heavy influence from Ico's bloom lighting

and desaturated colours in its eerie Twilight Realm. *Dark Souls, Bloodborne*, and *Elden Ring* director Hidetaka Miyazaki said that *Ico* "awoke [him] to the possibilities of the medium," in an interview with The Guardian. The game has even impacted artists outside of video games, like filmmaker Guillermo Del Toro, and Jonny Greenwood of *Radiohead*. While *Ico* may not have been a huge success, it left a massive impact on the people who *did* play it, and it continues to find further acclaim. Ueda's next game, however, was a smash hit upon release and continued to illustrate what this wonderful medium was capable of.

Shadow of the Colossus is a journey through a nameless land, to kill sixteen beautiful colossi in the name of your deceased love. Thanks to its sophisticated artificial intelligence, detailed keyframe animation (building on something that *Ico* pioneered), incredible physics engine, and its stamina management system driving everything at its core — the game's loop of killing each colossus and moving onto the next, as you wandered through an empty world to snuff out all remaining life, was brilliant.

Through its gameplay, *Shadow of the Colossus* explores the stages of grief, and the selfishness that comes with fighting for that which has been lost. You're killing all that remains of this desolate world for the sake of your lost love, Mono. For the slim chance that *she may* be revived. As you play through the game, you begin to ask yourself if the consequences of your actions are worth pursuing. As Kentaro Miura once wrote in his fantasy epic *Berserk*, "The reward for ambition too great is self-destruction." The game was yet another example of how Ueda's storytelling is innately tied to interactivity, and further showcased what video games were capable of during this era.

It, to me, solidified the PlayStation 2 — but more importantly this period as a whole — as an era that let the *games* speak for themselves. Moreover, it let games just be art with no strings attached, and it was one of the last generations to do that. Though the industry continues to evolve, learning lessons from previous games and continuing to explore how the medium can grow as an art form, the industry also tends to be a predatory place for extracting as much money from consumers as possible. Games also aren't released in finished states, and rough launches are almost commonplace. This seemed unacceptable at one point in history, and I wish we could once more focus on how games make us *feel*, and how they bring us together. How they impact our culture in a positive way. That is the legacy of the sixth generation.

A Legacy of Licenses

Licensed video games have always been a part of the industry, however the sixth-generation systems have a particularly large catalogue of them. Often released in time for the holidays to coincide with a big film of the year (as is the case with The Incredibles or Ratatouille), these games were of an inconsistent quality but almost always of some third-person action format. Not all the licensed games were timely though — this was also the era of Reservoir Dogs on PS2!

363

364

363
The Incredibles
2004

364
Ratatouille
2007

Packaging Perspectives

Throughout The Console Chronicles are high-quality photos of system packaging from The Embracer Games Archive. These photos are of people's personal console boxes, offering a glimpse into both the presentations of these myriad machines, but how much they've been uniquely treasured by their owners.

365

366

367

368

365
Dreamcast
1998

366
PlayStation 2
2000

367
Xbox
2001

368
GameCube
2001

Due in part to its massive install base and in part to the Wii's underpowered hardware, many games which came to Nintendo's seventh-gen platform also came to PS2! From Star Wars: The Force Unleashed and Silent Hill: Shattered Memories to Sonic Unleashed and Tomb Raider: Underworld many high-profile titles hit the system well after its successor hit the market. This was a phenomenon largely unique to the PS2, though. GameCube and Xbox owners didn't get the same treatment!

369

370

371

372

369
Sonic Unleashed
2008

370
Star Wars: The Force Unleashed
2008

371
Silent Hill: Shattered Memories
2009

372
Tomb Raider: Underworld
2009

DREAMING IN ARGENTINA.

words *Mer Grazzini*

It all starts with this: a jewel containing the ultimate power...

The '90s in Argentina is a weird moment in the time-space continuum to analyse. The government back then decided to sell or privatise most state companies and services, trying to put the Argentinian peso at the same exchange rate as the US dollar. "One peso, one dollar" was the slogan. Cheap imports from China and Taiwan were everywhere, and the multicolour propaganda of the times tried to hide the fact that people were losing their jobs at a fast rate. Similar to what Thatcher did in the UK.

It was a time of pirated Chinese versions of things, especially video games. Most kids from the '90s grew up with a machine we called "La Family" (like that, in English). It had big, colourful cartridges and featured *Circus Charlie*, *Mario Bros.*, and a lot of other titles, especially Japanese action games. Many of us grew up not knowing that it was actually a Famicom. Or to be fair, a bootleg version of it. Just like that, many of us grew up not having the slightest idea that games should come in a box. Or with a manual (a what?) — some of the most successful NES games didn't exist to us either, such as *The Legend of Zelda*, *Metroid* or *Final Fantasy*, because they were hard or expensive to bootleg.

But I was too young to know about "La Family" just yet. I was almost four years old in 1995, and my parents moved briefly from the big city of Rosario, in the centre of the country, to Posadas, far in the north, where my grandpa lived... because they didn't have a job and could use my grandpa's help. They had some friends there, and I enjoyed those visits because I'd go play with the family's kid, Martín.

One day, Martín told my parents they needed to come see me. "Look at her, she plays so well! You need to get her this game!" There I was, with a controller bigger than my hands, playing *Mortal Kombat*. My

mom only said, "Okay but... can't she play something with less blood?" And Martín replied, "I think she also loves *Sonic*." It was settled.

My parents liked computers and games, and they used to go to arcade pubs — mainly during the era of mechanical games. But, they fondly remember the first time they tried a *Pong* machine and could *move a square on the screen*. My mom was astonished. The Sega Genesis was a bit more expensive than the Family, and my parents had little money. But Posadas is just a river away from Encarnación, Paraguay, and Paraguay is known for having little to no import tax. So if you live near the border, it is common to go buy stuff there. You could also get some smuggled goods for an even cheaper price if you knew where to look, and my parents knew where to look.

They took me there and made me choose. My dad wanted to buy the Famicom, because it was an original Japanese version, while the Genesis, although also an original copy, was manufactured in China, and Japanese versions of the Genesis were impossible to find. But I only cared whether it included *Sonic* or not. And only the Sega one had it, so the choice was made. Martín could not know back then that by teaching me how to play *Sonic*, and convincing my parents to get me a console, he was shaping my future. As of now, almost 30 years later, I make a living from designing games. All thanks to *Sonic*.

I grew up playing and replaying my set of cartridges forever. Each (bootleg) cartridge cost ten pesos, which was ten dollars — a lot of money. And I don't mean for a child, I mean in general. My mom would go to the supermarket every couple of days and buy the daily needs for a family of three with that money.

My absolute favourite cart contained *Sonic The Hedgehog 2* (I had no idea what 'Hedgehog' meant, so I assumed it was something like 'adventures'). This one was a double cartridge; it also included *Ecco*

photography *Imogen May*

The Dolphin. There was no way of selecting which game you wanted to play. You'd turn on the Sega and randomly be welcomed by a bright and loud "SEEEEGAAAA!," or a dark and quiet logo for *Ecco.* I also had a notepad full of passwords for the *Tiny Toons* game, and a couple more titles. Of course, I had my friend's games as well. We'd swap our cartridges after a couple of weeks each, so that we could play more stuff.

One of the games I'd always ask for was *The Lion King.* You start the game at the Pridelands, maybe get a Timon and Pumba mini-game, and then you get to the "I Just Can't Wait to Be King" part. Thing is, I couldn't beat this section. And neither could the owner of the game. We would get stuck at a certain island, unable to keep moving. At some point, we realised — there was some (potentially) helpful text at the start! But what did it say? We couldn't read any of it. We'd watch movies with subtitles with our parents, but these games had no such thing. I wrote those words, asked my mom for a Spanish-English dictionary, and... "Roar At Monkeys!" That was the secret. The rest of the game was a piece of cake after that. So, I quickly realised I'd need to learn English to play games. So be it.

I started simply reading this small dictionary, grabbing it at random pages, or just asking, "How would you say (insert word) in English?" Suddenly, I felt like I was unlocking a secret code. The obscure, super-hard *Ecco The Dolphin* became less secretive, when playing with the small brown book next to me as I searched for each word. This was still super hard for a kid, but at least I could understand and be aware of what I needed to do. It's not uncommon to find people my age now who speak English mostly thanks to the urge to understand video games.

I didn't get to play as many titles back then, only having my small collection and my friends' libraries at hand. Older kids would go to rent games, but I rarely had the opportunity to rent any myself. These were also bootleg — none of my childhood consoles ran an authentic piece of software ever. I only got to see them as an adult, but bootlegs had their own charm.

At eight years old, I was a big Pokémon fan. However, Nintendo machines were impossible to obtain. No one owned Nintendo consoles unless they were rich, and I remember seeing the TCG decks sold for thirty pesos. A fortune. But I used to play a weird platformer that featured Pikachu on my Genesis. Pikachu would fight against a Pinsir and some other random non-Pokémon creatures. This is as close as the bootlegs would come to Pokémon, but I'd get creative: designing board games based on the little info I had about what the actual Pokémon games were like.

Around the time of Pokémania, in 1999, my friend Franco got a PlayStation for his birthday. 3D was officially a thing... but not for me just yet. I do remember, though,

that the last cartridge I ever bought for the Genesis was *Sonic 3D Blast.* It was incredible, you could move along a new axis and also jump! All in just 16-bits! It was great, but I was already aware of the news from across the ocean. Sega was releasing a new console soon, and it would include a Sonic game in actual 3D. And I needed it.

Christmas 2000 came with a small baby sister and a visit from my grandpa. My dad sent him 100 pesos and asked him to go to Paraguay and get me a thing called a "Dreamcast." When I returned home from visiting a friend on the afternoon of the 24th, my dad smiled and pointed at the TV table. The Dreamcast was there, connected and all!

It came with two legit discs — an internet setup thing that I never used (connecting to the internet via phone cable was super expensive) and a demo disc. Among those was a demo for *Sonic Adventure.* I booted it up immediately and watched a city get drowned in water, a big dragon monster emerging from it. *I got so scared.* I played the only level that was in the demo, and then we had to go to my cousins' place for dinner. During the car trip, I couldn't stop thinking about that monster, and how Sonic had to fight it. *Poor Sonic.*

I didn't have any games beyond these demos, and there were still no stores selling them in my city. Luckily, another son-of-a-friend-of-my-parents, Germán, came to study architecture in Rosario, from Iguazú, another city far in the north. I made a list of games I wanted, so he went to Paraguay and bought a whole bunch.

If only it were that easy. These games were stored on weird pitch-black discs I had never seen before. And my Dreamcast could not read them. I was told I needed something else, a 'booter' disc ("buteador" in Spanglish) that would help the machine read these pirated games. Luckily, the *102 Dalmatians* game didn't need such technology and was fun enough for memory-card-less me. Soon enough, game stores in my neighbourhood started filling themselves with bootleg copies of Dreamcast games, priced somewhere between three and five pesos, and afterwards, three games for five pesos. They had homemade copies of the discs with photocopied covers — as well as the essential booter disc.

The next time Germán went north to visit his parents, for the winter break, I asked him to bring me a memory-card and another controller so I could play with my dad. That was the start of the happiest time of my gaming life. I have very fond memories of playing titles like *Sega Rally* and *The House Of The Dead 2* with him — not to mention *Fur Fighters* and *Toy Commander.* These last two are still among my favourite games ever.

These new games featured a lot more text than I was accustomed to or had previously learned. Luckily, many of them had Spanish translations, but not all of them.

Tony Hawk's Pro Skater 2 had a lot of English text for me to widen my vocabulary with. *Sonic Adventure*, with its fully voiced gameplay and cutscenes, allowed me to learn its dialogue exchanges by heart, and then read them in English. That, alongside the DVD player my dad bought, made me level up my language skills the most. But the ultimate test was *Legacy of Kain: Soul Reaver*. I fell in love with that game immediately, but it had long cutscenes with English audio and no subtitles at all. I'd turn the volume super loud, and pay these sequences my undivided attention, listening to those sounds and trying to understand.

Many of these games had Spanish translations in Europe, but we took what we could get. That meant playing *Jet Set Radio* in Japanese, and getting stuck at one point, not knowing how to progress (this time it wasn't as easy as with the *Lion King* game). Some games were broken, because the copy wasn't good, so they would just fail at some point or have some inaccessible elements. And also, we'd get weird titles. We had the big mainstream releases, but I wanted more! So I'd go after school to the game store, run my fingers through the photocopied covers of games I hadn't heard about, and take home some Japanese RPG I couldn't understand. No worries though. If I didn't like it, I could go the next day and exchange the game for another one. I played and loved not-so-popular titles, like the aforementioned *Fur Fighters*, *Floigan Bros*, and *Super Magnetic Neo*.

I remember the joy of finally having a new console, for which games were still coming out. Of course, Sega had already discontinued the system, but I didn't care about that. *Sonic Adventure 2* was on every game magazine cover, and it was everything I could ever dream of. I still remember that game's script by heart.

On December 19th, 2001, an economic and political crisis was starting, and the president appeared on TV very late at night, announcing a state of siege. I was aware of the news, and I remember asking my mom what that meant. When she explained, I got desperate, and asked if people could say no to something like that. People did. We went to a big riot — my first riot. The whole family together. Those were weird days. We had five presidents in a single week. The next school year started amid a big crisis. There was no money, there were no jobs. People were getting paid with coupons, and I soon learned that the colourful vibe of the '90s was over. No more Pokémon stickers on every cookie and chocolate, no more toys in the chip bags, no more game magazines, especially not the ones imported from Spain. And no more games for the Dreamcast. The TV commercial that announced the *Sonic Adventure 2 Battle* for the GameCube shattered my heart. Sonic on a Nintendo console! Betrayal! Luckily the Dreamcast catalogue was big, and I still had a ton of games to play. My love for the console did not waver, and it hasn't done so to this day.

Things got a lot better in the country in the subsequent years. I could buy a PlayStation 2, the console that took gaming to every house in my country. I then reconciled with Nintendo, buying the DS, DSi, and even became a part of the 3DS community... but that's a tale for another time.

A new day brings new adventure. But for now... rest easy, heroes.

373

374

375

373
Legacy of Kain: Soul Reaver
2000

374
Super Magnetic Neo
2000

375
Fur Fighters
2000

219

SEGA DREAMCAST .

words *Tom Charnock*

I think it's fairly safe to say that for gamers of a certain age, there was a period in time when having more than one game console in the household was something of a rarity. That's the landscape I grew up in; one in which you made your choice of platform and then became an acolyte of the brand you swore allegiance to. In my case, the banner to which my house belonged was the one emblazoned with the blue, four-lettered portmanteau of Service Games.

First Released:
1998

Manufacturer:
Sega

Launch Price:
JP ¥29,000
US $199
UK £199

Following a brief romance with an Amstrad CPC464+, the introduction of a Sega Mega Drive in 1991 cemented my following of the Sega brand through thick and thin. A series of add-ons in the form of the 32X and Mega-CD, followed by a Sega Saturn in 1996, inevitably led to the early adoption of the system that — with hindsight — became the albatross which almost sent Sega to the wall. But, it was an albatross which had no real weakness. To gamers everywhere, it represents one of the brightest constellations twinkling in the vast heavens of the games cosmos: the Sega Dreamcast.

As a card-carrying Sega kid, growing up in the UK in the '90s was a really exciting time. Without the constant online news cycle of modernity, printed media was really the only conduit through which gaming news could be consumed. So, when grainy captures of games and half-true rumours of new hardware trickled onto the pages of Computer & Video Games, Edge, Mean Machines Sega and Sega Power, people sat up and took notice. Of course, there were the multiple console formats during those heady days of the polygon-fuelled mid-to-late '90s, with the Sony PlayStation and Nintendo 64 vying for attention. But when the first whispers of Sega's follow-up to the Saturn started to find their way onto the pages of the monthly periodicals, it was a big deal and for me as an avid fan of all things Sega — probably more so than was healthy.

At this point, I'd like to make an admission. I did swap my Sega Saturn for a Nintendo 64 at one point in early 1998 simply because it was the new kid on the block, and I absolutely *had* to have the newest, fastest, most powerful console on Earth. Even so, my devotion to Sega wasn't swayed by no longer owning a Sega system. As soon as the name Sega64, Black Belt or Dural (whatever the press were dubbing the new Sega 'super console' that month) was planted in my psyche, I knew that I'd be changing lanes again in the near future and getting back on the Sega hype train.

Much has been written about the storied Dreamcast development history, and being an avid consumer of many multi and single-format magazines during my youth, it was something of a hobby of mine to hoover up as many fresh factoids on the console's hardware revisions as I could force into my retinas. Rumours of internal turmoil, 3dfx chips, name changes and (sometimes quite hilarious) 'artists impressions' of the console that were printed on those hallowed pages made for some highly entertaining reading and are, for me at least, part of the allure of the Dreamcast and that particular period in gaming history. Separating the fact from the fiction was almost as compelling a pastime as actually playing games themselves.

The first time I saw Dreamcast game screens (as opposed to flashy tech demos) in those magazines, I was filled with a mixture of bemusement and curiosity. Japanese title *Sengoku Turb*, with its bizarre polygonal avatars, looked reminiscent of an Atari Jaguar title (*Club Drive* with swords, anyone?), while *Seventh Cross* appeared to be some kind of *Terminator 2* simulator, replete with a gleaming humanoid emerging from the ocean flaunting an impressively modelled pair of buttocks. Not going to lie — I was expecting something more 'Sega blue skies,' but for better or worse, those screens will forever

photography *Damien McFerran*

221

be imprinted in my mind's eye. Angular princesses and sculpted backsides aside, though, one thing was certain: the Dreamcast was en route and represented a tangibly exciting new direction for home gaming.

It wasn't long before the true promise of the Dreamcast hardware was unveiled; boasting unrivalled console specifications in the form of a 200Mhz Hitachi SH-4 CPU coupled with NEC's PowerVR2 GPU. The Dreamcast was a beast that blew the contemporary competition out of the water and promised to truly bring arcade perfect NAOMI and Model 3 conversions to CRT television sets across the globe. But it wasn't just the technical specs that had gamers such as myself eager to get our hands on the Dreamcast; the many innovative features the system bristled with also made the competition seem a bit staid in comparison.

The Visual Memory Unit was a memory card that was also a console in itself, complete with an LCD screen and buttons that meant you could remove it from your controller and play *actual* games on it. The bundled modem meant you didn't have to wait until the teacher wasn't looking at your computer screen during school lessons in order to browse Alta Vista for game cheats — you could do so in your own house! The allure of literal 'arcade perfect' home conversions and a tidal wave of games ported from the PC (thanks, Windows CE integration!) meant you could realistically look forward to the likes of *Sega Rally 2*, *Virtua Fighter 3tb*, *Black & White* and *Rainbow Six* all being playable on the same box! Dreamcast meant only one thing: Sega was back in the game, and it was taking no prisoners.

The Sega Dreamcast finally hit Japanese store shelves on Friday, November 27th, 1998, along with a grand total of four launch titles: *Virtua Fighter 3tb*, *Pen Pen Trilcelon*, *July* and *Godzilla: Generations*. However, it would be several months before I finally got to sample the delights of the Dreamcast for myself. Not via a console I owned personally, but one that a far more affluent friend had purchased from a small brick-and-mortar import shop, along with copies of *Virtua Fighter 3tb* (complete with *Project Berkley* preview disc), *Shutoko Battle* and *Dynamite Deka 2*. To say that I was blown away by the fidelity of the visuals being pumped out of the console (especially the super shiny, high-resolution vehicle models in *Shutoko Battle*) would be quite the understatement. Indeed, I was never able to look at my own copy of *Buck Bumble* for the Nintendo 64 in quite the same way after that afternoon's glimpse at the future of gaming.

The wait to get my own Dreamcast, complete with blue swirl and shoddy PAL game cases, was fairly brief, as the new hardware finally dropped in the UK in October 1999. Ashamedly, I couldn't secure a console at launch as my militant, anti-gaming late mother refused to let me have more than one 'brain-rotting' console (her words, not mine) at any one time, and so I had to wait until I

could sell my Nintendo 64 in the small ads before I could reinvest in Sega's new technology. Transaction completed, I can vividly remember gleefully leaving Electronics Boutique with a Dreamcast in an oversized plastic carrier bag one Saturday in November 1999. At that moment, a love affair began — a love affair which went on to be something of an emotional rollercoaster, but which has endured to the current day.

The first game I owned for my new Dreamcast was Ubisoft's *Speed Devils*, an intriguing racing title that encouraged players to place wagers on the outcomes of races. It was a fun and good-looking arcade-style racer, and even more notable as I bought it roughly two weeks before I actually got my Dreamcast. I read that game manual more than a few times during that painful fortnight, believe me.

Once the Dreamcast became something of an established system in the UK, the floodgates really opened for me. Naturally, I was aware (once again via the magic of magazines) of the US launch's barnstorming success and the slightly more edgy 9.9.99 and "It's Thinking" advertising campaigns, which swept the Dreamcast to the most successful console release in gaming history — but it was during that first year-and-a-half of Dreamcast ownership that I was fully assimilated into the ecosystem Sega and its partners were building.

An absolute ton of incredible arcade ports — such as *Soul Calibur*, *Power Stone*, *Virtua Tennis*, *Sega Rally 2*, *Marvel vs. Capcom*, *Hydro Thunder* and *The House of the Dead 2* — were matched by new and original titles, as well as those which brought classic Sega IP bang up to date. *Sonic Adventure*, *Ready 2 Rumble*, *Sega Bass Fishing*, *Metropolis Street Racer*, *Blue Stinger*, *Outtrigger*, *Quake III Arena*, *Resident Evil – Code: Veronica*, *Shenmue*, *Phantasy Star Online*, *Jet Set Radio* (*Jet Grind Radio* in the US), *Samba de Amigo*... the list of incredible Dreamcast titles goes on and on.

As somebody who was completely immersed in the Dreamcast scene as it existed in the UK at that time, I would pore over the import news sections of magazines and absorb information about the weird and wacky releases players were experiencing in other territories, endlessly fascinated by the differences in the systems and features we simply didn't get on these shores. The orange swirls, the mesmerising variety of the Dreamcast's expanded online services in the forms of SegaNet and Dricas (both of which seemed more advanced than Europe's Dreamarena), the bizarre peripherals and special edition consoles... it was all so exotic, mysterious and exciting.

The period from late 1999 to early 2001 was one of the best I have ever experienced as a gamer. Not just because of the introduction of the internet and the increasing availability of news and information regarding the subject that I was enamoured with, but because the

Dreaming of Accessories

It's only natural that a system running on a modified version of Windows CE would utilise a keyboard and mouse extensively. They are just two of the Dreamcast's many peripherals, and also some of the most interesting. The combo was arguably most useful when playing PC shooters ported to the console, functionality that has since become standard on systems like Xbox Series X|S. But of course, the system also had an official arcade stick, as well as an official light gun — not to mention a Jump Pack and Microphone to slot into your controller.

376

377

378

379

380

381

376
Dreamcast Modem
1998

377
Dreamcast Mouse
2000

378
Dreamcast Controller
1998

379
Visual Memory Unit
1998

380
Dreamcast Jump Pack
1999

381
Dreamcast Microphone
1999

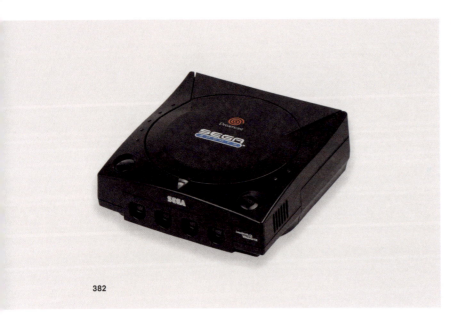

Unlimited Dreams

From Hello Kitty models to the famously rare Divers console — the Dreamcast has no shortage of limited edition variants. The Sega Sports Edition from 2000 is just one of these, coming bundled with both an NFL and NBA game.

382
Sega Sports Dreamcast
2000

Dreamcast was front and centre. So many unparalleled gaming experiences sprang from the little white box, and I have so many fond memories of multiplayer sessions and visiting game stores to see what new titles had been released; would there be a hitherto unknown gem waiting for me? In the case of *Project Justice: Rival Schools 2* — a game I had never even heard of when I picked it up for a mere £20 — that's *exactly* what I found. Naturally, the opposite sometimes occurred, as was the case with *Dragon's Blood*... but you have to take the rough with the smooth, as they say.

Like most things, though, it couldn't last forever. I would say I had a good 18 months with the Dreamcast where everything seemed rosy and the system was going from strength to strength. Games were coming, there was talk of new and interesting peripherals such as the Sega Swatch (a watch which could communicate with the Dreamcast and certain arcade cabinets), a VMU MP3 player, and a broadband adapter to replace the stock dial-up modem. Alas, neither of the former materialised at all, while the latter was never launched outside of Japanese and US markets. The news got much worse in early 2001, when rumours began to circulate that the Dreamcast was proving too expensive for Sega to keep afloat and that production of the console would soon cease.

From a contemporary standpoint, I recall being utterly baffled by this — it felt totally unfair and unjustified. As a Dreamcast owner who had only been enjoying Sega's renaissance for nearly two years, how could it be that this awesome powerhouse of a console was being discontinued so soon? Maybe I was blinkered, so enthralled by the ride I was on. But in hindsight, the Dreamcast wasn't nearly the financial success I was hoping it would be, nor that Sega needed it to be. Indeed, by late 2000, Sega was in deep financial trouble, and the PlayStation 2 was looming on the horizon.

Of course, it is now common knowledge what fate befell the Sega Dreamcast. Production eventually halted in March 2001, and the system entered a sort of zombie phase for a year or so after that in the UK (while still being propped up by posthumous releases in Japan for several more years). And then it sort of just gradually faded away as the masses embraced the PlayStation 2 and the other systems from Microsoft and Nintendo.

The curtain fell on the Dreamcast far too soon. But it's not all doom and gloom. The Dreamcast has one of the largest and most active fanbases of any classic system, with new peripherals and hardware releasing with impressive regularity alongside a deluge of new independent and homebrew titles. Unreleased games are being resurrected all the time, and the online functionality is back up and running due to the community supporting the console.

The Dreamcast today is far from a 'dead' system, but the way in which it shone so brilliantly for such a short period as an officially supported platform represents one of the greatest tragedies in the entire history of gaming. The reasons for this are myriad and have been discussed to death on many forums over the last couple of decades. But as someone who was there from the start, through the good times and then the bad, I firmly believe that there is no console which deserves its legendary status as legitimately as the Sega Dreamcast.

383

384

385

383
Dreamcast Keyboard
1998

384
Dreamcast Gun
1999

385
Dreamcast Arcade Stick
1998

386

387

388

389

390

391

386
Sonic Adventure
1998

387
Sonic Adventure 2
2001

388
Jet Grind Radio
2000

389
Crazy Taxi
2000

390
Seaman
1999

391
Power Stone 2
2000

392

393

394

395

396

397

392
Ikaruga
2001

393
Samba de Amigo
2000

394
Marvel vs. Capcom 2: New Age of Hereos
2000

395
Sega Bass Fishing
1999

396
Skies of Arcadia
2000

397
Shenmue
1999

PLAYSTATION 2.

First Released:
2000

Manufacturer:
Sony

Launch Price:
JP ¥39,800
US $299
UK £299

"That trash looks like a PS2 game."

Modern players love to get into it regarding every conceivable aspect of a new title these days, and when it comes to describing shoddy visuals, the older generations of consoles are usually all in line for a right good ribbing. The PS3, PS4, Xbox...yep, they *all* get dragged into it. These marvels of technology that were once right at the bleeding edge are now nothing more than a cheap and easy way to slag stuff that doesn't look so hot.

However, of all the lazy comparisons made on a daily basis, it's the PS2 ones that get my goat the most. Yes, of course, things age and they don't look as impressive as they once did — I can tell you that from personal experience — but to mock the graphical prowess of the PS2 is to do dirty a console that genuinely, actually, helped change things. It makes you look like you haven't been doing your computer games homework properly, pal, and as a result, you're not putting enough respect on the Emotion Engine's name.

Let's cast our decrepit minds back to the halcyon days of winter 2000. The Baha Men had just let the dogs out, the very first crew had taken up residence on the International Space Station, and Sony, not to be outdone by those nerds at NASA, had finally dropped its brand-new home console. Never mind living in space; *this thing had USB ports.*

The PS2 was at the vanguard of a proper technical revolution for video games. With the power of the GameCube and Xbox following closely behind, it was part of what felt like an almost overnight advancement, the sort of big shift between generations that doesn't really happen anymore in the games space. Where today's consoles push boundaries at a much slower pace, in 2000, there was far more creative wiggle room for developers to play with, and when it comes to the PS2, they took full advantage. We're not just talking about boosts to resolution or a few more frames here — we're talking about graphical advancements that changed video games on a more fundamental level.

We'd reached a point where we were now taking a leap into what were recognisably more modern video games. Not just in terms of how they looked but in how much more detailed, reactive, responsive and, as a result, compelling they would become because of this new level of creative freedom. This was an era when many foundations were laid down for some of the most engrossing gaming loops and experiences we still enjoy today. The power to create impressive three-dimensional worlds that could be fully explored and interacted with in fresh ways had arrived. Proper *modern* open worlds, convincingly deep sports games, online play... so many of the things that we now take for granted were being introduced in this period of change, in a time when consoles were allowing devs to create new experiences with far fewer barriers.

Of course, the initial shift from PS1 to its incredibly successful successor served us up a bunch of very shiny but mechanically underwhelming games to begin with. We're talking about games such as *Ridge Racer V* and *Tekken Tag Tournament*, stuff that *looked* jaw-dropping, stuff you'd play in front of your mates, stuff that immediately showed off just how powerful your new console was. However, we had to wait a little bit longer for devs to really start serving up experiences where all this graphical power did more than just make things look nicer.

229

I'm talking about the likes of *ICO* and *Shadow of the Colossus*. Team ICO's stunning adventures, released in 2002 and 2005 respectively, aren't just important because they're *Very Good-Looking Games™*, but because they mark some of the most obvious examples of the art form really starting to break free from its technological shackles. These were adventures with newfound ambition, embedding the player in worlds packed full of detail that had previously just not been possible.

When climbing up some Colossus as it lumbered across a haunting landscape or making your way through one of *Ico's* majestic, all-encompassing puzzles, *everything* felt more natural. The console had the power to make it so, and as a result, you felt connected to these digital worlds in ways which very few games had managed previously. It wasn't the first time ever that we'd had beautifully animated games, of course. But from this point on, it felt as though the industry had crossed a boundary into a new period where its elaborate fictions could be much more convincingly brought to life.

There are smaller-scale examples of this, like the increased dynamism and freedom given to sports games by the larger range of animations they could employ, to bigger instances like *Red Faction's* fully destructible environments. These were blowing our minds at the time because of how cool they looked, sure. More importantly though, they were also showing us how fidelity was about more than how 'good' something looked on a surface level. We'd reached an era of incredibly detailed watermelons (still the first thing I think about when remembering *Metal Gear Solid 2*), but what truly mattered was the fact that you could make them explode in different ways depending on how you interacted with them.

The sixth generation of consoles may have kicked off in 1998 with the Dreamcast, but the PS2 felt like the first properly viable heavyweight in a generation that changed everything. This was the era that first allowed for the epic scale and scope of Kratos' ancient Greek adventures, completely changing the action-adventure genre in the process, as well as delivering the first truly modern open-world experience in the form of *Grand Theft Auto 3*.

The team at Rockstar had chosen the PS2 specifically as the home for the first 3D GTA, and they were relying on the extra storage available in the form of the system's DVDs to deliver all the detail (both visual and aural) that made this such an evolutionary outing for the open-world genre. The ability to serve up so much dialogue and music, to create such huge worlds and to really run wild with ideas, opened the floodgates for smaller developers too. The PS2 — although graphically it would be outdone by the Xbox — became home to an enormous catalogue of wide-ranging and experimental experiences.

There's a reason why this console was around for so long, why it's still ranked first in terms of hardware sales. There'd never been a bigger or more diverse range of games to dive into, with cutting-edge AAA games alongside hidden gems that broadened the horizons in terms of what players could experience and enjoy.

Over the course of a decade, it was fascinating to watch studios, big and small, manage to wrangle every bit of processing power

398

399

400

398
Grand Theft Auto III
2001

399
Grand Theft Auto: Vice City
2002

400
Grand Theft Auto: San Andreas
2004

from Sony's console, and looking back now, it's quite something to compare the first big titles on PS2 to what arrived shortly before it finally came time to move onto the seventh generation. Over its lifespan, the system gave us *God of War 2, Gran Turismo 4, Metal Gear Solid 3: Snake Eater, Final Fantasy X, Splinter Cell Chaos Theory, Ratchet and Clank, Silent Hill 2, Tony Hawk's Pro Skater 3, Tekken 5*... I could go on and on here, but the point is that not only did these games look great, but they also completely recontextualised what games could aspire to be.

These are titles that became templates for so much of what we're still playing, and concepts that you could see half-realised on platforms of the past were now being successfully implemented. There was a more complex, adult style of marketing around the PS2 as well — it had a DVD player (which got the console into lots more homes) and basic online capabilities. The console was around for long enough that by the time folks were moving on to PS3 the gaming landscape had changed entirely. We should be looking back at older platforms like this with nothing but reverence, seeing the boundaries that were being pushed back and broken down over time, revelling in how designers were able to manipulate lesser hardware into doing some incredible things.

It's a lazy comparison, I know, but there's such a huge difference between how games and other art forms celebrate their histories, origins and technical achievements. Only an idiot would point and laugh at *Citizen Kane* for being shot in black and white or dismiss *Nosferatu* out of hand because it doesn't have any CGI vampire karate fights in it (although, I'm not gonna lie, I would watch the hell out of that). Instead of using PS2, or any other ageing console, as shorthand for 'bad graphics,' we should be making a much more concerted effort to become fully literate in how we speak about the origins and history of games as an art form. We need to be more educated, mate, is what I'm saying. Take it *serious*, like.

When I reflect on what my favourite console of all time most probably is, my mind immediately gravitates towards the Super Nintendo Entertainment System. This was my first proper console, one that was all mine, and something that (to put it mildly) I'd wanted for ages before I finally got it for Christmas of 1992. I have a lot of special memories with that machine and its incredible library of games. This was probably when I became properly and fully hooked on the medium, through *Street Fighter II, The Legend of Zelda: A Link To The Past* (still has the best world map in games), *Earthbound, Secret of Mana*, and all that great stuff.

However, when I sit down and consider it properly, there's no doubt that the PS2 was *easily* the console that I spent most time with overall. It had all of the huge hits, the games at the forefront of the graphical revolution, the big-budget AAA fare (a lot of which still looks great today), and also had a ton of experimental indie titles and lower-budget adventures that made for one of the most exciting and rich periods in games. Really, it's a time of experimental and wide-ranging experiences that has only recently been matched by how indie games have succeeded and finally become more widely embraced. We've still got a lot of work to do in this regard, of course. Making sure that players don't just see old as being equivalent to bad will help in the long run.

231

401

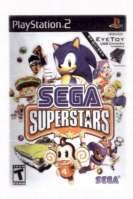

402

401
EyeToy
2003

402
Sega Superstars
2004

Foresight

In 2003, Sony launched the EyeToy — a webcam peripheral for the PlayStation 2 that allowed for motion-controlled gameplay. Pre-dating Xbox's Kinect by seven years and foreshadowing Sony's PS3 control experiments, the EyeToy was ahead of the casual gaming curve. But it was not especially well supported, with only 25 games worldwide requiring the accessory. Sega Superstars is a relatively high-profile example, but the whole EyeToy exercise was middling at best. Selling about ten million units, roughly one in fifteen PS2 owners bought the device.

403

404

405

It kinda feels like this turned into a bit of a lecture, which wasn't the point at all. It's fine to use old things as a shorthand way to slag something for looking, well, not very modern. But it feels as though it's become more and more common to rather ignorantly point and laugh at old generations of consoles, to dismiss them out of hand as antiquated. Of course, if you're into games at all, you know this just isn't the case. I could plug a PS2 into my TV right now (that's an actual threat) and have a great time with some of the best-looking games out there; your *Snake Eater* and *Tekken 5*, *Silent Hill 2* and *3*, *Jak 2*, *Odin Sphere*, *Gran Turismo 4*, *Valkyrie Profile 2*, *Final Fantasy XII*... the list goes on and on.

The same can also be said for Xbox, for PS3 — all of the older consoles that you've been ripping on social media, *you clod*. They all have their place in this rich tapestry, in the history of the medium that we all love and care about so much. Sure, a lot of older computer games look... *interesting* these days, when judged through your cold and calculated modern eyeballs. *You monster.* However, look beyond the initial reaction you've just had to that awful-looking RPG from 2002, look deeper and see the technological boundaries being slowly pushed back. Appreciate these things for how they overcame shortcomings, smoothed over technical impossibilities and laid the groundwork for the ridiculously good-looking worlds that you get to blast around in nowadays.

So yes, in summation, when you make the remark that a bad-looking game reminds you of something from the PS2, I understand the point on a basic level. Believe me, I was there for *Catwoman*, for *The Sopranos: Road to Respect* and *Little Britain: The Video Game*. However, the PS2 deserves more respect put on its graphics than this; it deserves to be remembered for the silky-smooth animations of *Soul Calibur 2*, the slick and satisfying carnage of *Burnout 3: Takedown*, the incredibly atmospheric horror of *Manhunt* and the Silent Hill series, the fine detail of *Gran Turismo 4*. It deserves to be remembered for *Psychonauts*, *Beyond Good and Evil*, *San Andreas* and for those great big juicy watermelons. Let us never forget the watermelons.

Brick By Brick

While Lego games had been launching reguarly since 1995, 2005's Lego Star Wars: The Video Game changed the franchise's trajectory. Although not the first title based on a licensed IP (that honour goes to 2001's Lego Creator: Harry Potter), it was the marquee console brickbuster. The game not only spoiled the plot of Star Wars Episode III: Revenge of the Sith by launching two months prior to the film, but it also began a historic run of action-platformers that touched iconic series from Batman and Indiana Jones to Jurassic Park and Lord of the Rings.

403
Lego Star Wars: The Video Game
2005

404
Lego Batman: The Video Game
2008

405
Lego Indiana Jones: The Original Adventures
2008

Buzzing for a BAFTA

While they might not look like much, the Buzz! series of casual quiz software (which began with The Music Quiz) won The Best Casual and Social BAFTA award with its second entry, The BIG Quiz. Controlled by the Buzzer peripheral, this party game franchise eventually sprawled into the action-oriented Junior subseries and then continued onto PS3, with the likes of Quiz World. In total, 18 Buzz! games were released between 2005 and 2010.

406

407

408

409

406
Buzz!: The BIG Quiz
2006

407
Buzz! Junior: Jungle Party
2006

408
Buzz!: Quiz World
2009

409
Buzz! Buzzer
2008

410

411

412

413

414

415

416

417

418

419

420

421

410
Metal Gear Solid 3:
Snake Eater 2004

411
Tekken 5
2005

412
Silent Hill 2
2001

413
Silent Hill 3
2003

414
Odin Sphere
2007

415
Gran Turismo 4
2004

416
Valkyrie Profile 2: Silmeria
2006

417
Final Fantasy XII
2006

418
Soul Calibur 2
2002

419
Burnout 3: Takedown
2004

420
Psychonauts
2005

421
Beyond Good & Evil
2003

234

It's a TV, too

The most famous revision of the PlayStation 2 is no doubt the Slimline — but it wasn't the only iteration of the hardware released. 2010's BRAVIA KDL22PX300 is not only a mouthful, but a fascinating TV-PS2 hybrid. Launched several years after the PS3, the KDL22PX300 largely exists as a historical footnote.

422

423

424

425

422
Sony BRAVIA KDL22PX300
2010

424
PlayStation 2 Slimline
2004

423
PlayStation 2 Slimline Satin Silver
2005

425
PlayStation 2
2001

GAMECUBE.

First Released:
2001

Manufacturer:
Nintendo

Launch Price:
JP ¥25,000
US $199
UK £129

At the start of 2004, just as the excitement of Christmas and the New Year was beginning to wane and the prospect of a new school term was starting to creep into my mind, I sat in my bedroom on a grubby blue swivel chair when my father walked in. I was playing *Mario Kart: Double Dash!!* at the time, which had launched in the UK just a couple of months prior. I remember being enamoured with its bold new direction for the franchise. *Two* racers in *one* cart? Ingenious!

Anyway, my dad walked in and asked what I was playing. "*Mario Kart,*" I said, a look of mild confusion etching itself onto my face. You see, my dad asking this was a bit odd, because for as long as I could remember, he frankly wasn't interested in games unless they had the words *Gran Turismo* or *DOOM* in their titles. He certainly wouldn't find anything remotely like that on the GameCube. Things got even more bizarre, however, when he asked if I'd like to play a multiplayer session with him and my brother.

Although I thought this a bit strange at the time, as a 13-year-old teenager, I didn't really care. I was just thrilled that my dad wanted to join in with something that I was particularly passionate about. So I shouted for my brother to come and join us in the typically blunt way that siblings do, hooked up a couple of additional controllers, and started to set up the session.

From what I remember, it all started off rather well, at least during the first race. The skills that I'd honed over the last couple of months had done me well, and I stormed ahead during those first few corners on Mushroom Bridge. However, as we progressed through the Flower Cup Grand Prix (which also consisted of Mario Circuit, Daisy Cruiser, and Waluigi Stadium), things took a turn for the worse for me. Of course, anybody familiar with Mario Kart will know that just one or two items can mean the difference between victory and a crushing defeat. If you're cruising along in first place, there's a good chance that a Blue Shell will crash into your backside and send you tumbling down the leaderboard. It's Mario Kart, it happens.

That's exactly what happened here. Even after I lost the first race, I didn't learn my lesson. I shot ahead of the pack as early as possible and tried to maintain this position for each race, not considering the notion that I'd suddenly become a big, red target to everyone else on the track. So after the last race — during which I'd lost to both my brother *and* my father — I threw a bit of a hissy fit. Look, I was 13. To my mind at the time I couldn't quite grapple with the idea that I could lose at a game that I personally owned. It was *my* game, for goodness sake. *How could I lose?* Needless to say, the atmosphere turned sour. I tossed my controller onto the desk (though gently enough that I wouldn't damage anything — I wasn't *that* mad) and stated defiantly that I didn't want to play anymore, causing both my dad and brother to leave the room, clearly disappointed in my reaction.

It might seem strange that such a seemingly mundane event could stick in my memory nearly twenty years later. Although a great deal of my gaming escapades have become lost in the relentless passage of time, this particular memory has remained tucked away in the storage cabinets of my mind, poking its ugly head out whenever I see references or mentions of *Mario Kart: Double Dash*.

At the time, as I'd mentioned, it seemed more than a bit odd that my dad would want to play Mario Kart, of all games. But given the dire events of the days and weeks that followed, I would come to understand his intentions that day. He had wanted to create one final happy memory with his two sons before he left the family for good. And I wrecked it.

We (and by 'we,' I mean my mum, brother, and myself) would learn of my dad's extramarital affair only a day or two after this particular Mario Kart session. I was sitting in my room watching the horrendous 2000 remake of *Bedazzled* starring Brendan Fraser and Elizabeth Hurley on my 19-inch CRT set. My brother came up the stairs crying, and after I asked him to tell me what was wrong, he said that our dad would be leaving for a while. I knew what that meant, of course. My dad had previously been away for weeks at a time for work, even travelling as far as Texas in the United States. But something in the way that my brother delivered this news felt distinctly different. I knew, then and there, that 'a while' meant 'for good.'

The evening very rapidly escalated into one of the worst of my entire life, and indeed, the family dynamic from that point on had been irrevocably changed. I would spend the weeks, months, and even years following in a state of intense confusion, sadness, and fear. Yet given my age at the time, I was still unable to fully comprehend the reasoning behind the events and the ramifications (and to my parent's credit, they tried desperately to shield me from as much of it as possible). So, for me, that *Mario Kart* session during which I lost my temper remained a source of immense pain.

Why did I react so negatively? Why did I have to sour what had been such a rare and precious moment in my life? *Why?* These questions circled my mind constantly for weeks and months on end because, for me, it was the only aspect of my life at the time that I felt I had any kind of agency over. All of the stuff that was happening between my parents was beyond my comprehension, and so I focussed, perhaps selfishly, on the only thing that seemed to matter at the time: my own stupid behaviour.

I never directly linked my outburst to anything that would happen in the days following that Mario Kart session. My dad would have left regardless of whether we spent that half hour or so on the GameCube or not, and it's not like he could have warned me ahead of time. Ultimately, it didn't matter. Yet I still felt an immeasurable sense of guilt that I ruined what should have been one final happy memory in which my dad was, well... my *dad*. So for a good while — years, in fact — I couldn't play *Double Dash*, nor could I even look at its box art. But, as I'm sure many other teenagers would do in the wake of intense trauma, I frequently hid in my room for hours on end and indulged in the only thing that brought me a modicum of joy: playing my GameCube.

So, while I avoided *Double Dash* like the plague, I sunk ungodly amounts of hours into single-player games like *Super Mario Sunshine*, *The Legend of Zelda: The Wind Waker*, *Sonic Adventure 2 Battle*, and *Metroid Prime*. It was my escape from the outside world, and I simply couldn't get enough of it. Better yet, when *Metal Gear Solid: The Twin Snakes* launched in March of 2004, it proved to be yet another perfect opportunity to slink away from the horrific reality of life for a handful of hours every day.

I played in the morning before school, I thought about playing *during* school, and, of course, I played for hours in the evenings. It was my own personal getaway. In those days and months following my parents' split, I must have cleansed the island of Isle Delfino at least three or four times, saved the world from terrorists on Shadow Moses twice, and sailed over the ocean above Hyrule for countless (and I mean *countless*) hours. As for *Sonic Adventure 2 Battle*, I more or less did the bare minimum. Hey, nothing against the game, of course; it's a perfectly fine jaunt into the world of 3D Sonic (albeit one that hasn't aged terribly well), but while my friends at school were becoming increasingly enamoured with the Chao Garden, I couldn't bring myself to demonstrate a similar level of enthusiasm.

The one game that sunk its hooks into me and never let go, however, was *Metroid Prime*. I played that game front-to-back more times than I care to admit, but I simply couldn't get enough of it. Whenever I was away from it, I just wanted to land back onto the planet of Tallon IV again and explore the fiery depths of Magmoor Caverns, the frozen ruins of Phendrana Drifts, and the deadly Space Pirate-infested Phazon Mines.

At a time when I felt the full weight of loneliness and isolation, *Metroid Prime* was a game that, oddly enough, I could relate to. While I was very much alone with my thoughts, so too was Samus Aran, traipsing across Tallon IV with nothing but her Arm Cannon and Scan Visor to keep her company. She overcame immense odds with nobody around to support her, and for that, she was (and still is) my hero. Now, I wouldn't want to insinuate that I had nobody around to support me during such a difficult time of my life — that couldn't be further from the truth — but, as a teenager, it's very easy to internalise and exaggerate issues beyond your control.

So, wandering around the environments in *Metroid Prime* brought me a sense of comfort that I can't quite put into words. It simply felt like an escape, but more so than any other GameCube title I was playing at the time. It also kickstarted a love of nature that still remains strong to this very day. If ever I feel down, I will head out into the world and go for a lengthy walk. And if I can't do that? Well, then I'll simply boot up *Metroid Prime* again and blast a few Space Pirates.

As the months and years went by, the pain I felt from my parent's divorce began to subside, though, of course, shadows of it remain to this very day, lurking in the depths of my heart. What I can't deny, however, is just how fundamental the GameCube was in getting me through such a horrendous time of my life. Do I acknowledge that *Super Mario Sunshine* has its issues and is 'objectively' a lesser game than its siblings? Yes,

of course. But it's still my favourite 3D Mario purely for how it contributed to my coping process back in 2004. Same with *Wind Waker* and *Metroid Prime*.

A few years later — probably around 2007 or 2008 — I'd gone to stay with my dad for a couple of days. He was seeing someone new at the time and, lo and behold, they just happened to own a Nintendo Wii (gosh, *Wii Sports* really roped in the most unlikely gamers, huh). Not only that, but they also owned a copy of *Mario Kart: Double Dash*. I think it belonged to his partner's son since I couldn't imagine my dad figuring out that the Wii was backwards compatible with the GameCube. Regardless, they had two GameCube controllers at hand, and this presented a perfect opportunity for me to make amends. Not with my dad, you understand, but with myself.

So we played *Double Dash* together again, marking the first instance I would play the game since that fateful day in 2004. And you know what happened? I lost again... I *actually* lost again. This time, however, with a bit more wisdom at my side, I took it for what it was and simply enjoyed the race. Subsequently, we wound up playing more sessions until we made our way through all sixteen courses in the game. It felt like a weight had been lifted from my shoulders. All those agonising months I'd spent blaming myself for wasting what should have been one final, happy memory with my father at home just seemed to melt away.

It wasn't *exactly* the same, of course. Nothing was ever going to be the same again after my dad left the family. But after that brief period of time when we reconnected over Mario Kart, I felt like I could forgive myself for my misguided reaction in 2004.

For many reasons I won't go into here, the Nintendo Switch really should be my favourite console of all-time. Heck, some days, it probably *is*. But in my heart of hearts, the GameCube will always be the winner simply for how it helped me cope with what was undoubtedly one of the most difficult and troubling times of my life. I will always treasure it for that, and though I still look back on that *Mario Kart: Double Dash* session just a few days prior to my parent's split with disdain, I am at least thankful that I had the opportunity to set things right with myself.

Packaging Conventions

The GameCube library had an entirely different packaging philosophy in Japan than it did elsewhere. The standard DVD-size cases known in most parts of the world were replaced with much smaller cases in Japan, made of clear plastic with a cardboard sleeve over top. Like the form factor, the cover art was often unique to the territory. The quaint footprint of Japanese GameCube boxes is not only distinct, but well suited to the system's compact design.

426

427

426
Mario Kart: Double Dash!
2003 (North America)

427
Mario Kart: Double Dash!
2003 (Japan)

Don't Let The Handle Deceive You

During its commercial life, the GameCube was derided as a "kiddie" system. The system having a handle didn't help, the system's marquee Zelda title being cel-shaded (dubbed Celda by haters at the time) didn't help. But Nintendo didn't wait for hindsight to change the narrative. The system was home to several tentpole M-rated exclusives from Metal Gear Solid: The Twin Snakes to Eternal Darkness: Sanity's Requiem. Resident Evil 4 even coexisted alongside Kirby Air Ride as a GameCube exclusive at the time of its release!

428

429

430

431

428
Pikmin
2001

429
Metroid Prime
2002

430
Kirby Air Ride
2003

431
Star Fox: Assault
2005

240

The GameCube era marked the start of Nintendo's long-standing partnership with Bandai Namco. It began prior to Bandai and Namco merging, with the latter responsible for titles including Donkey Konga and Star Fox: Assault. From there, the companies became one and worked with Nintendo on games including Mario Superstar Sluggers. The relationship continues to this day, where Bandai Namco's internal team Studio 2 & Studio S work closely on series including Mario Kart and Super Smash Bros.

432

433

434

435

432
Chibi-Robo! Plug Into Adventure!
2005

434
Eternal Darkness: Sanity's Requiem
2002

433
Metal Gear Solid: The Twin Snakes
2004

435
The Legend of Zelda: The Wind Waker
2002

gamecube.

436 437

438

Legends Can Coexist

After the fall of the Dreamcast, Sega flirted with bringing games to Xbox before aligning the lion's share of its post-hardware efforts on GameCube. Sega's Amusement Vision team was particularly active, helping to launch the system with Super Monkey Ball. The studio also developed F-Zero GX and its arcade counterpart, F-Zero AX. All of these games were helmed by Toshihiro Nagoshi, who continued to lead Amusment Vision until 2021 under its now famous banner: Ryu Ga Gotoku Studio.

436
Super Monkey Ball
2001

437
F-Zero GX
2003

438
F-Zero AX
2003

Plug and Play

The GameCube has some of the medium's very best accessories, like the DK Bongo controller used in a host of Donkey Kong-themed games. There was also a seldom-used microphone that'd get inserted into the Memory Card slot — prominently featured in both Odama and Mario Party 6. The GBA and GameCube could talk to each other in games like Animal Crossing as well, thanks to the Link Cable... that was most famously used to bring four Links together in the Zelda spin-off, Four Swords Adventures! You could even just play your GBA Game Paks on the TV via the Game Boy Player while relaxing with your wireless WaveBird controller. You'd be the envy of any Nintendo fan, especially if you had a Panasonic Q — an extremely rare GameCube variant!

439

440

441

442

443

444

439
DK Bongo
2003

440
GameCube Game Boy Advance Cable
2001

441
Panasonic Q
2001

442
WaveBird Wireless Controller
2002

443
Game Boy Player
2003

444
Nintendo GameCube Microphone
2004

CHIBI-ROBO! PLUG INTO ADVENTURE!

Developer:
Skip

Publisher
Nintendo

Release Year:
2006

Available on:
GameCube
Wii (Japan)

Chibi-Robo is an often underappreciated 3D adventure game. Taking place in the Sanderson household, you play as the titular cleaning bot, Chibi-Robo, exploring the home and solving the family's problems. With a melancholy narrative about interpersonal relationships, familial expectations, and kindness, the meaningful story alongside its charming cast of characters make this one of the most joyous open-world games in Nintendo history.

445

446

447

448

445
Chibi-Robo! Plug into Adventure!
2006 (America)

447
Chibi-Robo! Plug into Adventure! Disc
2006 (America)

446
Chibi-Robo! Plug into Adventure!
2006 (Japan)

448
Chibi-Robo! Plug into Adventure Disc
2006 (Japan)

DOSHIN THE GIANT

Developer:
Param

Publisher
Nintendo

Release Year:
1999 (N64), 2002 (GameCube)

Available on:
Nintendo 64 DD (Japan)
GameCube (Europe, Japan)

First released for the Nintendo 64DD before seeing an expanded launch on GameCube, *Doshin the Giant* is a peculiar God game. Playing as the game's titular protagonist, you'll wander the island around you either assisting or antagonising its residents as you terraform the landscape to your liking. Experimental and imaginative, Doshin is a forgotten face of Nintendo experimentation.

449

450

451

452

449
Doshin the Giant
2002 (Europe)

451
Doshin the Giant Disc
2002 (Europe)

450
Doshin the Giant
2002 (Japan)

452
Doshin the Giant Disc
2002 (Japan)

P.N.03

Developer:
Capcom Production Studio 4

Publisher
Capcom

Release Year:
2003

Available on:
GameCube

Developed as part of the 'Capcom Five' deal which saw five Capcom titles launch exclusively on GameCube (including legendary then-exclusives like *Resident Evil 4*), *P.N.03* is perhaps the most overlooked of the bunch. An austere sci-fi shooter from the iconic Shinji Mikami, this stylish action title is a throwback to lock-on shooters of the sixth generation — equipped with DNA that clearly went on to inspire *Bayonetta*.

453

454

455

456

453
P.N.03
2003 (America)

455
P.N.03 Disc
2003 (America)

454
P.N.03
2003 (Europe)

456
P.N.03 Disc
2003 (Japan)

PIKMIN

Developer:
Nintendo EAD

Publisher
Nintendo

Release Year:
2001

Available on:
GameCube
Wii
Switch

A brilliant new IP of the era, *Pikmin*'s take on the strategy genre was as whimsical and imaginative as it was tense and unsettling — a sophisticated adventure that spawned one of Nintendo's best series. With exceptional art direction and music alongside approachable yet deep gameplay, there are few games that define the GameCube console as well as *Pikmin*.

457

458

459

460

457
Pikmin
2001 (Japan)

459
Pikmin Disc
2001 (America)

458
New Play Control! Pikmin
2009 (United Kingdom)

460
Pikmin Disc
2009 (Europe)

VISIONS OF NINTENDO'S FUTURE.

words Abram Buehner

Imagine that you're in Tokyo. In the Shibuya Parco shopping centre, on the sixth floor. Nintendo Tokyo stands in front of you. Printed across the glass face of Nintendo's flagship store is a parade of the company's most important characters. As you'd expect, Mario takes the lead. Directly behind Mario is an Inkling from Splatoon, a series which sold more than 30 million copies across three entries in less than a decade. And behind the Inkling: two Animal Crossing characters — Isabelle and Villager.

During an Iwata Asks interview about *Animal Crossing: City Folk*, the wonderful former Nintendo president, Satoru Iwata, reminisced about first seeing *Animal Crossing* in 2001. It was then known as *Dōbutsu no Mori*, a Japanese-exclusive title slated for the Nintendo 64 Disk Drive add-on. "I remember this game which didn't demand expert gaming skills striking me as clearly being very original. Of course, I didn't imagine it was going to turn into a hit title selling five million copies, but I did think that there was something genuinely unique about it," he said.

A great bout of development telephone brought *Dōbutsu no Mori* in Japan from the ill-fated Nintendo 64DD to Nintendo 64 in Japan for its commercial release, gaining the status of last first-party title on the system. It was ported to GameCube in Japan as Dōbutsu no *Mori+*, then finally journeying overseas as *Animal Crossing*, before heading back to Japan on GameCube once more as *Dōbutsu no Mori e+* in a complex endeavour that saw bespoke iterations of essentially the same original *Animal Crossing* game hit various platforms and global markets. And yet its sales weren't pushing a collective three million.

But *Animal Crossing* was immediately important to its players. Like my friend Jonathan Holmes, who told me the following story:

"When I was a young man, head full of hair and heart full of love, I met a girl on a train. We became instant friends, asking each other questions at a rapid pace, shamelessly laying the groundwork for a small and sweet social adventure to come. Looking back on it now, it was a lot like the player's initial meeting with Rover in the opening moments of *Animal Crossing*. Little did I know, this game would later define our entire relationship.

I was poor back then, and my GameCube was broken in a way where it would overheat after loading for more than a couple of seconds. Because of its very small file size, *Animal Crossing* was the only game it would play. So it's all I played, and I played it a lot, with everyone who was willing to play with me. And thankfully, that included her. Before I knew it, I found myself walking across town from my little house to hers nearly every day of the week, holding my underdog console by the handle as I navigated the winding walkways.

These after work play sessions led to the inevitable smooches, but I still had no idea how she felt. When I asked, her face would turn red and she wouldn't say a word. Like an overheating GameCube, she was only able to process so much emotional data at a time.

Then one night, while she was totally absorbed in the game, shaking trees and catching bugs, I asked her if she loved me. She said something like "Well of course I do, you dummy!" All of her usual self-consciousness had been transferred to her concern for her in-game villager, leaving her flesh-and-blood self unfiltered and uncontrolled.

Shortly thereafter, in what seemed like an instant, she moved away. I wrote her letters, sent her gifts, and even caught her tarantula. She wrote back, said she missed me, said she cared, but that she couldn't come back. Not ever. And that was that.

photography Damien McFerran

I still have those letters, somewhere in my basement, probably in the same plastic bin as my old broken GameCube. But like the village on my *Animal Crossing* memory card, I can go back to that era in my mind at any time, all those thoughts and feelings stored cosy and tight inside my old heart and hairless head.

I really owe myself the trip."

Animal Crossing: New Horizons released in March 2020 to a world wherein everyone was trapped and uneasy. So we signed ourselves up for Nook Inc.'s Getaway Package. By the tens of millions. And in the years after — during which things didn't get much better — more than 40 million took their own trips into *New Horizons*.

We were all living preoccupied among nature and jubilant creatures. We were also living peacefully with each other. "I wanted to find a way to make people happy and feel a sense of community when we were all so isolated," Paige Broadhead told me. "So, I decided to throw an in-game carnival [in *Animal Crossing: New Horizons*], complete with dramatic costume changes, over 1,000,000 bells in prizes, and numerous fun activities for everyone to enjoy. I built a hedge maze with dead ends, obscured views, and pitfalls across one-third of the island. We played a *Holes*-inspired game of finding buried shells with fake dig spots on the ground, had a costume contest, and played hide-and-seek in the museum. So many people wanted to join in, it took me two whole days with two-hour slots to let everyone come. It was exhausting, but we had so much fun and everyone made new friends. It really meant a lot to me to be able to do something ultimately so small to give a lot of people joy when there was so little of it to go around."

To become the playground it is now, Animal Crossing had to overcome anxieties about whether games could succeed on the basis of this open-ended creativity, without a traditional framework. *Dōbutsu no Mori*'s Co-Director, Katsuya Eguchi, gave a robust GDC talk in 2006, shortly after the launch of the Nintendo DS title, *Animal Crossing: Wild World*. He discussed the philosophies at the heart of the series, returning to this point of development uncertainty.

Dōbutsu no Mori initially bore similarities to games like *The Legend of Zelda: Ocarina of Time*, when it was to be released as a showpiece for the Nintendo 64DD's unique capabilities. The concept was still communal, still interested in giving players space to connect. But the game was to be adventurous, goal-oriented. Its helpless protagonist would recruit animals like dogs and birds to solve environmental challenges — all in an adventure that featured dungeons and combat.

The development shift from Nintendo 64DD came with design concessions, which also resulted in a prioritisation of the values which now define Animal Crossing.

In a 2008 EDGE interview, Katsuya Eguchi said that the series "features three themes: family, friendship and community." Stripping away the traditional design framework of the action-packed original concept, these notions became central. The development team began ideating in a planning phase more concerned with psychology than with traditional game structures, reinforcing this trio of themes through a basis in personal communication.

Dōbutsu no Mori's philosophies and gameplay systems were based on practical human emotions — desires to compare unique experiences, desires to share in common moments. The series is inherently abstract, but yet intimately familiar. If you can get past the absurdism of a talking hamster in a t-shirt boasting about doing dumbbell curls, there is a universally understandable quality to the activities within Animal Crossing.

"I played it as an adult on the Gamecube," Steve Morton told me. "I was due to be away from home for a long weekend, so I gave my mum brief instructions on what to do about weeding and buying turnips [in-game]. When I returned home a few days later, she was hooked and ended up with her own village."

Satoru Iwata suggested that *Dōbutsu no Mori* "marked a milestone in deciding the [then] present direction of Nintendo." The Blue Ocean theory, which defined the Wii and DS era of the company, involved appealing to atypical players by designing intuitive hardware and software far different than the hardcore offerings of its competitors.

Take the Wii Remote, a device attuned to concepts that make implicit sense to non-gamers. You point it at the television like a TV remote and you gesture with it to emulate logical movements. There is no dissonance between pressing 'A' to swing Link's sword and him swinging it on screen, when you are actually swinging your arm in *Skyward Sword*.

Dōbutsu no Mori 's unconventional gameplay is similar when viewed from an intellectual, opposed to a tactile, perspective. Everything just makes sense. You wait for stores to open in the morning, you rush to get your shopping done before they close at night. You plant flowers, you buy a new couch for your house. You do little favours for your neighbours, you feel sad when they decide to move away. You tidy things up and invite your friends over. You spend your days without worry, without an oppressive routine and repressive social structures around you.

Tyenuki shared the following story with me:

"I met my partner of 14 years through Animal Crossing, which drastically changed my life. I've been a fan of Animal Crossing ever since the GameCube days, but it was *Animal Crossing: Wild World* on Nintendo DS that

was the truly life-changing game for me. In early 2006, we had just gotten Wi-Fi at home for the first time. My brother and sister and I were excited to play *Wild World* online with other people. We found an online Animal Crossing forum, Animal Crossing Community, and searched for people to play with. That's how my sister found Shadow from Arizona — their player and town name — and I caught a glimpse of her screen as she was visiting this person's town. What I saw was the most beautiful Animal Crossing town I had ever seen, covered by a custom path lined with gold roses. I immediately asked my sister to hook me up with this person so we could exchange Friend Codes and I could visit their town myself, but little did I know how life-changing this event would be for me.

I met this 'Shadow' and we instantly hit it off and became good friends. Before I knew it, they had become my best friend and we would play together every day and just talk for hours. I had never felt a connection quite like this to someone before — we had so much in common and they just understood me in a way that no one else did. Our bond only grew stronger and stronger over time (while our DS Touch Screens became more and more worn out from the constant typing to each other) and, barring a period where I was struggling with my own issues, we talked pretty much every day for years. I didn't realise it at the time due to having repressed my sexuality for a variety of reasons, but in hindsight I was totally in love, as were they. They helped me come around to accepting my queerness, and once that happened we immediately accepted our true relationship. That's when we 'officially' started dating.

This was in 2009, just as I was graduating high school. Home had become a hostile environment for me after my family found out about my queerness, and by that point I just needed to get out and desperately wanted to be with them. One problem — we lived on opposite sides of the country. But that didn't stop me from running away from home by sneaking out in the middle of the night with all the belongings I could fit in a suitcase and hopping on a plane to Arizona. Despite having never met in person before, we knew each other extremely well and had complete trust in one another by this point, so I wasn't worried at all. Though we had some troubles due to resistance by both of our families at first, everything worked out in the end."

To think that Animal Crossing's greatest strengths were once considered unpalatable, that a sandbox to coexist within wasn't enough unless there were creatures to slay. "I actually chose a GameCube specifically as my sixth-gen console immediately when I first saw *Animal Crossing*," Jordan Starkweather said. "I had just played my first Harvest Moon game and it left me asking 'Why aren't there more games where you can just live your life in peace?' Video games were already starting to become pretty homogenised. Drive the car, shoot the gun, use this universally-accepted input method to do the thing you're used to doing. *Animal Crossing* promised something truly different. Something genuinely ambitious. The idea that a video game came be about anything, even nothing."

Satoru Iwata suggested that "The first *Animal Crossing* title was released at a time when progress in game development was opening up a huge divide between highly-skilled game players and those who were much less proficient." Katsuya Eguchi and company realised that proficiency is a poor substitute for profundity. That people do play to connect. To be together. That something intuitive, something real could intertwine players the world over. That the biggest games in the world didn't have to look a particular way or subscribe to particular notions. These ideas, just five years later, would launch the Nintendo Wii.

461

462

461
Dōbutsu no Mori
2001

462
Animal Crossing
2001

XBOX.

words Liam Doolan

First Released:
2001

Manufacturer:
Microsoft

Launch Price:
JP ¥34,800
US $299
UK £299

Before the PC juggernaut Microsoft entered the market in 2001, home consoles hadn't truly succeeded in the world of online multiplayer. In most cases, the only social gaming experiences you had were with your immediate group of friends or family in the same room. And heck, Sony was still only offering a two-player option by default for local play in the early '00s. While you could sit and claim Sega's Dreamcast (powered by Microsoft Windows CE) technically did the whole online thing first, this concept wasn't fully realised due to poor system sales, so it never reached the mainstream masses like Xbox's original green machine did. Microsoft also played a significant role in popularising LAN play on console as it paved the way for online gaming — drawing from its success on PC with proven hits like *Age of Empires*.

Enter me, a diehard Nintendo fan in the late '90s. Unfortunately, the seemingly indestructible Japanese company fell from grace when the GameCube launched. It was even worse from my perspective, because I was the only person who owned a GameCube in my entire grade and perhaps the whole high school. The system sold 21.74 million units worldwide, so I'm sure I wasn't the only Nintendo loner out there. But even so, most of the kids in my class had already been ingratiated into the PlayStation family with series like Crash Bandicoot and Metal Gear, and I owned the weird-looking purple system that was more comparable to a Fisher-Price toy, or so I was told. I'd fought plenty of lunch time battles over the years, ruthlessly defending Mario and friends. But by the end of 2001, I was at my breaking point.

I remember going down to my local electronics retailer in the years leading up to Nintendo's sixth generation console release and seeing a dwindling collection of Dreamcast titles as Sega struggled to maintain relevance in the hardware space. It only got worse for the blue hedgehog's system when Sony's PlayStation 2 arrived

on the scene and became the hottest-selling item, partly because of its handy built-in DVD player. I never ended up getting a Dreamcast during these years — as much as I wanted to play *Sonic Adventure* and games like *Jet Set Radio* — and there was no way I was swapping to PS2, even if games like *Devil May Cry* looked utterly amazing. I was stuck with Nintendo's cube, and it just didn't *quite* deliver the same level of buzz as its predecessor.

Don't get me wrong, Nintendo's newest hardware had an outstanding first-party library. However, it was arguably downhill from there due to the lack of third-party support and the fact that PlayStation had already won before Nintendo was even on the starting line. In PAL regions, the GameCube actually released *after* the Xbox as well, so while I had committed to another generation of Mario, there was admittedly an instantaneous sense of regret when the hype for this new American gaming console reached fever pitch in the school yard.

Following Xbox's launch, the arguments with classmates quickly shifted from Sony and Nintendo to the new player on the block, along with its oversized hardware, now-famous Duke controller, and Spartan super soldier Master Chief. By the holiday season of the same year, Xbox had become a massive disruptor thanks to *Halo: Combat Evolved* and other platform exclusives. Nintendo had already well and truly lost this generation by then, falling back on the GBA, and although Sony was riding high on its pile of money, it now had a new, resourceful competitor that was showing interest in taking a sizable chunk of its mature audience while revolutionising the way console gamers play together.

The small team of masterminds behind the Xbox not only had the belief but also the foresight to see that online gaming could develop into a core experience on console. So, these same talented people pushed executives at Microsoft to fund a built-in Ethernet port to future-proof the

photography Damien McFerran

253

system for the rollout of broadband. Adding to this was the system's DirectX origin, which aimed to make creating games for this console easier than ever.

Xbox's Ethernet port and *Halo: Combat Evolved* proved to be the perfect combination, immediately igniting phase one of Microsoft's grander vision. And yes, while other companies like Sega had dabbled in online console gaming previously, Xbox's aforementioned inclusion of an Ethernet port from day one (as well as broadband support) was a massive upgrade from the dial-up days, and this simply revolutionised online console multiplayer.

Gaming with friends quickly transformed from split-screen affairs to LAN parties. Halo's first outing almost exclusively fuelled this and was immediately touted as the Xbox launch game you simply *had* to own. Linking your system to other units and playing with up to 16 Spartans in firefights across a battlefield — it was a blast in every sense of the word.

Similar scenes played out across the world. Friends and Halo fans in general would come together over a few days (or entire weeks) to play non-stop. It was these moments of pizza, corn chips and fizzy drinks that ended up making Bungie's first-person military sci-fi series a household name and one of the greatest video game franchises of all-time. Adding to this was a huge campaign and memorable quotes about Master Chief "just getting started," which also reinforced the fact Xbox was very much here to stay.

At this point, I couldn't resist the electric-green glow any longer. My brother and I had a friend who secured an Xbox at launch, and from there, word about this absolute beast of a console (not to mention Master Chief's mission to save humanity) spread far and wide across town. Hungry for a next-generation multiplayer shooter, we finally pulled the trigger. This was our first time ever owning a rival platform, and it really did give me a newfound appreciation for video games.

I can't count the amount of Halo LAN parties I participated in, each filled with heated moments, hysterical laughter and someone doing a Warthog manoeuvre that nobody else thought was possible. At the same time, I also went from being an isolated gamer to actually having a social life again thanks to Xbox. On weekends, I would hang out with mates and play *Halo* late into the night, and then head to school on Monday ready to do it all over again.

That's not to say there weren't other quality games on the Xbox. Microsoft's new hardware ended up being a gateway to more third-party titles for my younger self. Although I still hadn't properly experienced a 3D Sonic game at this stage, I was introduced to other modern Sega titles like *Jet Set Radio Future* and eventually the arcade racing hit, *OutRun 2*.

Xbox also had a selection of quality RPGs, ranging from *Star Wars: Knights of the Old Republic* to Bethesda's first Xbox release, *Elder Scrolls III: Morrowind*. And then there was FASA Studio's *Crimson Skies* and Lionhead's *Fable*. Even if it didn't live up to everyone's expectations or fulfil certain promises made by the ever-optimistic Peter Molyneux, *Fable* was one game that charmed my socks off with its infectious humour and those groundbreaking 'good' and 'evil' decisions that could impact your time in Albion. You could even get married and own a house! I still remember one friend describing the gameplay to me before I even knew what *Fable* was, and I was completely sold. And to top it off, you had other series like Project Gotham Racing, Dead or Alive and Blinx. Microsoft bolstered the system's library further down the line with games like *Forza Motorsport* and Rare's debut Xbox title, *Grabbed by the Ghoulies*.

However, it wasn't just Xbox's variety of games and exclusives in the spotlight. The major breakthrough for the system was the arrival of Xbox Live. That famous Ethernet port linked Microsoft's green army of gamers to the online world, and this was followed with the rollout of the Xbox Live starter kit: containing a basic headset and a subscription to the new online service. And yes, *you had to pay for it* — that was even a bit of a controversial decision within the walls of Microsoft. This was a new concept back then, but it was a model that the rest of the industry would eventually replicate.

As envisioned, online gaming was part of Microsoft's long-term plan for its console business. New users signed up to the ecosystem, created their own online alias in the form of a Gamertag and were welcomed into this exclusive worldwide club. While the service started off with some decent games like *MechAssault*, it was Bungie's seismic follow-up to *Combat Evolved*, *Halo 2*, that comprehensively sold the masses on Xbox Live — reinforcing Microsoft's position as a serious competitor in the console arena.

The combination of *Halo 2* and online play was unrivalled. After years of the original game's multiplayer, the second game took this sci-fi universe higher with a new arsenal, new mechanics, and a rich narrative. The sequel evolved the FPS genre on console and then took it to another level with online multiplayer, connecting Halo fans around the globe. It really was a moment in games history like no other, Xbox's vision of an online community on full display.

I took drastic measures to play *Halo 2* online, befriending someone from my school simply because he had access to Live before everyone else. I'm ashamed to say that I wasn't actually in it for the friendship. But that's just how keen I was for a fix when my family didn't have access to broadband yet. I recall the first time that I went over to his place to play against other Spartans online — it was truly wild and everything ran great.

463

464

465

466

463
Halo: Combat Evolved
2001

465
Xbox Controller – "The Duke"
2001

464
Halo 2
2004

466
Xbox Controller S
2002

xbox.

Dream On

Given that the Dreamcast ran a bespoke version of Windows CE, it's no surprise that Sega and Microsoft remained friendly after the Dreamcast went under. Jet Set Radio Future, the direct sequel to the 2000 classic, and Sega GT 2002 are perhaps the most iconic Sega games on Xbox. They were even pressed onto the same disc together late in 2002, sold as part of a hardware bundle that also included a Controller S.

467

468

As my video game magazines of the time told me, Halo was uniting gamers globally. This new online multiplayer model for Microsoft was proving to be a huge victory, and this social experience became revolutionary.

Microsoft's success on the console front snowballed, with Xbox Live becoming its defining feature — thanks in no small part to *Halo 2* and Bungie's blockbuster efforts. It made the Xbox a must-have console, despite its DVD playback functionality being behind PS2's (one of that console's major advantages). All Nintendo and Sony could really do was watch Xbox's online service break one subscription milestone after the other and take notes — once again reinforcing how pivotal the Xbox Live era was to the rest of the industry, changing console gaming forever. While it only sold a modest 24 million consoles worldwide, the original Xbox made an outsized impact.

I rode the Xbox bandwagon from the earlier years of high school until I graduated, and while I was still a Nintendo fan during this time, it was Xbox's networking abilities, Live service and Halo series that provided me some of my most memorable gaming moments because they were shared with others. *Halo 2* also announced itself as top dog to the rest of the entertainment industry — breaking records and being classed as the event of a lifetime by some diehard fans. The anticipation was off the charts and the launch ended up making a small fortune for Microsoft. All of this combined to lay the key foundations for modern gaming as we know it — continuing Chief and Cortana's space adventure while driving the online multiplayer boom.

On a personal level, the Xbox and Xbox Live vastly broadened my understanding of video games and the world around me — offering up all sorts of new and unmatched moments. My love of Halo has also stuck over the years, and the series has been a mainstay in my gaming schedule since the launch of the original title.

Without Microsoft's original system, home console gaming wouldn't be the social experience it is today. Xbox set solid foundations. The team behind it had enough knowledge and ambition to see the way the world was going in the new millennium and with Bungie's help, Microsoft was able to deliver a killer first-party exclusive in the form of *Halo 2*. It changed gaming forever, pushing online multiplayer into the mainstream and creating the company's most recognisable IP in the process. Microsoft needed a serious weapon to enter the console market, and it got just that, thanks to the success of Master Chief, the ingenuity on the Xbox Live and a simple Ethernet port.

467
Xbox Live Headset
2002

468
Xbox DVD Playback Kit
2002

469

470

469
Jet Set Radio Future
2002

470
Sega GT
2002

xbox.

257

A Rare Appearance

After Microsoft purchased longtime Nintendo partner Rare in 2002, the acclaimed studio made two appearances on the original Xbox. The first was 2003's Grabbed by the Ghoulies, and the second was Conker: Live & Reloaded. The former began life on GameCube but was retooled for Xbox, whereas the latter was a remake of the raunchy N64 favourite, Conker's Bad Fur Day.

471

472

473

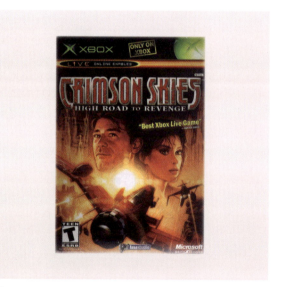

474

471
Star Wars: Knights of the Old Republic
2003

472
Jade Empire
2005

473
Forza Motorsport
2005

474
Crimson Skies: High Road to Revenge
2003

A Galaxy Far, Far Away

The sixth generation was perhaps the greatest era for Star Wars video games, and BioWare's Star Wars: Knights of the Old Republic is often considered to be among the very best of that bunch. But it wasn't the only Xbox-exclusive Star Wars game, as that list also includes titles such as Star Wars: Obi-Wan and Star Wars: Republic Commando.

475

476

477

478

475
Conker: Live & Reloaded
2005

476
Fable
2004

477
Elder Scrolls III: Morrowind
2002

478
Blinx: The Time Sweeper
2002

JADE EMPIRE

Developer:
BioWare

Publisher
Nintendo

Release Year:
2006

Available on:
Xbox
Windows, Mac, iOS, Android

BioWare's crowning achievement on the original Xbox is doubtlessly *Star Wars: Knights of the Old Republic*. However, its mythological epic which succeeded it, *Jade Empire*, is no less deserving of recognition. Its action-RPG framework is complete with the sorts of complex narrative choices which defined its Star Wars predecessor — all set within a rich mythological world.

480

479

481

479
Jade Empire
2006 (America)

480
Jade Empire Limited Edition
2006 (America)

481
Jade Empire Disc
2006 (America)

STEEL BATTALION

Developer:
Nude Maker, Capcom Production Studios 4

Publisher
Capcom

Release Year:
2002

Available on:
Xbox

Hifumi Kono's *Steel Battalion* has a reputation for its particularly hardcore tenor — take just one look at its mammoth, mega complex controller's many buttons, pedals, switches, and sticks if you need proof. But that's what makes *Steel Battalion* such an essential mech game. The incredibly thoughtful design puts you in the cockpit and has attracted a dedicated following which has persisted well beyond the series itself.

482

483

484 .

482
Steel Battalion
2002 (America)

483
Steel Battalion
2002 (UK)

484
Steel Battalion Disc
2002 (America)

THE STORY OF GENERATION 7.

words Ashley Esqueda

As March 2005 began, Sony sat atop its throne and enjoyed its position as champion of gaming's sixth generation. The PlayStation 2 had sold over 87 million units to date, and would go on to become the best-selling console of all time — a record the PS2 still holds today. The modern console wars had officially begun: Microsoft was looking to expand its footprint in gaming after the modest success of the first Xbox; meanwhile, Nintendo's then-President Satoru Iwata had made some grandiose-but-vague statements about its next-generation hardware at E3 2004, saying "Nintendo is working on our next system, and that system will be a gaming revolution." It was time for each company to show their hands and reveal their newest consoles. They would all converge in a single moment: E3 2005, which quickly became one of the wildest, most exhilarating industry conferences in video games history.

Xbox was practically bursting with enthusiasm and optimism about its successor to the Xbox and decided it needed more than demo booths at a trade show; it wanted to speak directly to the youths. And so, with YouTube.com in its infancy (having just gone live a few months prior), Microsoft opted to reveal the Xbox 360 in a 22-minute long MTV broadcast special on May 12th, 2005 — almost a full week before E3's scheduled press conference day — to try to get ahead of the buzz its competitors were sure to generate once E3 began. "MTV Presents Xbox: The Next Generation Revealed" remains a perfect relic of its time: Elijah Wood as the host, performances by The Killers, a myriad of mid-'00s b-listers spouting marketing messaging, and an ironically prescient focus on the Xbox 360's now-ubiquitous 'ring of light' design concept during a hardware tour segment.

Unfortunately, the special ended up being largely mocked as a grossly corporate infomercial, sucking some of the wind out of Microsoft's sails as it kicked off E3 with a press conference that didn't contain any new information or surprises. That loss of momentum was made worse when Sony's PS3 reveal event went straight for Xbox's jugular later the same day, showcasing jaw-dropping graphical prowess, 1080p output (higher than every other console at the time, including the Xbox 360's planned 1080i resolution), and a radical, dramatic controller prototype that was quickly nicknamed 'the boomerang.' And not only was the PS3 ready for next-gen, it was backwards compatible with the two hardware iterations before it, meaning there would be thousands of titles available at launch. Compared to Microsoft, which opted to only make some of its best-selling titles backwards compatible, Sony had 'won' the battle in the eyes of most gamers.

After Iwata's bold proclamations a year prior, everyone was curious and excited about what Nintendo would announce the day after its competition. However, instead of going into detail about its newest console, the company chose to once again remain vague about almost everything. Iwata referred to the console by its codename 'Revolution,' remaining tight-lipped on specs and performance, and did not show any game footage captured natively. The controller for this new device was also conspicuously absent, leading many to feel deep disappointment in Nintendo's showing — creating far more questions than answers after the event concluded. While we now know the outcome of what would eventually become the Wii, at the time, it seemed like Nintendo wasn't quite as confident in its hardware or its capabilities as it claimed to be.

Even though it would have an almost yearlong head start, Xbox still eventually had to face its competitors at retail. And if E3 2005 was a digital earthquake felt around the globe, E3 2006 proved to be an almost-equally powerful aftershock by its own merit, one that altered the course of games history forever.

photography Damien McFerran

263

485

486

487

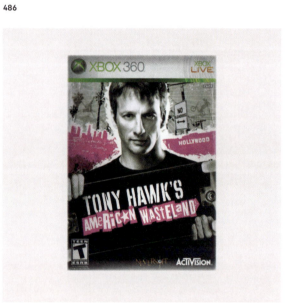

488

485
Super Mario Galaxy 2
2010

487
The Legend of Zelda: Skyward Sword
2011

486
Ridge Racer 7
2006

488
Tony Hawk's American Wasteland
2005

In a move that seemed incomprehensible at the time, Sony's E3 2006 press conference was jam packed with cringe-inducing, meme-worthy moments and disappointing information. Though it tried to claim the next generation of gaming didn't officially start without PlayStation, it certainly had (Xbox 360 had already launched) — giving the impression the company was too flippant about its competition. Sony also backpedalled on the radical design of the prototype controller it showed off a year prior, revealing an official controller that looked almost identical to the PlayStation 2's. But its biggest stumble came at the end of the show: a pricing announcement that, to Microsoft's shock and delight, set off a firestorm of criticism from consumers and the press alike. The PS3 would cost $499 for the 20GB model, but the real story was the $599 price tag for the 60GB model — a whopping $300 more than the PS2's launch price. That number surprised even Microsoft executives, who had launched the Xbox 360 at $299 and $399 for its respective base and premium models. They would gain a foothold this generation by attacking Sony on price, directly appealing to the wallets of working class parents and young adult gamers.

After its bland showing the year prior, and an eyebrow-raising controller reveal nine months afterward (which left many questioning what the company was doing), the pressure was on Nintendo to show something truly spectacular at E3 2006. It did not disappoint. While Sony's press conference that year is remembered for its stumbles, Nintendo's will go down as one of the all-time greats. The company veered sharply away from the skirmishes between Sony and Microsoft, choosing to simply do whatever felt was exciting to itself. The event kicked off with Shigeru Miyamoto taking the stage in a formal white tie tuxedo and conducting an orchestra to play a theme from The Legend of Zelda, using a Wii Remote held in a single hand. 'Playing is Believing' was the motto of the day, and articles about the inherent fun factor of the Wii, its low barrier of entry (everyone could find something to enjoy), and the joy of playing motion-controlled titles quickly spread like wildfire. The Wii captured the imagination of the gaming collective. Even though a price wasn't officially announced until later that year, Nintendo strolled out of E3 2006 as the winner of the show in a massive upset nobody saw coming. There's simply no way words can describe the electric energy coming from its booth at E3 that year; you had to be there to experience and understand it. People waited hours in line to use the Wii Remote the way Miyamoto had, and they left Nintendo's booth at the Los Angeles Convention Center with a sense of childlike whimsy and sheer joy from what they'd just experienced.

It's wild to reflect on the Xbox 360's November 22nd, 2005 launch in the United States and Canada. It featured 18 physical launch titles (plus 10 Xbox Live Arcade games), including Call of Duty 2, Ridge Racer 6, and Tony Hawk's American Wasteland. Demand for the console was high, but instead of enjoying 12 months of unopposed sales, Microsoft spent most of 2005 struggling to keep up with rabid consumer demand — leading some community groups to theorise the company had intentionally created scarcity as a sales tactic.

And then came one of the biggest fumbles in games console history.

Early on in the Xbox 360's life cycle (around Q4 2006), there were reports of a technical issue that prompted the console's power light ring to turn an ominous red, indicating a general hardware failure. Microsoft's Windows software had the well-known 'Blue Screen of Death,' and so the natural nickname for the company's console error light came easy. Gamers quickly dubbed it the 'Red Ring of Death,' or RROD.

Engineers worked tirelessly to pinpoint the issue, but could not figure out exactly what was happening to fully brick units. By the end of 2007, the problem became so pervasive that some surveys suggested overall failure rates of more than 50% of Xbox 360 consoles. Microsoft eventually had to completely shut down production of its console to solve the problem, extend existing warranties by three years, and offer shipping and full repairs for every customer. It was a misstep that could have ended Xbox. Instead, Microsoft's then-CEO Steve Ballmer gave a thumbs up to doing right by its customers and sticking beside the brand, to the tune of $1.15 billion in costs for the company. It was a decision that could've easily gone the other way, with Microsoft opting to shutter Xbox entirely, focusing on PC gaming and Windows Marketplace. Fortunately, we live in a timeline where that didn't happen. For the first half of generation seven, the Xbox 360 was winning the fight for the hearts and minds of console gamers. However, the back half of the generation found Xbox executives too complacent, as well as too interested in trying to wrestle market share from the iron grip of Nintendo with the interesting-but-unfortunately-doomed Kinect accessory.

Ultimately, by the time the Xbox 360 ceased production in 2016, it had sold around 84 million units, cementing the Xbox brand as a worthy long-term competitor to Sony and Nintendo. The console also bet early (and big) on a turn towards digital distribution — not to mention its continued efforts from the original Xbox to expand and push the limits of online multiplayer gaming via Xbox Live — marking massive trajectory shifts in the industry that continue inspiring corporate games strategy to this day.

Meanwhile, Sony was facing intense industry-wide (and self-imposed) expectations after the PlayStation 2's explosive success. How could the PS3 possibly clear the incredibly high bar its own predecessor had set? After its somewhat disappointing showing at E3 2006, the success of the PlayStation 3 looked less and less like a sure thing, especially when compared to the Wii's radical

new hardware and the Xbox 360's cutthroat pricing and year-long headstart on sales.

The PlayStation 3 launched in North America on November 17, 2006, with the same pricing it had announced at E3 earlier that same year. If the Xbox had solid online multiplayer titles and the more attractive price point — and the Wii had the casual market cornered with its family-friendly 'revolution' — then the PlayStation would have to lean on the versatility of its Blu-Ray capable optical drive and the quality of its launch titles. But the PS3 hit retail alongside just 14 games on launch day, with almost half of them either sports or sports-adjacent titles like *Madden NFL 07* and *Tony Hawk's Project 8*. Developers privately lamented that it was simply more difficult to develop games for the PS3's architecture compared to the Xbox 360's, making Sony focus even more on ensuring the exclusives it did have were good enough to convince gamers to shell out $600 for a console.

The well-reviewed *Resistance: Fall of Man* from Insomniac, as well as new instalments from the Ridge Racer and Call of Duty franchises helped prop up the PS3's initial sales numbers while other launch window titles and big exclusives made their way to the system over time. But the true shift in the PS3's fortunes came alongside two major updates: the launch of Trophies in 2008 as an answer to the Xbox 360's wildly popular Gamerscore Achievement system; and the launch of the PS3 Slim at a $299 price point. The massive drop in price made the console an incredibly attractive proposition for consumers, particularly when bundled with blockbuster titles from franchises such as Uncharted and Final Fantasy. Units were flying off the shelves throughout the 2009 holiday season. By the end of its production cycle, Sony had reversed its fortunes and (by some estimates) managed to squeak out ahead of the Xbox 360 with around 87 million units sold. But none of these numbers really matter, because the Nintendo Wii entered the market a week after the PS3 and plunged the entire globe into a weird, wild new era of gaming.

The Cinderella story of generation seven, the Wii re-established Nintendo as a (tri)force to be reckoned with, selling over 101 million units in its lifetime — absolutely dominating the market in a way many didn't think was even possible with three major console manufacturers competing for customers. Families on a budget found the Wii to be the clear winner on price (launching in the US at only $249.99) and variety of titles. The Wii Remotes were a huge hit with even the most casual players, and Nintendo had struck a long-dormant community desire for whimsy.

While Xbox and PlayStation offered up 'hardcore' experiences through Gears of War and Resistance, Nintendo continued forging its own weird, wondrous path with simple, easy-to-play games like *Wii Sports* and *Wii Play*. Anecdotally, most gamers with a Wii considered it

so completely different compared to the Xbox and the PlayStation that it was its own value proposition. Often, you'd visit a friend and find a Wii plugged in alongside either an Xbox 360 or a PlayStation 3. The Wii was the must-have console, and your choice between the other two was down to your personal allegiance in the PS3 vs. Xbox 360 console war. The Wii wasn't a participant in this generation's battle at all. Somehow, it became such a juggernaut that it transcended the skirmishes happening on the ground between Sony and Microsoft and soared alone in the skies, completely unbothered by the tiny battle being waged below.

This generation of consoles brought with it a veritable embarrassment of riches: new IP designed to push the technical capabilities of each console to its limits, fresh takes on classic characters and beloved franchises, an explosion of indies, and a mountain of ideas built upon the fad foundation of motion controls.

Microsoft leaned into its infrastructure when developing exclusive titles for the Xbox, focusing on robust features for its user base, not to mention more stable online servers — a critical component of multiplayer requiring massive amounts of optimisation due to bandwidth capabilities of the time. There were some killer franchises launched on the platform too: Gears of War, Mass Effect, Crackdown, BioShock, Alan Wake, Dance Central, Left 4 Dead and more all originally launched as exclusives and directly contributed to the overall success of the Xbox 360, with most of these becoming massive franchises that live on today and continue to influence their respective genres, even if their sequels didn't remain exclusive. Speaking of sequels, the Xbox 360 also managed to host a slew of excellent instalments in wildly popular Xbox franchises like Halo, Forza, and Fable. In a strategic move that continues to bear fruit to this day, Xbox also made great efforts in the Xbox Live Arcade service, a home for both major and indie game developers to launch smaller, downloadable games — a progenitor to the ID@Xbox program that helps independent publishers get their games visibility through Xbox Game Pass. Titles like *Hexic HD*, *Limbo*, *Braid*, *Fez*, and *Shadow Complex* were all part of the service, giving users a new way to discover unknown gems and try something they might not have, if it meant paying for a standalone, full-price game.

Sony, on the other hand, found itself at the bottom of an uphill battle to win over consumers. It needed to build a path littered with exclusives to lure buyers over to the PS3 side of the equation, and it attacked that strategy with all the energy it could muster. The list of exclusives initially launched on the PS3 is borderline obscene: *LittleBigPlanet*, *Metal Gear Solid 4: Guns of the Patriots*, *Demon's Souls*, *Resistance*, *inFamous*, *Uncharted 2: Among Thieves*, *God of War 3*, *The Last of Us*, *Twisted Metal (2012)*... the list goes on, and on, and on. Despite the initial collective baulking at the console's $599 price point, when the PS3 Slim launched, it launched

alongside a stacked library of genre-defining games that made the refreshed hardware a no-brainer for anyone who'd previously been on the fence. The extent of Sony's PS3 exclusive catalogue was likely the biggest contributing factor to its stunning turnaround in the second half of this generation, and that trend continues as Sony has since maintained this exclusives-first strategy.

The Wii did not have the kind of power to compete with the technical prowess of the PS3 or the Xbox 360, but it did have two things Sony and Microsoft did not: radical new hardware that put motion control at the forefront of gameplay, and a team of ubiquitous mascots so rich with history and so well-known that a new game from any one of them would move consoles like hotcakes. Nintendo put those two unique advantages to good use. It created blockbuster first-party titles that are often referred to using terms like 'groundbreaking,' 'genre-defining,' and 'best-in-class.' *Super Mario Galaxy* and its sequel are considered the pinnacle of modern platformer games; *The Legend of Zelda: Skyward Sword* made swinging Link's weapon an immersive, active experience; *Metroid Prime 3: Corruption* is simultaneously regarded as one of the Wii's best games, and also one of the best in Metroid's entire history. All these critically acclaimed Ninten-darlings don't hold a candle to *Wii Sports*, though, which is the fourth best-selling game of all-time with 82.9 million copies sold. The only games with more copies sold are *Tetris* (a mobile version of a puzzle game created and enjoyed in various iterations since 1985); *Grand Theft Auto V* (a game with ongoing online support and launches across three different console generations and PC); and *Minecraft* (a sandbox game available on just about every platform imaginable with its own metaverse). With 101 million consoles sold, *Wii Sports* had an astounding 82% attachment rate to the sole console on which it was available, meaning eight-in-ten people who bought a Wii also bought *Wii Sports*. For a little added context, the second-best selling game in Wii history was *Mario Kart Wii*, and it didn't even sell *half* of what Wii Sports did, with a still astonishing 37.38 million copies sold. And if you really want your mind blown, consider this: *Wii Sports* sold more than *Mario Kart Wii*, *Super Smash Bros. Brawl*, *Super Mario Galaxy*, *Super Mario Galaxy 2*, *The Legend of Zelda: Twilight Princess*, *The Legend of Zelda: Skyward Sword*, and *Metroid Prime 3: Corruption*... combined!

By the end of generation seven, the entire industry had been shaken up. Nintendo was on top of the world, enjoying success that had been unimaginable to it just ten years prior, working on what it felt confident was a killer followup to the Wii. Xbox was licking its RROD wounds, wondering what had gone wrong after the launch of the Kinect and making plans for its next console to expand on the self-proclaimed 'digital revolution' it had launched in 2005. Sony had emerged barely victorious after a generation of painful lessons learned and a dramatic comeback in the second half of the PlayStation 3's lifespan. But, much like this generation of consoles, *nobody* could have predicted how generation eight would unfold, and where each corporation would stand when the fog of war had abated.

Casual Conducting

Nintendo did finally allow players to conduct at home like Mr. Miyamoto did at E3 2006... but the results weren't as rosy. Wii Music is perhaps the most infamous entry in the 'Wii' series. While it's amusing to pantomime playing an instrument for a few minutes, there just isn't much depth or content — plus there's an inherently meme-worthy quality to the whole game. Wii Music is good for a laugh, but not for much else. It's no Wii Sports!

489

489
Wii Music
2008

Something for Everyone

The power disparity between Wii and its HD counterparts resulted in a lot of creative thinking when it came to cross-platform releases. In the case of more casual or lower fidelity software, all three platforms often got the same (or nearly the same) game. However, when Capcom was gearing up to launch Resident Evil 5 for example, the company couldn't just drop that game onto Wii. Instead, Nintendo's audience received the excellent light gun game, Resident Evil: The Darkside Chronicles! Ubisoft did something similar, launching Far Cry Vengeance on Wii ahead of Far Cry 2 on other platforms. Creative compromises and bespoke, complementary releases were the theme of the era.

490

491

492

493

490
Far Cry 2
2008

491
Far Cry Vengeance
2006

492
Resident Evil 5
2009

493
Resident Evil: The Darkside Chronicles
2009

Despite the power issues, everyone still wanted a piece of Wii's success. Games like Capcom's Monster Hunter Tri represented what an ambitious, uncompromised Wii exclusive could look like, while Activision's Goldeneye reboot played on decades of nostalgia. When it comes to games like Lego Indiana Jones or Silent Hill: Shattered Memories though, sometimes the goal was just to get something out on the most popular standard definition systems — the PS2 and Wii.

494

495

496

497

494
Monster Hunter Tri
2009

496
Lego Indiana Jones
2008

495
Goldeneye 007
2010

497
Silent Hill: Shattered Memories
2009

XBOX 360.

From the day I was first handed a console controller, I was destined to be a Sony fan. From the early PS1 days to the PS5 era and my pursuit of games journalism — gaming has been synonymous with Sony. So, of course, when asked if I wanted to take part in this book, there was really only one console I wanted to talk about: the Xbox 360!

First Released:
2005

Manufacturer:
Microsoft

Launch Price:
JP ¥37,900
US $399
UK £279

The Xbox 360 launched in the US in November of 2005, categorically ending a half-decade of PS2 domination. The Xbox 360 was a tale of being in the right place at the right time — launching a year before its competitors. Yet, despite its launch hype, I remained oblivious. I was probably busy playing something like *Star Wars: Revenge of the Sith* on PS2, as I wouldn't get my very own Xbox 360 until much later.

I had been an avid gamer for most of my childhood. During the mid-'00s when my friends were playing *GTA III* or *Bully*, I was honing my craft in *Spy Vs. Spy*, *007: Nightfire*, *Cel Damage*, and even *Shark Tale* — yes, 'Will Smith is a fish' *Shark Tale*. Having a brother three years my junior, my parents weren't *quite* ready for us to make the jump to digital crime and brutal acts of murder.

Truthfully though, we didn't know we wanted to make that jump anyway. It would be a few more years until I discovered YouTube as my internet access was limited. So, I hadn't even heard of a series like Grand Theft Auto — boosting my brother to reach my dad's copy of *Call of Duty: Finest Hour* from atop his cupboard was the wildest my younger gaming years ever got. I still remember playing through that opening Stalingrad mission like the police would bust down the door at any second.

However, my comfortable gaming bubble was about to burst as I progressed to high school. There, I discovered a wider gaming world that I'd been missing out on, and my lack of knowledge quickly labelled me an outsider. While everyone spoke of their summer *GTA IV* sessions on 360, I remained a passive listener with no means of contributing to the conversation. At 13 years of age, this talk was all-consuming and my requests for a PS3 quickly shifted towards Xbox instead.

After months of wishful thinking (and a fair share of begging), Christmas 2009 arrived and before me sat my very own Xbox 360 Elite. My excitement was mountainous. With its matte black design, shiny 128GB of storage, and a controller that felt tailor-made to my hand, it was one of the most beautiful things I'd ever seen — a gift I couldn't believe I'd actually received. It felt futuristic in a distinctly 2009 sort of way, with its curvy design and iconic green glow from the power ring. Along with it were copies of *Forza Motorsport 3*, *Need For Speed: Shift*, *Modern Warfare 2*, and *Assassin's Creed 2*. Suffice it to say, Christmas day and the subsequent holidays were spent rinsing through these games. *It was glorious*.

I felt like I'd won the lottery as soon as I booted up the Animus for the first time in *Assassin's Creed 2*. On a purely technical level, this was something else. Graphics, music, and even voice acting were now movie-quality in my eyes, and the tech enthusiast in me awakened as I played through an HDMI connection for the first time.

From an entertainment perspective, it was an eye-opening experience. Becoming emotionally invested in a game's campaign wasn't something I imagined was possible. It was as if during the years I'd spent with co-op party games and ancient split-screen shooters, gaming had grown up. I was now immersed in mature stories with deep subject matter and gripping direction.

271

Undoubtedly, that had already been the case for some time. Nonetheless, the seventh generation ushered in a new age of video game storytelling. Visuals reached a new level of nuance on 360 — physicality and detailed character models meant that direction and intent were a lot clearer. The floodgates had been opened for developers to expand and innovate the methods of narrative delivery, and I was there for the ride.

I felt like a new man as I returned to school after the holidays. Most of the lads had gotten their copies of *Modern Warfare 2* and *Assassin's Creed 2* also, and we spent weeks chatting about the tragedy of Ezio Auditore, or how shocking that No Russian mission was. The palpable passion that reverberated through classrooms and corridors made gaming feel like *the* most exciting medium. And that sense of communal enthusiasm was elevated onto another plane when someone asked for my Gamertag.

Online gaming up until this point for me had meant *Mario Kart Wii*, so the switch to the infamous *Call of Duty* lobbies was quite the awakening. While spending every week night and weekend trying to race through Prestige ranks or best each other in games of Mike Myers, I began to make friends with more people in my year and generally have a bit more confidence at school. I was finally a part of the club I'd been missing out on for years.

And I wasn't the only one. The online boom of the 360 era introduced an entire generation of gamers to multiplayer. While the Halo series and earlier Call of Duty entries had laid the foundations for online console multiplayer, more and more games were pushing boundaries in the 2010s — just a few years later titles like *Destiny* would introduce themselves. Multiplayer was all the rage. Like many, I was trading in old games to afford the cutting edge Microsoft Wireless Network Adapter and a fresh set of Turtle Beach headphones.

However, although this exciting frontier that had swept me up wholeheartedly, it wasn't all sunshine. As the weeks and months went by, I was steadily exposed to the darker side of online gaming. Our Xbox parties were filled with relentless slagging that continually went too far, whether that be from friends or randoms in our lobby. Attention eventually turned to the scoreboards, so suddenly there was pressure to perform. As someone that desperately wanted to fit in, my inability to conquer leaderboards got to me — especially if it was brought up at school the following Monday.

In time, fun became replaced by anger and frustration. It was like my teenage social life depended on playing well; like I wouldn't have a person to call friend if my prestige rank wasn't up to scratch. I became erratic and agitated at home without even realising why. As online competitive play steadily gripped the mainstream more tightly, I'd wager I wasn't the only one to feel the effects

of this new addiction. We'd entered the big leagues in the deep end. I wasn't playing because I wanted to, but because I *needed* to.

Thankfully, my pocket money couldn't sustain my unhealthy relationship with competitive play when the first wave of DLC released for *Modern Warfare 2*. I was busy saving for my first big release as a newly minted Xbox player: *Red Dead Redemption*. The fear of missing out was too strong. Having a moment of respite forced upon me, I reminded myself of why I was playing at all — an epiphany coming alongside my first truly open-world experience.

Taking to the dusty trails as John Marston was borderline therapeutic. This was a *big* game, and it was exciting to be a part of the collective excitement I'd missed out on with Rockstar's previous marquee releases. Exploring towns like Armadillo, Blackwater or the McFarlane Ranch was like taking a western retreat, and I could already feel the pressures of *Modern Warfare 2* fade away. Basking in those HD graphics, it was the first time I remember a game fully capturing the essence of a setting. Through its sound design and visuals, the Xbox 360 realised a digital world in a way we had never experienced.

My *Red Dead* renaissance only amplified as its online portion launched, a multiplayer offering that didn't focus on performance or levels. Instead, it was all about having fun with your friends in an awesome cowboy sandbox. I don't think I've ever laughed as hard as when myself and a couple of friends were ravaged by grizzly bears in Tall Trees. It was a counterpoint to the multiplayer experience I'd been exposed to since first becoming an Xbox player.

By the time *Call of Duty: Black Ops* launched in November of 2010, the Xbox 360 I'd received 11 months prior was no longer a means of fitting in, but a vessel through which I could travel to other worlds. I was still an ardent fan of FPS titles from then on out, but now that I was 'in' with the gaming crowd, I truly wanted to educate myself. The independence that this era of gaming served me was invigorating. I felt like an adult as I soaked up every major release that *I* wanted to play (and could afford), rather than my library being dictated to me. That chunk of plastic steadily became a beacon of freedom.

My sophomore year as an Xbox player saw titles like *Batman Arkham City*, *Dead Space 2*, *Portal 2*, *Alan Wake* and *L.A. Noire* come and go. An ill-conceived policy at the local GAME meant I could buy and return any title in exchange for a new release within 10 days. I am ashamed to admit that I managed to play my way through the majority of 2011's big releases from one purchase... before the higher-ups finally realised what was going on. My Xbox 360 was like a library, giving me a new setting, story, or set of mechanics to study each week. I couldn't get enough. My previously destructive addiction had

The Xbox 360 had no shortage of excellent limited edition consoles and controllers. Most tied into marquee series like Halo, Fable, and Gears of War, but major third party releases such as Modern Warfare 3 and Kinect Star Wars received the same treatment. In addition to aesthetic variants, the 360 received in the form of 2011's 360 S (the base model for most limited edition systems), and 2013's 360 E, which resembled the Xbox One.

498

499

500

501

498
Halo 3: ODST Limited Edition Controller
2009

500
Halo Reach Limited Edition Controller
2010

499
Halo 3 Limited Edition Controller
2007

501
Fable 3 Limited Edition Controller
2010

xbox 360.

502

503

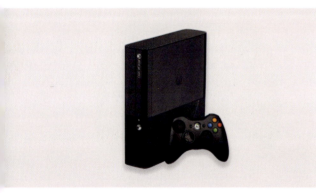

504

502
Xbox 360 Core
2005

503
Xbox 360 S
2011

504
Xbox 360 E
2013

turned into something positive and enlightening — and in my mind I had plenty to catch up on.

It was in this period that my passion for gaming really stepped up a notch. In the waning years of the seventh generation, I was no longer some outsider but instead an enthusiast that always had a new game in progress. Since I joined halfway through the 360's lifecycle, it was easy to pick up second-hand games on the cheap. From *Mass Effect 2* to *LOST: Via Domus*, there was no stopping me. The social aspect of gaming had also crept its way back into my life. A handful of equally passionate players would now come over for Friday playthroughs of titles like Telltale's *The Walking Dead* or *The Wolf Among Us*. This was where the system's detachable storage came in handy too, as I could snatch it straight from my 360 Elite and take it over to a friend's house, picking up right where we left off.

And then we reached the console's final year swan song: *BioShock Infinite*. The BioShock series was surprisingly one that had passed me by, but my sights were firmly set on its third entry. As I ascended to the streets of Columbia and witnessed the atrocities of its people, to me it was the pinnacle of video game storytelling. Its visuals were immaculate, its narrative multi-faceted. I was utterly dumbfounded that a game could be this engrossing. It represented the medium's growth in my eyes, as well as my deepening ability to interpret and analyse. I remember sending reams of text to friends explaining how it was one of the greatest games ever made. Funnily enough, I'd be doing the same thing three months later, after playing through *The Last of Us* for the first time.

However, my time with the 360 had come full circle before I'd taken on the role of Booker DeWiit. The year prior, my brother had finally been deemed old enough to join me in the realms of Xbox 360. While my love for the medium flourished during this era, the foundations were laid during our co-op sessions on the PS2. That was the first time I'd bonded with someone over games, after all. It meant the world to be sitting shoulder-to-shoulder with my brother once more, and the 360 would be home to our first *Battlefield* session together — a tradition that's alive to this day.

In my 24 years of gaming, just four were spent with the Xbox 360. Yet despite the Sony-centric past and future that surrounded it, this remains the most influential era of my time in the space. It was my first opportunity to dive headfirst into a new passion — one that felt like it was growing up alongside me. And despite a tumble through my tumultuous teens, it proved and reaffirmed the social power that gaming had. I might not have started my 360 crusade for the right reasons, but damn, was it a journey worth going on.

505

506

507

Signs of the Times

Nothing says 'mid-2000s' console like a standalone HD DVD player and a detachable controller keyboard. The Xbox 360 was very much of its time, even with the Kinect — a device somewhere between the EyeToy and Wii Remote in concept. One part trend capturing and one part visionary, this late-gen idea had its time in the motion-gaming sun before becoming the object of people's ire during the Xbox One generation.

505
Xbox 360 Messenger Kit
2007

506
Kinect
2010

507
Xbox 360 HD DVD Player
2006

xbox 360.

508

509

510

511

508
Halo 4 Limited Edition Xbox 360
2012

510
Call of Duty: Modern Warfare 3 Limited Edition Xbox 360
2011

509
Gears of War 3 Limited Edition Xbox 360
2011

511
Kinect Star Wars Limited Edition Xbox 360
2012

Although there is clearly homogenous design uniting a lot of the seventh generation's blockbuster software, this era also brought gems like Alan Wake to market alongside experiments from s-tier studios, like Rockstar Games' glamorous and highly-publicised period detective drama, L.A. Noire.

512

513

514

515

516

517

518

519

516

520

521

522

523

520

512
Alan Wake
2010

513
Call of Duty:
Modern Warfare 2 2010

514
Assassin's Creed II
2009

515
Red Dead Redemption
2010

516
Dead Space 2
2011

517
L.A. Noire
2011

518
Mass Effect 2
2010

519
BioShock Infinite
2013

520
The Walking Dead
2012

521
Batman: Arkham City
2011

522
Portal 2
2011

523
Forza Motorsport 3
2009

FINISHING THE FIGHT.

words *Brendan Hesse*

Few things are more synonymous with '00s-era gaming than the midnight launch party. While midnight releases were common in the decades preceding, they saw a burst in popularity during the sixth and seventh console generations thanks to franchises like Grand Theft Auto and Call of Duty broadening the medium's appeal beyond its relative niche of the '80s and '90s — into a massive, new market that rivalled other forms of entertainment. As the audience expanded, the lines at midnight launches grew longer and longer for each new, highly-anticipated game. And though the '00s saw many record-setting launch nights, one of the biggest was *Halo 3*'s.

"I always think of that midnight launch as the end of my childhood, so I have a lot of reverence for it," says Jacob McCourt of Ontario, Canada. McCourt is one of the thousands of Halo fans around the world who attended the *Halo 3* midnight launch on September 25th, 2007. Like many launchgoers, McCourt and his friends lined up early at their local game shop in hopes of securing a good spot in line. A local LAN cafe had set up generators and consoles in the parking lot for attendees to play multiplayer matches while waiting for the store's doors to open.

Similar *Halo 3* midnight launch events were held at over 10,000 retailers around the world that night, and expectations were high for one of the biggest media launches in history. *Halo 2* had made over $125 million USD in the first 24 hours after its November 2004 launch, and thanks to the explosive popularity of Microsoft's Xbox 360, *Halo 3* was projected to surpass those sales, racking up over 1.5 million pre-orders ahead of launch. While crowds lined up in excitement for the game, the folks who made it were planning their own celebration — and it all started with a premonition.

"One of the artists came to me and said he had a dream that Bill Gates would be at our launch party," recalls Marty O'Donnell, the co-composer of *Halo 3*'s iconic soundtrack. O'Donnell had worked alongside Bungie as a third-party contractor starting with 1997's *Myth: The Fallen Lords*, composing the soundtracks for its games, including the Halo series. But by *Halo 3*, he was a full-time member of the team, working as the in-house composer and one of the studio's leads. His responsibilities at that time included planning and running the launch party.

While the team had celebrated the launches of all its previous games, the *Halo 3* launch party was the first held at Bungie's Kirkland, Washington studio, so they went all-out, decorating the studio, hiring a caterer and open bar, and inviting the entire staff's family and friends to celebrate what was — at the time — the conclusion of Master Chief's story.

Upon hearing the Bungie artist's dream about Gates attending the event, O'Donnell thought, "'y'know, that is a great idea.' So, I called Bill Gates' office and invited him, thinking he would probably say no." To O'Donnell's surprise, Gates "excitedly said yes."

Even more surprising was how Gates arrived at the celebration. "We had a little traffic cone, saving him a space [in the studio's parking lot]," says O'Donnell. The team expected Gates to arrive in the back of some flashy car, potentially with a cadre of guests and security guards. Instead, as O'Donnell notes, "[Gates] drove himself. He wasn't in some limo. No entourage, no security people or anyone else.

photography *Damien McFerran*

I greeted him, brought him in [to the party], and started introducing him to everyone."

Naturally, as the wealthiest man in America in 2007, Gates drew a crowd, but O'Donnell says the owner of Microsoft couldn't be happier to meet and greet the Bungie development team. "At one point I asked [Gates], 'Hey is this too much?' and he just said, 'Oh no, this is great! I'm so used to being in a room full of engineers and business people, it's so much more fun to be here.' I think he really enjoyed being around a group of creative people like that."

Gates wasn't the only person excited to be at the launch party. "I remember it was a very fun night," says Michael Salvatori, Halo 3's other co-composer and long-time collaborator with O'Donnell. While Salvatori would eventually join the studio as a full-time employee, at the time he worked remotely on Bungie's games as a third-party contractor based in Chicago. "I flew in that day, but I was excited to do it. It was just cool to be included in that."

The entire Bungie staff enjoyed the festivities for several hours into the night, until "around 11-ish [p.m.]," according to O'Donnell, at which time the entire group piled onto a line of coach busses and drove off to greet the fans waiting in line at nearby stores for Halo 3's imminent release.

The crew's first stop that night was the Best Buy in Bellevue, Washington, which was advertised as one of the marquee midnight launch locations along with other locations in New York City, Los Angeles, and Miami ahead of release — and where Gates sold and signed the very first copy of Halo 3 at 12:01 a.m.

"I remember getting off the bus at Best Buy and seeing fans with signs cheering," says O'Donnell. "My oldest daughter was on the bus with us, and it was fun to see her experience that and [to see] the payoff for the work I had put in over the years."

Bungie's buses made several other stops that night, including the Redmond Town Center, a two-level, open-air mall bisected by a busy street in downtown Redmond, Washington. "Once the Bungie folks rolled up it was a huge, raucous party," says Mat Olsen, who was waiting at the mall in a long line of other Halo fans eager to get their hands on what was easily the Xbox 360's most anticipated title yet. "I remember them hopping off these party buses that brought them in from their company launch party right in the middle of Redmond Town Center. The line for Halo 3 stretched around the entire ring on the second level, probably a few times."

Olsen had previously attended the Halo 2 midnight release — which was a massive launch in its own right — but recalls the turnout for Halo 3 was even bigger. "The energy for Halo 3's midnight launch was much like the one for Halo 2, just bigger. It was astounding to see so many people gathered for the launch of the game."

The Bungie staff were equally excited by the turnout. "There was already a line of people outside the stores waiting to get in and get their pre-orders or buy the game, and when we pulled up, there [was] a big crowd of people cheering. Everyone wanted autographs," O'Donnell notes. Salvatori shares the sentiment. "By the time we were working on Halo 3, it was like, 'we got this.' There was never any doubt in my mind that [it] would be great. But pulling up in the bus and seeing the fans — some had been waiting for quite a long time — was pretty humbling."

The Bungie group mingled with fans at the mall, chatting and signing copies of Halo 3 and other merch, including Olsen's collector's edition that came with a replica Spartan helmet (which was too small for human heads, but the perfect size for cats, resulting in the collectible's infamous 'cat helmet' nickname).

Eventually, the Bungie buses rolled onto their next locations. Meanwhile, fans headed home with their new copy of Halo 3, and many chose to follow up their late night with a full day of gaming. "I remember waking up and feeling legitimately like crap the next day because we'd been out so late," says Olsen. "I stayed home from school, started [the campaign] late afternoon, and then finished it around midnight."

———————————————

Halo 3's midnight launch surpassed previous records set by Halo 2, earning over $170 million USD in its first 24 hours. News outlets compared the fervour around Halo 3's launch to other pop culture touchstones like Harry Potter or Star Wars. Following such a staggering release, you would expect the team at Bungie to be awestruck by its success. But by that point, most of the team had already moved on.

"I remember hearing that expectations were high and we exceeded them," says O'Donnell. "[But] there's a certain point where your mind can't grasp the numbers — the idea of selling a million of something just seems unattainable, and by the time you get to the tens of millions, you just can't comprehend [it]. It's really hard to absorb the kind of impact it might be having out in the world."

Salvatori feels similarly, noting that it's hard to get too invested in a game's success when the next project is already underway. "When a game actually releases, it's old news to us. We've been done with it for months, and we're already knee-deep into the next release," says Salvatori. "So, by the time the [Halo 3] release party happened, we were already working on ODST, and that's what was on my mind."

Of course, that doesn't mean Bungie wasn't paying attention to the response. "For us, the fans were number

one," says O'Donnell. "We felt that if we made the games we wanted to play, the fans would love [them]. We crossed our fingers and hoped we were right." The confirmation that *Halo 3* was the success Bungie was hoping for came when O'Donnell and the rest of the team saw the community response. *Halo 3*'s online multiplayer was wildly popular. Over a million players hopped onto online matches via Xbox Live during its first day, and the game remained dominant for years following its launch. A major factor in that popularity was the thousands of screenshots and clips shared online, which O'Donnell paid close attention to. "Even to this day, I hear from people about the friends they made online, or how they would be up into the night playing split-screen, sharing their screenshots and forge creations — it's confirmation to me that we succeeded."

While the online community flocked to *Halo 3*'s social features, many of those shared moments were created while playing together in split-screen co-op matches or LAN tournaments — often fuelled by caffeine. "I made my parents go across the [Ontario] border to Detroit, Michigan to pick up the special Halo Mountain Dew Flavor," recalls McCourt. "We had way too much of it during our first LAN party a few weeks after the game came out." Nevertheless, those late caffeinated nights are a source of nostalgia for McCourt. "I have no desire to be 17 again, but sometimes I think 'wouldn't it be cool just to have one night where you could experience that child-like whimsy of crackin' a *Halo 3* Mountain Dew and just playing on LAN for an entire night?'"

524

While McCourt and his friends would get together for many more split-screen sessions over the coming weeks and months, it was the midnight launch that he still remembers most fondly. "It was the last time that my friends and I did a midnight release before we started dating or left for college. It's a stark contrast from midnight launches today, especially as everything goes digital. Who knows if we'll even have physical media in ten years?"

That sentiment becomes more common as the video game industry continues to pivot to digital ownership and away from physical media. "Everything going digital [and] every company under the sun following similar marketing playbooks — these feel like two blows that killed the midnight launch as something kind of special and not just a hollow marketing spectacle," says Olsen, lamenting the industry's changing business model. "I just can't picture that same vibe being there for a midnight launch anymore."

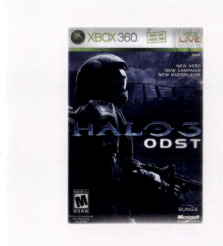

525

The nostalgia for midnight launches isn't just a feeling among fans and players; the developers that were around to see and appreciate them feel the same. "That was the golden era of console and game releases, where it meant something to release at midnight," says O'Donnell. "We got to see the fans and see the people buying the games. For all three [Halo games], it really was an amazing few years there. Those launch nights were really special to us, we really loved them."

Salvatori is similarly nostalgic for that time as well, but is quick to remind that "In life, nothing lasts forever. There's an arc to everything."

These days, midnight launches are more about waiting for a digital copy of a game to unlock than waiting in line to buy your copy of the next big release. But for those who were there — ready to finish the fight at 12:01 a.m. on September 25th, 2007 — the memories, friends, and stories they made that night will always remain a part of their arcs.

524
Halo 3
2007

525
Halo 3: ODST
2009

281

PLAYSTATION 3.

words Stephen Tailby

I'm just about of an age where the idea of being online used to be novel. You're telling me I can plug my computer into the telephone line and, after a cacophony of screaming bleeps and bloops, I'll be on *The Internet*? I'll be able to *Surf The Web*? Wait, *wait* — you're saying I can connect my *game console* too and *play with strangers*? And it all happens live? Gosh! What a strange new realm to explore.

First Released:
2006

Manufacturer:
Sony

Launch Price:
US $499.99
JP ¥59,800
UK £499

For a corporation neck deep in cutting-edge electronics and tech, Sony did feel slightly behind the curve when it came to bringing its PlayStation consoles online. The PS2 could *technically* get connected, but it wasn't built with that in mind — at least initially. While the bulkier model required a similarly bulky adapter to hook it up to the tubes, the slim model had an ethernet port built in. This was actually how I played my very first online game, trailing a phone wire across the living room floor so I could challenge fellow *Burnout 3: Takedown* racers from across the globe. Our home connection was terribly slow, but even with egregious latency and competitors popping in and out of existence, I loved it. It felt impossible, wild, and exciting. Simpler times.

The PS3 was the company's first proper, online-ready console. It would come with an ethernet port from the start, and Sony would establish PlayStation Network, its answer to Xbox Live, to ensure a smooth experience for all. And, unlike its competitor, playing online multiplayer would be free of charge. Having grown up playing PS2 games mostly alone in my bedroom with a 13-inch TV, the prospect of the PS3 — and entering a new realm where there would always be someone else to play with — was extremely exciting.

After scraping together *just* enough money to get the pricey machine at launch, I vividly remember picking up my pre-ordered PS3 with a copy of *MotorStorm*. I got home and excitedly set it up in the living room, where an HD TV I'd cunningly convinced my mum we *absolutely* needed was waiting. My gaming was about to level up: from standard definition to 1080p, from PS2 to PS3, front and centre in the family lounge. That first afternoon was a real occasion as the console's orchestra pit startup sound rang out, and Evolution Studios' brilliant off-road racing game slid into view. I spent hours with it, loving every second.

Eventually, it dawned on me that I needn't be playing *MotorStorm* alone. No one else in the house was interested for more than a few minutes, but an online community was forming in real time as the world's PlayStation fans created their PSN profiles and dived into playing games with one another. I could be part of that! Ensuring the PS3 was hooked up to our pitiful broadband, I looked for a lobby.

Launch day was quiet. There weren't many lobbies when I fired up the online mode, but I did manage to find one with a couple of other players. They had microphones and were chatting with each other, but I couldn't join in because I didn't have a headset... and I couldn't speak German. Despite these hurdles, I had a grand time, finding much satisfaction in trouncing them while driving a slow, heavy big rig. *Friss meinen staub!*

Actually, the fact that they were using microphones would prove to be an anomaly. Unlike the Xbox 360, the PS3 didn't come prepackaged with a means of communication, so you had to opt-in by buying a headset yourself. This meant the PlayStation Network was a strange, voiceless venue for online multiplayer in its first years. In public games, it was a rarity to hear teammates chatting or smack talking the opposition. I'd hear idle banter from time-to-time, but generally, people on PS3 kept to themselves.

photography Damien McFerran

Age of Experimentation

The PlayStation 3 era was not only home to online experiments, it was also home to a grab bag of curiosities like the safari game Afrika, PS2 series continuations like Gran Turismo 5, and original IP ranging from inFamous to Resistance to Ni No Kuni. Some of these gambits paid off, others never continued beyond PS3 (Heavenly Sword and Haze come to mind), but they all came together to define one of Sony's most curious periods.

526

527

528

529

530

531

532

533

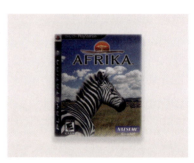

534

526
LittleBigPlanet
2008

527
Haze
2008

528
inFamous
2009

529
Resistance 2
2008

530
Heavenly Sword
2007

531
Ni no Kuni: Wrath of the White Witch
2011

532
Demon's Souls
2009

533
Gran Turismo 5
2010

534
Afrika
2008

One of my favourite online multiplayer games on PS3 was *Warhawk*. I'd play endless rounds of Team Deathmatch and Capture the Flag, but one in particular descended into madness, partly due to a lack of voice chat. Friendly fire was off by default, but in a panic, I shot at a teammate by mistake. The other player responded by firing straight back at me. Neither of us could be harmed by the other, but with no way to say sorry or laugh it off, this exchange was a declaration of war. Neither of us were willing to back down.

We spent the remainder of the match — maybe 20 minutes or so — throwing everything we had at each other. The rest of the game fell away; this was no longer a conflict between two teams of 16 but instead a petulant, one-on-one dance that saw us fruitlessly attacking each other however we could. Mercifully, the time limit put an end to our insanity, or we might still be at it today. It was hilarious — perhaps even more so because we couldn't communicate. I did eventually get a simple headset, but the strangely mute PSN was hardly an encouraging place. Why talk if no one would respond?

Playing online wasn't quite as socially engaging as I was expecting. Actually, the wider promise of a connected console took a while to really come to fruition on PS3. I remember reading glib arguments that Xbox Live was worth paying for because it never faltered, in contrast to the unreliable PlayStation Network. While the truth is that all online services have their ups and downs, it certainly *felt* like PSN went offline more than others.

On this point, we can't talk about PS3's online experience without bringing up the great PlayStation Network outage of 2011 — one of the largest cyberattacks of all time. Incredibly, I was completely unaware of this entire episode, wandering through the streets of Venice on an Easter holiday. It wasn't until we landed back in the UK that I discovered the shocking news. This was bigger than the games. This was a key moment in a world more connected than ever, showing a global audience how fragile it could all be. The private information of millions was compromised, and PSN went offline for several weeks. Sony survived the fines and lawsuits, but a lot of damage was dealt to its reputation, with PS3 marked as an 'unsafe' and 'untrustworthy' place to engage online. Though it didn't affect me personally (and I gladly accepted the free games given to all users), it was a bleak time for PlayStation and served as a lesson for everyone. Cyber security is important, and the online world can quickly fall apart.

Despite its faults, I liked the Wild West feeling of PS3's exploration of the online frontier. It was as though Sony was laying down the track as the train came hurtling along it. The PlayStation Store in 2006 was little more than a webpage accessed by the console's ropey browser, offering up oddities like *Super Rub 'a' Dub* and *Trash Panic*. Years into the machine's existence, Trophies

came into the fold, awarding players with digital trinkets. Later would come PlayStation Plus, a subscription service that gave members free games each month, discounts on the PS Store, and other benefits. Sony obviously took a lot of inspiration from its competitors.

Everything I just mentioned is important and valuable, but I was much more interested in the weird initiatives Sony was exploring. Folding@home is a distributed computation project — still going today — all about running simulations of protein dynamics, with anyone able to lend their help by simply booting up the software on their various devices. All that generated data contributes to disease research. A client for PS3 meant anyone with a console and an internet connection could take part. According to Folding@home's website, over 15 million PS3 users accumulated more than 100 million computing hours between the app's launch and its closure on PlayStation in 2012. It's hard to know what that means in the project's wider context, although the same web page describes PS3's involvement as a "game changer." I was fascinated by Folding@home and ran the app quite often to watch those molecules bouncing about. Of course, this was on a games console, so its appeal was somewhat limited. But it was a worthy PS3 online experiment.

The other major one, of course, was *PlayStation Home*. This application launched free for everyone in 2008, and while some would scoff at its largely empty public spaces and meagre gameplay, *Home* was at least a decade ahead of its time. It was sort of Sony's metaverse long before that was even a term, and it grew to be very popular in spite of its limitations. Everyone had their own private space (where you could proudly display your earned Trophies), social spots like a bowling alley provided some entertainment, and you could even tune into live broadcasts or watch movies within it. An alternate reality game named *Xi* and various other games and events occurred within this digital realm too. I never got particularly deep into that side of things, but it was fun to poke around from time-to-time. Starting conga lines of strangers all doing the running man dance never got old. Unfortunately, it wasn't carried forward onto later consoles and was ultimately shut down in 2015, but *Home* definitely found an audience. People still look back fondly on *PS Home* and, arguably, it'd make a whole lot more sense nowadays.

It was strange punts like these that gave PS3's online culture a completely unique feel. It was avant-garde, unusual, and interesting in a way that today's more settled online landscape isn't. Publishers and developers were trying various new things in a bid to find the online golden goose, resulting in some truly fantastic experiences (amid *a lot* of copy-paste shooters).

I've got to talk about some of my favourites. The aforementioned third-person shooter *Warhawk* was online-only, which was a rarity at the time — especially

535

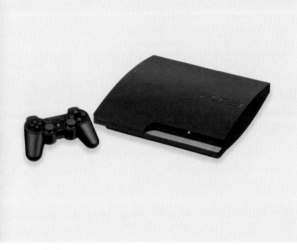

536

535
PlayStation 3
2006

536
PlayStation 3 Slim
2009

on consoles. *Noby Noby Boy*, from Keita Takahashi, was a strange plaything all about becoming as long as you possibly could, with the cumulative length of all players being added to the space-bound character, Girl. The goal was to have her extend from Earth all the way out to Pluto and back again, unlocking new levels as she reached milestones. The common goal was a great way to incentivise coming back, not only to contribute your points, but just to see how much progress had been made.

Later on, *Journey* also reimagined online multiplayer. You could run into another anonymous player at any moment, and you could only communicate through your character's chirrups and whistles. These moments felt profound and meaningful in a way that most online interactions didn't.

However, *Call of Duty 4: Modern Warfare* made arguably the biggest splash, its RPG-like progression almost single-handedly changing the course of online multiplayer. Its speedy, high-intensity action felt incredible, and the time-to-kill was low, meaning standoffs would likely be won by whoever shot first. It could be maddening, but also incredibly gratifying when you were on a roll. And you were always making headway; as you levelled up, you unlocked new weapons, kill streaks, and customisations for your favourite guns. I loved it, even though all I was effectively doing was ensuring my kill-to-death ratio stayed suitably embarrassing.

This generation of consoles had a varied and innovative spirit with respect to online play. And that's what kept me coming back. While I'd consider most of my favourite games to be single-player adventures, it'd be a mistake to forget the countless hours of fun I've had playing with friends and strangers over the wires. PS3 was definitely the most engaged I've been by this part of the medium, and I distinctly remember many good times playing *Battlefield: Bad Company 2* with friends, chasing and smashing into people in *Burnout Paradise's* open roads, and going round after round in *Calling All Cars!* with, well, the few other people playing.

Online multiplayer became such an important part of the games landscape that it started infiltrating traditionally solo series. Some were successful, such as the energetic skirmishes of *Uncharted 2* and *3*, while others just felt out of place — hi, *God of War: Ascension*! Even Assassin's Creed got into the multiplayer scrum, albeit in a quite different way. I remember thinking some of these modes felt tacked on and unnecessary, but at the very least, developers were taking creative swings and (mostly) hitting the mark.

Looking back on PS3's online journey, I have more nostalgia for it than I thought. It definitely had some rough edges in the early goings, but it was also an endlessly experimental and interesting period, resulting in some great innovations and superb games. I somewhat miss the days when Sony hadn't quite figured things out, feeling its way forward with weird and wonderful ideas. In today's more risk-averse landscape, I'd love a little of that ingenuity to return. What a time.

537

538

539

540

537
MotorStorm
2006

539
Journey Collector's Edition
2012

538
Warhawk
2007

540
Battlefield: Bad Company
2010

Consoles for any Occasion

From understated colour variants to more elaborate designs tied into games including Final Fantasy XIII-2, Tales of Xillia, and Ni No Kuni, PS3 special editions were in no short supply. While most are less iconic than the best 360 limited edition systems (particularly in the controller department), anime fans in particular had plenty of fantastic PS3s to choose from.

541

542

543

544

545

546

541
Tales of Xillia Limited Edition PS3 Slim
2011

542
Ni no Kuni: Wrath of the White Witch Limited Edition PS3 Slim 2010

543
Splash Blue Limited Edition PS3 Slim
2011

544
One Piece: Pirate Warriors Limited Edition PS3 Slim
2011

545
Scarlet Red Limited Edition PS3 Slim
2011

546
Final Fantasy XIII-2 Limited Edition PS3 Slim
2011

Uncharted 2 changed the game for Sony, setting the PlayStation brand on a course that still defines it generations later — a path further reinforced by The Last of Us. But marquee series or studios like God of War or Insomniac Games really weren't at their peak during this time, releasing titles like the solid-but-forgettable Ratchet & Clank: Into the Nexus. No one could've predicted how these then-played out franchises would revitalise themselves just years later.

547

548

549

550

547
Uncharted 2: Among Thieves
2016

549
The Last of Us
2013

548
God of War: Ascension
2013

550
Ratchet & Clank: Into the Nexus
2013

playstation 3.

WII.

words Ryan Craddock

First Released:
2006

Manufacturer:
Nintendo

Launch Price:
JP ¥25,000
US $249.99
UK £179.99

Nintendo has a history of authoring some of gaming's most out-there ideas, often offering up industry-leading innovation or, at the very least, an imaginative new way to play. Prior to the launch of the Wii, it had already given us the Nintendo 64 controller, the Virtual Boy, and the Nintendo DS, a foldable handheld device that introduced all-new touch screen capabilities and a built-in microphone — just to name a few. So, when it was time to launch a successor to its uniquely-shaped GameCube (ironically one of the company's most ordinary consoles, despite sporting a lunch box-style handle), it was only natural that Nintendo would do *it* yet again. In a room full of others competing mostly over graphical power, Nintendo was the weird kid. And it was proud of that fact.

By the summer of 2006, I'd evolved from a child who found video games to be a fun way to pass the time into a slightly older child for whom gaming had become a way of life. My love for the medium started in the same way it did for many people my age: Pokémon. Thanks to a deadly combination of its wonderful animated series being on TV every week and my best friend letting me try out his copy of *Pokémon Blue*, it wasn't long until a Game Boy Color found its way to the top of my birthday present wish list. With *Pokémon Red* and *Blue* devouring all of my spare time over the next year or so, my mum thought I'd probably also enjoy a special edition Pokémon-themed Nintendo 64 console that could play my favourite series on the big screen. And she was right.

Pokémon may have kicked things off for me, but the bright colours and bold designs of Nintendo hardware paired with the company's fantastic lineup of mascots had subconsciously turned me into a loyal Nintendo fan. I was lucky enough to eventually receive a Nintendo GameCube to supplant my trusty N64, and no doubt in part thanks to *Super Smash Bros. Melee*'s roster of Nintendo heroes, I soon found myself exploring more and more series, like Super Mario, The Legend of Zelda, Metroid, and more. Nintendo was almost becoming my identity — in the same way that being into certain music scenes can influence everything from your dress sense to your attitude. But until now, I'd relied on the adults in my life to keep tabs on what video games and consoles were appearing in shops and hopefully pick up things that I might like.

I would have been twelve-years-old at this point, and my gaming hobby had transformed from simply playing voraciously into also making sure that I hoovered up news and information on the latest releases. It was around this time that I got into reading gaming magazines, and I was soon aware that Nintendo's next console — the Wii, or 'Revolution' as it was initially code-named — was just around the corner. Previously, my first introduction to a new games console was either seeing it on a store shelf or actually unboxing it on Christmas morning, so reading preview pieces and getting early looks at a new system and its software was a hype-inducing experience.

In May of that year, Nintendo truly showed what the Wii was all about during an E3 press conference, an industry trade event that was also streamed online for gaming fans to watch. I'd never seen anything like it; the company's executives took to the stage to play the widest variety of games you could imagine, each swinging around what looked like a glorified TV remote instead of sitting down with a traditional pad plugged into the console. Highlight reels showcased physical dual-controller swordplay, remotes being turned left and right to steer cars, crazy mini-games where you needed to fling, rattle, and shake the controller, and even tennis matches complete with accurate forehand, backhand, lob and spin shots — all made possible by swinging your arm as if you were holding a *real* tennis racket. I didn't really know what I was looking at, but I knew I had to have one.

photography Damien McFerran

Connecting New Experiences

The Wii Remote was not only intuitive, it was smartly modular. The port on its base allowed for many peripherals to modify the basic controllers everyone already had. While some accessories like the Balance Board or Wii Speak didn't connect, nearly everything else plugged directly into the Remote for use, standardising the play experience. Even the Classic Controller and Classic Controller Pro must be plugged in! The same would've been true of the ill-fated Wii Vitality Sensor. And if your attachment didn't go into the Wii Remote, the Wii Remote often went into it — the Wii Zapper and Wheel being key examples. In some ways, this design philosophy laid the groundwork for the elegantly modular design of Nintendo Switch.

551

552

553

554

556

555

551
Wii MotionPlus
2009

552
Wii Balance Board
2007

553
Wii Remote + Nunchuk
2006

554
Wii Classic Controller
2006

555
Wii Classic Controller Pro
2009

556
Wii Vitality Sensor
Unreleased

Surprisingly, to me at least, my excitement for Nintendo's upcoming hardware wasn't shared by my peers. September 2006 saw the start of my second year of high school — a grubby but serviceable state school in the UK's East Midlands. For the past year or so, my small circle of friends — as well as the school's 'cool' kids — had all become obsessed with Microsoft's Xbox 360; the console had launched in the UK the previous year. You couldn't go a few hours without discussion returning to its most popular titles, like Call of Duty, *Gears of War*, and *The Elder Scrolls IV: Oblivion*. It had rapidly become the norm for everyone to run home from school, boot up their 360s, and socialise all night in multiplayer lobbies before talking about all the fun they'd had shooting each other the next day.

None of this even remotely appealed to me. I'd never been good at fitting in and didn't really have any care for jumping on bandwagons just because everyone else was. To me, the Wii looked exciting, fresh, and different — no amount of mocking, jokes about its name, or people trying to call me 'babyish' for liking 'cartoony games' was going to put me off. It seems a bit silly now, but at the time, it felt as if there was a cultural divide between school kids who were Nintendo players and those who were in Xbox or PlayStation's corner — kind of like mods and rockers or your stereotypical nerds and jocks — except I was the only Nintendo fan I knew. Just like Nintendo, I was the weird kid. That probably made me like everything about the company's unique approaches even more.

Christmas was fast approaching, and the Wii was due to launch a few weeks before the big day. By this point, there was very little else I could think about, and I'd already started dreaming of the games I'd soon be playing. *Wii Sports* was top of my must-play list. Ever since that demonstration at E3 a few months before, I'd been waiting for the day that I could whack tennis balls about in my living room and delicately sink intricate little golf shots with the flick of my wrist. The new *Legend of Zelda* game was also right up there; I'd struggled a bit with my first taste of the series on GameCube in *The Legend of Zelda: The Wind Waker*, perhaps due to how young I was at the time. But the upcoming *Twilight Princess*' darker tone and the fact that you could virtually hold a sword and shield in your hands thanks to the Wii's controllers had me beyond excited.

My parents were separated but had seemingly agreed on a plan between them to ensure I'd get my hands on what I wanted when Christmas rolled around. It was my dad's job to secure the console itself, and my mum would check in with me to figure out what games I'd like to go with it. It was a decent and welcome plan — except for the fact that securing the console didn't turn out to be as simple as you'd expect.

I don't think I was even aware of the concept of pre-ordering a product before this Christmas period, but it soon became clear that anyone who hadn't been ahead of the game simply wasn't getting their hands on a Wii in time for December 25th. In fact, it turned out that even those who *did* pre-order a Wii weeks in advance weren't guaranteed to get one straight away, either.

The run-up to Christmas consisted of my dad driving all around the county in hopes of finding just one single Wii sitting on a store shelf somewhere. The mission reports always came back as a resounding 'nope,' and I couldn't believe that a video game console of all things could be so hard to find. At school, it was made very clear to me that I was the odd one out wanting one of these things, yet news headlines spoke of its mass popularity and reports stated that retailers simply couldn't keep up with demand.

Suffice it to say, I didn't get a Wii for Christmas that year. The next few weeks felt like torture. I naively thought I'd already be a Bowling champion by then, but tracking down a console remained a mighty challenge. Whispers of stock being available in local stores would come and go, only to be met with more disappointment, and retail workers were struggling to offer any real advice beyond 'keep trying and move fast if any arrive.' Eventually, thanks to some persistent searching and a bit of good fortune, a Wii finally found its way into my eager hands in mid-February — about seven or eight weeks later than initially planned, but thankfully, the moment was no less exciting.

What a weird and wonderful machine. The console itself was an oddly-shaped, upright brick that had its own stand, two little trapped doors that concealed controller and storage ports, and a pulsing blue light around the disc drive that made it look like a miniature spaceship. It was accompanied by that glorified TV remote I'd been eager to try out, officially called a Wii Remote, and this was connected to a second controller called a Nunchuk — both of which could be moved around for motion controls or used more traditionally, thanks to their buttons. A Sensor Bar hooked up to the console tracked the Wii Remote, and had to be placed either on top of or directly below the TV. It might have been pretty cheap as video game systems go, and it was several leaps behind its rivals when it came to graphics and processing power, but this thing felt like the future.

I was lucky enough to have four games waiting for me at my own private (and late) Wii launch party — *The Legend of Zelda: Twilight Princess*, *Super Monkey Ball: Banana Blitz*, *Need for Speed: Carbon*, and *Wii Sports*, the latter of which came bundled with all consoles as standard. They all had to wait, though, because that first night was spent being wowed by the tech and exploring the uniquely compelling Mii Maker and Mii Channel apps.

When it was finally time to pop *Wii Sports* into the disc drive and jump into my first Tennis match alongside

my newly-created (and surprisingly accurate-looking) Mii, I instantly knew that ignoring the peer pressure and sticking to what genuinely interested me had been the right call. I'd been waiting the best part of a year for this moment, and whilst hyping things up to be amazing in your head can often lead to disappointment, those first few sets against Nintendo's collection of CPU Mii characters were everything I hoped they'd be.

And that feeling really lasted, too. For those first few weeks, each new game I explored and each new gameplay mechanic those titles introduced were a sight to behold — or rather an experience to feel — and even beyond that initial honeymoon phase, so many old favourites were given fresh new life too. Racing had never been as chaotic as it was in *Mario Kart Wii*,

both on-screen and in the living room as everyone steered their plastic Wii Wheels left and right, and fishing, of all things, had never been as satisfying as it was in *The Legend of Zelda: Twilight Princess* — where a flick of the wrist would simultaneously cast your line and put a smile on your face. Any new game console is exciting, but there's something different about a system that can consistently impress and surprise thanks to its fundamental design and the unique possibilities its technology presents.

Including the original model and its two eventual revisions, the Wii went on to sell a staggering 101.63 million units across its lifetime, making it one of very few game consoles that have ever broken the 100 million sales milestone. It was marketed as being a console for everyone — right down to that odd but memorable name, which was intended to sound like 'we' and promote inclusivity — and it certainly was that, finding its way into homes all around the world, enjoyed by players from all walks of life.

Aside from the obvious factors, such as the brand strength and marketing expertise, I firmly believe that the Wii managed to be so successful thanks to all of those ways it initially appealed to me as a kid. It was fresh. It inspired new ways to create games as well as play them, and it stood out from the crowd and wasn't afraid to be a little odd. Most importantly, though, it was unequivocally fun — isn't that what gaming is all about?

557 558 559

557
Wii
2006

558
Wii Family
2011

559
Wii Mini
2012

Weaker Hardware, Wonderful Games

Each subsequent Wii model removed more and more features. The Family console dropped GameCube support, and the Mini dropped Wi-Fi connectivity too. Luckily the Wii had a vast library of games from developers across the world for players to enjoy, from Western blockbusters like Metroid Prime 3, The Conduit, and Dead Space Extraction to Japanese curios including Captain Rainbow and Let's Tap — a Sega game that you controlled by tapping the surface around your controller! The spirit of innovation flowed freely in this era, resulting in a catalogue which spanned from Excitebots, Kirby's Epic Yarn, and Rhythm Heaven to WarioWare: Smooth Moves, Wii Play and Wii Fit. There truly was something for everyone.

560

561

562

563

560
Wii Zapper
2007

561
Wii Wheel
2008

562
Wii Speak
2008

563
Wii Sensor Bar
2006

564

565

566

567

568

569

570

571

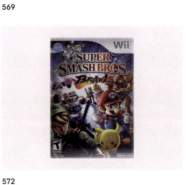

572

564
The Legend of Zelda: Twilight Princess 2006

565
Wii Sports
2006

566
Wii Fit
2007

567
Mario Kart Wii
2008

568
Endless Ocean
2007

569
Metroid Prime 3: Corruption
2007

570
Wii Play
2006

571
Excitebots: Trick Racing
2009

575
Super Smash Bros. Brawl
2008

573

574

575

576

577

578

579

580

581

573
WarioWare: Smooth Moves
2006

574
Super Mario Galaxy
2007

575
Dead Space: Extraction
2009

576
Let's Tap
2008

577
Captain Rainbow
2008

578
The Conduit
2009

579
Xenoblade Chronicle
2010

580
Rhythm Heaven Fever
2011

581
Kirby's Epic Yarn
2011

Wii.

ENDLESS OCEAN

Developer:
Arika

Publisher
Nintendo

Release Year:
2007

Available on:
Wii

A serene and beautiful spiritual successor to Arika's Everblue series, *Endless Ocean* is the literal interpretation of Nintendo's Blue Ocean strategy. This is all ages explorative fun. Few experiences in games are as peaceful as diving through Manaurai Sea among exceptionally realised fish, turtles and whales, guided only by an interest to get closer to the wonders of nature.

582

583

584

585

582
Endless Ocean
2008 (America)

584
Endless Ocean Disc
2008 (America)

583
Endless Ocean
2008 (France)

585
Endless Ocean Disc
2008 (Europe)

298

MADWORLD

Developer:
PlatinumGames

Publisher
Sega

Release Year:
2008

Available on:
Wii

This was PlatinumGames' debut title, a striking black-and-white action game which put the studio on the map and began its legendary run that was followed up with the likes of *Bayonetta and Vanquish*. Heralded as one of the essential mature titles on Wii, *MadWorld* hasn't aged a day.

586

587

588

589

586
MadWorld
2008 (America)

588
MadWorld Disc
2008 (America)

587
MadWorld
2008 (Japan)

589
MadWorld Disc
2008 (Japan)

THE LIBRARY WE OVERLOOK.

words *Grace Benfell*

The Wii is commonly understood, to put it in gamer terms, as a console for casuals. The console's imprecise (but responsive) motion controls gave it a charm that enticed even those completely unfamiliar with the hobby. The fact that Wii made it into so many households without even having a DVD player is a testament to its simple appeal. You could sell the system to your parents entirely on its own terms.

This, to be clear, is *cool*. There is beauty in the simplicity of a shared activity that makes you laugh or scream together. The Wii is hardly as efficient as a ball or a sprinkler in creating that sensation. But within the world of video games, it is a lean machine of play.

Nonetheless, between some useless peripherals and endless party games, the Wii became known for lining the shelves with landfill-ready plastic. Small and large companies alike sought to cash in on the broader family demographic. Because of this gold rush, as well as the tendency of the usually white, usually male gatekeepers of video gaming to dismiss anything outside of their purview, the Wii now has something of a meagre reputation. Outside of some bonafide Nintendo bangers, and a few well-regarded party classics, it's easy to write off the Wii's library as shallow and wide.

There's certainly truth to that, but the Wii was also a purveyor of the weird and wonderful. You just had to take a closer look. On a hypothetical Wii-marked shelf in your local game store, you could find an action game where you play as a tarantula and scorpion stalking treasure hunters played by Dennis Hopper and Billy Bob Thorton. You could find a Castlevania fighting game, with character designs from the artist of *Death Note*. You could find a soap opera drama about various members of a trauma response team. In practice, many of those games are hard-to-find or expensive now. Still, underneath all the noise, a simple truth is revealed: the Wii was for weirdos.

That weirdness is, in part, explained by the Wii's timing. It did not hop to HD along with its peers, but instead stayed in the patchworked, hazy realm of standard definition. While the world of mid-budget games flickered, faded, and changed shape as the first HD console generation marched on, eventually being largely replaced by what we now call indies, it was still relatively cheap to make a disc release for the Wii. This fact resulted in a lot of absurd cash-ins and bad ports, but it also created space for weird ideas and marginal visions that might not have had a spot on other platforms, at least not in the same way.

Some of these visions still had a distinctly Nintendo flavour, like the storybook-styled *Little King's Story*. As the titular tiny monarch, you lead a brigade of peasants and soldiers to conquer a fantasy world, as well as free imprisoned princesses. In practical terms, it's similar to *Pikmin*, a real-time strategy game about tossing your allies to fight big monsters. The principal twist on *Pikmin*'s formula is your responsibility as a king. As you play, you can find new roles for your villagers to take on, expand the capabilities of your army and your town, and build relationships with your advisors as well as the princesses.

Little King's Story was bright and buoyant, but it had a darkly comic edge. The little king marries every princess you save on your world-conquering trip. Your subjects could die and their families would be upset if you didn't throw them a funeral. The tone is somewhat akin to *The Little Prince* (one of the game's explicit inspirations) or *King Matt The First*. It has an absurd, childlike, and allegorical attitude towards monarchy, but it also paints itself with a warm, melancholic tone.

photography *Damien McFerran*

Some of the comedy is unfortunately mean-spirited, but generally the game is sincere rather than smarmy. It was not superior to the work it pulled from, rather willing to sit in its weird contradictions. Many people have written essays or snarky posts about the 'surprising darkness' of Nintendo games. It would be silly and redundant to write such a thing about *Little King's Story*. Like all good fairy tales, it's willing to bite you.

However, the console was hardly limited to party games and fairy tales. The Wii Remote's tactile movement could be applied to practically anything. The swing of a tennis racket could be the chop of Link's longsword could be a chainsaw severing a head. Games like *MadWorld* and *Manhunt 2* gave the Wii its own brand of ultraviolence, one distinctly unsettling and controversial. The most famous and influential example of this is *No More Heroes*, an unholy blend of Grand Theft Auto and bloody shonen. It would be silly to characterise any of those games as "adult," most of them have a gleefully juvenile energy. However, they do show off the diverse genres and tones the Wii could exhibit. Its toy-like construction made it able to be perverted as well as sincerely played with.

That flexibility extended to genre as much as anything else. Many of the Wii's strangest games did not exactly break convention, but they did reshape it. One such twist is *Fragile Dreams: Farewell Ruins of the Moon*. It's a horror game that takes cues from Silent Hill and Resident Evil, but is decidedly not focussed on tension or dread. Instead, the game suffused its haunted halls with melancholy.

Of the games I've highlighted here, *Fragile Dreams* is the most startlingly artful. The delicate space between the dusk and the night. *Fragile Dreams* follows Sen, a fifteen-year-old boy, as he journeys through a post-apocalyptic Tokyo. His grandfather dies before the game begins, and it opens with the sounds of Sen burying him in the yard. In his final note, his grandfather urges him to seek a nearby tower, somehow still shining, though all other lights have gone out. On the way, he finds a girl his age who vanishes. Desperate for connection, Sen follows her into the dark.

The game has the usual tension-building horror trademarks like limited inventory space, degrading weapons, and hidden enemies. In its harsher moments, the game can be tense, but it is generally more eerie than scary. The game's power comes from the tenderness with which its locations are rendered and the stories that dwell in them. As you explore, you find resources for fighting foes and healing yourself, of course. You'll also find whispers of what came before. There are short stories abound in *Fragile Dreams*: they're attached to letters and documents, or are simply objects of sentimental value. While many other post-apocalypses are content to focus on the terror of this new world, *Fragile Dreams* emphasises the world prior, what was lost even before the apocalypse came, the mundane tragedies of a lonely world.

This apocalypse brings out basic sorrows that are at the core of living: the fear of disconnection, the inevitability of loss, the impossibility of surviving alone. Sen meets many companions and friends, most of whom die, vanish, or wither away. The systems give you a sense of fragility, of scrambling survival, that supports this heartache. Every human being you encounter in *Fragile Dreams* wants to help. There are simply not that many of them.

The game does sometimes indulge itself too much. Twists of tragedy can feel too neat or too considered to really land. But, the narrative's tone is so enveloping that it's hard to hold ultimately minor shortcomings against it. Of the games I've highlighted here, *Fragile Dreams* is the most startlingly artful. Its aesthetic inhabits the delicate space between the dusk and the night, or the dawn and the day. Its empty world is full of detail that gives it ready life. Despite its familiar premise, and the way it settles into a conventional plot, I've never played anything else like *Fragile Dreams*. Perhaps appropriately, it has no successors.

Fragile Dreams is monumentally expensive now, but even at the time games like it could be hard to get. I have vivid memories of going to a GameStop on the release day of *Rune Factory: Frontier* and finding no copies. The worker there didn't even know what I was talking about. Even today, copies of the Wii's strangest creations can be difficult to find and expensive to obtain.

Even at the time, I didn't participate in this eclectic library as much as I wish I had. I was transfixed by a full page ad for *Fragile Dreams* in Shonen Jump, but did not play it for years. I would only rediscover the Wii, and *Fragile Dreams*, much later, as a weirdo trans woman looking for games at the margins of culture.

The Wii's unique features also made it tricky to develop for. Even if you didn't engage with the motion controls at all, the Wii still had strange controllers, and you couldn't rely on every one of your users having a more uniform Classic Controller. In short, if you wanted to make a game for the Wii, you had to make it specifically for the Wii. On the bright side, this only cemented the console's idiosyncrasy. Even simply interfacing with it was unlike everything else.

Take *Final Fantasy Crystal Chronicles: The Crystal Bearers*. As the title might imply, this is a spin-off of the spin-off *Crystal Chronicles*. The games prior to this are mostly cooperative action-RPGs. *The Crystal Bearers* takes an entirely different approach, one that probably could have only been imagined on the Wii.

The Crystal Bearers is an open-world game about a telepathy-having scoundrel. The game's combat has

you waggling the Wii Remote to throw enemies at each other, often resulting in peculiar outcomes. Its open world encourages you to experiment with your powers, providing a challenge list which includes activating particular enemy interactions, finding hidden places, and completing vague side quests. It's not as legible, inuitive, or as complex as *Breath of the Wild*'s playground, but it has some of the same energy. It too is about being willing to try new things, to test the boundaries of the systems you're presented with.

Despite the game's unwieldy and surprising depth, you can beat the whole thing and hardly engage with its core systems. That's because most of the game is a cinematic action-adventure that jumps from lavish cutscenes to elaborate and uneven mini-games — which include arcade shooting galleries and ballroom dancing. Like the open world, each of the mini-games have their own secrets, often revealed by unintuitive actions. You'll move through the world to get from point to point, but you barely have to play with it to see the game's credits.

The Crystal Bearers is, annoyances included, a whirlwind tour of the Wii's capabilities. It's an expansive, relatively big-budget game with a major franchise name attached, that has a distinctly Mario Party-like energy. It's an open world that does not beg for constant, tedious interaction, but instead asks for careful engagement, even as it doesn't exactly reward you for it. It's sprawling and limited, lavish and hazy, a contradictory object that could only exist on this system.

The weird space for the Wii was not only created by developer interests and the unusual hardware. Wii owners themselves recognised the system's potential and advocated for its audience. Despite already having English localisations thanks to their releases in Europe, *Xenoblade Chronicles*, *Pandora's Tower*, and *The Last Story* were initially not intended to have any American release. A fan campaign called Operation Rainfall sprang up, petitioning Nintendo and other publishers to get them to the US.

Operation Rainfall unambiguously won. All three of the titles the campaign pushed for got official American releases. *Xenoblade Chronicles* is now one of Nintendo's core franchises, even in the US, and the original game got both 3DS and Switch remakes. Though Nintendo did not believe it at first, it was Wii owners that proved there was an American audience for sprawling, anime RPGs. Fan campaigns in video games have a spurious history, to put it lightly, but Operation Rainfall is clearly an exception. A group passionate about the medium put these games in the hands of more people.

The Operation Rainfall games were also hardly the only such titles to grace the Wii. Long-running mech'em and date'em RPG Sakura Wars got its first official English localisation on the Wii, with *So Long My Love*. *Baroque*, a

remake of the cult classic Sega Saturn game, released on the Wii alongside a PS2 version. The delightful lifestyle RPG *Opoona* also saw European and US releases. Not everything made it over to the US or Europe, but you still had a wide sampling of the strange and exciting from Japan.

Outside of emulation, the Wii was once also the easiest way to play retro games. The Wii Shop Channel granted paid access to thousands of games from Nintendo's back catalogue, as well as many other consoles and companies. It was the first place I played *Mega Man* and *Majora's Mask*. Given that history, it's unfortunate that it can be difficult to play the weirdest Wii games now. Unlike the console's charming and uneven successor, comparatively few of the Wii's exclusive games have escaped its orbit. There are exceptions. You can buy a PC port of *Little King's Story* right now, but the hardware's unique specifications obviously made its games difficult to port.

That's perhaps why I still own the same Wii. Every console has its strange corners and hidden gems. However, the peculiarities of the Wii's hardware, the unusual circumstances of its release, its last gasp of standard definition games, create a mixture that is uniquely melancholy to me. The Wii represents a kind of game playing that we will not get back. That's far from all bad, but it is also worth preserving and remembering. I only wish it was easier for more people to do it.

590

590
Fragile Dreams
2010

WARIO LAND: SHAKE IT!

Developer:
Good-Feel

Publisher
Nintendo

Release Year:
2008

Available on:
Wii

Best known for its craft-themed Yoshi and Kirby adventures, Good-Feel first jumped into Nintendo's marquee IP with its take on Wario Land. *Shake It!* takes the gameplay tenets of the GBA classic *Wario Land 4* and streamlines them into a fast-paced 2D platformer with a timeless hand-drawn aesthetic. There are plenty of great platformers from Nintendo on Wii — but this one typically flies under the radar!

591

592

593

594

591
Wario Land: Shake It!
2008 (America)

593
Wario Land: Shake It! Disc
2008 (America)

592
Wario Land: Shake It!
2008 (Japan)

594
Wario Land: Shake It! Disc
2008 (Japan)

ZACK & WIKI: THE QUEST FOR BARBARO'S TREASURE

Developer:
Capcom

Publisher
Capcom

Release Year:
2007

Available on:
Wii

One of the Wii's early hidden gems, *Zack & Wiki*'s exceptionally charming point-and-click adventuring never connected commercially but accrued a hardcore fan-base. To this day, the title is celebrated as one of the best and most joyous journeys on the platform — a key counterpoint to the idea that Wii's third-party support was defined by shovelware. Between this and titles including the likes of *Sonic Colours* as well as *Monster Hunter Tri*, Capcom was a great supporter of Wii.

595

596

597

598

595
Zack & Wiki: The Quest for Barbaro's Treasure
2007 (America)

597
Zack & Wiki: The Quest for Barbaro's Treasure Disc
2007 (Europe)

596
Zack & Wiki: The Quest for Barbaro's Treasure
2007 (Japan)

598
Zack & Wiki: The Quest for Barbaro's Treasure Disc
2007 (Japan)

INDIES AS WE KNOW THEM.

words *Dan Adelman*

I stopped off at my local GameStop on my way home from my job at the Xbox campus to pick up a copy of *Star Wars: Knights of the Old Republic*. I was kicking myself for not having pre-ordered it. Sure enough, by the time I got there, they were all sold out. R Kelly's "Ignition" was playing on the radio for what seemed like the millionth time, and I was getting sick of the Creed CD I had in the tray. I was in a bit of a sour mood by the time I got home until I checked my mailbox and discovered the familiar red Netflix envelope. *The Lord of the Rings: Two Towers* on DVD had arrived, and it was mine to keep for as long as I wanted without worrying about late fees. Such a step up from the Blockbuster experience!

Instant access to virtually any form of media is taken for granted these days. Back in 2003, games and movies came almost exclusively on shiny discs. Thanks to relatively small file sizes and illegal peer-to-peer sites like Napster, music offered a glimpse of the future, but downloading songs still took a lot of effort for the typical consumer. iPods had been out for a couple years by that point, but most people had to rip their CD collections to fill them, an act that was still shrouded in legal ambiguity. The iTunes Music Store, which offered music fans a way to download music legally, had just launched in April.

But now digital distribution, once a hot industry buzzword, sounds as anachronistic as referring to a colour TV. It seems simple in retrospect, but in fact it took multiple components for it all to come together: high-speed internet, large storage capacity, and a user account system. The PC was the first device to bring all of those pieces together, so it comes as no surprise that digital distribution of games began there. Casual gaming portals like Yahoo! Games, Big Fish, RealArcade, and MSN Gaming Zone offered card and puzzle games both within the browser as well as separate downloadable files. They experimented a great deal with new business models like membership subscription programs that offered sitewide discounts and ad-supported games.

Among the consoles, the original Xbox was the first platform to assemble all of the key ingredients. On Valentine's Day of 2000, Bill Gates and Steve Ballmer approved the Xbox project and vowed to give the team whatever resources it needed to challenge the PlayStation 2. Since Sony had a year's headstart, the Xbox needed to distinguish itself with superior hardware including an ethernet port and a built-in eight gigabyte hard drive. Microsoft could also rely on its considerable experience in running online services to give Xbox an advantage with Xbox Live. The hard drive in particular was a significant cost driver for the system and one that had never justified itself. We could promote to consumers that they wouldn't need to purchase expensive memory cards to store their save files, but from a business standpoint, that only meant we replaced a potential source of revenue with a cost burden.

As much as I'd like to take credit for coming up with the idea of a downloadable games service on Xbox, that really belongs to Greg Canessa and the MSN Gaming Zone team. Katie Stone Perez and Travis Howland really drove the original Xbox Live Arcade (XBLA) project from a development standpoint. As a member of the Xbox Live business development team, I was asked to help formulate policies that would govern the business, from how certification processes would differ from those of 'real' games to whether we would onboard new developers. In the end, it was decided that the MSN Gaming Zone team would handpick the games that would be included, and they hired a studio called Oberon to do the porting work. The games that were selected were the top sellers on Zone: *Bejeweled*, *Zuma*, *Joust*, and others, eventually growing to a massive library of 27 titles.

When the original Xbox operating system was created, no one had anticipated the advent of downloadable games. So as an anti-piracy measure, the operating system ensured that

photography *Damien McFerran*

599

600

599
Xbox Live Arcade
2004

600
Xbox Live Arcade Unplugged: Volume 1
2006

games could not launch directly from the hard drive. As a result we needed to create a separate disc-based application that could both enable people to buy new games as well as access their existing library. The games may have been stored on the hard drive, but without the disc, they could not be played. We made the launcher disc as broadly available as possible. People could call Microsoft for a free disc. We also put it on the monthly demo disc included in the Official Xbox Magazine as well as in major first-party games like *Forza*. The launcher disc also included a free copy of *Ms. Pac-Man*. Looking back 20 years later, it's funny to recall that digital distribution was in such a primitive state then — we couldn't digitally distribute the XBLA client. Around this time, planning for the Xbox 360 had begun, and it was decided early on to build XBLA directly into the dashboard for the next generation.

In 2005, I left Microsoft to join Nintendo of America. The industry was poised for a new console generation with Xbox 360, PlayStation 3, and the Wii (then still code-named Revolution) on the horizon. I had always wanted to be more involved with actual games in development rather than dealing with issues at the platform level, so I was originally hired to scout games that Nintendo could publish. In addition, because of my experience working on XBLA, I was looped into conversations about Virtual Console: Nintendo's service for downloading classic games from the NES, SNES, and Nintendo 64. Rumour had it that Virtual Console was really being created as a hedge against the unknown potential of the Wii's motion-based controls. If people didn't seem to like them, we could pivot to marketing the Wii as a console for downloading classic games from past generations.

Nintendo veterans Darren Smith and Brian Cheney worked closely with NCL (Nintendo HQ in Japan) to develop the downloadable games system infrastructure, including a points-based transaction system (to reduce credit card fees) as well as the digital storefront. Darren in particular had been proposing projects like this since the NES days. I remember he once showed me a presentation he had put together outlining a service very similar to what Xbox Live would eventually become, but three generations earlier. In fact, by the Nintendo 64 generation, Darren had designed an entire service for downloading full games to a hard drive which never launched.

It was apparent that the same system for Virtual Console could be used for new games, but there was no one focussed on turning that into a new business. The moment that would define my career for the next twenty years came when my boss stopped by my desk. He asked if I thought a carnival game would be a good fit for a downloadable games service. I told him that I couldn't give him an answer, since I didn't know what we even wanted to achieve with this service. I asked him to give me some time to come up with a strategy, and then we could see how this carnival game would fit into that framework.

I started thinking about the potential of the Wii and how it could usher in a new age of innovation in game design. I had gotten bored with an endless parade of first and third-person shooters on the one hand and match-3 casual games on the other. Surely there were new game mechanics to be discovered and more interesting stories to be told than 'super soldier defeats hordes of enemies with giant guns.' I knew that most third-party game publishers were reluctant to embrace motion-controlled games or really any new gameplay styles due to the immense financial risk inherent to the physical games business. There was never an official decision from the company to put me in charge of this new line of business, but since no one else was doing anything about it, I just started working on it. Little by little, I just stopped looking for games for Nintendo to publish and just focussed on this new service we decided to call WiiWare.

One would think that when looking for developers who'd experiment with WiiWare, my first stop would be the indie scene. But at the time, the term 'indie games' was largely unknown to those in the mainstream games industry, myself included. In the days before large scale digital distribution, indie developers could only sell their games through their own personal websites and usenet forums through a shareware model. Valve, which had created Steam to distribute and update their own games, had only just allowed a third-party indie developer, Media Molecule, to release *Rag Doll Kung Fu* on their platform for the first time in 2005 — the team which would go on to create *LittleBigPlanet* and become a PlayStation staple. Most development studios busied themselves pitching games to publishers, hoping to get their next project funded to keep their studios afloat.

Instead of indie teams, I looked towards casual game developers. I wasn't personally a fan of casual games, but my thinking was that they knew what it took to make compelling small games, and that they could perhaps pivot from making endless *Bejeweled* and *Diner Dash* clones to experimenting with new gameplay mechanics. This approach utterly failed. Casual games portals only seemed to be interested in tried-and-true concepts, and the developers were only too comfortable with that model.

I also started thinking about critically-lauded developers with cult followings who nevertheless struggled to have a large hit in the retail market. My first call along these lines was to Tim Schafer at Double Fine. *Psychonauts* had almost been a Microsoft Games Studios first-party title, but that arrangement had been cancelled. A small publisher called Majesco had picked it up and did its best to market and distribute it, but the game was a little too out there to reach mainstream success. I told Tim that I believed he could find much more success selling his games directly to his fans through digital distribution. Although he never wound up making a game for WiiWare, I like to think my advice was somewhat prescient. Within a decade, he often became referred to as king of the indies.

I came across the indie scene when I randomly typed experimentalgameplay.com into my browser. This site included a bunch of short browser-based gameplay mechanics built around some theme, very much along the lines of a game jam. As I played through them, I noticed that my favourites almost always tended to be made by the same person: Kyle Gabler. I got in touch with Kyle, who held down a day job as a game designer at EA. He told me that he and a programmer friend from work, Ron Carmel, were thinking about taking one of his gameplay prototypes and turning it into a full game. He wanted to take *Tower of Goo*, a physics-based game about seeing how high you could build a tower made of goo balls that cling to each other, and turn it into a full *World of Goo*. I'd love to say that I saw the full potential of what *World of Goo* could be, but I have to confess: I couldn't see how his tower-building toy could be made into a full game. What I'm glad to say I did recognise, however, was that Kyle was a far better game designer than I would ever be, and that if he thought it could be done, I should trust his instincts over my own.

Kyle introduced me to several rising stars of the indie scene, none of whom had had a hit game yet since they hadn't had the opportunity. People like Edmund McMillen and Tommy Refenes, who were designing a tough as nails platformer called *Super Meat Boy*. Derek Yu was working on a little project he called *Spelunky*. From there, word spread that Nintendo was interested in working with indies. In reality, it was just me — no official mandate from the company, no official platform I could provide any meaningful details on. But at least I knew I had found the development community I'd been looking for.

I discovered that my counterpart at Sony must have been thinking along the same lines. In my search for new types of gameplay, I came across a prototype of a motion-controlled game about flying called *Cloud*, made by two USC graduate students named Jenova Chen and Kellee Santiago. I spoke with them about what I was trying to build with WiiWare, but someone named John Hight from Sony had already offered them a sweetheart deal to make games for their fledgling digital distribution service. I never actually met John, but his name came up time and again. It seemed like we were following the same trail, though he had the enviable advantage of a content budget. And in case Jenova and Kellee's name don't sound familiar, perhaps the company they formed, literally called thatgamecompany, might. Or perhaps their game of the year award-winning game, *Journey*.

My dreams of a service fuelled by innovation — limited only by the creativity of a new generation of game developers no longer tethered to retail publishers' myopic vision — crashed against the reality of technical constraints. Like indie developers themselves, Nintendo recognised that in order to compete with Sony and Microsoft, it would have to do so on the merits of creativity and innovation, not by having the most expensive

big-budget hardware. The Wii's CPU and GPU were about a generation behind those of the Xbox 360 and PlayStation 3. The storage was limited to 512MB, and the team at NCL focussed on building out the Wii Shop Channel was miniscule.

Many late nights were spent negotiating with NCL about policy decisions for WiiWare. One major concern I had was that as soon as we opened the floodgates, the casual games portals would be waiting in the wings, ready to unleash all of their seemingly unlimited match-three puzzlers, a genre I grew to loathe. Or that we'd be inundated with low quality shovelware that would clog up our storefront, which had virtually no discoverability features. I recommended a concept approval committee to curate what would go in the store.

The strongest voice against this (not that the voice had to be that strong — I was a relatively junior Nintendo of America employee who had been at the company for less than a year) was the CEO of Nintendo, Mr. Satoru Iwata. Although we disagreed on this issue, the absolute highlight of my career at Nintendo was when Mr. Iwata sat down with me, one-on-one, for over an hour to discuss my thoughts on the matter. He recalled the days when Nintendo had gotten arrogant during its heyday SNES years and formed a concept approval committee for the Nintendo 64. Publishers were rightfully incensed that Nintendo had had the gall to tell them how to run their business and flocked to the more open PlayStation. He recognised that it's very hard to predict what will resonate with people. Even now, I often try to evaluate my predictive powers. Would I have seen the potential in *Undertale* or *Vampire Survivors*? Or even *Minecraft*?

My concerns about game discoverability were not unfounded. Despite Darren Smith and Brian Cheney's push for even basic e-commerce features like an account system or the ability to list games by genre, the user interface was a very clean, but ultimately boring, pure white screen with only a list of recently released and top-selling games. Unless a game was on one of these lists, you would only find it by searching its name. And even if a customer stumbled upon a game that might be interesting, they would only see two screenshots and a text description. Trailers, demos, user reviews, and metacritic scores were all beyond the technical capabilities of the Wii Shop Channel.

At one point, halfway through the Wii's lifecycle, Darren Smith conducted a usability study where current Wii owners were asked to connect the system to Wi-Fi, find a game they were interested in playing, and purchase it using a credit card. Despite the fact that everyone in the study already owned a Wii, most didn't realise they could download games to it, and even when they were informed that it was an existing service, they struggled to navigate all of the necessary steps to complete their transaction. At one point during the study, an 11-year old girl had gotten stuck so the moderator left the room to see if her parents could help. When she thought she was alone, she echoed all of our thoughts when she said aloud to the two-way mirror, "Man, fuck this."

One other constraint surrounding the content side of the business was that it cost the company thousands of dollars to test and certify each game, in a process called Lotcheck. In the retail paradigm, this was an acceptable cost since the minimum order quantity of discs would more than cover the expense. At some point, someone proposed making WiiWare utilise a similar model. In the traditional world of physical discs, even if a game had gone gold and was ready to go into production, in theory a publisher may have chosen not to produce the discs if they expected sales to be too low. In an all-digital world, there would be no reason not to release the game, since even a few dollars were a few more dollars than they would have had if they chose not to launch.

The proposed solution was to establish a performance threshold. If a game sold below a certain number of units, all revenue generated by the game would be kept by Nintendo as a way to offset Lotcheck expenses. Once the threshold was reached, the developer would receive full royalties on a retroactive basis. Because there was limited storage space, Nintendo wanted to provide an incentive for developers to keep their games small, so the thresholds were set at 6000 units for games above 16MB and 4000 units for games smaller than that. And if your game didn't cross that threshold within two years, it would never qualify for royalties — even if it crossed the performance threshold later.

My absolute biggest regret at Nintendo was not squashing that plan at the outset. It turns out that there's no magic number of units which would simultaneously be high enough to discourage shovelware but low enough not to penalise developers for taking a chance on a new game concept. As the WiiWare storefront filled up, the lack of discoverability options meant that almost every game failed to reach the performance threshold.

After the first couple years of WiiWare, I found myself in the uncomfortable position of actively warning developers away from WiiWare since I knew they would probably get nothing in return. I tried to have that clause retroactively removed from the WiiWare agreement and to pay all developers their royalties regardless of whether they hit the unit threshold, but I wasn't able to get certain key people (who shall remain nameless) to budge. One particularly tough moment came when the developers of *Super Meat Boy*, Tommy Refenes and Edmund McMillen, told me they had been approached by Microsoft to release their game on XBLA. It had already been announced for WiiWare, but I recommended that they focus on XBLA, as that is where they'd have the best chance for success. They followed my advice (or far more likely, did what they would have done regardless of my advice) and launched

on Xbox. I held out some hope that they would eventually make a WiiWare version, but by the time the game was done, it had far outgrown the limitations of the platform.

Microsoft and Valve went through their own growing pains as they navigated the technical and curation challenges. Like WiiWare, XBLA had file size limitations at the beginning. First 30MB, then 50, and later 150MB. Its solution to the curation issue somewhat reflected some of Mr. Iwata's concerns. Although there was a curation committee for approving indie developers' games, publishers of traditional retail games were each given two slots per year they could use to release whatever games they wanted. This created a somewhat perverse market where traditional publishers would essentially sell their slots to indie developers. The publisher would 'publish' the game and keep a percentage of the revenue, often 50% or more. Many indie developers who couldn't get approved directly by Microsoft grumbled at having to pay a publisher tax just to get placement on the storefront. Valve, for its part, also approved concepts by committee but didn't give any formal preference to publishers. Eventually Valve switched to a community-based concept approval process called Project Greenlight, and finally allowed anyone to release whatever game they wanted, provided it didn't violate any objective criteria. Essentially, Valve adopted Nintendo's lack of a concept approval policy about ten years after the fact, but they had a far superior system both for discoverability and for helping players decide if a game was right for them.

Microsoft partially addressed the discoverability issue by creating a system that enabled players to demo any game on Xbox and convert it into a full version without having to re-download the entire game again. (I call this a partial solution because although it reduced consumers' uncertainty about whether a game would be a good fit for them, it didn't help people find games they hadn't previously heard of.) Essentially players would download the full game up front, and there would be a flag in the game, either time-based or at a specific milestone in the game, where the demo would end. If the player wanted to keep going, they only needed to download a key (essentially a small text file) whose presence on the hard drive would indicate to the game that the full version had been paid for. I caught up with my old colleague Katie Stone Perez who reminisced about how that system came to be. "I remember waking up one morning scared shitless about how we were going to solve our issues, and after spending a full day on a whiteboard with Brian Ostergren, we had the solution. One of my favourite work days ever!"

Beyond the developer outreach and e-commerce functionality, a great deal of work was required at Nintendo (and I'm sure the other platforms aside from Steam) to adapt its systems to go from working with a small number of publishers to hundreds of indie developers. I recall many meetings with IT and legal to establish a new click-to-accept publishing agreement in the days before DocuSign. I learned about all of the tax forms we would need to collect from international developers who could take advantage of the various tax treaties with the United States. And my very small team and I (shout out to Scott Cardenas, Luke Matthews, Shannon Refenes nee Gregory, and Nathan Clark) cobbled together a low tech operations system whereby we could track and collect everything we needed for the Wii Shop Channel and put together the release schedule. (The observant reader may recognise Shannon's last name as being the same as that of Tommy Refenes of *Super Meat Boy* fame. They met at a WiiWare press event and married after Shannon left Nintendo.)

It can be challenging enough to change long-established company processes without some key stakeholders actively resisting progress. At least one key member of the NOA Software Development Support Group (SDSG) had long held that they were only equipped to deal with experienced, professional game developers. The developer portal, WarioWorld, had a command line interface and looked like a GeoCities site circa 1996. This was by design, not a byproduct of not having enough resources to modernise the website. Nintendo specifically requested that the site not show up on Google search results, the idea being that true professionals would know how to find it, but lowly amateurs would not. And true professionals would spend years learning the idiosyncrasies of Nintendo's processes so not only was there no need to streamline them, they served as another moat the unwashed masses would be unable to cross.

One rule held that game developers had to work at an office separate from their home. (Apparently there was no way to enforce a rule requiring developers to wear a suit and tie.) There were people who spent their time looking up the developers' addresses on Google Maps to determine if the place of business was a residence. In one case, I was encouraging industry veteran-turned-indie Chris Hecker to bring his game *SpyParty* to the Wii U. After he applied, one ardent proponent of the keep-out-the-riffraff SDSG philosophy pointed out that Chris worked from his home. Chris responded that he had a detached garage separate from his residence where he did his development work and could keep any development equipment secure. The SDSG person (who I'm keeping nameless for the sake of trying to be the better person, though I'm still salty just thinking about it) demanded Chris take photos of his studio to check if it was, in fact, a development space. Unfortunately, a washing machine could be seen in the background of one of the pictures so he was nearly rejected on that basis alone. (To be fair, it's probably impossible to work on a game while the washer is running.) I apologised to Chris for the embarrassing incident and escalated the issue to get him approved. It took years to get the home office policy changed, and years more still before Melissa Bacon from the third-party publisher team got approval to create a new user-friendly developer portal.

Despite the setbacks, after all of the processes were established and ready to go, we opened the floodgates. The first WiiWare game to pass Lotcheck and be slated for a day one launch was a charming game called *Defend Your Castle*, a tower defence game featuring stick figures with buttons for heads attacking a castle with tongue depressor sticks. Although the system was far from perfect, I think in retrospect we were able to bring about that vision of cultivating a new generation of developers who embraced their newfound freedom to be as creative as they dared. Some of my personal favourites from that era include *World of Goo*, *Cave Story*, the BIT.TRIP series, *And Yet It Moves*, *Retro City Rampage*, *La-Mulana*, *Toribash*, *LostWinds*, *LIT*, and so many others. As I had feared, though, we got a sizable number of shovelware games and tried to keep track of whenever we felt a game hit a new low. Members the hall of shame include *Frat Party Games: Pong Toss*, *Mart Racer* (a buggy game about racing around a supermarket in shopping carts), and an endless sea of screensaver apps that tried to mimic the inexplicable success of *My Fireplace*, which held the #2 spot on the Wii-Ware best-sellers list for nearly a year.

Once all of these systems were established, we pivoted and adapted them to DSiWare with only minor modifications. From there, we abandoned the convention of '[platform name] + Ware' and simply branded all of our digital distribution platforms as the Nintendo eShop, which was far more future-proof. As the downloadable games business grew, it made less sense to distinguish it from the physical games business. Games were games. My team was folded into the larger third-party publisher team, headed by Steve Singer. I missed having control over the operations and marketing for the platform, but it was a necessary step in the maturation of the business.

As my role devolved from creating and running a new line of business into just a regular developer relations position, I decided it was time to move on. My work there was done and a new segment of the industry was forever established. I was immensely proud of the part I had played in establishing this space. Yet, the more I hung out with indie developers, the more envious I felt of their freedom.

I realised that I was on the wrong side of the fence. For years I'd told myself that I wouldn't be a Nintendo lifer, and I came to a realisation that if I didn't make the leap soon, I should resign myself to the fact that I never would. So like so many of the amazing game developers I'd met over the years, I went indie myself. Since then, I've helped publish bold and innovative games at digital and retail, including *Axiom Verge 1 & 2*, *Chasm*, *Mages of Mystralia*, *Salt and Sanctuary: Drowned Tome Edition*, *Guacamelee! One-Two Punch Collection*, and *Animal Well*. We've come a long way since the days when the industry constrained its vision of what a game could be to a limited set of pre-existing genres. And I love enjoying the fruits of being part of this new segment that I had a hand in creating.

601

602

601
World of Goo
2017

602
Axiom Verge
2015

603

Shifting Indie Tides

Although the indie boom existed primarily in the digital sphere, it always had an analogue component. From the Unplugged series that brought XBLA titles to retail via compilation disks to download cards and points cards — these physical objects remain from the early days of modern indie gaming. And that era birthed legends, titles which have gone on to not only see re-release time and time again, but that have also made it to physical formats as standalone projects, alongside boutique and mainstream publishers alike. The indie scene is always changing, and every inch of progress is owed to the work done by Dan as well as his similarly visionary colleagues.

604

605

603
Retro City Rampage DX
2017

604
Super Meat Boy
2010

605
Nintendo Points Card
Unknown

indies as we know them.

313

THE STORY OF GENERATION 8.

words *Mike Diver*

Nintendo was on top of the world, at least in raw sales figures, for the seventh generation of home consoles. The Wii consistently outsold its contemporaries — Sony's PlayStation 3 and Microsoft's Xbox 360 — and come the close of 2010, its lifetime sales had passed 84 million (it'd fly past 101 million by the time of its 2013 discontinuation). But look closer, and cracks were showing: the Wii's market share had been steadily shrinking, dropping 10% between 2007 and 2010 to finish the decade on about 41% of the global picture, as its rivals clawed their way into contention.

Nintendo's then-president, Satoru Iwata, acknowledged in 2008 that the Wii wasn't appealing to what he saw as core gamers — those who had turned, in growing numbers, away from Nintendo and to the machines made by Microsoft and Sony, to series like Halo, Forza, Gears of War, Uncharted and Resistance. In the wake of that year's E3, where there was a notable lack of 'core' reveals (stage time instead taken up by lengthy demonstrations of *Shaun White Snowboarding* and *Wii Music*), Mr. Iwata took it upon himself to effectively apologise for the casual turn so much Wii software had taken.

A 2013 feature on gamesindustry.biz, "The life of the Nintendo Wii – through the eyes of Satoru Iwata," quotes the company's hugely popular late president: "We are sorry about the [E3] media briefings, specifically for those who were expecting to see Nintendo show something about Super Mario or Legend of Zelda. However, the fact of the matter is the so-called 'big titles' need a long, long development period... [and] we really didn't think this year's E3 was the time to do so."

Behind the scenes, this feeling that Nintendo was losing its core audience, loyal through previous generations, was a massive motivator for the development of its eventual Wii successor, which had entered preliminary planning in 2008. The next year's E3 would see a number of more traditionally 'core' titles shown off for Wii, including *Xenoblade Chronicles* (then titled *Monado: Beginning of the World*), *Metroid: Other M* and *Super Mario Galaxy 2*. But that next console, the Wii U, would shift things considerably, as evidenced by its launch line-up in November 2012.

The company's iconic mascot was present and correct in *New Super Mario Bros. U*, and the theme park-styled *Nintendo Land* was a first-party local multiplayer triumph of the kind it feels only Nintendo can make. But there were also big-budget third-party titles that'd graced the Xbox 360 and PS3, with the likes of *Batman: Arkham City*, *Assassin's Creed III*, *Mass Effect 3* and *Call of Duty: Black Ops II* appearing on day one in North America and Europe.

Assassin's Creed makers Ubisoft also contributed the dark and gory *ZombiU*, a survival-horror exclusive (at the time) that made fantastic use of the Wii U's GamePad screen. This display allowed the player to manage their inventory in real-time without pausing, meaning the brain-hungry horrors on the TV remained very much active and alert to their next meal. It was a hint of the potential the Wii U possessed: here was a console that could be a home for genuinely new experiences thanks to its dual analogue stick configuration and touch-sensitive second screen. That it was compatible with the Wii's waggly Remotes — and that system's huge library of software — only sweetened the deal. And yet, that close kinship with the console that came before it undermined the forward-thinking aspects of the Wii U and contributed to its somewhat unfair reputation as a flop.

Nintendo is rarely a company to simply iterate on its hardware's form and functionality, the last straightforward evolution from one generation to the next probably being the step from the 8-bit Nintendo Entertainment System (the Famicom in Japan) to the 16-bit Super Nintendo Entertainment System (or the Super Famicom). The clue's in the name there, really. Besides a lot more buttons on the controller and a massive increase in graphical and audio capabilities, the leap from NES to SNES didn't feel like it was reinventing anything — rather, it was building

photography *Damien McFerran*

upon its maker's strengths with supreme confidence, developing famous franchises with series-best entries and becoming a home for the highest-quality arcade ports (well, the *affordable* home, anyway, given it shared a generation with the Neo Geo AES).

After the SNES, however, it seemed that each new Nintendo console was tearing up at least some of the previous system's rule book and replacing well-thumbed pages full of established practices with all-new thinking — both in regard to what we play and how we play it. The Nintendo 64 took Mario into three dimensions, with an analogue stick to better control the athletic plumber. The GameCube's controller might have looked traditional (for the time), but closer inspection of its inputs showed it was moving to its own rhythms compared to the PlayStation's similarly handlebar-like peripheral; and the Wii made interacting with its innovations as effortless as moving your arms around in front of the TV.

Come 2012, the Wii U's introduction of the GamePad *could* have been revolutionary, adding another plane of play and so many possibilities to traditional single-screen home gaming. It was an invitation to develop differently, to find fresh formulas to mix into the expected, into what Sony and Microsoft games were already doing. But it just never happened. Sales started slow and remained so, and consumers were confused by the nature of the product Nintendo was now supporting. Was it a Wii add-on or a whole new system? The latter, obviously, but early previews and marketing opportunities — including the console's perplexingly imprecise debut at E3 2011, which focussed on the GamePad and not the new console you needed alongside it — really didn't make the Wii U's position perfectly clear.

Alongside the low sales came reports of difficulties at studios making multi-platform titles.

Making a game for both Xbox One and PlayStation 4 required an ostensibly identical design approach — developing for the Wii U was more complicated and demanding. Games were released with no GamePad support beyond an option to play off-TV, and notable third-party titles all but disappeared. The list of games that were released for the Wii U's contemporaries but were announced only to be cancelled for Nintendo's machine — because of its small audience and production challenges — is lengthy, including such high-profile names as *Crysis 3*, *Metro: Last Light* and *Project CARS*.

Nintendo, naturally, stuck by its console, ultimately giving the Wii U a fine send-off with *The Legend of Zelda: Breath of the Wild* releasing on the same day, March 3rd, 2017, as the Switch and said hybrid system's own version of the open-world epic. The Wii U had officially been discontinued a couple of months earlier, ahead of the Switch's arrival, but this date — representing the birth of something new and the death of something that never really arrived — felt like the passing of a flickering and sputtering torch, getting weaker all the time.

The Switch would totally turn around Nintendo's hardware fortunes, but it really was a make-or-break product for the veterans of video gaming. During the Wii U's dismal lifetime, where sales totalled around 13.5 million worldwide (for comparison, the Wii shifted over 100 million units), profits had fallen off a cliff and operating losses had become an uncomfortable norm. Slim though it was, there was a chance that Nintendo could go the way of Sega and bow out of console production if the Switch bombed like its predecessor.

But the Wii U became, to quote former Nintendo of America president Reggie Fils-Aimé, a "failure forward" — which is to say its design, the ethos behind its creation and Nintendo's aim to realise a console that could be used by those desired core gamers but offer something neither Sony nor Microsoft could (at least, not without additional hardware and apps), directly influenced the Switch. The dual-screen approach evolved into a refined take on off-TV play, the GamePad into a portable device that could support local multiplayer without the need for a big screen. And it worked. Across three main models produced since 2017, sales of the Switch have passed 132 million, making it the second-highest-selling home console of all time (it's got a dock, so it counts). The biggest-selling, at 155 million, remains the PlayStation 2 — but Sony's eighth generation machine has been no commercial slouch, either.

Launched in North America and Europe in late 2013 and Japan in early 2014, the PlayStation 4 was an instant hit in a way the Wii U and the Xbox One couldn't match. By the end of 2013, Sony's console had passed 4.2 million sales worldwide — a healthy million units (and some) ahead of Microsoft's hardware. And that lead would only grow. By January 2016, after two years as the world's best-selling console, the PS4 had reached 35.9 million units sold, whereas the Xbox One was lagging behind on an approximate 18 million consoles activated. This was a notable contrast to the seventh generation's competition between the two manufacturers, as the Xbox 360 had not only launched ahead of the PlayStation 3 but maintained a sales lead for much of the two consoles' lifespans (ultimately, both shipped in the region of 80 million units).

Lifetime sales for the Xbox One at the time of its 2020 discontinuation — for all of its models combined — came in at around 58 million. The PlayStation 4 has sold more than double that figure. Exactly what caused this sizable schism can be debated, but there are certain Microsoft decisions which most commentators can agree were impactful missteps.

For starters, upon its official reveal in May 2013, the Xbox One was pitched as an all-in-one device for TV and film, video communication, internet browsing,

606

Taking It Back

Rayman Legends was famously announced as Nintendo exclusive before Ubisoft made the understandable decision to pivot the title to a multiplatform release. The result was an unhappy Wii U audience but also some Nintendo-centric costumes in that version of the game. This wasn't an uncommon practice — Nintendo costumes were one of Tekken Tag Tournament 2's marquee features when it launched on Wii U.

Consoles that Won't Quit

The PS3 and Xbox 360 ushered in a trend that'd soon follow with the PS4 and Xbox One as well: long periods of cross-generation support. Seventh generation systems received ports of marquee games like Metal Gear Solid V and Call of Duty: Black Ops III well after their successors released, with less-demanding software pushing seventh-generation ports with regularity through 2016. The same is true of the eighth-generation systems, which readily enjoy ports of PS5 and Xbox Series games, several years after the release of those machines.

607

606
Xenoblade Chronicles X
Limited Edition Wii 2017

607
ZombiU
2012

Four-for-Four

There are seldom few games which received synchronous physical releases across Wii U, Xbox One, PS4, and Switch, and none that received synchronous worldwide physical releases. But at least in North America, Just Dance 2018 and 2019, as well as Cars 3: Driven to Win, were released across all four! However, if you count staggered releases, there are significantly more games that cross each, such as Darksiders: Warmastered Edition or Minecraft: Story Mode.

608
1-2-Switch
2017

609
Call of Duty: Ghosts
2013

610
Metal Gear Solid V: The Phantom Pain
2015

611
Mario Kart 8 Deluxe
2017

612
The Witcher 3: Wild Hunt
2015

613
Just Dance 2019
2018

608

609

610

611

612

613

playing music and, every now and then, enjoying some video games. This drew criticism from Xbox's own audience who wanted what they already had with the 360, only better, faster, more powerful. The Xbox One was all of those things, and games showcased alongside the machine's multimedia abilities — the likes of *Quantum Break*, *Forza Motorsport 5* and *Call of Duty: Ghosts* — looked good. There just weren't many of them. "There'll be more at E3 — and hopefully some games will be there, too," was a telling line in Eurogamer's live blog coverage of the reveal event. Kotaku was much more blunt, with a headline that read: "That Xbox One Reveal Sure Was a Disaster, Huh?"

Microsoft wasn't oblivious to the sentiment spreading across the video games media, and subsequently to consumers, and its E3 2013 was pitched as being "all about the games." It opened with *Metal Gear Solid V: The Phantom Pain* — quite the statement given Konami's stealth-action series had long been associated with PlayStation consoles. This was followed by the impressive-looking *Ryse: Son of Rome*, *Sunset Overdrive* and *The Witcher 3: Wild Hunt*, before the show was closed by confirmation of a new Halo game and the reveal of the console-exclusive *Titanfall*. Strong stuff indeed, and evidence that Microsoft's new machine would be a worthy successor to the 360 when it came to games. But doubts lingered. Messages remained muddled.

The Xbox One shipped initially with a revised Kinect camera, a motion sensor first released for the Xbox 360 in 2010. This device was intended to be integral to using the console. A proposed always-on listening mode, designed to allow the user to awaken their console with voice activation, had people worried that they were basically being spied on. Despite publicly stating that privacy was of the utmost importance, a top priority, Microsoft couldn't quell the discomfort its potential customers were feeling towards the Kinect's mandatory implementation. By the time of the console's release, the requirement to have a Kinect connected had been walked back, but still the Xbox One shipped with the sensor, increasing its cost to the consumer — its launch price of $499 was $100 more than the PS4, stirring memories of PlayStation's famous "two-nine-nine" announcement at its E3 1995 press conference, which as good as killed the more expensive Sega Saturn's chances in North America.

Then there was the matter of sharing games. Or, buying second-hand discs rather than paying full price every time you wanted to slide something new (to you) into your Xbox. Throughout gaming history, friends have swapped carts or discs with each other, picked up bundles to build collections, and taken advantage of used titles at discounted prices. At its reveal, Microsoft stated that the Xbox One would need to be connected to the internet every 24 hours to authenticate the user's account for offline play and their access to games — including the use of physical versions, which would be essentially watermarked once inserted and subsequently unusable on another user's machine.

This ambition to restrict the reselling of software was hopelessly misguided, and PlayStation capitalised on Xbox's bizarre decision with a hastily produced skit at E3 2013, filmed between Xbox's conference and Sony's, which you can find on YouTube, titled "Official PlayStation Used Game Instructional Video." In it, the then-president of SIE Worldwide Studios, Shuhei Yoshida, appears beside the then-VP of SIE's Publisher and Developer Relations department, Adam Boyes, and the pair illustrates how sharing a game is as simple as handing the game to your friend. That's it. That's the whole video. In just 21 seconds, a lot of which is simply a screen with "Step 1: Sharing the game" written on it (there is no Step 2), PlayStation had dealt a substantial blow to its closest competitor of the previous generation. Secondhand games were welcome on PS4, and there were no digital rights management hoops to jump through.

Microsoft again listened and took action: the DRM restrictions were scrapped, and the company announced that used games would play just fine. But the damage was done. An Amazon poll posted on Facebook in the wake of E3 2013 asking users to vote for their favourite of the two new systems reportedly had to be taken down early after Sony's system raced to a 95% share. The people had spoken: Microsoft's initially proposed user experience wasn't what they wanted, and despite the about-turn on its most controversial aspects, the Xbox One was in a distant second place before the race had even begun. Unless you're counting the Wii U, of course. But Nintendo seems to occupy its own orbit, while Sony and Microsoft largely scrap for the same path around the gaming world.

The Xbox One may have failed to match the 360's commercial performance, but it did introduce what's possibly Microsoft's greatest contribution to how modern games are enjoyed: Game Pass. Launched on June 1st, 2017, this subscription service, giving customers access to a large library of games for a monthly fee, split across various pricing tiers and today available on both Xbox consoles and PC, has been a superb success for its owners. At the start of 2022, subscriber numbers had reached 25 million, and Microsoft reported its best-ever quarterly financials in Q1 of 2023-24, which included a 13% year-on-year rise on services, including Game Pass. Still, this new high of almost $57 billion in revenue came despite a drop in hardware revenue. Although ninth-generation Series X|S consoles weren't flying off the shelves, Microsoft's subscription-based library of first- and third-party titles — from AAA blockbusters to innovating indies — had become a very attractive product; so much so that Sony effectively copied it with its revamped PlayStation Plus service's Game Catalogue, which launched in mid-2022.

As the PS4 and Xbox One pulled further and further away from the flagging Wii U, Nintendo remained

614

615

614
Limited Edition
PS4 Uncharted 4: A Thief's End
2016

615
Limited Edition
Xbox One Forza Motorsport 6
2015

remarkably quiet about the console that'd become the Switch. E3 2016 came and went in June with no new hardware on show, despite abundant press coverage on a rumoured new system codenamed the NX. As was often the way at Nintendo, planning for its next major piece of hardware began around the time of the current model's launch, so initial internal thinking on the Switch can be dated back to the Wii U's release in 2012. Noise about the so-called NX began in earnest in early 2015 when a partnership between Nintendo and Japanese mobile company DeNA was made public, and a 'brand-new concept' for said hardware was mentioned. But such was the uniqueness of this concept that Nintendo was keen to keep further details under wraps.

Nevertheless, leaks occurred. There were reports of Nintendo's new system having a hybrid design with removable controllers suitable for portable and home play; that it'd use cartridges again rather than discs, that it'd be supported by a robust digital store — powered by Nvidia's Tegra X1 chip. Shortly after E3 2016, in late June, Nintendo's Shigeru Miyamoto confirmed to shareholders that they'd held back the formal reveal of the console due to fears about having it copied: "Normally we would have shown the NX at E3... [but] we're worried about imitators if we release info too early." The console was finally shown in October 2016, although its full specifications weren't announced until January 2017, just two months ahead of launch.

And when those specs landed, they confirmed what everyone already expected: the Switch wasn't designed to be as technically advanced as Sony and Microsoft's consoles and certainly not on par with their incoming ninth-generation systems. Instead, it was a console designed with functionality and flexibility in mind, its tablet-like design giving it a sleekness — its docked form striking a more diminutive profile than its peers. A kickstand on the rear of the console meant three play patterns were possible: fully handheld with both controllers connected; tabletop play with controllers (named Joy-Con) in hand; and TV style with the console docked and Joy-Con detached. The launch title, *1-2-Switch*, aptly demonstrated all of these gameplay modes.

What might have been gimmicky without considered research and development proved anything but. The Switch's ability to fit around its user's lives, rather than being a device you had to find time for, proved to be a huge selling point. That, and some incredible software, with Nintendo again refining and reinventing its major franchises for a new generation. The Switch became a second home for many great Wii U games too, another chance for the likes of *Captain Toad: Treasure Tracker*, *Pikmin 3*, *Donkey Kong Country: Tropical Freeze* and, most notably, *Mario Kart 8* (the highest-selling Switch game) to be enjoyed by players who'd previously missed them. Even as the games media anticipated new Nintendo hardware to be announced in 2023, the company's lips stayed sealed — and Switch sales continued to rise.

What the Wii U started in 2012, then, the Switch is far from finishing — which is to say, the continuation of creative thinking when it comes to hardware design at Nintendo, the eagerness to explore expanding virtual worlds in ways we couldn't before. PlayStation and Xbox follow one console with another and largely crib from what worked before, and will likely continue that philosophy into any new dedicated hardware. But Nintendo's propensity for providing surprises leaves us all with nothing but thrilling uncertainty as to what will come next. Simply a 'Switch 2' or a 'Switch Pro' feels too elementary — but then, perhaps, the greatest surprise of all will be a Nintendo that only lightly iterates, realising that it's never had it better than in home gaming's eighth generation.

616

617

618

619

616
Cars 3: Driven to Win
2017

618
Just Dance 2018
2017

617
Darksiders: Warmastered Edition
2017

619
Minecraft: Story Mode
2017

WII U.

First Released:
2012

Manufacturer:
Nintendo

Launch Price:

JP	¥26,250 (Basic Set)	
	¥31,500 (Deluxe Set)	
UK	$299.99 (Basic Set)	
	$349.99 (Deluxe Set)	
US	£249.99 (Basic Set)	
	£299.99 (Deluxe Set)	

Storage Struggles

The Wii U launched with two versions, and this immediately caused an issue. The Basic Set console only had 8GB of internal storage, although it was expandable via external HDD. Nevertheless, Nintendo Land would've taken up half that space on day one. The Deluxe Set Wii U didn't fare much better with a still weak 32GB of internal storage itself.

I began eighth grade in September 2014. After my first day of classes, I excitedly changed into exercise clothes as it was time to start tennis practice for the year. I was ecstatic, tennis being my favourite sport. Standing in the middle of three courts, drills unfolding on either side of me, I got to playing. It couldn't have been more than thirty minutes into the session by the time that I found myself with my feet where my head should've been, my wrist making first contact with the court upon landing after a *Loony Tunes*-type accident saw me slip on a haphazard ball which rolled in from another court. I picked myself up, held my arm out straight to assess the damage... and my wrist swung like a saloon door well past ninety degrees. All that remained between my forearm and hand were fragments of bone. It took mere hours before I was in full-arm cast.

But this injury and its accompanying pity provided me with something that I'd wanted since its launch: a Wii U. After being denied one during Christmas 2012 (as it turned out, I was receiving an iPod Touch that year, unbeknownst to me at the time), I finally reopened the conversation. I loved my 3DS but part of me always itched for Nintendo's HD home system too, which I obviously couldn't afford since I was eleven at the time of its release. Two years later, dejected from the loss of my tennis season and grappling with a serious injury, my disposition made a strong enough case for the console.

Sort of. In a deal that I should've better negotiated in hindsight, my parents *drove* me to the store to get the Wii U. *I* paid for it by trading in years upon years upon years of old hardware and games. They did cover the remaining cost of *Mario Kart 8* after the majority of my GameCube and Wii collection didn't quite go the distance in trade-in credit (I feel queasy writing that) and bought me some accessories. I returned home with a 32GB Wii U Deluxe Set, *New Super Mario Bros. U* and *New Super Luigi*

U packed in, as well as the aforementioned copy of *Mario Kart 8*. And that, I was certain, would be my entry point into a long generation with this sterling, flagship machine.

The Wii U was a commercial disaster. Not even Nintendo would deny that, selling a mere thirteen million units total as of the last-reported sales data in 2023. Given that the Switch has since outsold the Wii U at a rate above ten-to-one, there's little doubt that on a dime Nintendo turned its fortunes around.

Ask just about anyone what Wii U's legacy is, and they'll tell you that, although the system failed, it was a prototype Nintendo Switch. That the GamePad's off-TV functionality was proof of concept for its successor's hybrid design. I distinctly remember enjoying *Mario Kart 8* on the GamePad as my family flicked on yet another nightly cooking show. And that was great — but didn't feel like anything I hadn't been doing with *Mario Kart 7* or *DS* before it. To me, off-TV play just made my Wii U into a clumsy handheld replacement, when I was well into year three of being inseparable from my 3DS. This feature isn't why I loved my Wii U, why I lugged it to and from college all four years despite having a Switch in my backpack alongside it. My Wii U doesn't occupy HDMI 3 to this day because it offers a primordial Switch experience. My appreciation requires decoupling the system from its successor.

Released in November 2012, the Wii U's initial suite of titles suggested a unique priority: proving that the Wii U GamePad could evoke the unprecedented joy of two-screen home console play. At the core of this effort sat a launch title which encapsulated all that the system hoped to stand for: *Nintendo Land*. For my money, it was every bit as effective as *Wii Sports* but even richer, a crossover on a scale typically reserved for *Super Smash Bros.* It aptly distilled the company's spirit and history into a series of easily digestible but nonetheless replayable attractions through its theme park motif.

323

Peripheral Vision

The Wii U was compatible with the Wii's controllers and accessories, from the Wii Remote and Nunchuk to the Balance Board. And not just for the sake of backwards compatibility! Many Wii U exclusives supported the Wii Remote, even releasing new designs to coincide with marquee titles like Super Mario 3D Land. But the Wii U had just a few accessories of its own outside of the Pro Controller (such as the GameCube Controller Adapter, Microphone, and Fit Meter) and only a single special edition console with a unique hardware design, released to accompany The Legend of Zelda: Wind Waker HD.

620

621

622

623

625

620
The Legend of Zelda: The Wind Waker HD Wii U Deluxe Set 2013

623
Wii Remote Plus, Mario Edition
2013

621
Wii U Pro Controller
2012

624
Fit Meter
2013

622
Nintendo GameCube Controller Adapter 2014

625
Wii U Microphone
2012

Most importantly, *Nintendo Land* demonstrated what the GamePad could do. The answer, it turned out, was just about anything. In the mini-game Takamaru's Ninja Castle, it was the platform from which you launched throwing stars with a swipe of a finger. In the multiplayer Luigi's Ghost Mansion, it was the asymmetric screen from which one player stalked others on the TV as an invisible poltergeist. The tablet controller was not a mirror of the TV's action, but instead its complement.

New Super Mario Bros. U — a comparatively straight-forward adventure — thought of the GamePad not as a way to platform while your family watched a movie, but instead to invite an extra player into the fray. Boost Mode, its marquee gimmick, allowed a fifth person to place temporary platforms for the other four scampering around the stage. In fairness, it wasn't a particularly deep idea. Nonetheless, it reinforced that the Wii U was interested in showcasing how a detached touch screen could explore previously impossible gameplay concepts.

Many of the Wii U's best games ventured further down this design path, always wondering what more the GamePad could do. 2013's oft-overlooked (and now ludicrously expensive) *Game & Wario* stands shoulder-to-shoulder with the most unique software on the platform, having arguably the most GamePad ideas per square inch. The only WarioWare game to forgo microgames as the driving force behind its overarching structure, *Game & Wario* instead has you turning the GamePad inside out as you ponder all that the controller can achieve in larger mini-games. Perhaps the most novel usage sees you doing your best *Rear Window* impression, treating the GamePad as a camera's viewfinder through which you snap photos of people in the surrounding buildings, those rendered on the TV. This creates a particularly intimate relationship between the TV and GamePad that sees each talking to the other in a way no other system can recreate.

We'd have to wait until 2015 for the next wave of titles that truly had this two-screen dynamic at the core of their design. First came *Splatoon*. I don't think a day passed that summer where I didn't play the game, enjoying this funky multiplayer explosion of creativity. Its success was infectious, becoming one of few Wii U titles that reminded the industry at large that Nintendo is not to be counted out even in its lowest moment. Winner of Best Multiplayer at the 2015 Game Awards ceremony (an accolade I wouldn't shut up about at school, blabbing about it to my Wii U-hating friends), *Splatoon* felt like a turning point. It seemed like another affirmation that the GamePad mattered. From a revelatory gyro aiming system to novel between-round mini-games and battle functionality mid-match, the controller was critical to *Splatoon*'s success.

Although, no title urged people to understand the GamePad like September 2015's *Super Mario Maker*. How

could it not? The most intuitive and playful piece of UGC software ever created, building stages on the Wii U was an effortless joy. The controls were so elegant that its successor on Switch — while the better game — felt somewhat rigid by comparison. The stylus and GamePad screen were unbeatable.

But few cared. *Super Mario Maker* sold just over four million units, nearly two million less than *New Super Mario Bros. U*, and nearly a million less than *Splatoon*. The game should've been *everything*, it should've turned the corner. Make-a-Mario in the YouTube era should've been the golden ticket. But it ended up instead as just the final game to breach the Wii U's top ten best-selling games list. Not a single title after September 2015 could break in, unable to surpass the tenth best-selling game, *Mario Party 10*, at 2.2 million units. Not even *The Legend of Zelda: Breath of the Wild*. By the second half of 2015, few cared about the Wii U. Fewer still were interested in the GamePad.

Often, it felt like Nintendo wasn't either. For all the experiences which worked to establish the GamePad as core to the system's success, just as many both passively and actively worked to undo it. *Star Fox Zero* was certainly the face of overt anti-GamePad sentiment. To the crowd which took issue with the system, that 2016 release was a perfect encapsulation of what the controller represented to some — unnecessary innovation shoehorning half-baked ideas into games crushed under their weight. Considering that *Star Fox 64* is my favourite game of all time, I was there day one picking up my pre-ordered copy of *Zero*. I didn't hate it. I'm certainly not in the overwhelmingly large group who turned their unshackled ire upon the game.

Star Fox Zero represents the peculiar wheel spinning that ran parallel to the clear, boundary-pushing design present elsewhere in the Wii U generation. The game forces you to look away from the TV to the GamePad at arbitrary points solely out of some obligation to use the second screen. 2015's *Animal Crossing: amiibo Festival*, perhaps Wii U's most infamous release, likewise employed totally arbitrary GamePad control. *Paper Mario: Colour Splash* also stuck strange touch battling where it didn't belong. Some system menus even require use of the GamePad to access. Many choices were made across hardware and software to uncreatively send reminders that the controller existed.

While many Wii U games discovered creative implementations for the GamePad, and another contingent actively seemed hampered by its use, many more were totally uninterested in the controller. But this vast selection of middle-ground titles wasn't bad. To the contrary, these were often some of the system's best. *Pikmin 3* introduced little to its series but executed upon its existing ideas brilliantly, as did *Donkey Kong Country: Tropical Freeze*. *Super Mario 3D World* is derivative of its

626

627

628

3DS predecessor, but it's exponentially stronger. *Xenoblade Chronicles X* is another wonderful example and perhaps the most technically impressive game on the system. It, like *Super Smash Bros. for Wii U*, and the aforementioned titles all disregard the GamePad. *Pikmin 3* is best played with a Wii Remote, and all of the rest just ask you to pick up a Pro Controller. It does the system's two-screen approach no favours to have the majority of its greatest games disregard the central hardware gimmick.

There was a lack of clear vision within Nintendo during this era. It's no surprise that the machine failed to resonate, as the library itself struggled to find direction. The Wii U was a gambit to recapture past success — remaining in the familiar Blue Ocean environment that brought Nintendo to the stratosphere one generation prior. But when that failed, when the casual player moved elsewhere, Nintendo had no plan. Nintendo was stuck with a machine impossible to market, its games often at odds with its hardware.

It looked like a system stuck in the previous decade. The name, the reliance on Wii Remotes — Nintendo hoped to create a contiguous experience from Wii to Wii U, retaining a similar vocabulary in the process. Instead, Nintendo created an optical nightmare. The system looked like an add-on for the Wii. Games like *Wii Sports Club*, *Wii Party U*, and *Wii Fit U* didn't help create a new identity either. Many couldn't understand whether the Wii U was even a new console, let alone appreciate the concept of the two-screen home gameplay experience.

By the time that the Switch began subsuming the Wii U's lineup, it became harder and harder to see the Wii U as anything other than a first whack at a hybrid design. Chunks of the Switch's 2017 and 2018 lineups consisted of myriad Wii U games, eroding what little identity the system had clawed to establish, turning these titles into de facto Switch exclusives. And it worked — not many feel compelled to celebrate the Wii U these days or truly re-engage with it. Why should they, when the lion's share of Wii U conversation is relegated to listicles querying which remaining games could make the jump to Switch?

The Wii U was never given a fair shake. But the fault for that lies with Nintendo, who could not clearly market and message the platform. The system started life looking like a Wii peripheral and trundled along afraid of its best ideas. There is an alternate universe wherein the console had a more distinct name, launching with *Super Mario Maker*, pumping out *Nintendo Land*, *Splatoon*, *Game & Wario* in sequence. Where the games that followed had the same love for the GamePad and none rejected it.

Yet that's not our reality. I loved my Wii U long after my broken wrist healed. For better, for worse. For richer, for poorer. In sickness and in health. We had our rough patches — 2016 was not very good. I have a very close relationship with this system, though. How could I not, having gotten it at thirteen? The vast majority of its games are among my very favourites, and I'm telling the truth about HDMI 3. In loving it so closely, though, I only see in it what I came to adore. But maybe what others say about it is more true than I admit. Perhaps the only simple narrative is that the system is a proto-Switch, because the reality is a lot messier. Ultimately, I don't really mind. I love the Wii U anyway.

Nearly Failed Characters

While the extremely lucrative amiibo figures long outlived Wii U, the Animal Crossing range released to accompany amiibo Festival threatened the entire brand back in 2015. Far too many toys were produced and immediately discounted, tying into a universally panned and financially underwhelming game. Luckily Nintendo righted the ship, continued ahead with amiibo, and even successfully reused these figures in Animal Crossing: New Horizons.

626
Mabel amiibo
2015

627
Mr. Resetti amiibo
2015

628
Animal Crossing: amiibo Festival
2015

629

630

631

632

633

634

635

636

637

629
Captain Toad: Treasure Tracker
2014

630
Splatoon
2015

631
Nintendo Land
2012

632
New Super Mario Bros. U
2012

633
Animal Crossing: amiibo Festival
2015

634
Game & Wario
2013

635
Pikmin 3
2013

636
Donkey Kong Country: Tropical Freeze
2014

637
Super Smash Bros. for Wii U
2014

Wii U.

TO LOSE CONSOLE WARS.

words *Kell Burkitt*

I remember reading an opinion piece online which set me off. My blood was hot. My heart was racing. I really felt it. I grabbed the cases of all my favourite Wii U games and put them in a neat pile on the floor. *Super Mario 3D World, Donkey Kong Country: Tropical Freeze, Bayonetta 2, Mario Kart 8, Nintendo Land, Pikmin 3, Splatoon, The Wonderful 101, New Super Mario Bros. U* and on and on. I pulled my phone out of my pocket, opened the video camera, and carefully centred the stack of game cases in the middle of the frame. I pressed record.

At first, I was silent. Just pulling case after case away to reveal the game underneath. After I'd shown enough to make my point, I said in a deeply sarcastic tone, "Yeah, the Wii U just has no good exclusive games."

The idea, I think, was to post this video to Twitter. But even as I was filming, I could feel that maybe it wasn't a very good idea. Maybe this was a bit much. Maybe the world didn't need this video of me defending the Wii U. Maybe none of this meant anything, and I was wasting my time.

But on the other hand, *we* were losing. I had to do something. I had to show everyone that the Wii U was good, actually. That this machine I had invested my money and my time and my energy and my life into was really, really good. Actually. That I was good. Actually.

I deleted my Twitter a few years ago and the Wayback Machine doesn't have any good snapshots from that time, so I have no way of checking if I really did post this video. I hope I didn't. I probably did.

The Wii U may have been the first Nintendo home console I ever bought, but I had been a faithful foot soldier in their console war battalion for years. I would monologue endlessly to friends and family about how it wasn't a problem that the Wii didn't have HD graphics and how the 3DS didn't need a second Circle Pad and how the waggle controls in *Twilight Princess* were really good and how the glasses-free 3D didn't actually hurt my eyes at all and how Nintendo's terrible online architecture wasn't a problem because couch co-op is better anyway. These were mostly lies, of course. But lying didn't matter. What mattered was winning. And for a long time, we were winning. I was winning.

The DS was an unimaginable success. Then the Wii was a huge hit. Sure the 3DS wasn't a massive winner, but it did well enough for me to feel good about buying one. And anyway, that momentary lapse didn't matter because Nintendo's next big home console was hurtling into the station. A surefire hit. The Wii U.

Except it wasn't a hit. We lost. Massively and undeniably. We lost in the first week it was released and then we kept losing every week and month and year after that too. The perverse thing is that those losses just spurred me on. *They need me now more than ever*, I thought. I have to keep the faith.

We call it the console war, but I'm not convinced 'war' is actually the most accurate term. I think it's more like a competitive sport. I pick a team and I buy its paraphernalia and I support it no matter what, even when in defeat. But this competitive sport obviously isn't about athleticism or speed or endurance. Instead, it's about marketing. It's about which company can convince the most people to buy its plastic box. Each game announcement, or unique feature or price cut is a strategic play to be analysed in those terms, as if it were a lineup change or a new coach. How might the massive, imagined public full of deeply fickle swing buyers react to *Nintendo Land* or *Pikmin 3* or, worst of all, the Wii U GamePad?

Of course, the ultimate display of that marketing prowess back then was E3. An opportunity to distil a pitch into a one or two-hour slice of pure advertising. I spent months looking forward to it. Counting down the days by watching endless multi-hour

photography *Damien McFerran*

videos that attempted to forecast Nintendo's next big announcement by means of digital water divining. *They usually announce their biggest games on a Tuesday and the conference is on a Tuesday this year so we must be hearing about a new Zelda.* That kind of thing.

E3 2011 was a bit of a worry. Nintendo's pitch focussed on this new controller, and within hours there was already confusion. Most people thought it was just a peripheral for the Wii, even some of my friends who were prolific gamers. And so I got straight to work dispelling that misconception in as many people as I could, and when I wasn't doing that, I was desperately coming up with examples of how the GamePad would revolutionise gaming.

E3 2012 was a hard watch. We needed games. We needed big, impressive games because it was increasingly clear people weren't convinced by the GamePad concept on its own. The show opened with *Pikmin 3*, a fantastic start. But then we trudged through *New Super Mario Bros. U* and *Wii Fit U*, both of which looked like they could be Wii games. But, of course, there would be a final surprise. The one last thing. *Metroid Prime 4*, hopefully. Or maybe a dark, open-world *Zelda*. Something to appeal to the core gamers. Unfortunately, the one last thing was *Nintendo Land*. A mini-game collection, the scourge of the Wii generation. And so I got straight to work convincing everyone that *Nintendo Land* was a much more meaningful experience than *Wii Sports*. Once we actually got our hands on it we would understand that.

E3 2013 was solid. *Smash Bros.*, *Mario Kart 8*, *Super Mario 3D World*, *Donkey Kong Country: Tropical Freeze*. A strong lineup of classic Nintendo winners. But it was also the year of *Titanfall*, and that was all anyone was talking about. And so I got straight to work evangelising Wii U games. I started by studying the trailers and marketing materials to make sure I had all the talking points just as Nintendo wanted them. The anti-gravity in *Mario Kart 8* fundamentally changes the experience. *Donkey Kong Country: Tropical Freeze* has some of the series' most dynamic level design. *Super Mario 3D World* is, uh, multiplayer I guess.

And then came E3 2014. The feeling of watching Nintendo's presentation that year was among the happiest of my life. I say that without a hint of irony or sarcasm. It was the most sustained and intense elation I had ever experienced. I watched it again the next morning. Twice. And then I watched hours of other people reacting to it in the hopes I might feel some of that exhilaration again. And then I rewatched it probably once or twice a week for months afterwards.

When you're neck deep in the console wars like this, buying a console is self-actualisation. I'm sure that's obvious to anyone on the outside, but the above descriptions should clearly demonstrate that it wasn't obvious to me at the time. The machine I spend my money on is who I am. And because the console is so closely tied to my identity, its success becomes a matter of personal survival. The games stop mattering. They aren't art I draw meaning from or experiences that enrich my life or even simply toys I enjoy playing with. No, each game is just a premise in the ongoing argument proving the worth of the console I purchased. *Super Mario 3D World* is an amazing game, and therefore the Wii U is good, and therefore I am good, and therefore I am worthwhile.

But the wheels keep turning and soon it stops being about playing the games at all, because playing games is good, of course, but being right is so much better. Suddenly it's just the games being announced that I care about. At this year's E3 or Summer Games Fest or Whatever Games Fest they announced all these amazing new *WORLD EXCLUSIVE* titles for my bundle of chips and wires... and that proves it's the best bundle of chips and wires, and also that I'm a very good boy.

I may never even play the games they announced. But who cares? That's not the point. Playing games, engaging with art or even just enjoying myself has never been the point. The point is that the announcement of this exciting, new product is the 9D chess move that proves Nintendo had a master plan all along. That I was right to put my faith in the company, even if the Wii U isn't selling. And maybe, if I'm lucky, that announcement might make me feel something.

We talk often about how deeply problematic the console wars are for games as an art form. How they reduce our games to products or 'content.' How they pit people against one another in service of corporate greed. How they weaponise genuine enthusiasm for art to satiate the exponential lust of the investor class. All of that is true.

What we don't talk about nearly as much is how, on an individual level, enlisting in the console wars is a deeply intoxicating proposition. We don't talk about how easy it is to have your life consumed by the need for your multinational of choice to win. We don't talk about how delicious it feels to be so enveloped in that way.

Part of the reason we don't, of course, is because the console wars often rear their head in horrific ways. They are steeped in, and informed by, the same toxic gamer rhetoric that led to people's lives being destroyed by the depraved hordes of Gamergate. And so I don't ask for forgiveness or even kindness towards those still caught up in those cycles. All I ask for is an understanding of the particular mix of systems that lead so many to get caught up to begin with, and how truly potent that particular mix of systems can be.

You're locked in battle, buffeted by the co-conspiring forces of aggressive platform holder hype campaigns and deliciously curated YouTube recommendations of angry

Lots of Library Stumbles

The Wii U's reputation in the console war was not helped by titles like Star Fox Zero or Mario Tennis: Ultra Smash, which not only reviewed poorly but sold even worse — landing around half a million total units each. This is a far cry from where Nintendo would end up with the Switch, where games like Mario Tennis Aces would go on to sell about nine times better. Even Wii U's wonderful games, like Donkey Kong Country: Tropical Freeze, could barely push past two million units sold.

638

639

people shouting the precise sleeper agent trigger phrases that keep the endorphins pumping. Your corporate overlords are constantly handing you a powerful reason to care about something, to get angry about something, to feel excited for something. It feels good. It feels loud and desperate. It feels crucial, in the way so few things in life usually do.

That's how it felt to me, anyway. To be a soldier in the console wars was to have my heart constantly exploding with feeling, but the kind of feeling that never lasted and never satisfied. So I had to do whatever it took to keep that feeling going. To keep the hype alive. It's why I monologued endlessly to my friends and family about how good *Paper Mario: Colour Splash* was. It's why I pre-ordered every Wii U game I could, even the ones I didn't really care about. It's why I filmed and then probably posted an embarrassing video to Twitter about how unfairly everyone was treating my poor Wii U.

It was a deeply hollow way to live. It was hollow because it didn't mean anything and it didn't mean anything because the awful truth, that I always knew but could never admit, was that the Wii U didn't actually need my defence. It didn't need my defence then and it certainly doesn't need my defence now. It doesn't need anyone's defence. To defend it in that way reduces it to a product. It reduces me to a product. A means for someone somewhere else to bolster the value of their stock portfolio.

I see that now, of course. But back then the success of the Wii U was the single most important thing in my life. I would never have actually admitted that to anyone, but it was. I spent four incredibly anxious years desperately hoping that a massive company that doesn't care about me might earn a bit more money, and trust me when I say that's no way to live.

The other day I saw an article about how Switch exclusives accounted for nine out of the ten best-selling games in the past week in Japan. I started to feel it again. A throb in my chest. The old instincts. The deep need to let everyone know. I screenshotted the article to send people as proof once more of how good of a person I am because my favourite video game company is successful. This time I stopped short of actually sending it.

Nintendo doesn't need me, and it doesn't need you. None of these game companies do. They want us. Of course they do. They want us to love them so much that we spend our horrifyingly limited time arguing with strangers on the internet about whose one-to-two-hour E3 marketing presentation is more likely to convince people to spend money. But they don't deserve us. They don't deserve our time in that way. They don't deserve you.

638
Mario Tennis: Ultra Smash
2015

639
Star Fox Zero
2016

331

PLAYSTATION 4.

words *Ryan Binieki*

First Released:
2017

Manufacturer:
Nintendo

Launch Price:
JP ¥39,980
US $399
UK £349

If you ask me what stands out most about the PlayStation 4, my answer is often different depending on the day. Sometimes my mind jumps to the games or the controller, or maybe the console's design. I often think about PS4's development story and the experiences of those working on the machine. Usually, I'll look back at the famous E3 presentations of the PS4 cycle that ended up becoming generation-defining moments. I guess what I'm trying to say is — there's a lot to think about. But all these elements have something in common. In some way, shape, or form, they're all positive. This console, for all intents and purposes, nailed it.

That's what I keep coming back to. That's the conclusion to draw as we start looking at PS4 in retrospect. According to Sony financials, there are more than 117 million consoles in the wild. As such, it's the fifth highest-selling piece of video game hardware. And if we consider only home consoles (and depending on how you would categorise Nintendo Switch), this would make PS4 second or third place instead. It's a ridiculously impressive feat when you also consider what generation they were exiting. Now look, I love the PS3. And there's no denying that it saw an incredible turnaround towards the back half of its life. However, to quote the PlayStation 4 Lead System Architect Mark Cerny when reflecting on the PS3 generation, "It was pretty brutal, honestly."

It was Mark. It was. That quote came from a Wired interview about how the PS3 was difficult to develop for. And that is why Cerny asked the company around 2008 if he could be the Lead System Architect for the next console. He wanted to build a platform that would be significantly easier to work with. And much to his surprise, Sony let him do it. This certainly was unusual given the company was still primarily a Japanese organisation that never had an American lead one of its flagship products. But this was the result they needed, a platform that developers of all sizes could easily use. And so the story goes that PS4 became an x86-based machine with a developer friendly SDK (Software Development Kit) which led to a tremendous amount of support.

This is arguably the most important part of PlayStation 4's success, but it cannot be understated how so many other parts of this console came together in much the same way. It really did feel like a total reset for the PlayStation brand. The DualShock 4 is a great example, because Sony had been using the same general shape and controller design since the original DualShock in 1997. They really went three entire console generations with the same general design and minimal refinements. When Mark Cerny revealed the new controller at that press event in New York back in February 2013, I remember audibly gasping. *They were finally changing that well known PlayStation controller!* It's funny looking back because outside of some game trailers and mission statements about what PS4 was going to be, the controller and PS4 camera were the only pieces of hardware that they showed. Online forums at the time tore Sony apart for doing the reveal without showing the machine, even though the company historically always made console announcements without unveiling a box.

So, for a few months, the DualShock 4 was the poster child for PS4 — until Sony finally did reveal the console's design during its E3 2013 presentation, which announced *The Order: 1866* among other games, just a few months later. Speaking of which, that E3 will go down in history as one of Sony's greatest. It's nigh impossible to acknowledge this console's success story without the obligatory 'ah yeah, and Microsoft dropped the ball big time.' It really did, at such a crucial time too! For Microsoft, the Xbox brand had never been stronger since the company was exiting a platform cycle that nearly matched Sony in total install base. But they had a completely different view on what the next Xbox should be doing compared to PS4. So, the company came in at a higher price with a next-generation Kinect camera. Requiring an online check-in to validate game purchases. Wanting to curtail the secondhand physical games market. The messaging surrounding all of this was messy and confusing. It was an easy PR win for PlayStation.

photography *Damien McFerran*

Highly Desirable Designs

The PS4 had no shortage of limited edition system and controller variants, releasing many to coincide with the platform's biggest games and brand milestones. The 20th Anniversary Edition is one of the most beloved (and rarest) models, released to celebrate the PS1's 20th anniversary.

640

642

641

643

640
Uncharted 4: A Thief's End DualShock 4
2016

641
God of War DualShock 4
2018

642
The Last of Us Part II DualShock 4
2020

643
Death Stranding DualShock 4
2019

You had genuine applause erupt throughout that venue when SCEA's Jack Tretton confirmed PS4 was going to support used games and not require an online check-in. Then, to top it off, SCE's President & CEO Andrew House proudly announced a $399 price point, again to thunderous applause. Oh, and we can't forget the famous "How to share used games on PS4" viral video with Shuhei Yoshida and Adam Boyes. The contest was so one-sided that Sony effectively got off scot-free after sneaking in the PS+ requirement for online gameplay. That's how badly Microsoft did.

But again, this is all sort of perfunctory when discussing PS4's success story. I still find it's important to highlight that everything else came together beautifully. Sony's laser-focussed approach to courting independent developers being a key example. When you look back at that first year of PS4, many consider it to have been a bit dry when it came to new software. And that might be true — if you're only looking for blockbuster releases. The truth is, there was always something interesting hitting the PlayStation Store. On day one, you had Housemarque's *Resogun* and Compulsion Games' *Contrast*. In January 2014, there was *Don't Starve* from Klei Entertainment. The following month featured *Outlast* from Red Barrels. Then Young Horses released *Octodad: Dadliest* Catch in April. During the Summer, Just Add Water released *Oddworld: New n' Tasty*, and Honeyslug shipped *Hohokum*.

Sony made an effort to approach all these talented independent teams, giving them some development kits and seeing what they can do. Usually, this kind of support would also mean Sony was asking for a console exclusive debut. But equally important — that was the only thing the company asked for. Unless they were directly publishing the title, these teams kept their IP, could ship on PC, and eventually could ship on competing consoles. And that paid off, not just for Sony and for the players. Many of these studios are still around! They've grown organically and shipped sequels, or have been acquired and now have major financial backing. I am so happy to see Housemarque go from shipping PS4's best day one title to now joining PlayStation Studios, releasing what I consider to be PS5's best game, *Returnal*. So whenever I hear about PS4 having a slow start because the first party was only able to ship *Knack*, *Killzone Shadow Fall*, and *inFAMOUS Second Son*, I'm always a bit puzzled. Those games were a lot of fun, but so was everything else that oftentimes resonated more with me than the big releases.

And again, since Sony was typically asking for a console exclusive debut — there was a lot of unique software to play if you just so happened to pick PS4 as your console of choice. Bonus points if you were more deeply invested in the PlayStation ecosystem during this time. Within those early years, Sony was actively supporting three different platforms: PS3, PS4, and PS Vita. So, if you were coming from a PS3, or you were an early adopter of

PS Vita, you were often benefiting from Sony's cross-buy and cross-save initiatives. In modern times we take this for granted due to how commonplace cloud saves, backwards compatibility, and streaming have become. But it was so unbelievably novel and rewarding as a customer if you did own multiple PlayStation systems back then.

Especially coming from PS3, yet another part of why PS4 felt like a total reset was that there was no backwards compatibility. Slight tangent here — but it really highlights just how long that last generation felt when you had so many consumers eager to get new consoles knowing full well they couldn't take their existing library over. But the reality is, some games did get brought over thanks to cross-buy. There were a number of games I bought near the end of the PS3 generation that got native PS4 ports, and I was entitled to that game for free on my new console. It was the cherry on top when I would also get a PS Vita version that allowed me to carry a local save over. Because let's face it: Remote Play was still a bit of a novelty... even though it was a developer mandate that every PS4 game be remotely playable on PS Vita. It was still a lesser experience with the reduced image quality and input latency. I personally never dabbled with it much because of that, but I know many did. Some players were completely finishing games in that manner. So between that and the cross-buy, save, play initiative — this really was a great time to be sold on the ecosystem Sony had built.

So, let's look back at what we've covered so far. The console was much easier to make games for. The pricing was aggressive and favourable against the closest competitor. Sony supported independent developers which paid dividends, filling out the early game catalogue. And the company built a robust ecosystem that rewarded the customer for being invested. They did all of this within the first year. And the incredible part is that it was only going to get better. Eventually those first party studios did start releasing big blockbusters. And one could easily argue PS4 was the platform that finally enabled these studios to bring their creative visions to a new level. Naughty Dog's *Uncharted 4: A Thief's End* and *The Last of Us Part II* set new medium standards for cinematic storytelling. Sony Santa Monica's *God of War* proved you could reinvent a beloved franchise and elevate it in a way that many thought wasn't possible. Sucker Punch Productions' *Ghost of Tsushima* put to bed all fears that this studio wouldn't be able to create an authentic samurai experience that respected the country of Japan. Guerrilla Games' *Horizon Zero Dawn* was able to show that a studio which primarily made first-person shooters could pivot into a new genre and IP with gravitas. Insomniac Games was able to make arguably one of the best superhero titles ever in *Marvel's Spider-Man*.

These are the games that really shaped PS4's identity in the later years. The games that solidified the PlayStation name as a platform that's home to these

644

645

646

big budget, narrative-driven single player adventures. Some consider this a bad thing. It's viewed as PlayStation evolving away from its history of funding smaller, more obscure projects. And in a way this is true. Near the end of the PS4's lifecycle, and further on into the PS5 launch, we've seen Sony double-down on games that command an eight or nine-figure budget. The company is also placing a larger financial bet on live service titles. So, things have certainly changed, albeit in a way that still has the same end result.

The days of Sony funding and releasing a new *Patapon* or *No Heroes Allowed!* may be gone. But the continued support of indies has blossomed into new initiatives like the China Hero and India Hero Projects. These are great programs that provide funding and marketing support to independent studios in these countries. This also comes with the benefit that these teams can ship on PC and potentially competing platforms down the road. So it really depends on where you place your importance when considering what PlayStation has become since PS4. But if you're asking me, I think the company made wise decisions that resulted in a net positive for the industry.

So when I look at PlayStation 4, I see a console that did a lot of things right. It went back to the company's roots by being developer-friendly. It became a home to an incredible lineup of indies. It features some of the most mind-blowing AAA titles from PlayStation Studios. It was also a console that offered an accessible VR platform. It eventually offered a mid-cycle update with the PS4 Pro, which was still a relatively new concept as far as consoles go. There's so much more that I could wax on and on about, but it still stands that all of these moves were generally positive. There certainly were some sore spots as far as this console goes. But they're so easy to overlook when there was so much fun to be had. Especially because this console also had *Bloodborne*. Oh, and *P.T.* We can't forget the best Playable Teaser ever made for a game that we'll never get, one that's exclusive to PlayStation 4.

644
PlayStation 4
2013

645
PlayStation 4 Slim
2016

646
PlayStation Pro
2016

Verifiable Risks

The 2016 launch of PlayStation VR was a massive gamble, parallel to the risky hardware refresh of the PS4 Pro (and PS4 Slim). Unfortunately, the results were middling. While the headset's repurposing of PS3 controllers (PS Move) and the PS4's camera was novel, and some games like ASTRO BOT were quite compelling, PSVR failed to convince the masses or accrue a convincingly robust software library. However, while its roughly five million units sold mean the machine was adopted by less than 5% of PS4 owners — it remains among the best-selling VR headsets. Despite its shortcomings, PSVR was a pioneering innovation in the console space.

647

648

649

650

647
PlayStation Camera
2013

649
PlayStation VR
2016

648
PlayStation Move
2010

650
ASTRO BOT Rescue Mission
2018

651

652

653

654

655

656

657

658

659

651
Bloodborne
2015

652
Ghost of Tsushima
2019

653
The Last of Us Part II
2020

654
Marvel's Spider-Man
2018

655
inFAMOUS Second Son
2014

656
Killzone: Shadow Fall
2013

657
The Order: 1886
2015

658
Horizon: Zero Dawn: Complete Edition
2017

659
God of War
2018

660

661

662

663

664

665

660
PlayStation 4 20th Anniversary Edition
2014

661
PlayStation 4 Star Wars Darth Vader Edition
2015

662
PlayStation 4 Pro 500 Million Limited Edition
2018

663
PS4 Metal Gear Solid V Diamond Dogs Limited Edition
2006

664
PlayStation 4 Pro Spider-Man Edition
2018

665
PlayStation 4 Destiny Edition
2014

XBOX ONE.

words *Fraser Gilbert*

First Released:
2013

Manufacturer:
Microsoft

Launch Price:
JP ¥49,980
US $499
UK £329

Say what you like about the Xbox One, but its legacy is defined by much more than just a horribly botched launch back in 2013. In the years that followed, Microsoft embarked on a path of course correction that would not only turn the console's fortunes around but also leave a lasting legacy on the entire industry. Some of the most important innovations in Xbox history came out of this era, including Xbox Game Pass and Xbox Backwards Compatibility, and it's fair to say if Microsoft *hadn't* made mistakes at the time of its unveiling, these game-changing features may never have come to pass. Of course, we didn't know any of that back then. At the time, it felt like an absolute disaster for the Xbox brand.

The date was May 21st, 2013, and the location was Redmond, Washington. Microsoft's big reveal event for the Xbox One couldn't have gone much worse, sparking a mixture of confusion and disappointment as Microsoft placed heavy emphasis on the console's entertainment-based features rather than the games themselves. There was also concern about the company's plans to implement controversial policies, such as forcing owners to connect to the internet once every 24 hours and placing restrictions on used games. The former sparked an infamous quote from then-Xbox boss Don Mattrick, who advised a bemused Geoff Keighley at E3 2013 that anyone who couldn't access the internet would just have to buy an Xbox 360 instead.

Microsoft ended up relenting just a few weeks later by announcing that the Xbox One would no longer require a permanent internet connection and that game sharing would work the same way it did on the 360. But the damage was done. Sony had already taken shots at the used game policy with a brutal "Used Game Instructional Video" that showed how easy it was to share games on PS4, clearly responding to the controversy that surrounded Xbox at the time. And even though Microsoft had done a 180 on some of these policies, a lot of trust had already been eroded — not helped by the fact that the Xbox One cost significantly more than the PS4 at launch. Ultimately, the console never stood much of a chance when it launched in November 2013.

Even so, the original Xbox One was a very competent console from the outset. It was chunkier than any version of the Xbox 360, but it was nearly whisper quiet, even when putting its formidable graphical capabilities to good use. The controller received numerous improvements compared to the previous iteration, adding in the likes of rumble-powered Impulse Triggers and textured analogue sticks to provide a more comfortable and immersive gameplay experience. The Kinect 2.0 was a legitimately impressive upgrade on the Xbox 360 version, too, and the fact that it was bundled with the system meant quite a few games made use of it in the early days. The console was truly ready to kick off a new generation, which made it all the more frustrating that Microsoft had fumbled its unveiling just a few months prior.

A lot of people missed out on some great Xbox One games in those initial 12 months as a result of understandably favouring the PlayStation 4. *Ryse: Son of Rome* was an absolutely breathtaking launch title that ended up being one of the best-looking games of the Xbox One's entire lifespan, while *Forza Motorsport 5* and *Forza Horizon 2* served up a treat for simulation and arcade racing fans alike. The original *Titanfall* was an essential console and PC exclusive that defined early 2014 for the Xbox brand, and Insomniac Games brought us some colourful chaos in the form of *Sunset Overdrive* later that year. The first few months were admittedly quite a barren time for new releases, but even then, a fairly strong launch lineup coupled with some major third-party arrivals meant that the Xbox One never ended up grinding to a halt.

photography *Damien McFerran*

Heavy Duty

*Microsoft's
hardware has
always weighed
quite a bit, with
the Xbox One
X clocking in
at 8.4 pounds,
heftier than PS4
Pro (roughly 7.3)
and the launch
Xbox One (7.8).
However, it pales
in comparison to
Xbox Series X's
9.8 pounds.*

There was definitely a 'next-gen' feel to the Xbox One. It obviously helped that the games looked *so* much better than their Xbox 360 counterparts, but some of the extra features were pretty revolutionary as well. The ability to save clips before editing and posting them via the Upload Studio was a fun novelty. Snap Mode was also a big hit, allowing you to watch TV on the side of the screen while playing games. You could even download Skype and talk to friends and family across the world using Kinect! These were all key selling points of the console back at launch, but it's telling that Microsoft ended up getting rid of Snap Mode along with various other early Xbox One ideas in the years that followed.

Behind the scenes, things were beginning to change for the Xbox team inside of Microsoft. Xbox boss Don Mattrick left the company in early July 2013, and it wasn't until March 2014 that Phil Spencer was appointed to that role. Spencer, who had been Head of Microsoft Studios up until that point, ended up admitting years later that the company had been having discussions around this time about whether to remain invested in Xbox moving forward. He made a pitch to the then-new Microsoft CEO, Satya Nadella, who was willing to make a bet on Spencer and his team. His promotion to Head of Xbox ended up being arguably one of the most important decisions in Xbox history — one that would drastically change the way the Xbox One era played out.

Something that Spencer has long talked about was a desire to focus on what the players wanted, and this was really kicked into gear in 2015 with the arrival of Xbox Backwards Compatibility. The announcement was a total surprise and sent the live crowd at E3 into a frenzy. By the end of that year, over 100 Xbox 360 games were playable natively on Xbox One, and the collection eventually grew to over 700 original Xbox and Xbox 360 games over the next few years. The best bit? If you owned them already, you didn't need to pay again. For a brand that had been heavily criticised just two years prior, the arrival of Backwards Compatibility on Xbox One felt like a major turning point and a sign of much brighter days ahead.

In terms of the console itself, there's a good chance you're more familiar with the Xbox One S or Xbox One X than the original model. After all, Microsoft's mid-gen refresh occurred when the system was finally beginning to develop a significantly more impressive reputation. 2016's Xbox One S didn't reinvent the wheel by any means, but a more compact design complete with an attractive launch price and some neat new features such as HDR support was enough to receive some top-notch reviews back in August of that year. This was also the first variant to ditch the Kinect 2.0 port in favour of an optional Adapter Cable, while various entertainment-focussed features such as TV DVR and the aforementioned Snap Mode were either removed or cancelled entirely around this time. By this point, the Xbox One was clearly becoming all about the games, with Microsoft ditching the "ultimate all-in-one home entertainment system" tagline that defined the console a few years prior.

The Xbox One X took things to the next level, as Microsoft promised to deliver the world's most powerful console. Featuring six teraflops of graphical processing power, it sported the ability to deliver true 4K gaming along with improved frame rates in many cases, with hundreds of titles being fitted with the "Xbox One X Enhanced" branding that guaranteed an improved experience. The £499 / $499 price tag was never going to sway the masses, but those who forked out for the Xbox One X were treated to a console that delivered superb results in some of the generation's very best games.

Just before Microsoft unveiled the Xbox One X back in mid-2017, Phil Spencer and his team unleashed yet another groundbreaking new feature in the form of Xbox Game Pass. Taking the form of a digital subscription service that would allow Xbox One users to play over 100 games for just £7.99 / $9.99 per month, this new offering was received with a mix of excitement and scepticism. The initial lineup wasn't bad by any means, but it was also missing quite a few recent first-party titles, and you'd have been forgiven for suggesting it perhaps didn't live up to the price tag. After all, was it really worth spending that much money on games you didn't even own?

While Xbox Game Pass had its detractors, it was also another feather in the Xbox One's cap. Sony's most relevant competition was the PlayStation Now service, but until September of 2018, it only allowed players to stream games rather than download them natively like Xbox Game Pass. And as Microsoft's offering grew, it began to not only add more titles, but it also

666

667

668

666
Xbox One
2013

667
Xbox One S
2016

668
Xbox One X
2017

integrated Xbox first-party releases on day one. *Sea of Thieves* was the very first of these to launch on Game Pass at no extra cost, setting a precedent that would define the Series X|S generation. Suddenly, even the detractors were forced to take notice of the value that Game Pass was beginning to provide.

In the space of a few years, Phil Spencer and his team had successfully turned the Xbox One's fortunes around, establishing a positive new identity for the brand in the process. The next step was to prepare for the future, which led to a huge slate of studio acquisitions in 2018 and 2019 including the likes of Ninja Theory (*Hellblade: Senua's Saga*), Double Fine Productions (*Psychonauts*) and Undead Labs (*State of Decay*). Not only was Xbox Game Pass growing far stronger as a result of these purchases, but Microsoft was showing clear intent to come out swinging when the Xbox Series X|S arrived in late 2020.

Despite continuing to support the Xbox One in an admirable fashion, Microsoft officially ceased production for all versions of the console by the end of 2020, bringing its seven-year run to an end. The company had stopped providing sales figures years prior, but numerous reports suggested it was heavily outsold by the PlayStation 4 overall. By that point, though, it almost didn't matter. Xbox had lost that particular battle almost a decade prior, and now the focus was on establishing a spectacular launch for the next two consoles. June 2020's limited edition *Cyberpunk 2077* Xbox One X ended up being the final variant of the Xbox One to ever hit the market, arriving just five months before the Series X and S made their debuts in November.

In direct contrast to the way the Xbox 360 generation ended, the culmination of the Xbox One era never felt like an actual finale. It certainly helped that Microsoft continued to release first-party titles on the console for years after the launch of the Xbox Series X and S, including the likes of *Forza Horizon 5*, *Halo Infinite*, *Psychonauts 2*, and many others. The original Xbox One and Xbox One S were beginning to show their age without a doubt, but for the most part, they still supported the same games as the company's new systems. Then, with the implementation of Xbox Cloud Gaming a little while later, Xbox One owners were given access to exclusive Xbox Series X|S titles through the power of streaming, increasing the console's lifespan even further.

I've long been of the opinion that Phil Spencer used the Xbox One era as a testing ground for the next generation. The writing was always on the wall — Microsoft was never going to fully recover from the errors that occurred in mid-2013. Therefore, his team quietly worked away in the background, developing new ideas that would go on to reinvent Xbox in the late 2010s and early 2020s. When the time finally came, the Xbox Series X and S were ready to go with a stacked lineup of Xbox Game Pass titles, extensive backwards compatibility integration, significant Xbox One cross-compatibility, support for Xbox One X Enhanced titles and much more.

And because of all that, the Xbox One ended up becoming one of the most influential consoles in the company's history; a redemption story that went down a path few of us could ever have imagined. The pivotal decisions made during that seven-year period are still being felt across the games industry today, and the device itself ended up thriving for years past its sell-by date as a result. It's still easy to look at the Xbox One as a 'failure' because of the mistakes that were made at the outset, but if we're taking its entire lifespan into account, it surely deserves to be hailed as an unprecedented turnaround.

Cataloguing Controllers

Microsoft led the charge on limited edition and variant controllers during the eighth generation. Most major game launches and hardware milestones were commemorated with a bespoke controller design. Further, Microsoft beat Sony to the premium controller market with the launch of the Xbox Elite Controller — even taking customisability a step further with 2016's Xbox Design Lab initiative which allowed players to customise their own gamepad.

669

670

671

672

673

674

669
Xbox One Halo 5: Guardians Wireless Controller
2015

670
Xbox One Minecraft Creeper Wireless Controller
2017

671
Xbox One Elite Wireless Controller
2015

672
Xbox One Gears 5 Kait Diaz Wireless Controller
2019

673
Xbox One Cyberpunk 2077 Wireless Controller
2020

674
Xbox One Project Scorpio Controller
2017

Although the Xbox One was frequently criticised for lacking exclusives, the console still built up a respectable roster across its life. 343 Industries' Halo 5 and Master Chief Collection were doubtlessly the highest-profile on the system, joined close behind by Playground Games' Forza Horizon titles. Around these blockbusters were the family-oriented Super Lucky's Tale, Remedy Entertainment's game-TV hybrid Quantum Break, and Keji Inafune's ReCore — to name a few.

675

676

677

678

679

680

681

682

683

675
Halo 5: Guardians
2015

676
Halo: The Master Chief Collection
2014

677
Sunset Overdrive
2014

678
ReCore
2016

679
Super Lucky's Tale
2017

680
Ryse: Son of Rome
2013

681
Quantum Break
2016

682
Forza Horizon 3
2019

683
Titanfall
2013

xbox one.

Sleek Console Stylings

Although many of Xbox One's special editions aren't as flashy as those for Xbox 360, Halo, Gears of War, and big third-party series like Call of Duty continued to receive great looking machines. These sat alongside interesting colourways that spanned all three iterations of the One's hardware but didn't tie into particular releases.

684

685

686

687

684
Xbox One Call of Duty: Advanced Warfare Limited Edition
2014

686
Xbox Forza 6 Limited Edition
2015

685
Xbox One Halo 5: Guardians Limited Edition
2015

687
Xbox One S Deep Blue Special Edition
2016

688

689

690

691

688
Xbox One S Gears of War 4 Limited Edition
2016

690
Xbox One S Fortnite Battle Royal Special Edition
2019

689
Xbox One S Battlefield 1 Limited Edition
2016

691
Xbox One X Hyperspace Special Edition
2019

FAMILY GAME NIGHTS.

words *Caleb Sawyer*

On a temperate day in December 1991, likely very near the day that I was born, my grandmother bought my uncle Ben an SNES. We were a Navy family: loads of moving, switching schools, making new friends. The only constant was my uncle's desire for a game system. They had owned an Atari, but in my uncle's words, "It was a bit wack." The SNES was *the* upgrade. The SNES was the first console his parents bought specifically for him. My grandmother recalls thinking, "Let him play himself out of it." It couldn't be more than a brief fixation, right? On Christmas Day, ten days after I was born, she let him play the entire day after he opened it. A few months of putting up with it, and then they would be able to put video games behind them. *Surely.*

In 2012, I quit playing baseball, joined the school newspaper, travelled to a journalism convention in Seattle, and then spent the summer in Saint Louis writing for any game website willing to publish my work. I ended up writing for five or six outlets, publishing over 40 pieces (news and features mixed), and starting NerdyBits. The latter became my focus in the years following. It was a year full of instrumental and drastic changes to the way I lived my life. But outside of those changes, right alongside them, truly, was my grandmother's slow and growing entry into the world of video games. She had sat on the sidelines for years, watching my uncle and I play, experiencing games vicariously through us. She had tested the waters before: a couple of nights of Street Fighter, a dip into the Borderlands bucket, a half-glance at Assassin's Creed. But during the busy summer of 2012, my uncle found the perfect onboarding game: *Portal 2*.

Now, if you were to say to me, "Hey, *Portal 2* isn't exactly a kind game to learn two-stick navigation through," then you would be absolutely right. Ben and I sat and watched on, ever patient with Nanny's slow progress, and every ten minutes we would just look at each other. It was all so surreal. Here sat my sixty-year-old grandmother, his mother, playing games with intention. It was a pivotal moment. She would study her way through *Portal 2* in a few weeks. When she finished she was adamant to attempt *Mass Effect*. Having watched us play for years, the Mass Effect trilogy had left an impression she couldn't shake. The remainder of the summer, while I tried to break into journalism, Nanny had inherited a contact high. Before Christmas, she beat *Portal 2* a second time while also finishing the first game, completed *Mass Effect 2* and *3*, and had started *Mirror's Edge*.

The first system I was ever given was a birthday present. On my seventh birthday, Ben bought me, or perhaps gave me, a Sega Genesis. I'm still not entirely sure if it was or wasn't previously his. I distinctly remember plugging it into my grandparents' living room TV on a cold December afternoon and jamming *Sonic the Hedgehog* in. I had played with Ben for years, though playing was often disproportionately coupled with watching him play things. Having my own system, my own little portal to freedom, one destined for my living room at home, was like being handed a thousand bucks. The same day Ben also gave me a list of cheat codes, the most important on the list being the instructions for how to unlock Super Sonic. He told me not to use them until I beat the game first.

I ignored that advice.

The Genesis era was a bit of a blur. I have these distinct memories, some of which will emerge from moments of nostalgia or daydreaming. Little blurs of *Vectorman*, the pang of anger accompanied by *Ranger X* and its difficulty, *Sonic & Knuckles* and playing Knuckles in *Sonic 2*, co-op mayhem in *General Chaos*. What I don't have in this period of time is any recollection of thinking about games as a career. That would come later.

photography *Damien McFerran*

My grandma just kept chugging through games. Ben was living with them during these months, so there was easy access to his entire library of games. By the summer of 2014, the list she amassed became a bragging point I worked into any conversation I could, organically or otherwise. *Deus Ex, BioShock, Braid, Fez, Thomas Was Alone, LIMBO,* Telltale's *The Walking Dead, Life is Strange.* She just kept on going. It was magical. When I graduated from college in 2014, I moved back to Saint Louis and brought my Xbox One with me. My uncle had moved out, taking his new system with him but leaving his 360 behind. Nanny built a routine around my grandpa's nap schedule; he went to the bedroom and slept, she set up shop in the living room. But in the two years since we got her started, games had pushed beyond the boundary of 'game time' and began to creep into daily conversation. In the summer of 2014, those conversations almost always centred on one thing: the impending release of *Destiny*.

We had dragged her around with us through a couple of Halo campaigns, fixing her to the turret of a warthog and mowing down enemies before they could hurt her. She had obviously begun to master the Portal games, so the FPS style didn't deter her, but the act of shooting moving targets and exploring on her own was still a bit foreign. She had tried and bounced off of *BioShock Infinite*, a game she would come back to a few years later. But the fever of *Destiny* consumed our minds. Space, exploration, the history of Bungie — we were glued to every bit of information we could get our hands on.

Then, in late July, I was at a wedding. This wedding overlapped with the *Destiny* Public Beta test. My grandma, in my absence, logged into my account and spent ten hours over two days doing everything possible. She was hooked. I constantly wonder if she ever told herself the same thing she thought about Ben back in '91. Surely she would get tired of these games and move on from them... right? Nearly ten years later, she has put more than a month's worth of hours into *Destiny* and *Destiny 2*.

In the years that followed after receiving my Sega Genesis, I would inherit three brothers (two from my mom's marriage and one via adoption) and we worked our way into a PlayStation. I would constantly have fever dreams about little tactics games I would play, or Final Fantasy titles I would start and never finish, or long nights of MLB brought to us by 989 Sports, or getting in touch with my stealth hunger in *Syphon Filter* (also a 989 joint). We had the whole setup: a multitap, four controllers, Dance Dance Revolution pads. It was the dream. We played the screws off of that PlayStation. Then, in 2004, my uncle gave us a PS2 for Christmas and my parents flipped out.

See, we were on the bottom of the economic ladder. I remember working in food pantries in the area because if you volunteered you could take home a milk crate full of food for your family. There were three of us old enough to help, so we would work every few weeks and bring

home a few crates of food. It helped us get by. So when my parents bought us four or five PlayStation games for Christmas it was a big deal. It's also worth mentioning that my parents have never really been good at technology. Not at using it, not at understanding it. So on that Christmas morning, after we opened several gifts containing games, our opening a new system kind of broke their brains. *How could Ben do that?* They thought. *Now everything we bought them has to be taken back.* A few hours later, they told Ben to take it back. We were destroyed.

What my parents, in the moment, failed to understand was the fact that the PS2 was backwards compatible. So rather than needing to return everything they had bought us, we could still play those games on the PS2. Furthermore, the PS2 also played DVDs. My uncle pitched tirelessly, but the first breakthrough was the idea my parents could plug us into a movie on the same system we played games. Less than a week after Christmas, the PS2 found its way into our living room. Enter the *Star Wars: Battlefront*, Lord of the Rings, *XIII* era of household gaming.

When I moved into an apartment with my now wife in September of 2014, the last Xbox One left my grandparents' house. Nan had received someone's 360 — not sure if it was mine or Ben's — but we left her with something to continue her habit. But a few months was all it took to realise she needed to make the leap. We bought her an Xbox One S for Christmas and her completed game list blossomed. *Deus Ex* again, *Dishonored, Tomb Raider*, all three *Mass Effects* in order (without help). We had a full-blown gamer on our hands. Grandpa began joking about it at dinner time. Conversation would inevitably dive into games and he would lean over to my wife and shrug. They would talk about other things while we dug into *PUBG* strategy.

One of our favourite stories to tell about this time centred on a visit to Best Buy to purchase a headset. My grandparents set out together to get something with better sound quality. *PUBG* had all of us by the ear and everyone had made the transition to higher-end headsets for the audio advantage. Dad-Dad (my childhood nickname for grandpa) stood by while Nan detailed what she was looking for in a headset to a Best Buy associate. I can't remember specifically which headset he suggested, but I remember logging in that afternoon and Nan being wholly displeased. When she told us what she had bought, we all echoed her displeasure and she returned to Best Buy immediately. The way Dad-Dad narrated what happened next had the family in stitches for months.

Back in the store with her previously purchased headset, she returned it and found herself in the headset aisle again. Would you believe the same associate was still there, deeply confused at my grandmother's sudden reappearance? With a twinkle in his eye reminiscent of a young man recounting the moment he fell in love, Dad-Dad

692

Destiny
2014

693

PlayerUnknown's Battlegrounds
2017

692

693

recounted a tale of an unassuming grandma explaining to a young twenty-something that the headset she had been sold just wasn't up to snuff. She needed surround sound, preferably with the ability to balance chat and gameplay sound via a dongle connected to the controller. That, while she had taken his advice to buy a cheaper headset, what she needed was the Astro A20, which she had come to buy in the first place. That, while playing *PUBG*, she needed to reliably hear incoming assailants so she could react with precision and agility. Dad-Dad described an associate entirely caught off-guard by a woman in her 60s speaking with detail and eloquence about gaming. He described a gaggle of associates who had overheard the conversation, gathering in the wings to gaze upon the spectacle before them. Nan wasn't mean or condescending, she just knew what she was talking about. The associate apologised and shook her hand afterwards. To this day, when people say I have a cool grandma, I think of this, and agree wholeheartedly.

I didn't get my first Xbox until I was given one by my childhood best friend when he moved to New Hampshire in 2010. He was moving in with his brother and he had a PS3, so he didn't need the Xbox 360. Elated I had a system to myself, just before leaving for college, I fell headlong into Mass Effect, Assassin's Creed, and *Halo 3*. Halo had long established itself as my favourite franchise. Ben used to bring his Xbox over all the time and no visit left more of a mark than the day he came over right before my birthday in 2001 and started *Halo: Combat Evolved*. I read *The Fall of Reach* over Christmas break and quickly bought each following novel for the next eight years. Now I had my own access to them, and I never turned back.

So many years later, it all feels like a whirlwind. After receiving the 360, I never missed a console launch. I waited in lines for the Xbox One, the Xbox One X, and the Series X. I had lived most of my life getting systems years late, often as hand-me-downs. Ben kept up. Nanny kept up too. When my grandpa passed suddenly in 2018, Xbox would become our therapy. Her sister bought a One S less than a month after his passing and Nanny and Kacy began a *Destiny* partnership that persists to this day. In 2020, amidst the worldwide pandemic, we started a family game night. The stories we told bubbled over into family gatherings and my mom raced to get her own Xbox. We have been playing together ever since. *Sea of Thieves*, every Halo game, *Diablo 3* and *4*, *Deep Rock Galactic*, *Anthem*, the list continues to grow. Now we all play *Starfield* and share our unique journeys.

There is something special about sharing your passion with your family. Where others have found sports, film, music, or any number of things to share, we have games. We have Xbox. 'The Moms' are getting better every day, but they still lack some of the core skills Ben and I learned over the span of 25 years. Navigating the dungeons of *Diablo 4* can get extremely tedious, not to mention trying to explain the complexity of the skill tree over party chat to two people who have never had to engage with systems like that. But despite the tedium, there are countless moments where Ben and I get to observe two people we love deeply as they experience some of the best things games have to offer. Listening to them *ooh* and *ah* at the beauty of *Anthem*, cackling at the explosions and particle effects, turned a game we played and didn't really enjoy into a lesson about stepping back and appreciating the process. We beat the Last Wish raid, without cheesing it, with a party consisting of a 29-year-old, a 30-year-old, a 42-year-old, a 49-year-old, a 61-year-old, and a 70-year-old. For me and Ben, games never went away, we just brought our moms to the party.

We get to teach them how to play while they remind us why we play. Thirty years later, Ben gets to show his mom why he never got tired of picking up a controller and blasting off into a digital world. My mom gets to understand why I became a game journalist each night as we play a game together and I explain to her why a level is designed the way it is. All of this is made possible through little boxes in our homes that have the ability to rip open portals to different dimensions while simultaneously building bridges between our own. Therapy, bonding, discovery, fellowship, family.

family game nights.

NINTENDO SWITCH.

words Alex Olney

First Released:
2017

Manufacturer:
Nintendo

Launch Price:
JP ¥29,980
US $299
UK £279

It's 2015. It's not, but bear with me, it's a narrative thing that screws with the tenses.

I've just begun working full-time for the website Nintendo Life — which is part of a network of around five full-time staff — making videos of dubious quality. It's the Wii U era, so funding is not abundant. But I'm still living with my parents, so my outgoings are limited. I'm about to spend in excess of two years surviving on what little a channel of 20,000 or so subscribers can generate. It was a dream job, but I'm not going to lie; it was tough for a *very* long time.

Late nights editing 'top ten' videos, early mornings capturing gameplay of the hot new weapons in *Splatoon*, all for the lovely people who watched — but the cromulent view counts absolutely were not worth it. I did it anyway. I did the lot, and for not a lot.

The Wii U was no longer going to be able to catch on enough to make it a success, but (it's still 2015, bear with me) Nintendo had announced something new on the horizon; an ill-defined future console. All that Nintendo revealed was a pair of letters: NX. In actual fact, it was announced whilst I was on a plane with a Nintendo representative as we flew into Frankfurt for a *Splatoon* preview event. I remember her saying that "Nintendo's announced a new console," the moment she snagged some signal, but I'm afraid you'll have to make up the colourful language that surrounded that yourself.

My relationship at the time was not entirely solid; my partner then wasn't convinced that this was a viable career. So I had two years to make a go of it. If things hadn't picked up financially by then, I had to 'get a proper job.' By 2016, that relationship was over, which is just as well all things considered, as two years and three months was precisely how long I needed to suffer the Wii U before things got better.

Now it's 2017, and I'm about to head out to the midnight launch of the Nintendo Switch, a hybrid portable device that could be hooked up to a TV on the whim of whoever had it in their hands at the time. I'd never been to a midnight launch before. They don't seem to be as big a thing in Swindon, but a new Nintendo console is apparently enough to make one happen. There were even some other people present, perhaps as many as four!

I grabbed my unit and drove back to the home of my partner's mother, who very kindly allowed me to slam it (figuratively) into her brand new and very expensive TV, despite it being about arse o' clock in the morning. I powered everything up, slipped *The Legend of Zelda: Breath of the Wild* into the card slot, and after I'd disabled the TV's frame interpolation and switched it to game mode, I stepped into a timeline where things really would get better.

The midnight launch may not have been entirely representative of the console's popularity. This thing was *big*, and we knew competition on YouTube would be fierce. Even before I'd acquired my own system, I'd been turning out videos to capitalise on the hype, and in this period, I managed to achieve one of the highest-viewed videos of my career. The timeless classic: "How to Install a Micro SD Card in Your Nintendo Switch."

But I'd have to wait for a Thursday 20 days after the console's launch before I'd reveal unto the world my most viewed video of all time: 'Top 10 Best Weapons in *The Legend of Zelda: Breath of the Wild* ft. Arekkz.'

photography Damien McFerran

If you think having a basic top-ten video as my career-topping achievement is a bit anti-climactic, then you'd be right — but despite its safe and simple nature, I don't think I'll ever forget the day it went live.

I was at my partner's mum's house again. Her internet speeds were substantially better than what I could get in my parents' house, and this *absolute unit* of a video wouldn't upload in time before I was due in that particular abode, so I just held off and waited to utilise her fibre optic connection. It was a weirdly rocky upload for some reason; I had to keep my laptop on this big wooden chest she had in her hallway. Her connection was great, but her Wi-Fi wasn't.

It shouldn't take the best part of an hour to upload an 18-minute video, but that's just the world we were living in at the time. It went live sometime later, and as I did with every video, I watched the view count rise like a technology-literate hawk. In 2015, I was happy if a video got 1,000 views overnight, but by this point, I expected that same number within an hour. I didn't get 1,000 views though. I got around 8,000.

I was ecstatic; I don't think I'd ever managed to have a success even close to this, even when *Super Mario Maker* was blowing up at the end of 2015. The numbers continued to rise at a steady rate despite what I'd picked for weapon number one, and by the time I went to bed, I was practically shaking at the sight of 50,000 views in a handful of hours. My partner, whilst endlessly supportive, was getting a bit tired of me refreshing the YouTube Studio app every fifteen seconds. So I did eventually have to go to sleep.

By Monday morning, it was sitting at nearly 350,000 views. I know that's no record-breaking feat compared to some people who film themselves harassing underpaid workers in the name of 'pranks,' but this was far and away the biggest and most successful video I'd ever produced — and at 4.7 million views, it still is.

Not too long after, I became engaged to my partner and bought her a Switch of her own. It turns out a proposal of marriage and a successful Nintendo console are enough to achieve cohabitation, even if the marriage doesn't happen for another seven years. Before the Switch was even a year old, it had provided me with enough financial stability that I was able to, at last, move out of my parents' humble abode and into an even humbler flat of my own. Two-and-a-half years after my job began, I was at last standing on my own two feet. Nuts to you, previous relationship.

This was a hell of a milestone for me. I don't want to put words into anyone's mouths, but many of those close to me, whilst very supportive, were rightly sceptical as to how viable this whole 'playing video games all day' malarkey was in the long term. Turns out it's not too bad, and now I had the monthly rent payments to prove it. I was happy, *really* happy, with the lot I'd been given. True, the water heater had significant problems, and the room sizes were limited. But the Switch had handed me my own space, and the importance of that can't be overstated.

Just as ennui is fun to type though, it also plagues us all. *Something something*, the human condition, *something something*. I could lie and say that what I'd been given was enough for me, but a year after moving into my flat, I was ready to get out. Envy is an ugly word, but as I was seeing my friends with real jobs buying homes and having monthly payments lower than my rent (a societal problem for another time), I was feeling tremendously cabin feverish. I also wanted a herb garden.

354

Portable Priorities

With both the Lite and OLED models, Nintendo further positioned the Switch as a handheld device first. The former was unable to be docked to the TV, whereas the latter's better screen obviously didn't benefit TV play either.

694

695

696

694
Nintendo Switch
2017

695
Nintendo Switch Lite
2019

696
Nintendo Switch OLED
2021

Looking back on it, maybe I was being ungrateful, but I was already somewhat tired of what the Switch was offering. *Super Smash Bros. Ultimate* may well be one of my favourite games of all-time, but after 2017 handed us *Breath of the Wild*, *Super Mario Odyssey*, *ARMS*, *Splatoon 2*, *Sonic Mania*, and so many others, 2018 just wasn't cutting the mustard for me. Despite how grateful I had been before, the Switch wasn't giving the goods to me in the same way it had before. My expectations were too lofty, and I began to resent the thing. I'm not proud of that.

2019 would bring with it another mix of emotions, and it's all thanks to a very dear friend and colleague of mine, Zion Grassl.

I'm ashamed to say that after four years of nurturing the channel and moulding it in my image, I did *not* want to share it, let alone with someone I'd never met at the behest of my bosses. In the privacy of my own head, I objected to one of the best humans joining me in my journey; the Switch had given me all that I had, yes, but it wasn't enough to go around.

This mindset was childish and painfully blinkered. The idea that what I do has a finite amount of resources to go around is unfounded, especially between such a small number of people. I don't like who I was back then, but credit where credit is due — it gave me more drive than I'd ever had before. If the new guy was going to muscle in on my territory, then my territory needed to expand. And come with a mortgage.

The first new game I played in my new house was *Luigi's Mansion 3*, but the one that sticks with me the most in those early few months was *Pokémon Sword & Shield*. It's not the best game by a long shot, and I knew that — even when I was more enamoured with it than I think I deserved to be. But for a whole week, it overtook everything I did.

I don't often get to write reviews for games these days, but being the resident Pokémon Knower™, it was down to me to understand the ins and outs of the first mainline HD Pokémon game, provided you don't count the *Let's Go* games, which I don't. From dawn to way past dusk, I imbibed everything that game could offer, from the bizarre new evolution methods to the really ropey online. I ploughed through and sunk more than 50 hours into the land of Galar for the sake of the review, while skipping meals and ruining my back with a terrible hunched posture. That was still better than the sub-20 hours I've put into *Pokémon Violet*.

I even managed to convert my deep understanding of the game into another big hit in the form of "*Pokémon Sword & Shield*: How to Evolve Applin, Snom, Yamask & More!" If you can think of a catchier title that pulls in over a million views, let us know.

The importance of this week wasn't being able to actually play games all day and get paid for it, though. The real watershed moment it bore was me leaving the channel alone for a week in Zion's hands. In that time, he proved to me that he could handle things and, just as importantly, that there was enough Switch goodness to go around. I wish it hadn't taken me so long, but I finally grew to appreciate his efforts, and him.

You could easily make the argument that without the Switch existing, I would likely never have met Zion and thus, such an arc wouldn't have happened at all. But I like to think that the Switch helped me overcome the preciousness which had stemmed from what it had given me in the first place. It makes no sense when I write it down, but in my head, it's as clear as a *really* clear thing.

The two Nintendo Switch docks may look similar — and that's because they are. The OLED dock is largely the same cradle used for connecting your Nintendo Switch to the TV that its predecessor was, but it did integrate one major quality of life feature: a LAN port. The original dock required an external LAN adaptor, much to the consternation of Super Smash Bros. Ultimate players fighting against countless combatants using Wi-Fi. Just because the OLED dock featured a LAN port didn't mean people used it, but that's another story...

697

698

697
Nintendo Switch Dock
2017

698
Nintendo Switch OLED Dock
2021

nintendo switch.

699

Corrugated Creativity

Throwing back to Nintendo's toy-making roots, the Nintendo Labo series asked players to build cardboard contraptions that their Switch system and Joy-Con slotted into which then acted as peripherals for various mini-games. Perhaps the most impressive was Toy-Con 04 VR Kit, whose virtual reality headset, alongside its compatibility with the likes of Breath of the Wild, entirely recontextualised the system. With four Toy-Con Kits released between 2018 and 2019, Labo was a prolific albeit short-lived experiment.

699

Nintendo Labo Toy-Con 04 VR Kit (Headset) 2019

Now, with my own home, having finally accepted Zion into my ample bosom, 2020 was going to be *the* year... that introduced a global pandemic which shut everything down.

As cold as it feels to say, the COVID-19 pandemic was a tremendous boon for the channel. With our powers combined, and the frighteningly timely release of *Animal Crossing: New Horizons*, Zion and I cooked up what was easily the most successful six months we ever had a duet. That was, in part, due to the fact that later in the year, we would become a three-piece with the lovely Jon Cartwright — but no one could deny that for the first half of 2020, Zion and I were a *dynamite* couple.

We would enjoy Jon's company and contributions for a little over a year before he moved on to pastures anew, but in 2022, the Switch was arguably more popular than ever. Game Freak actually made great strides in the Pokémon series with *Pokémon Legends: Arceus*, and at the end of the year, undid a lot of what it had got right.

With Jon supping from a different payslip, we had space for the wonderful Felix Sanchez. The Switch didn't feel old to me in the slightest despite its five-year vintage, so when Felix came into the picture exclaiming how he used to play *Mario Kart 8 Deluxe* with his friends at school, my bones immediately and painfully turned to dust.

I knew the Switch would be for some people what the N64 and GameCube were to me, but to be *working* with someone for whom it was a key part of their teenage years was a big ol' wake-up call for how long the Switch had been a part of my life, professionally and socially.

And it continues to provide for me to this day. I think if I'd joined Nintendo Life a year earlier, I may have already given up by the time the Switch came out, and I certainly wouldn't have the life I have right now. A home of my own, a loving partner, two sleepy cats, and a *seriously* impressive spice drawer.

I worked bloody hard, but I'd be a fool to suggest that I got here on my own steam solus. My colleagues, my family, my friends, a heaping boatload of luck, they're all to blame for me still saying "Hello there, lovely people" rather than working for a loss adjuster or something equally tepid.

But the biggest contributor was that little black-ish slab of a screen and those red and blue Joy-Con straddling it. For all the ups and downs, the growth, the mistakes, the victories, the swathes of IKEA furniture, I just want to say:

Thank you, Nintendo Switch. Thank you for everything.

Cream of the Controller Crop

Only a small group of Switch titles received tie-in Pro Controllers, often reserving that treatment for the biggest and more 'hardcore' titles on the system. From Monster Hunter to Splatoon to Xenoblade Chronicles. and The Legend of Zelda — these beautiful designs paired excellently with the sorts of titles you'd want to sit back and enjoy on the TV.

700

701

702

703

700
The Legend of Zelda: Tears of the Kingdom Pro Controller
2023

701
Splatoon 2 Pro Controller
2017

702
Xenoblade Chronicles 2 Pro Controller
2017

703
Monster Hunter Rise: Sunbreak Pro Controller
2022

357

Taking Stock

The Switch features one of Nintendo's greatest game libraries, which spans almost every IP the company owns. Not only are its games extremely well-received, nearly every series has its best-selling entry on Nintendo Switch. Super Smash Bros. Ultimate, for instance, sold more than 30 million units, trouncing the previous best-seller, Super Smash Bros. Brawl, and its roughly 13 million copies sold.

704

705

706

707

708

709

710

711

712

704
The Legend of Zelda: Breath of the Wild 2017

705
ARMS
2017

706
Xenoblade Chronicles 2
2018

707
Super Mario Party
2018

708
Super Smash Bros. Ultimate
2018

709
Fire Emblem: Three Houses
2019

710
Luigi's Mansion 3
2019

711
Pokémon Sword
2019

712
Astral Chain
2019

713

714

715

716

717

718

719

720

721

713
Clubhouse Games: 51 Worldwide Classics 2019

716
WarioWare: Get It Together
2021

719
Bayonetta 3
2022

714
Animal Crossing: New Horizons
2020

717
Kirby and the Forgotten Land
2022

720
Super Mario Bros. Wonder
2023

715
Metroid Dread
2021

718
Splatoon 3
2021

721
Pikmin 4
2023

nintendo switch.

GENERATION 9: THE STORY SO FAR .

When we started this journey back into the private lives of game consoles, the games industry — if you could even call it an industry — was a very weird place. It was inchoate and filled with possibilities, but it was also riddled with quirks and genuine oddities. The first proper game console could only depict three dots and a line, and it required plastic sheets placed on the television screen to make sense of more complex games. The first genuine hit, meanwhile, could only play a single game: *Pong*. If a video game fan from the '70s were to leap forward from the days of the Magnavox Odyssey and *Home Pong* to the present day, right in the middle of the ninth generation of game consoles, they would be dazzled. But they might also conclude that you can't have video games in any era without a little oddness, a little eccentricity.

The ninth generation's early years have been very eccentric. For most of their history, console power has noticeably increased with each new generation, with emphasis on 'noticeably.' We have the movement from 8-bit to 16-bit, which brought with it parallax scrolling, more intricate sprite work, and more expansive 2D games. We have the shift from 2D to 3D, and, following that, from relatively simple polygon worlds — simple but beautiful in their starkness and strangeness — to worlds filled with realistic textures and bump-mapping, worlds that had meaningful physics where a single virtual space could continue far past the horizon.

Such striking leaps forward in technology are no longer quite as common. The ninth generation consoles, the PlayStation 5 and the Xbox Series X|S machines, are all more powerful than the consoles of the eighth generation, certainly. When it comes to graphics alone though, you might feel you have to squint to see the differences. Ray-tracing and 4K displays deliver a certain amount of wow factor, but compare that to the leap from the Super Nintendo to the N64, or even the N64 to the GameCube, and these modern changes are more so a matter of nuance.

This shift away from obvious graphical improvements is complex. It's partly because indie games have helped bring in a revolution in which more designers and players are happy to question what a new game should look like. Should it be mo-capped, aiming for photorealism, running at 60 FPS and 4K? Or should it be an interesting, artful throwback? Should it look like an old '30s cartoon or a watercolour? Should it be *Assassin's Creed* — could it be *Cuphead* or *Dordogne* instead?

It's also because realism (or something like it) represents a tricky target for games: the closer you get, the smaller the changes seem to be. And it's also, most importantly perhaps, because the ninth generation of consoles is not about differentiation through sheer graphical grunt, although that still matters somewhat. Look at the ninth generation consoles, and what you can actually see is a series of different philosophies in play.

The PlayStation 5, like its predecessor, is well on track to being the dominant console of its hardware generation. The PlayStation 4 and PlayStation 5 both share the same lead architect, Mark Cerny, who also created Sony's beautiful curate's egg, the PlayStation Vita, started development on the new machine by speaking to game studios, including both Sony's in-house teams and third-party partners, asking what their staffs most wanted in a new console.

According to Sony, the answer was unambiguous. Any new hardware should address the problem of loading in games. Standard hard disk drives were no longer able to access information at speeds that modern games, with their open worlds and streaming needs, required. Above all else, then, the PS5 would be built around a solid-state drive, allowing for load times noticeably faster than anything that had come before.

361

Physical or Digital?

Both Sony and Microsoft came out swinging in 2020 with physical and digital console SKUs on day one. However, while Sony's two PS5 versions are identical aside from the presence of a disk drive, Microsoft's Series units have a major power disparity. The all-digital Series S is weaker than the Series X. While Sony has since released a Slim PS5 with an optional disk drive, Xbox players still have to choose between a lower-powered digital unit or the all singing, all dancing Series X.

722

723

724

725

722
PlayStation 5
2020

724
PlayStation 5 Slim
2023

723
PlayStation 5 Digital Edition
2020

725
PlayStation 5 Spider-Man 2 Edition
2023

You can see the fruits of this in a lot of PS5 games, where loading screens are significantly shorter than they would have been were the game running on the PS4. Most interesting, though, are games that find unique ways to display the power of faster loading. Insomniac's *Marvel's Spider-Man 2* has almost instantaneous fast travel around its expansive open-world New York, although it's worth noting this comes at the loss of one of the first game's sweetest gags, which saw Spider-Man, in full costume, crammed into a subway train with other commuters as he moved from A to B. Elsewhere, and even more impressive, Insomniac's colourful platformer and shooter, *Ratchet & Clank: Rift Apart*, managed to load game worlds within other game worlds, meaning that you could be exploring one level and could enter an entirely different space, tucked TARDIS-like, inside the first.

Other hardware improvements for the PS5 were far more tangible. When the console launched, it came with a pack-in game, *Astro's Playroom*, which was designed purely to show off the PS5's new controller, an evolution of the DualShock called the DualSense. With a strange two-tone visual design, which can make the controller look like it's wearing fishing waders, the DualSense also comes with Adaptive Triggers and Haptic Feedback, to allow for greater immersion. Pull a bowstring in-game, and you'll feel its tension through the triggers. When rain falls on the screen, you will sense it through the controller in your hand. Gimmick or not, when it's handled well, it feels a bit like magic.

Briefly, on the subject of the visual design of console hardware: the ninth gen has been mixed. Microsoft has made two of the most elegant and minimalist consoles of recent years — a duo of plinths, basically. Sony, meanwhile, has experimented with two tones, prongs and something that feels a bit like a cape. If for nothing else, the PS5 will go down in history as the only console that conceivably has been modelled on the home of a bad wizard, or perhaps a well-paid dentist who LARPs.

Microsoft also opted for solid-state drives in its Xbox Series X and S consoles, but while Sony's machine was clearly made with big-budget first-party games in mind, Xbox was increasingly focussed on its marquee service. Xbox Series X and S are the Game Pass machines, much in the same way that the Xbox 360 would come to be defined by Xbox Live. Game Pass offers a catalogue of games for a monthly fee, which means that as soon as you turn the console on — if you're a Game Pass subscriber — you have near endless choice.

It is impossible to overstate how important Game Pass is to Microsoft's vision for the console — a vision that increasingly suggests that one day, Game Pass might actually become the console itself, that hardware will have become pure software: an app on a smart TV or even a phone. It's a reminder that Microsoft will always, deep down, be more comfortable with software. But it's also a sign of the way our approach to games as consumers has changed over the years, changes that Microsoft has noticed.

Back at the start of the eighth generation, Microsoft tried to challenge existing ideas of game ownership in ways that almost destroyed the brand and certainly provided the Xbox One with launch troubles that it never entirely recovered from. But in 2020, with people used to Netflix and Amazon Prime replacing physical DVD collections and Spotify replacing stacks of CDs, the concept of media ownership has morphed in quite profound ways.

It can still get messy, of course. Game Pass titles are ones that you may come to *feel* you own, until one day they disappear from the service and you're reminded that you're merely a subscriber. Equally, Game Pass has had a profound impact on the business models of publishers and developers — particularly indie studios. Audiences are now more likely to hold back from a purchase because the game might come to Game Pass at some point. The financial realities of this are very different to the realities of making a game that you try to sell to as many as possible. It can be an uncomfortable place to be, particularly since huge companies have proved, time and time again, that they're not always worthy of trust when it comes to being custodians of a marketplace.

PS5 has its own game subscription service, and many third-party publishers have their own as well — but Game Pass has provided Microsoft with something that it can truly be a leader in. And for now, in the ninth generation, it means that Sony and Microsoft's machines really do represent different visions for the future. One is trying to sell discs, or at least games, above all else. Another would prefer a monthly payment.

As different as the machines are, they both share a lot of similarities. As the demand for physical media retreats, both Sony and Microsoft decided to launch two versions of their consoles, one with a disc drive and one without (although the Series S has other compromises in terms of power, which are increasingly making developers forced to aim for platform parity a little irritated). Both have experienced what the industry terms soft transitions, too. Many Xbox Series X|S games still support Xbox One, just as many new games on Sony's platform are available on both PlayStation 4 and 5.

Tied to this concept is the idea that backwards compatibility is only becoming more important in general. Why is this? In the days of previous hardware transitions, players were still used to the idea that their new machine would not run games for its predecessors — and that both old games and old hardware would eventually work themselves into the attic or onto eBay. Steam, though, introduced PC audiences to a world in which their game collections could follow them around from one machine to the next, and now console audiences expect the same

thing. It's worth remembering that games as an art form are older now, too. Along with the sense of history comes the desire to preserve and make sense of it.

So along with the soft transition, Sony can boast that 99 percent of PS4 titles work on the new machine, while Xbox is similarly focussed on keeping older games playable as much as possible. It's lovely to see that when more and more smartphone games — even classics — disappear into the abyss with each hardware upgrade, over on consoles, there is a movement to keep games around in a meaningful way.

This has its limits, though. And the limits are often commercial ones. Just as Disney+ or HBO Max will make films and then pull them from release, effectively snuffing them out because the spreadsheets tell them to, earlier in 2023, it was announced that Crystal Dynamics' big-budget *Marvel's Avengers* would be sunsetted. This was a gigantic game, and a recent one. Player memories aside, it represents a lot of people's work for a meaningful chunk of their lives. As more and more big games follow the live service route, there is more and more danger that one day, once the numbers have started to go down, the servers will be unplugged and whole worlds of imagination will be lost.

In fact, if there's another thing that defines the ninth generation, alongside the focus on continuity and convenience represented by services like Game Pass and backwards compatibility, it's an absence of games, relatively speaking. Over ten years ago, publishers started talking about having to make fewer-and-bigger bets when creating games. It led to mega-series like Assassin's Creed and Forza, but it also meant that publishers that might once have made tens of games every year were now releasing far fewer. Bigger games with longer tails, but less of them — which means less range in the catalogue and less exciting risk in the ideas being presented.

To see this play out, all you have to do is look at the launch titles for the PlayStation 5 and Xbox Series X|S. In terms of exciting new games to play on day one, whichever console you chose, the ninth generation got off to a rather lacklustre start. Including cross-platform games, there were standards like the latest instalments of *Assassin's Creed* and *Call of Duty* to pick from, but on the Xbox, real first-party exclusives were almost non-existent — even *Gears Tactics* had previously appeared on PC.

Sony fared better, with a sequel to *Marvel's Spider-Man* featuring Miles Morales in the lead, but the heavy lifting was handled by *Demon's Souls*, a new version of a PS3 cult classic, yes, but an absolutely luxurious remake. Even with that, though, there was nothing like the breadth and depth that previous hardware launches had required. And as the months passed, more remasters and upgrades followed. Many Xbox owners spent the first months with their new machines playing standards like *Fortnite*.

Over time, the generation has found its feet, but those fewer, bigger bets still mean that stand-out first-party games are often sequels, like *Halo Infinite*, and that is a live game to boot. Once again, if you're after invention and imagination in games, the indies are leading. The desire for cosy games and wholesome games means that you're never far from a witch simulator or a game about running a post office for root vegetables, regardless of your platform.

Elsewhere, the ninth generation has seen a continued growing understanding of the needs of players with disabilities. Following the release of Microsoft's excellent Adaptive Controller, Sony — whose shift to DualSense actually shut a lot of players with disabilities out of their games as bespoke hardware solutions were no longer supported — announced the PS Access controller which can be reprogrammed and reconfigured from one game to the next. Unlike the Microsoft product, it's a controller rather than a hub, and with half the inputs of the DualSense, it's far from ideal. But it's a start. Publishers like Ubisoft, meanwhile, have joined Microsoft and Sony in putting genuine effort into accessibility options within their games, and so we're moving — too slowly still — towards the day when video games really are for *everyone*.

Meanwhile, it's worth remembering that Xbox and PlayStation don't tell the whole story of a console generation. Nintendo Switch, which also belongs to the eighth generation of hardware, has continued to be a place for wonderful games throughout the ninth, with in-house series that other platform holders can only dream of. At the very least, the Kyoto-based outfit lags far behind everyone else in terms of accessibility thinking, so there's very clear room for improvement in its Switch successor.

Where do games go from here? For one thing, there will continue to be a greater focus on how games get made. The number of stories illuminating practises like crunch and revealing the depths of sexual harassment and other abusive behaviour within studios and publishers has started to bring necessary and long overdue change. Beyond that, it can be hard to tell. Games are becoming more diverse both in terms of their audience and the people making them, but we're also still deep in the era of fewer, bigger bets. On top of that, it's a time of massive consolidation within the industry. In the last few years, Sony has bought numerous studios, while Microsoft has bought huge publishers like Bethesda and — after a lot of legal manoeuvring — Activision. All of these decisions have massive implications on the future of games and consoles.

Everybody seems to have a competing idea of where things are headed, but it's tempting to say that the future of game consoles is unguessable. But then again, if you look back to the Magnavox Odyssey and the strange creatures that flickered to life in the first console generation, you'd know that this is always the case.

726

727

728

726
Xbox Series X
2020

727
Xbox Series S
2020

728
Xbox Series X Console Wrap [Starfield]
2023

Infinite Possibility

Console customisation has become more modular than ever this generation. While both Sony and Microsoft alike are still releasing beautiful limited edition consoles which tie into their biggest games (like Spider-Man 2 or Halo Infinite), they're also offering ad-hoc design pieces as well. The launch PS5 models feature interchangeable faceplates, whereas the Xbox Series X supports magnetic console wraps.

729

729
Xbox Series X Halo Infinite Edition
2021

Although the rare title like Demon's Souls has remained available solely on PS5, both Sony and Microsoft have taken increasingly large steps towards mitigating the presence of exclusive titles. Games like Returnal and Deathloop, for instance, began as PS5-only releases before arriving on PC and Xbox, respectively.

730

731

732

733

734

735

730
Returnal
2021

731
Halo Infinite
2021

732
Ratchet & Clank: Rift Apart
2020

733
Starfield
2023

734
Demon's Souls
2020

735
Deathloop
2021

367

Collaborations Through Time

No matter how much changes with each generation, our favourite teams and their partners forge ahead. Armored Core has been with PlayStation forever — from PS1 to PS5. FromSoftware has also released key Sony-exclusive Soulsbourne titles alongside multiplatform hits like Elden Ring. Microsoft and Team Ninja's early collaborations on Ninja Gaiden have flourished into games like Wo Long: Fallen Dynasty. Naughty Dog has gone from Crash Bandicoot to The Last of Us and Uncharted with Sony. Atlus continues to bring Shin Megami and related RPGs (like Soul Hackers 2) to Microsoft systems, from SMT: Nine to Persona 3 Reload. Despite the inherent competition between these companies and their players, the medium's collaborative spirit has only grown stronger.

736

737

738

739

740

741

742

743

744

745

746

747

736
Armored Core
1997

737
Elden Ring
2022

738
Armored Core VI
Fires of Rubicon 2023

739
Crash Bandicoot 2:
Cortex Strikes Back 1997

740
Uncharted: Legacy of
Thieves Collection 2022

741
The Last of Us Part I
2022

742
Ninja Gaiden Black
2005

743
Stranger of Paradise:
Final Fantasy Origin 2022

744
Wo Long: Fallen Dynasty
2023

745
Shin Megami Tensei: Nine
2002

746
Persona 3 Reload
2024

747
Soul Hackers 2
2022

Although new IPs like Returnal and Avowed are making headlines, generation nine has been one of sequels in long-standing franchises. Final Fantasy remains prolific as always, as does Forza. Even dormant series like LittleBigPlanet and Psychonauts found their way back!

748

749

750

751

748
Sackboy: A Big Adventure
2020

749
Final Fantasy VII Rebirth
2024

750
Psychonauts 2
2021

751
Forza Horizon 5
2021

752

753

754

755

752
Mortal Kombat 1
2023

753
Prince of Persia: The Lost Crown
2024

754
Lego Star Wars: The Skywalker Saga
2022

755
Hogwarts Legacy
2023

Although many will put the Nintendo Switch in the eighth generation, there is solid case for it belonging in the ninth too. Regardless of where you classify it, many titles cross-release on PS5, Xbox Series X|S, and Switch — albeit with noticeable levels of compromise, like with NBA 2K. The best performers are titles like Sonic Superstars or LEGO Star Wars, games which also came to PS4 and Xbox One, or games like No More Heroes III and Prince of Persia, which targeted Switch as their primary platform. Titles like Mortal Kombat 1 or Hogwarts Legacy, whose only console launches were on PS5, Xbox Series and Switch, are compromised to near unplayable levels on Nintendo's system. Others still, like Guardians of the Galaxy, made it over only via the cloud!

756

757

758

759

756
NBA 2K23
2022

757
Sonic Superstars
2023

758
Marvel's Guardians of the Galaxy
2021

759
No More Heroes 3
2021

generation 9: the story so far.

RETURNAL

Developer:
Housemarque

Publisher
Sony Interactive Entertainment

Release Year:
2021

Available on:
PS5, PC

Housemarque has long held a prestige position in the PlayStation ecosystem, responsible for defining titles like *Resogun* and *Nex Machina*. However, *Returnal* took the studio's signature arcade design philosophy to an entirely new level of ambition. Pulling from *Alien* and Metroid alike, *Returnal* is an austere, foreboding work of sci-fi excellence. Layer on best-in-class gunplay alongside roguelike design, and you have a woefully overlooked ninth-gen gem.

760

761

760
Returnal
2021 (America)

761
Nex Machina
2017 (America)

372

CYBERPUNK 2077: ULTIMATE EDITION

Developer:
CD Projekt RED

Publisher
CD Projekt

Release Year:
2023

Available on:
Xbox Series X|S, PS5, PC

Cyberpunk 2077 is doubtlessly one of the medium's most notable and notorious works. Its eighth-gen console ports were near unplayable when the game originally released in 2020, marring both the studio's reputation and the creative brilliance of *Cyberpunk* itself. However, if that controversy turned you away from the game — give its Ultimate Edition a look and experience this masterpiece as it was meant to be played. Launched in 2023, this re-release features years of technical and gameplay improvements alongside the brilliant *Phantom Liberty* expansion. There's never been a better time to dive into the deeply immersive Night City, dense with quest lines and refined action-RPG mechanics.

762

763

762
Cyberpunk 2077
2020 (America)

763
Cyberpunk 2077: Ultimate Edition
2023 (America)

PRESERVATION THROUGH USE.

words Abram Buehner

"In the late 1970s, I went to a screening of a film made in the mid-'50s called *The Seven Year Itch*, by Billy Wilder, shot in the Eastmancolor process. This was the studio archival print of the picture with the iconic image of Marilyn Monroe. The lights went down, the screening began, and we were shocked by what we saw. The colour had faded so dramatically that it was almost impossible to actually see the film," Martin Scorsese wrote for Britannica in 2018, expressing his ardent belief in the necessity for film preservation. "This was beyond mere fading. This was visible evidence of deterioration and, since it was the studio print, of neglect."

The year was 2005. Players in America and Europe were enjoying *Donkey Konga 2*: the bongo-slapping rhythm game sequel from Namco and Nintendo which built on the chaotic fun of its predecessor. However, in Japan, players were already onto *Donkey Konga 3* — which actually hit the platform prior to the launch of *Donkey Konga 2* in the west. The third title never left Japanese shores, likely due to the low appetite for another entry so soon.

Here in North America, our Konga games were odd. Their tracklists were composed almost entirely of lowly cover band renditions of tunes like Smash Mouth's "All Star." You had the occasional Nintendo theme thrown into the mix, but you'd often spend your time trudging through these awkward, off-brand warblings. Well, Japanese players got a robust selection of Famicom songs to enjoy in *Donkey Konga 3* alongside other GameCube era Nintendo jams. I wish we had that same privilege in the States. So, the game remains high on my 'To Import' list.

But it's seemingly low on the mental register of pretty much everyone else. You'll be hard pressed to find anyone talking about *Donkey Konga 3*, least of all Nintendo itself. While it's safe to say that the game is no *The Seven Year Itch* (I doubt that future generations of students will study it as I studied the Wilder movie for my film degree), I feel similarly disquieted by the concept of 'neglect' that Scorsese posits.

A 2023 Video Game History Foundation report on the commercial availability of classic games (meaning any title released before 2010), written by Phil Salvador, found that "87 percent of classic games released in the United States are out of print. The results are striking, and [they prove] that we need to rethink the commercial marketplace's role in game preservation." I was able to pop over to Amazon Prime Video and spend $3.99 to instantly view *The Seven Year Itch* ahead of my class discussion (I could've grabbed it new on Blu-Ray also) — no analogous access exists for *Donkey Konga 3*.

I find it deeply unlikely that Nintendo will hurry to rectify this. I don't expect to wake up and find this game on the eShop. I certainly don't expect to have a re-released bongo controller available too. I *could* sate my DK desire with *Donkey Kong Country: Tropical Freeze*, or my Konga-particular interest with *Taiko no Tatsujin: Rhythm Festival* (the Switch iteration of the series which Konga hails from), but that's not the same.

"The problem is that video game history is more than just the bestsellers. If we want to understand and appreciate the history of video games, we need more than a curated list of the games that publishers decide have commercial value," Phil Salvador writes.

As University of Virginia Library's Brandon Butler remarked in this same report, "Previous studies on sound recordings, films, and books have shown that regardless of rights holder rhetoric about digital distribution and the 'long tail,' the commercial market continues to focus on new releases. This leaves libraries and archives as the only reliable long-term stewards of cultural heritage."

photography *Imogen May*

With this knowledge, I travelled to Sweden alongside Lost In Cult's Visual Director, Imogen May, to visit the Embracer Games Archive. Situated in Karlstad, Sweden, this archive contains over 80,000 commercially-available objects split between games, systems, and peripherals. The archive's intent is to curate history and culture for the benefit of the games industry, researchers, and players worldwide — not only keeping this legacy safe but also cultivating an archival space that acts as a hands-on, accessible resource.

"The initiative and idea for the Archive came from Lars Wingefors, who is the CEO of The Embracer Group." The Embracer Games Archive's CEO, David Boström, explained. "He had this very big video game collection that he built up. There were around 50,000 objects at that time. And he started thinking that it's a shame that these games [were just] lying around. They could become of use and be helpful for the video game industry, and help to promote culture and video game history."

From there, The Embracer Games Archive was born — sat in an industrial complex unassuming on its face, a monolith of little businesses joined within one massive, unassuming structure. At its front is a buffet-style cafe. It was here that I ate a quick and delicious schnitzel, as it did the backstroke in a pool of butter sauce. Around the side of the building sat a small parking lot, where we left our rented yellow sedan. It was a splash of colour against an otherwise meagre facade defined by warehouse-styled doors and plain walls.

The one sign that something grand was afoot peeked out from a window: the spiky hairdo of Kazuya Mishima

which, on closer inspection, revealed itself to be part of a massive Tekken statue. Yet, this is a treasure that doesn't even belong to the archive (despite David's best efforts), but to the Game Outlet Europe which shares the space. Stepping through the outside door, we entered the equally modest hallway to the archive itself, adorned with a PS2 demo kiosk which greeted us on the way in.

Once inside, the exterior's modesty fell away. The archive's ceilings were loftily high and the floorplan immaculately clean: an organised, modern home for the past, present, and future of games. The white walls were carefully adorned with framed posters celebrating titles from *Resident Evil 4* and *Super Mario Bros. Advance* to *Doom 3* and *Starcraft* — placed among more retail console kiosks which stood like monuments emblazoned with the likes of *Halo: Combat Evolved* and *Mario Kart 64*.

There's even an ultra-rare Virtuality VR setup (on which I played the compelling albeit dizzying *Pac-Man VR*) poised along a dividing wall, one of many astounding curios that the team curated in its few short years in business. "When I saw this job listing [for Archive CEO], I couldn't believe it was true," David recalled. "I'd been working as a team leader at warehouses, and I'd been playing and collecting video games for my whole life. So I could combine these two: my working career and my biggest interest. So I felt right away [that] this was the perfect job for me, and eventually I got it. It was the best day of my life!"

Beside the Virtuality stretched a generational tour of PCs and home consoles, and here Technical Engineer Jukka Kovalainen set us up with a late-'70s SHG Black Point console: a first-generation system of the sort that he remembers from growing up in Finland. As he and I competed in its then-sophisticated racing game, the spirit of historical discovery intrinsic to this space and the personal resonance which informed it became clear with every nudge of that 1978 joystick.

Maintaining the archive's objects in working condition is a cornerstone tenet of the project. "We really want to be able to use the items in the archive ... that's very important," Chief Archivist Natalia Kovalainen explained, describing her central doctrine of preservation through use. "We are ... really making sure that people can experience games as they were experienced when they were created."

That Black Point console is double my age and beyond the scope of my games scholarship — getting to go hands-on with it was a uniquely important experience. My historical experience with the medium comes from re-releases, compilations, and digital distribution foremost: wonderful tools for modern games scholarship but ones that woefully lack a particular dimension. "The human connection to the games," Natalia suggests. "That's hard to [illustrate] if we don't have the actual hardware. [It

allows us] to understand why people sat so close to the TV while they played the games, or why a joystick looks like it does today, because we can look back and say 'oh my gosh, that's where we started and here we are now!' There are many lessons to be learned."

These lessons are well-guarded, as statues of Master Chief and Lara Croft tower above the space. They stand atop an outcropping against the back wall, watching over the entrants and protecting the sophisticated coffee maker which has pride of place in the open-air kitchenette beneath John-117's feet. This area was purpose-built by Jukka. Here we enjoyed espresso and Swedish cookies around a bleached wood table as we pored over game books next to a carousel of Retro Gamer magazines.

Around the corner, beyond the kitchen, kiosks, and console setups, I was met with the team's desk spaces tucked inside their office room. Its walls are dense with complete-in-box games, vintage posters, and shelves of action figures — relics from around the archive with personal significance to each team member. Across from the offices long shelves sprawled containing multitudes: a library of game books, magazines, documents, as well as assorted collectors' editions and collectibles. And under the watchful eye of a *Destroy All Humans* statue: a complete set of Famicom titles — just one floor-to-ceiling display of many.

Past the office and past the library, through the towering threshold that divides the Embracer Archive in two, is its heart. An ornate, colourfully-lit stage sits to the side, surrounded by everything from a Vectrex to rare Nintendo 64 console bundles. Every object of my awe sat around the room. As my eyes scanned clockwise the room held just as many treasures beyond the stage in the archive's proper displays — full walls of Nintendo and Atari and Sega games caressed the perimeter, their volume still paling in comparison to the riches housed

inside the automated archival shelves that shuffled back and forth as we peered down row after row of full console sets and further unpacked boxes containing even more curios than the team has had time to organise.

The archive is as concerned with modern titles as it is classic ones. I traced my fingers along a wall of Xbox 360 spines and pulled out various boxed Nintendo 64 games as David and I discussed hidden gems on the system. I could've become lost in these shelves for weeks, invigorated by the magnitude of the collections. But it wasn't just the libraries of my favourite systems that I wanted to peruse. Standing in front of countless Commodore 64 titles with Jukka, I felt a desire to dive into the world of British PC gaming which largely passed me by.

When you can reach out and touch history, it's easy to be enveloped by curiosity. And it's this virtue which motivates game preservation. The archive is one thread in a larger tapestry of organisations working together with a common mission: tackling the urgent need for games' legacy to be curated for future generations to learn from and enjoy.

Considering that the problem of game preservation is so pressing and so large, it can often feel *too* big, perhaps abstract. Standing in the archive though, surrounded by thousands of games "critically endangered" (a term from The Video Game History Foundation which describes games out of official circulation) — all singing thanks to the enthusiasm of their curators — the peril once more becomes tangible.

When you sit down with Natalia and hear about her love of big box PC games, as she guides you through *The Secret of Monkey Island*'s inserts and Dial-a-Pirate anti-piracy measures, the issue of preservation is particularised. Holding a piece of history, assessing its details, the quirks intrinsic to its physical form, you begin to recognise what's being effaced by time.

Protection Misconceptions

Imagine your holy grail game — the one immensely rare and unfathomably expensive classic you've always wanted in your collection. It'd be incredible to find it sealed, right? Well, as Jukka explained, sealed games are actually ill-preserved. Over time, the shrink wrap will contract and destroy the packaging within. Even a steelbook can be crunched by this slow and constantly exerted pressure!

preservation through use.

The Details of History

One of the archive's collection goals is to acquire every regional variant of each game it houses — the team doesn't want any nuances lost to time. Regional game variants tell unique stories, each valuable and distinct. The archive team doesn't want to lose sight of that truth, capturing the experiences of everyone around the world in a global endeavor to remember details of this medium we cherish together.

And groups the world over have experienced this moment of recognition. "There are many, many efforts [from] different institutions and passionate people out there," Natalia explained. "But I do think that many of us are working in our own little chamber. And therefore I think one of the most important things that we have to do right now is start collaborating ... because preservation can't be done by just one person or one institution." The field is effectively advanced only when these groups all move in the same direction, while also employing disparate methodologies. "We are preserving the physical aspect, but there might be an institution able to do digital [preservation of games] or [that can] preserve their scans or maybe preserve playthroughs, or do other types of work from what we do here," Natalia considered.

We think often about archival work reductively as tradition, a rote process that has existed before we did, that will continue long after us. We think of dust and indexes and stasis — books and film reels and artwork

sequestered away in a vault somewhere. The archive team uniquely stands at the forefront of a movement with peers who together are pioneering a vocabulary and process that responds to this new frontier.

A frontier with sights that respond to the unique affordances and challenges of games. These sights look like Jukka poised over a decrepit CRT display, expertly tinkering it back to health alongside a vintage console he's masterfully swapped the power supply of. They look like Archive Administrator Mikel Rylander arranging a trove of Atari titles by packaging type and colour, building a wall-spanning rainbow of titles, each easily recalled and explained by his rich enthusiasm for the era which goes well beyond anyone else I know — complicating my understanding of the period while I traded him facts about the Nintendo 64 Disk Drive.

The archive's future lies in this exchange and the revelry of building shared knowledge. "We're trying to make [our] database publicly accessible. And not only that, we're also looking into how to better communicate [the technical knowledge of how to play old] games. For example, how to connect an Atari 2600 or Commodore 64 to a screen and play it, and so on. So with that kind of information, we're looking to create a Wikipedia or a similar kind of site, with the help of others. This has to be a collaborative effort," Jukka explained.

Doing our small parts to preserve what facets of culture we can is an endeavour that we should all undertake and celebrate. There is so much more to preserving a game than just the game itself. You can catalogue trailers and press events. You can film the ephemeral ads on buses and

billboards before they're taken down. You can scan game manuals or magazines. You can share information with the Embracer Games Archive or donate to it. You can do the same for archival initiatives around the world! There are countless small and large ways that we can contribute to the ever-advancing field and capture the dynamic elements of culture that become lost to time.

We can't sit passively and just wait for game companies to sort this out themselves — there's no shortage of evidence that they won't. But at the same time, community-driven preservation isn't just a second-string defence to employ when corporations practise neglect. Even when work is readily available, we cannot sell short either the essential personal or academic value of preservation. A game's preservation isn't 'complete' when a copy has been safely added to the archive shelves. Thus, we return to preservation through use: the ignition of curiosity, research, remix, analysis.

The Seven Year Itch wasn't preserved merely to be watched (although that is the essential dimension), it was preserved to also be learned from. The time that I spent discussing its social politics, its production context, its themes, its filmmaking technique — this all enriches the art and is born from a passionate interest to save the film, to treat it with care and to appreciate it as part of a larger context.

Even the ideal environment wherein Nintendo simply throws *Donkey Konga 3* onto its digital storefront is not

enough. If we existed in a landscape wherein the *totality* of games history was available at our fingertips, we'd still need The Embracer Games Archive. We need it to stand not only as a stronghold keeping games safe, but also as the place which facilitates that curiosity, research, remix, and analysis which takes us deeper into the work. The archive is not a closed-off site — its doors are regularly opened to scholars, developers, school groups, and more. The team is passionate about assisting others in their preservationist pursuits. The archive is both a resource to learn from and also a motivating, friendly space to learn within.

Ultimately, preservation is about taking games seriously and taking a multi-disciplined, collaborative approach to their celebration. After all, games have such a wonderful personal significance for so many of us. That must not be lost to time. Ever since the inception of the medium, before even the days of the SHG Black Point, games were meant to be shared and emotionally connected with. Something as silly as a mid-'00s rhythm game starring a big gorilla wearing a necktie that you control by smacking a plastic bongo drum is a harbinger of memory and fun which should be aptly treasured and studied.

"When everything is settled down and the database is [working] correctly, I would really like to somehow put up a linked database ... putting in people's stories so that we can also study them in the future. What was it like when you opened your Nintendo 64 for the first time? Or for a ten-year-old, [what was it like] to actually play on an old Commodore 64? Those are things that I would really like to see," Natalia remarked.

The Embracer Games Archive should be heralded as a home for this personal, cultural and academic knowledge — a hub that leads preservation efforts in its space, that uplifts the stories of games and their players. Its walls radiate with the evident passion of its staff and draws in the curiosity of others. The space is a monument to not only the legacy of the medium but also the relationships it has cultivated, the personal resonance it has. And that resonance will only continue to grow stronger.

"Everyone knows about the Svalbard Global Seed Vault. We want to be that for games. So that when people [say], 'yes, I want to [learn about] games,' then they come to Karlstad, Sweden," Natalia exclaimed. "That would be awesome!"

379